Artists
of the
Renaissance

Artists
of the
Renaissance

ℑ

IRENE EARLS

Artists of an Era

GREENWOOD PRESS
Westport, Connecticut • London

Library of Congress Cataloging-in-Publication Data

Earls, Irene.
 Artists of the Renaissance / Irene Earls.
 p. cm. — (Artists of an era, ISSN 1541–955X)
 Includes bibliographical references and index.
 ISBN 0–313–31937–5 (alk. paper)
 1. Art, Italian. 2. Art, Renaissance—Italy. I. Title. II. Series.
N6915.E172004
 709'.45'09024—dc22 2003061267

British Library Cataloguing in Publication Data is available.

Library of Congress Catalog Card Number: 2003061267
ISBN: 0–313–31937–5
ISSN: 1541–955X

First published in 2004

Greenwood Press, 88 Post Road West, Westport, CT 06881
An imprint of Greenwood Publishing Group, Inc.
www.greenwood.com

Printed in the United States of America

The paper used in this book complies with the
Permanent Paper Standard issued by the National
Information Standards Organization (Z39.48–1984).

10 9 8 7 6 5 4 3 2 1

Copyright Acknowledgments

The author and publisher gratefully acknowledge permission to reprint the following material:

Excerpts from *Renaissance Art*, Irene Earls. Copyright © 1987 by Irene Earls. Reproduced with permission of Greenwood Publishing Group, Inc., Westport, CT.

Text extract reproduced from *Signs & Symbols in Christian Art* by George Ferguson, copyright © 1956 Phaidon Press Limited.

Text extract reproduced from *Donatello* by David G. Wilkins and Bonnie A. Bennett © Phaidon Press Limited.

Excerpts from *The Oxford Companion to Art*, edited by Harold Osborne. Copyright 1970. By permission of Oxford University Press.

Excerpts from *Lives of the Artists Volume I*, by Giorgio Vasari, translated by George Bull. Penguin Classics, 1965. Translation © George Bull, 1965.

Michelangelo, by Howard Hibbard. Copyright 2004 by Perseus Books Group. Reproduced with permission, via Copyright Clearance Center.

Dictionary of Subjects and Symbols in Art, by James Hall. Copyright 1979 by Perseus Books Group. Reproduced with permission, via Copyright Clearance Center.

History of Italian Renaissance Art, 3/E by Frederick Hartt, © 1988. Reprinted by permission of Pearson Education, Inc. Upper Saddle River, NJ.

Contents

Color plates follow chapter 6.

Preface

This book focuses on 10 Italian Renaissance artists, each selected because of advancements in painting, sculpture, or architecture from the fourteenth to the sixteenth century. Each artist's entry provides a brief biography and details on some of his important works and contributions to the history of western art.

Arranged in alphabetical sequence, all entries are easily accessible. For further reference, the book provides a bibliography at the end of each entry. Also, although unusual terms are defined within the text, a glossary gives extended definitions. Finally, the subject index includes the names of other important and involved persons, general vocabulary mentioned in the text, and key words and phrases.

Always, before anything else, thank you to Ed Earls. A special thanks to the memory of Edgar Ned Newman, New Mexico State University. Very special recognition goes to Debby Adams at Greenwood, who worked especially hard to begin the project. Thanks to Edward DeZurko, University of Georgia, my endless inspiration; and Fernand Beaucour, Centre d'Études Napoléoniennes, Paris, who is always there for details. Also, thanks to editor Rob Kirkpatrick at Greenwood, who patiently read the entries and made important suggestions; Liz Kincaid at Greenwood, who handled the book's photographs; Audrey Klein; and the employees at Impressions. Finally, thanks to librarians Sandra Steel, Connie Maxey, Ann Black, and Judy Schmidt, who have always gone beyond the call.

Timeline

Beginning (not ending) dates are given for painting, sculpture, architecture, and other entries.

1228/30 Birth of Jacobus de Voragine, author of *The Golden Legend*
1266/7 Birth of Giotto
1302 Dante Alighieri writes *The Divine Comedy*
1304 Petrarch, Italian poet and humanist born
1305 Arena Chapel frescoes in Padua
1305 Giotto's *Joachim Takes Refuge in the Wilderness*
1305 Giotto's *Vision of Anna* or *The Annunciation to St. Anne*
1305 Giotto's *Meeting at the Golden Gate*
1305 Giotto's *The Annunciation*
1305 Giotto's *The Raising of Lazarus*
1310 Giotto's *Madonna Enthroned*
1334 Giotto's Campanile or Bell Tower for the Florence Cathedral
1337 Death of Giotto
1348 Black Death in Florence and Siena
1353 *Decameron* by Boccaccio
1370 Birth of Leonardo Bruni, Florentine responsible for theory of republican government
1377 Birth of Filippo Brunelleschi
1378 Great Schism in the Catholic Church
1386 Birth of Donato Donatello

1401	Birth of Masaccio
1404	Birth of Leon Battista Alberti
1406	Birth of Fra Filippo Lippi
1408	Donatello's marble *David*
1411	Donatello's *St. Mark*
1412	Birth of art patron Marquis Ludovico Gonzaga
1412?	Birth of Joan of Arc
1415	Donatello's *St. George*
1417	Donatello's *St. George and the Dragon* relief
1417	Donatello's *rilievo stiacciato* (or *schiacciato*)
1420	Brunelleschi's Dome of the Florence Cathedral
1420	Brunelleschi rediscovers one-point perspective
1420	Brunelleschi's Foundling Hospital (*Ospedale degli Innocenti*)
1423	Donatello's *The Feast of Herod*
1425	Masaccio's *Tribute Money*
1425	Masaccio's *Holy Trinity*
1425	Masaccio's *Expulsion of Adam and Eve from Eden*
1425	Masaccio's *Raising of the Son of Theophilus*
1426	Masaccio's Pisa polyptych
1426	Masaccio's *Crucifixion* for the Pisa polyptych
1426	Masaccio's *Adoration of the Magi* for the Pisa polyptych
1426	Masaccio's *Enthroned Madonna and Child* for the Pisa polyptych
1428	Death of Masaccio
1431	Birth of Andrea Mantegna
1432	Birth of Marsilio Ficino, Neoplatonic philosopher
1434	Medici family dominates Florence
1436	Alberti writes treatise on painting, *Della Pittura*
1437	Fra Filippo Lippi's *Tarquinia Madonna*
1437	Fra Filippo Lippi's Barbadori altarpiece
1440	Donatello's bronze *David*
1440	Fra Filippo Lippi's *The Annunciation*
1445	Donatello's *Equestrian Monument of Gattamelata*
1446	Alberti's Malatesta Temple
1446	Death of Filippo Brunelleschi
1446	Alberti writes architectural treatise *De re Aedificatoria*
1450s	Fra Filippo Lippi's *Madonna Adoring Her Child*
1451	*On the Dignity and Excellence of Man* by Giannozzo Manetti
1452	Birth of Leonardo da Vinci
1452	Alberti's Palazzo Rucellai
1452	Fra Filippo Lippi's *Madonna and Child*
1452	Fra Filippo Lippi's *Feast of Herod*

1453	Hundred Years' War ends
1453	Constantinople falls to Turks
1454	Mantegna's fresco *Saint James Led to Martyrdom*
1454	Mantegna's fresco the *Martyrdom of St. James*
1454	Donatello's *Mary Magdalene*
1454	Mantegna paints frescoes in Ovetari Chapel
1454	Invention of movable type by printer Johannes Gutenberg
1455	Fra Filippo Lippi's *Madonna and Child with Angels*
1458	Alberti's Santa Maria Novella
1458	Papacy of Pius II
1460	Mantegna's *Agony in the Garden*
1465	Mantegna's *di sotto in sù* perspective
1466	Mantegna's *Dead Christ*
1466	Mantegna's *in scurto* perspective
1466	Death of Donato Donatello
1469	Death of Fra Filippo Lippi
1469	Brothers Giuliano and Lorenzo de' Medici rule Florence
1470	Leonardo's *Annunciation*
1471	Papacy of Sixtus IV
1472	Death of Leon Battista Alberti
1474	*Camera degli Sposi.* Mantegna's *Room of the Bride and Groom* in the Gonzaga Palazzo Ducale
1475	Birth of Michelangelo
1478	Death of Marquis Ludovico Gonzaga
1483	Leonardo's *Virgin of the Rocks*
1483	Birth of Raphael
1484	Papacy of Innocent VII
1489	Michelangelo's *Madonna of the Steps*
1492	Papacy of Alexander VI
1497	Michelangelo's *Pietà*
1498	Leonardo's *Last Supper*
1501	Michelangelo's *David*
1503	Papacy of Julius II
1504	Raphael's *Marriage of the Virgin*
1505	Leonardo's *Mona Lisa*
1505	Raphael's *Madonna of the Meadows*
1506	Death of Andrea Mantegna
1508	Leonardo's *The Madonna and St. Anne*
1508	Michelangelo's Sistine Chapel ceiling
1509	*In Praise of Folly* by Erasmus
1510	Raphael's *School of Athens*

1512	Raphael's *Galatea*
1512	Raphael's *Sistine Madonna* (**Madonna di San Sisto**)
1513	Niccolò Machiavelli writes *The Prince*
1513	Papacy of Leo X
1514	Raphael's *The Madonna of the Chair* (*La Madonna della Sedia*)
1515	Raphael's *Baldassare Castiglione*
1516	Sir Thomas More writes *Utopia*
1517	Raphael's *Pope Leo X with Cardinals Giulio de' Medici and Luigi de' Rossi*
1517	Raphael's *Transfiguration*
1517	Martin Luther posts 95 theses at Wittenberg
1519	Death of Leonardo da Vinci
1520	Death of Raphael
1523	Papacy of Clement VII
1523	Medici power reestablished in Florence
1527	Sack of Rome by Spanish and German mercenaries of Charles V
1534	Papacy of Paul III
1534	Michelangelo's *Last Judgment* on the altar wall of the Sistine Chapel
1534	François Rabelais writes *Gargantua*
1536	John Calvin publishes *Institutes of the Christian Religion*
1537	Michelangelo's *Piazza del Campidoglio* (Capitoline Hill)
1540	Society of Jesus founded by St. Ignatius Loyola and St. Francis Xavier
1545	Council of Trent meets to define doctrine of Roman Catholic Church
1545	Giorgio Vasari publishes *Lives of the Most Eminent Painters, Sculptors, and Architects*
1564	Death of Michelangelo

Introduction

This book focuses on sculpture, painting, and architecture of the Italian Renaissance, a historical period between the fourteenth and sixteenth centuries. To understand mind-set changes caused by the Renaissance, one must be aware of individuals' thinking before its onset, a time of diligent religious hallowing of every action of daily life. Johan Huizinga, in his *The Waning of the Middle Ages*, writes:

> At table [Henry] Suso eats three-quarters of an apple in the name of the Trinity and the remaining quarter in commemoration of the "love with which the heavenly Mother gave her tender child Jesus an apple to eat"; and for this reason he eats the last quarter with the paring, as little boys do not peel their apples. After Christmas he does not eat it, for then the infant Jesus was too young to eat apples. He drinks in five draughts because of the five wounds of the Lord, but as blood and water flower from the side of Christ, he takes his last draught twice. This pushes the sanctification of life to extremes. (Huizinga, p. 15)

Replaced by a less regulated, more realistic, restrained approach, such devoutly controlled observance gradually faded. Notwithstanding all else that happened in early fourteenth-century Italy, an artistic and an intellectual wave swept over the country, a subtle, barely discernible, determined stirring like a tide resolutely inching forward. Persistent, purposeful, an enormous force, it eroded entrenched fossilized layers of Gothic philosophy and religion hundreds of years old. Courageous writers, painters, sculptors, and architects challenged mired-down, redundant thoughts and tradition-bound institutions. Artists helped destroy the old in sculpture, painting, and architecture. Gradually, replaced with new, confident, modern ideas based on scientific fact, the products of man's mind prevailed.

It is true that no part of this movement came easily. In view of such a brilliant, successful awakening, it remains impossible to imagine the medieval peasants' day-by-day struggle for life or to imagine a person's cradle-to-grave misery and suffering. All energies of common people who struggled through brief lives at that time went for finding food, fighting disease, and staying alive, sometimes in the ugly wakes of mercenary armies.

Despite the millions of brutish, untrained intellects, the craving for the primal excitement of executions, the fear of sudden death, despite the deep and drastically hardened opposition, new ideas found a place and new teachings, new philosophies, surfaced. Slowly observation and credence superceded superstition with the truth of observable science and sound factual ideas.

One can better understand medieval man's mind in contrast to what followed after c. 1300 by taking note of the biblical story of Lazarus (John 11:1–44). In medieval thinking, people convinced themselves that after Jesus raised him from the dead, Lazarus lived in continual suffering and horror at the thought that he would have again to pass through the gate of death. Renaissance artists, on the other hand, focused on and painted the miracle and joy of his resurrection, the new and joyous life that lay ahead.

Specifically, this period in history, indicating the renascence, or rebirth, of the knowledge of Greek and Roman forms and ideals, was first termed "Renaissance," the French translation of the Italian word *rinacita,* meaning rebirth. Giorgio Vasari (1511–1574) used it in the preface to his *Lives of the Most Excellent Italian Architects, Painters, and Sculptors from Cimabue to Our Own Day* (Florence, 1550).

Curiously, the style was Florentine, not Roman. Florence had been no more than a small provincial town when Rome ruled the world and therefore had very little antiquity to revive. Rome, governed by the popes, still with one foot in antiquity, had become nearly deserted. Even after 1420 and its restoration as the papal capital, the city remained smaller than Florence, at this time rich and powerful with a population of 40,000–50,000. Florence was the site of Brunelleschi's revolutionary double-shelled dome and where he rediscovered and developed his one-point perspective.

Subsequently, Italians started seeing individuals in a different way. Moreover, painters and sculptors started sensing that new observation, new knowledge, called for a break away from staid, flat Gothic figures, whether painted or sculpted, that looked at nothing and didn't live in this world. The Renaissance painters Giotto, Masaccio, and Donatello took steps into the world of painting and sculpture never remotely imagined by medieval masters. In their unique ways, they took artists away from stiff symbolic figures and standard flat gold backgrounds. For example, Giotto did not paint every picture with a gold sky as had his predecessors. Masaccio used aerial perspective for the first time after the fall of Rome. Donatello rediscovered that stance a body assumes at rest known as *contrapposto.* In fact, changes during the Renaissance in Italy were so deep and widespread they fostered a new culture and a different milieu that required a modified approach to the comprehension of not only God but nature as well.

One has only to look to the years just before the Renaissance to note a difference. St. Francis of Assisi (c. 1250) changed medieval thinking drastically when he made religion a matter of personal experience. Before Francis, religion had concentrated on the terrors of certain condemnation to Hell's eternal fires. Medieval theologians had preached that individuals were worthless creatures in God's eyes and redemption loomed distant. On the other hand, pointing out nature's beauty, Francis called it the handiwork of God. He told everyone to love, not fear, God, that a place waited for the divine, the good in heaven.

Whereas the medieval person found the world foul and rotten with vices and found mankind inexorably polluted with the most despicable sins, St. Francis found goodness in every person and every creature. And at the same time, artists helped individuals realize that the body, nude or otherwise, was a miraculous work of art, and one did not defile or degrade one's eyes to look at and enjoy it. With portraits they helped people see that the face was individual and beautiful and worthy of study and representation. A new question, utterly beyond the remotest consideration to medieval man, arose: Did God create man or did man create God?

At this time, painters and sculptors, with intense interest upon the many facets of God, found a new emphasis upon freedom of will, not total depen-dence upon God. Linear, single vanishing point perspective, which causes a painting to appear to extend beyond a wall or canvas, had not been seen since c. 50 B.C. Renaissance artists redeveloped this perspective in early fifteenth-century Italy, opening a world previously closed to artists. Because of a desire to reveal reality, Renaissance artists like Mantegna developed perspective extensively. Their ideas went beyond the tradition-bound opinion of the Gothic world, which believed no artist could depict objects on a flat surface that appeared to recede into depth.

Renaissance artists painted and sculpted portraits, not of Jesus, his mother, or a saint, but of a human being, a person known by name, a person others could recognize. Similarly they depicted the first nude man and woman after the fall of Rome, and they were not Adam and Eve, standing shamefaced and humiliated. Artists painted and sculpted real people in place of God, God's martyrs, or God's mother. Also, they no longer had reason to include traditional, revered iconographic details. When they painted Mary, the mother of God, many times she appeared pure and lovely, recognizable without her lilies. Standing or sitting in an ordinary room, she no longer reigned as the Regina, the enthroned queen of heaven high above, exalted, unapproachable. Renaissance artists put the baby Jesus on the ground, near a stable, or near a cave, or both.

Artists of the Renaissance focuses on 10 artists who moved out of the prevalent Gothic mind-set of suspicion, superstition, and crudeness and walked into new unexplored spaces of freedom, grace, manners, dignity. And with immense courage, they depicted beauty, politeness, formality, and propriety, as evidenced in, for example, Raphael's portrait of Baldassare Castiglione.

Despite the dismal glooms of pessimism over life's brevity, its pains and iniquities, enormous changes moved over Italy during the Renaissance. The me-

dieval culture, obsolete yet stubbornly entrenched, that had served individuals for centuries, declined and disappeared. And while it drew its last breaths, new ideas of the Renaissance soundlessly shoved it from existence.

Bibliography

Huizinga, Johan A. *The Waning of the Middle Ages.* New York: St. Martin's Press, Inc., 1924, reprinted in 1954.

CHAPTER 1

Leon Battista Alberti, 1404–1472

A playwright, mathematician, scientist, musician, athlete, architect, and architectural theorist, Leon Battista Alberti, beginning at an early age, immersed himself in painting, sculpture, and architecture of the most remarkable and original creativity. History recalls Alberti as an intellectual, an optimistic man who came closer than anyone to the Renaissance idea of a complete man. According to historian Peter Murry, he was without doubt one of the most learned persons of his age. Unlike other gifted individuals, Alberti was not totally consumed by his art and could move with ease to other activities; for example, Alberti trained to become a horseman of some accomplishment. He also became a vigorous athlete who left in awe more than a few trained gymnasts.

Alberti's Life

Leon Battista was probably born in Genoa in 1404. Although some scholars question the exact date and city, they know "[h]e was the illegitimate son of one of the most powerful and wealthy families of Florence, the members of which, though banished in 1387, had continued their activities as bankers and wool merchants in Genoa and Venice" (Holt, p. 203). His father, Lorenzo Alberti, as an exiled Florentine merchant, moved to Venice in 1414. Leon Battista's family, the Alberti, like other ancient families who came out on the wrong side of these oftentimes deadly fifteenth-century Italian city politics, had been sent into exile by the Albizzi family.

Rapid Italian political development at this time caused frequent changes in government. Stronger governments, amounting at times to genuine despotisms, frequently replaced the unstable governments of the free communes or small,

administrative districts of government. Also, regional states, dominated politically and economically by a single metropolis, often replaced the numerous, free, and highly competitive district communes. Government in the Italian towns of the northern and central portions of the peninsula in the thirteenth century had been in diverse forms of a republic. (In fifteenth-century Italy a republic was a kind of government free from hereditary or monarchical rule with complete control of the district.)

However free or strong these little republics grew, in the fourteenth century it was not uncommon for one man or family to take over and begin a dynasty. Then, after stamping out the weaker republican rule, power passed on only within the conquering family. A few states escaped the rule of a despotic family, but even these states moved toward stronger governments and the formation of territorial or regional states. Enemies of the current rule found themselves forced to leave.

Despite suffering just such an exile, the still prosperous and hard-working, Lorenzo Alberti ran a successful, flourishing merchant business (buying and selling goods for profit) that included branch offices as far west as France and England. To the east he established offices in what was left of the Byzantine empire and several Greek islands.

At the same time Lorenzo directed methodically what he intended to be the perfect developmental education of his son Leon Battista's considerable intellectual and athletic abilities, both of which had surfaced at an early age. He treated both Leon Battista and his other illegitimate son, Carlo, as his own (although the rest of the family did not recognize the two boys as Alberti) and educated them with the best teachers money could buy.

After perceiving Leon Battista's intelligence as far beyond average, around 1416 and until 1418 Lorenzo put his son under the tutelage of the famous Paduan teacher Gasparino Barsizza. Leon Battista studied thoroughly the Latin classics, and it is possible he studied the Greek classics as well (revealing throughout his life better than average understanding of the Greek language and culture). So rapidly did the boy learn that by 1421, at the age of 17, he attended lectures in canon law (laws governing the ecclesiastical affairs of a Christian church) at the ancient University of Bologna. Actually, when considering his curriculum, one would have thought he studied for a career as a professor of law or as a judge.

While at the university, at the age of 20 (in 1424), the precocious, tireless Alberti wrote a Latin comedy *Philodoxeos* (better known by the Latin *Philodoxus*, meaning "a lover of glory"). The work, severely classical, used the ancient Latin of Roman comedy (not the modern fifteenth-century Latin of the university of his day and the medieval church). *Philodoxus* was a work so extraordinarily Roman that for several years scholars genuinely mistook it for an original ancient Latin comedy. It must be remembered that more so than today, early fifteenth-century scholars might eagerly have labeled an unknown, newly emerged Latin manuscript an original—and also, upon discovering the manuscript's true origin, forgiven themselves just as eagerly. As Murry notes, "These were the very

years when a small number of humanist scholars were rediscovering a vast number of classical manuscripts and there was nothing very strange in the discovery of a comedy which purported to be antique" (Murry, p. 45). Furthermore, the practice of producing art and passing it to unsuspecting dealers, although not common, certainly found favor. (Whether Leon Battista purposely passed his comedy on as a true antique remains uncertain.) Some artists, Michelangelo (1475–1564) to name one, purposely burned, buried, mutilated, wrinkled, and ripped a work of art to "age" its appearance so that it might be mistaken for a Greek or a Roman masterpiece.

Philodoxus, birthed from the mind of a genius during a time of a rebirth of such stories and paintings and buildings, became a genuine product of its age—the Renaissance—along with Alberti's classical Latin. Leon Battista's complex *Philodoxus* tells how the young lover of glory Philodoxus seeks to win the hand of a young woman Doxia (or glory) with the help of his slave, the intellect Phroneus. Another young man, Fortunius (or fortune), also wants Doxia. In the end, Alberti conjures up a happy ending by having Philodoxus and Doxia marry. The play, according to Alberti, had to do with conduct. It demonstrates that an ordinary person, with study and hard work, can attain glory and all else, just the same as a rich person with every advantage. Alberti even designed the set—a fifteenth-century Italian city square with stone façades and tile roofs, all extremely classic.

All evidence reveals that Leon Battista used ancient Latin in order to revitalize Rome and bring the Roman arts back to life, if only temporarily. Even in the opening scene of *Philodoxus,* a sign bearing a Latin motto in golden capital letters appears before a large villa. It is important to an understanding of Alberti to know that the actors (all male with some dressed as women) conversed not in the colloquialisms of daily Roman life but in Latin.

Alberti's life did not remain tranquil. In 1424, while attending the university, after his first year as a student, his wealthy father died, leaving his son nothing, and Alberti experienced the first hardships of his life. Everything in his life changed immediately and drastically because his father's death took away his protection and strong financial support. Not a penny of the estate his father possessed, administered by an uncle, reached him. Although research has yet to reveal what actually took place, one might surmise that because Alberti's life was so totally regimented and ordered by his father, with not a detail left to chance, leaving Alberti penniless was not Lorenzo's intention. For the first time in his life Alberti lived without the security of dependable and considerable resources. It was thus that for a long time he suffered poverty, an especially dreadful predicament after living all his life with wealth, never with one thought concerning money. Art historian Peter Murry indicates that he received some money from members of his family: "When his father died he was supported by two uncles, both of whom were priests, since it was quite evident that the young man was developing into a prodigy . . . " (Murry, p. 45).

Not too long after his father's death, lack of proper food and care caused Alberti to fall into poor health. Paradoxically, it was at this time of sickness that

he turned to the arts. While convalescing, he also turned to writing and, purposely putting to use his superior education, he composed in the most difficult and classical Latin possible.

After his father died, 24-year-old Alberti returned with his family to Florence after the Florentine government lifted the ban against them and told them they could once again live in Florence. Also, in 1428, he received a doctorate in canon law from the University of Bologna. He found himself moving in the highest contemporary intellectual circles. He became acquainted with the most talented and advanced artists of his time. He also made the acquaintance of the humanist scholar Tommaso Parentucelli, later to become Pope Nicholas V (1397?–1455: Pope 1447–1455).

Being devoted to Latin during his youth, and for the rest of his life, Alberti chose the language as the best means to communicate his most dignified and important ideas. He chose Latin for those ideas he desired left to history, those ideas that would truly mark the end of the Middle Ages and emphasize the Renaissance for what it was, a rebirth.

Historians admire Alberti's knowledge of the Latin language and note that the study of Latin was at this time not an ordinary pursuit. Not many individuals, even the most highly educated, spent the time necessary to master the language well enough to write on the scholar's level, and more especially in the mode of classical Rome. The famous and highly admired fifteenth century Florentine architect Filippo Brunelleschi (1377–1446), for example, was unable to either read or write Latin.

Yet for all his perseverance and adherence to classical ideas and their exactness, Alberti's work may be, at times, confusing not from a lack of, but because of his Latin education. Murry cites this discrepancy: "It is slightly surprising to find Alberti referring to 'the temples' and 'the gods' when he [probably] means churches, God, and the Saints" (Murry, p. 47). His Latin terms have caused a long-lasting and unfortunate misconception of his ideas. Words such as *temples* and *gods* derive from Greek and Roman vocabulary. The Renaissance *churches* and *God*, used by other fifteenth century scholars, would have been, for Alberti, more readily and more easily understood and accepted. Although Alberti thought within the parameters of Christianity, he pursued the beauty of balance and harmony preferred by the ancients and the concepts of the practical, functional structures of the Roman tradition.

At age 27, undaunted and always enthusiastic, he took a job at the papal curia (the *Curia Romana* or judicial council of the 1430s). It was in this capacity that as Cardinal Molin's secretary he went to Rome in 1431. There he worked as an abbreviator (one who condenses manuscripts) in the papal chancery or office of public archives where he used his superior writing skills to serve the influential members of the higher clergy. Further demonstrating the breadth of his education, he wrote with ease in Italian as well as Latin. His work, so exceptional, found more readers than he had hoped and brought him more attention than he had anticipated.

While in Rome Alberti became fascinated with ancient Roman architecture and studied it from a point of view never before taken—that of the humanist, the classical scholar. It is in the realm of architecture that Alberti's work remains important.

Alberti's Architecture

Although an intellectual revival had occurred even before Alberti's time, medieval scholars were few; and those individuals fortunate enough to acquire the skills of reading, writing, and speaking a language other than their own, found little interest in architecture. The term *scholasticism* applied to scientific, philosophical, and theological learning, not building.

Before the Renaissance, a man with Alberti's education would probably never have taken an active interest in designing medieval cathedrals or buildings. Pre-Renaissance architects wanted to glorify God or to build reliquaries, as in the case of Notre Dame de Chartres in France, a reliquary in stone and stained glass built to house the Virgin Mary's dress. The very name given the cathedral, Our Lady of Chartres, denotes its status as a reliquary.

During the Renaissance ideas changed and the essence of architecture slowly evolved away from the glorification of God and the Virgin Mary and moved into the complicated, more modern forms of philosophy and mathematics. Laws of order and proportion became significant. Roman monuments based on order and not ideal beauty (as were the Greeks') assumed new importance. It was thus that for the first time talented individuals such as Alberti studied the language and structure of classical architecture with different purposes. In Rome and other Italian cities, he worked as one of Italy's primary experts on the ruins of ancient art and architecture. And because he read classical Latin, he read every passage he could find from all classical texts that mentioned ancient buildings. He sifted through the ruins of every site he discovered.

Along with the classical language of architecture, Alberti also studied the philosophy of Pythagoras (sixth century B.C. Greek philosopher and mathematician), and in the course of his studies, he discovered a completely new way of viewing architecture. Shortly after this, Alberti gained a reputation for subordinating a building's design to three main observations: He looked at a building mathematically, geometrically, and musically. This new triadic approach produced the newly formed infinite series of three that Alberti used to determine the calculations for the height of rooms in relation to their length and width. He also used the triad for the division of a building's façade, whose height was a multiple of the entablature and whose length balanced perfectly with the pilasters and doors and fenestration (windows). Three precisely measured sections are the most aesthetically pleasing to the human eye, and architects, especially Andrea Palladio (1508–1580), have used them since the mid-fifteenth century. Alberti's never-before-used measurements brought to Renaissance architecture

the balance, harmony, and symmetry historians still praise and lesser architects copy.

Alberti studied Roman architecture with an expertise that went way beyond a dilettante's eye. Unfortunately, he had one drawback. Some historians believe he may not have completely understood the complex structural systems underlying Roman architecture. Roman vaulted arcuated (arched) spaces reached into the noncreative, pragmatic realms of engineering, an area for which Alberti had no training. And though he studied them as thoroughly as he could from persistent observation, he could not view these structures as would an engineer. His talents, leaning not toward the Roman's vast utilitarian dimensions and ratios, however, led him in another direction that took him deep into scholarly realms, an impossibility, according to Nikolaus Pevsner, before the fifteenth century. "Before the coming of the Renaissance such a man [as Alberti] could hardly have taken an active, constructive interest in building. But as soon as the essence of architecture was considered to be philosophy and mathematics . . . the theoretician and dilettante was bound to assume a new significance" (Pevsner, p. 188).

Though he entered the profession of architecture late in life and had no training as an engineer, Alberti's studies of Roman engineering techniques, especially impressive new construction accomplishments with concrete and tufa (porous, gray stone formed from volcanic dust) proved valuable to all later architects who studied his work. Concrete (the technology of which disappeared after the fall of Rome did not appear again until the late eighteenth century, when engineer John Smeaton rediscovered it when building the Eddystone Lighthouse in England) eventually revolutionized the shape of buildings. Alberti found that with concrete the Romans had created an architecture of space rather than mass. Why he made no attempt to formulate it is not known. One can only speculate that engineering problems held no interest for him. With the strength provided by reinforced concrete the Romans constructed enormous, wide vaulted spaces. Although these interested Alberti, he had no inclination to duplicate them in concrete. On the other hand, he found interesting the fenestrated sequences of Roman groin vaults with no internal supports that stood both strong and fireproof. Here he noted the advantage over medieval clerestories (windows close to the ceiling) common to every Gothic cathedral.

With his Roman studies, Alberti fixed firmly the groundwork of his designs that eventually formed the foundation of most High Renaissance architecture. He found a friend and a patron in the creative and generous builder Giovanni di Paolo Rucellai, who did not criticize his tastes and visions of Rome and the ancient world. Rucellai gave him the free rein he needed.

The Palazzo Rucellai, c. 1452–1470

Alberti conceived his first independent work for Giovanni Rucellai. His rusticated (masonry blocks separated from each other by deep joints) three-story façade design for the Palazzo Rucellai in Florence, begun in 1452, is one of the

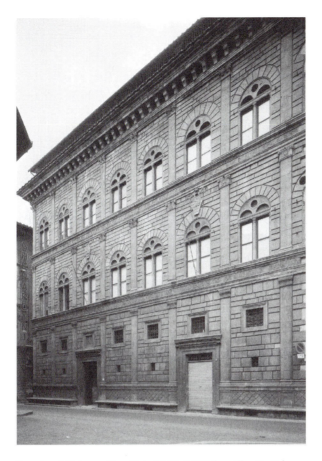

Façade of Palazzo Rucellai, 1455–1470 by Alberti. Palazzo Rucellai, Florence. © Scala/Art Resource, New York.

most ingenious and original contributions to the history of the Italian Renaissance palazzo (a large, imposing Italian residence).

For the Palazzo Rucellai Alberti abandoned the massive, exaggerated proportions of the old Florentine palaces. He used pilasters (flat, engaged columns) in three horizontal bands on the façade for the first time as a new way to articulate a wall. Using the Roman Colosseum (c. 80) as a model, he used a Doric Order on the ground floor, an Ionic on the *piano nobile*, or first floor (second story above the street noise and dust), and a Corinthian on the next or third floor reserved for lesser members of the household, children, or servants. (See the Glossary for explanation of orders.)

Alberti's Palazzo Rucellai differs from all its predecessors in that it displays the first use of the classical orders on a palazzo façade. The entire façade emanates an elegant classical air that measures perfectly balanced and harmonious from every angle, both horizontally and vertically. To further the idea of the antique or classicism, Alberti divided the floors with elaborately decorated entablatures (bands above the columns), the idea again taken from the theme

of the Colosseum in Rome (with flat, unfluted, plain pilasters substituted for columns).

Also following classical ideas, Alberti fixed the heights of the stories by the heights of the pilasters, which were predetermined because they had a proportional relationship to one another and, of course, to the rest of the façade.

At the Rucellai's base, Alberti used a typical Roman base carved in a diamond pattern to imitate Roman *opus reticulatum*, or reinforced concrete work. The Romans discovered that reinforcement strengthens concrete. They pushed pyramidal blocks of stone point first into wet concrete. The bases of the pyramids formed on the wall a pattern known as *opus reticulatum*. When the concrete dried, the wall became nearly indestructible. Although Alberti used the pattern (not the actual stone pyramids and concrete) deeply carved into his stones, he may have remained unaware of this Roman construction's purpose. He aimed for the visual effect of strength, which had nothing to do with the practical intentions of Roman builders, who aimed for strength.

At the top of the Palazzo Rucellai, one sees an extraordinary overhanging cornice (projecting molding along the top of a building). The cornice in Italian palazzo architecture was a necessary, functional part of the building: It shaded the side of the building during the hottest part of midday. Alberti found he could not design his cornice proportioned to the building. The resulting overhang would have been too small and impractical. It would not have functioned as a cornice should. He therefore designed the largest cornice possible and gave it an emphasized overhang supported by a bold classical corbel table (a series of bracket-like supports) inserted into the frieze or upper section of the entablature. This, also, he copied from the top story of the Roman Colosseum.

In the Palazzo Rucellai Alberti's architectural style represents an intellectual application of classical elements to fifteenth century buildings. Here he exhibits the exquisite and perfect adjustments of proportion, balance, and harmony all elements scholars recognize and admire in Renaissance architecture. Certain novelties designed by Alberti included unusually imaginative, never before seen square-headed door cases. Also, he designed a new bipartite window style with deeply cut voussoirs (blocks that form an arch) in a combination similar to the Roman Colosseum. He followed the Colosseum's style with a Roman Doric Order surmounted by the Ionic, which in turn is surmounted by the Corinthian. He used a slender column to separate the two windows that support an architrave (lower part of the entablature, directly above the column) beneath the newly designed rounded bipartite cap. All aspects of the Rucellai became guidelines for not only Renaissance architects, but also all architects who followed. Even today many of Alberti's ideas can be found in classically inspired buildings.

The Malatesta Temple, 1446—Never Completed

Another of Alberti's first works was the old Italian church of San Francesco (St. Francis) on Italy's Adriatic coast in Rimini. He redesigned the structure for Sigismondo Malatesta. An erudite although unscrupulous ruler of Rimini, Mala-

testa enjoyed the distinction of being the only man in history that he knew of to be publicly consigned to Hell while still living. The fifteenth-century humanist pope (who did not patronize art or literature), Pius II (1405–1464: pope 1458–1464) publicly consigned Malatesta to Hell in front of St. Peter's in Rome because he hired Alberti to reconstruct San Francesco.

Malatesta had offended the church by having the old monastic church of San Francesco converted into a secular temple dedicated to himself and his mistress, Isotta degli Atti, for whom he had ordered his wife suffocated. This conversion, the pope believed, desecrated a Christian building.

Today, history recognizes the old St. Francis church as the Tempio Malatestiano. Since Alberti redesigned only the outer shell, the interior remains mostly original Gothic. He began the building of the outer shell in 1446 under orders by Malatesta, who intended to make it a memorial to himself, to his mistress Isotta, and to the members of his court. He hired Alberti as architect of the project.

The importance of Alberti's three-arch façade design lies in his radically different alternative. Most churches have a high central nave with a lower aisle on either side in the manner of the ancient clerestoried (windowed) Egyptian hypostyle halls. Gothic architects covered each side aisle with a lean-to roof; the result looked awkward. The shape—not a classical form, although practical and still used today—had never been constructed with beauty in mind. Italian ar-

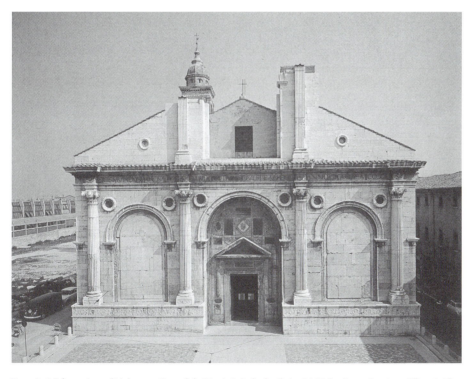

Tempio Malatestiano (Malatesta Temple), Rimini, Italy, built in 1450 by Leon Battista Alberti. The Art Archive / Dagli Orti.

chitects seldom used the medieval solution of two tall towers at the front façade to disguise the side aisles, as did French and German cathedral designers. Northern builders designed a right and left bell tower attached to the front façade as foils for the awkward side-aisle shape. These towers softened the hard, cut-off appearance of the shorter side aisle shapes.

To solve the problem (Italians did not build tall cathedrals with two bell towers and scorned flying buttresses), Alberti redesigned the west end of San Francesco and (influenced by Roman works) changed it to a form based upon the Roman classical tripartite triumphal arch. The tripartite Arch of Augustus exists in Rimini, and details used on San Francesco come from it. Another example known to Alberti, the Arch of Constantine in Rome, probably became the model for San Francesco. He designed a large central arch with a small one on either side separated by engaged (three-quarter columns attached to the wall) columns. Alberti was the first architect in Europe to bring the Roman triumphal arch configuration to church architecture.

Alberti designed for the south side of Tempio Malatestiano, seven round-headed niches and divided them with wide piers. The result, with its seven arcades, appears more Roman than any other building of the fifteenth century. Today these niches hold the sarcophagi of Sigismondo Malatesta's court humanists.

Santa Maria Novella, c. 1458–1470

Besides converting the old church of San Francesco to the Tempio Malatestiano, Alberti's interests found expression in ecclesiastical architecture. From 1448 to 1470, for Santa Maria Novella, a thirteenth-century Gothic church, Alberti devised (for the Rucellai family) an inventive façade solution to a difficult design question. He drew up plans for a small, classical temple front for the west façade's upper story. This he supported with a substantial base of blind arcades (an arcade applied to the surface of a wall). He framed two groups of four arcades with four slender Corinthian pilasters that mark the six tombs alternating with three doorways, including the large, tall central doorway, of the extant Gothic building. These are all surmounted by a wide entablature. On paper this design forms a single, large perfect square.

In the organization of these elements, Alberti took a long step beyond medieval designers. Using the classically derived philosophy of sixth-century B.C. Greek philosopher and mathematician Pythagoras, basing all blueprints on ratios, Alberti designed the upper structure so that it could be encased in a square one-fourth the size of the main square. More squares can be discerned throughout the design that relate in simple numerical ratios. Alberti found ratios, especially those based on the proportions of the human body, the most accurate source of beauty. (The ancient Greek Ionians adapted the arithmetic mean of 6 and 10 as a basis for perfect proportion.) So pleased was he with his system of perfect proportions, Alberti wrote a lengthy treatise to promote the intelligence of balanced, symmetrical relationships for designing aesthetically pleasing buildings.

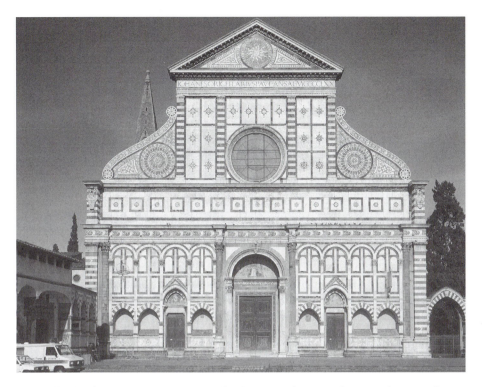

Alberti's façade of Santa Maria Novella Church, Florence, Italy, 1470. The Art Archive / Dagli Orti.

Furthermore, he conceived the idea of separating, in the most innovative and aesthetically pleasing way, Santa Maria Novella's first story from the second. He divided the whole space based on arithmetic proportions so that the height of the building is equal to its width. Moreover, the columns on the lower level outline are squares with sides about one-third the main unit's width. Between the two stories Alberti inserted a mezzanine (a low-ceilinged story between two main stories in a building) that serves as an attic for the top story and a base for the bottom. No one before him had thought of using a mezzanine for floor separation, and after seeing his example, numerous architects copied this design.

Alberti's façade also introduced large volutes (spiral scrolls) that unite the wide lower and narrow upper level and both the right and the left. These scrolls, with large, small, decorated, or plain alterations, later appeared in hundreds of church façades not only in Italy during the Renaissance after Alberti first introduced them, but also in the seventeenth century Italian Baroque style.

Alberti's Architectural and Other Treatises

Through his studies Alberti saw that during the nearly 1,000 years following the fall of Rome, artists had not brought the aesthetics of Greek and Roman art back to life, and no treatises other than Vitruvius's had surfaced. The painting,

sculpture, and architecture that emerged gradually during the Medieval period were produced entirely for the glory of God and revealed little genuine beauty and originality. He hoped to cause artists to abandon their anachronistic ideas with not only his architecture, but also his writing.

With this in mind, Alberti began work on the first modern treatise on classical architecture around the mid-fifteenth century. During the fifteenth century, archaeologists discovered several important classical manuscripts, the most important being Roman theorist Vitruvius Pollio's 10-book treatise on architecture, *De Architectura*, written before 27 B.C. It inspired Alberti's own 10 books. From the beginning Alberti intended to go beyond Vitruvius's highly regarded ancient work. Vitruvius's treatise is the only technical handbook of its kind to have survived from antiquity. Alberti's treatise became the next important work on architectural theory after Vitruvius. Today historians consider the work of Vitruvius and Alberti as some of the most influential and important in the history of architecture. Although Alberti's studies aroused jealousy and the sharpest criticism and may not have displaced Vitruvius, they gained him praise from contemporary patrons of Renaissance artists and scholars.

Alberti's essays on architecture, written during his 20s, are clever, highly developed treatises that easily match those of a mature scholar. He wrote the first-ever unified and logical theory of the use of the five architectural orders that modern scholars consider worthy. The work of Vitruvius, in contrast, is in sections, many unintelligible. Some scholars believe Vitruvius is authoritative because his treatise is ancient theory and there are no other architectural treatises from antiquity. His work, however, remains open for argument and interpretation. Alberti's work, complete in all its parts, stands higher in comparison.

Alberti's designs did not become a source of inspiration for fifteenth century Florentine architecture because he copied Roman buildings. He used Roman ruins as a foundation from which to launch his own ideas. He expressed his creativity using the ancient classical language of architecture, and in doing so returned to the civilized world the rules, the architectural syntax, and special rhetoric of antiquity. He did not merely copy Roman architecture. John Summerson sums it up well: " . . . the great achievement of the Renaissance was not the strict imitation of Roman buildings . . . but the re-establishment of the grammar of antiquity as a universal discipline" (Summerson, *Classical Language of Architecture,* p. 18). The classical language of architecture, lost after the fall of Rome, found new life under Alberti's pen.

When Alberti left Rome in 1434 he traveled to Florence with the Venetian Gabriele Condulmer, Pope Eugene IV (1383–1447: pope 1431–1447). In the milieu of some of the most magnificent art the world has ever known, Alberti became friends with the great Florentine architect Filippo Brunelleschi (1377–1446). He also met the accomplished sculptor Lorenzo Ghiberti (1378–1455), sculptor Donato Donatello (1386–1466), and the inimitable, albeit short-lived, fresco painter Masaccio (1401–1428). With the most gifted Florentines, a few of the greatest minds the world may ever see, he worked as a creative artist and studied art theory in depth. In 1434 he published his find-

ings, a revitalization of Roman ideas he felt had been close to permanently lost, under the title *De Pictura* (On Painting). He wrote:

> To Filippo I Ser Brunellesco [Filippo Brunelleschi]: I used to be at once amazed and grieved that so many fine and godly arts and sciences, which we know, from their works and the histories, flourished in those most virtuous ancients of old, are now lacking and almost entirely lost. (Holt, p. 205)

Two years later, in 1436, Alberti published *Della Pittura.* This work contains the first thorough description of scientific linear one-point perspective. In addition, he discusses for the first time the study of vision, colors, and the way individuals perceive objects. He said: "It appears to me obvious that colors vary according to lights, since every color, when placed in shadow, seems not to be the same one that it is in brightness" (Holt, p. 207). Most important in Alberti's treatise "he introduced—or rather—reintroduced—into the theory of the representational arts what was to become the central concept of Renaissance aesthetics, the hoary principle of *convenienza* or *concinnitas,* perhaps best rendered by the word 'harmony'" (Panofsky, p. 26). In other words, he stated that all parts of a painting must be balanced so that they harmonize into one aesthetic that the human eye will blend into beauty.

This first theoretical work on the arts in 1436, *Della Pittura* (On Painting), Alberti dedicated to Brunelleschi, Donatello, Ghiberti, Masaccio, and Luca della Robbia. In *Della Pittura,* besides giving artists the first description of scientific linear one-point perspective, he also presents the theories of the new Florentine art based on the scientific study of vision, colors, and the way individuals perceive objects. Alberti agreed with the philosophy that nothing can be seen that is not colored by light. (Any color, he noted, will cause a more pleasing effect than a lack of color, i.e., browns and blacks.) He argued that a close relationship between colors and lights with respect to the way an individual perceives objects exists. He gave colors original and new symbolic references: Red, for example, symbolizing sacrifice and Christian love in early Christian and Gothic art (used especially in stained glass), refers in Alberti's work to fire. Blue, originally indicating truth (Mary, mother of God, wears blue), symbolizes air. Green, originally representing new life, Alberti used when referencing water. Earth is grey and ashen with other colors such as jasper (red, yellow, or brown quartz) and the purple Egyptian rock porphyry (dark red or purple). He further theorized that green leaves are different from tree to tree, from every minute during the daylight hours to the hours of dusk. (No one explored this fact again in depth until the end of the nineteenth century, when Impressionist painters such as Claude Monet, 1840–1926, studied and painted light in scientific experiments.) Renaissance artists did not notice either light or its details. Shadows were always various shades of black. Dutch Baroque painter Jan Vermeer (1632–1675) experimented with the camera obscura and during the mid-seventeenth century produced shadows in color, tiny stippled pearls of paint. However, for color contrast studies similar to Alberti's one must move to the mid-nineteenth century, more particularly to the studies of French chemist

Michel Eugène Chevreul (1786–1889). One can see that 300 years earlier, Alberti's color theories had moved beyond his contemporaries and into the future several hundred years.

Panofsky believed Alberti wanted painters to look to Rome for inspiration. Always with color in mind, "Alberti advises the painter to turn to the humanist for secular (viz., classical) subject matter, offering as an example the story of the Calumny of Apelles . . . " (Panofsky, p. 26). The celebrated painter of ancient Greece, Apelles "became official painter at the Macedonian court and was the only artist allowed to portray Alexander the Great . . . [and also] painted Calumny . . . a beautiful woman beside herself with passion" (Earls, *Renaissance Art,* p. 52). Alberti's ideas in turning to the humanist for classical subject matter represent a complete break from all previous art.

In addition to architecture, painting, and perspective, Alberti found interest in sculpture. In 1465 he wrote *De Statua* (On the Statue). This treatise discusses individual techniques used on sculpture. Scholars have studied and praised his system of proportions, a system not used since the Greek sculptor Polykleitos. Polykleitos of Arbos, or Sikyon, active c. 450–420 B.C., wrote a canon of ideal male beauty in a system of mathematical proportions. Scholars recognize Alberti's ideas as among the most important of the Renaissance. It is interesting to note that although in his treatises Alberti refers to his own work in painting and sculpture, no known works by him exist, with the exception of one medal with his self-portrait, located today in the *Cabinet des Médailles,* the Louvre Museum in Paris.

Not limited to architecture, painting, or sculpture, Alberti wrote a treatise on the family, *Trattato della Famiglia,* concentrating on domestic virtues with a special focus on the history of the Alberti family. Also, he wrote verse, several *novelle* (novels) and, as mentioned previously, his Latin comedy *Philodoxus.* It appears, however, that although his interests remained mainly in the fields of architecture and the writing of architectural theory throughout his life, he had multiple interests, and he found success in every subject he published. According to John Summerson, "[h]e was a painter and a musician, though none of his studies in these arts have survived. But posterity remembers him chiefly as an architect and as a writer on architecture . . . " (Summerson 1963, p. 34).

Among the many projects he completed, he worked on his architectural theories until he died. He wrote his treatise on architecture in Latin, in 10 books *De Re Aedificatoria Libri Decem,* the first architectural treatise of the Renaissance, published in 1485 after his death in 1472. It brought a permanent form to contemporary ideas on proportion, the orders, and experiments in town planning. Summerson also found the work invaluable. "This work [*De Re Aedificatoria*] is the theoretical corner-stone of the architecture of the Renaissance and, as such, of immense value to anyone who hopes to understand that architecture . . . from the 15th to the 19th centuries" (Summerson 1963, p. 34).

Alberti based *De Re Aedificatoria,* evolving a theory of beauty in terms of mathematical symmetry and proportion of parts, on Vitruvius's treatise. Vitruvius's 10 books, written in the reign of Augustus, offer a comprehensive survey treat-

ing in detail town planning, design, construction, and professional practice. Although Alberti used these ideas as a guide without copying him, he never admitted a debt to Vitruvius and, in fact, asserted complete and direct authority. Always interested in the beautiful, Alberti went beyond Vitruvius and "distinguished the rational appreciation of beauty from the vagaries of individual taste, thought at times he held that beauty is what pleases the eye" (Osborne, p. 23). He also wrote the first rational theory of the use of the five architectural orders (Doric, Ionic, Corinthian, Composite, and Tuscan) since classical times.

A prolific author in a variety of areas, he wrote a coherent treatise on traction and the rules for calculating heights. He also composed a treatise on law. He wrote a treatise on the horse, the tranquility of the soul, and a few erotic works in both verse and prose.

Alberti's Accomplishments

Alberti was the architect of change. His ideas conspicuously altered Italian buildings during the fifteenth century and after. His designs moved architecture from the medieval attitude that a building was a symbolic expression to the glory of God to the humanistic philosophy that an individual person could be important. His treatises and his buildings, with their new proportions and measurements, revealed these new ideas. In the extraordinary domain of his knowledge and the intellectual and scientific breadth of his creativity, he became one of the most original early humanists. In addition to promoting new proportions and concise ideas concerning harmony and balance, he conceived architecture as communal. In this light he initiated new ideas in the context of imaginative, unified town planning, the relationship his building and its façade had to the rest of its surroundings.

Working within the Renaissance idea of the artist as a representative of building, painting, and sculpting with new unlimited freedom, no longer compelled to celebrate the glory of God, Alberti focused on the mathematical and scientific basis of the arts. He stressed the necessity for artists of every medium (sculpture, painting, and architecture) to gain an education in not only math but also history. He advocated poetry as well. He perceived the arts in ways different than anyone had before him. For example, he thought not in the least like the early Christian church builders, the Romanesque and medieval cathedral designers before him. Stained glass, vaulted roofs, great buttressed heights, although impressive, even astonishing, became anachronistic.

Sant' Andrea in Mantua (designed for the famed *condottieri*, or military leader, Marquis Ludovico Gonzaga [1412–1478] c. 1470), was Alberti's last work and yet one of his most innovative and daring constructions. For Gonzaga he replaced the old eleventh-century Mantuan church and in the process completely changed the traditional Christian church plan. His bold 1470 design omitted side aisles for the first time in church architecture. This idea, more than 1,000 years old, dates to Old St. Peter's in Rome, c. 333, constructed shortly after Con-

stantine legalized Christianity. Early Christian churches needed side aisles for catechumens (unbaptized Christians); medieval churches served as hostels (shelters) for Christians making pilgrimages, and side aisles were necessary for shelter. Alberti converted the side aisle space to chapels (pilgrimages had run their course) and enlarged the nave (central section of the church) so that it became one enormous hall. His reasoning was that the typical Roman basilican plan with side aisles flanking the nave was unsuitable because the columns conceal the ceremonies from worshippers in the aisles. Architects everywhere copied this more practical and functional design.

Alberti moved effortlessly from architecture to painting. When he defined painting, he indicated that the artist should search for and represent the ideal (in the manner of the Greeks). Furthermore, he stated that artists could never achieve the ideal by reproducing nature as a botanically correct landscape with black shadows (as all Renaissance painters did). He knew artists had to go beyond mere black shadows when painting plants in light. In fifteenth-century Italy this was a daring concept. He identified beauty with nature in its loveliest, sunlit state. Yet in his treatise on architecture, *De Re Aedificatoria,* he devised a different theory of beauty in terms of mathematical symmetry, harmony, and perfect proportion of all parts. Beauty, he believed, could be found everywhere— in nature's trees and flowers, in a building's stones and mortar. Beyond this he championed the well-educated person's intelligent appreciation of beauty and separated it from the vulgarities of common, unrefined taste. In the end, he admitted that beauty is what pleases a viewer's personal taste.

Alberti stood apart from even the most accomplished artists and authors. In fifteenth-century Renaissance Italy, Alberti represents the new architect–artist who, ignoring all the Gothic cathedrals offered (engineering; unheard-of height; buttressing and vaulting systems; historiated, didactic capitals; and stained glass), brought ancient Roman ideas to Renaissance building. He had no interest in Gothic builders who, from the eleventh to the fifteenth century, did not deviate from their plan to build higher, to create nothing more than an armature for glass, a reliquary for martyred saints' relics.

Historians view Alberti as the first and most outstanding of a line of dilettante–architects. With variations, his ideas influenced architects for years after his death. His novel, original buildings, the Palazzo Rucellai façade with its rustication and sequentially ordered pilasters, the Malatesta Temple triumphal arch design on its high Roman base, the Santa Maria Novella volutes used to hide the old Egyptian hypostyle hall design, stirred architects and even sculptors over most of Italy. They copied the Rucellai and Malatesta façades and they used volutes to cover side aisles on hundreds of church facades.

In addition, the early influence of his ideas on scientific linear one-point perspective found form in sculpture. In more than any other work it can be found in the architectural backdrop of Florentine sculptor Lorenzo Ghiberti's (1378–1455) gilded bronze relief *Jacob and Esau,* located on the Florence baptistery doors, the famous *Gates of Paradise.* Frederick Hartt says, "Ghiberti's *Gates of Paradise* were so profoundly influenced by Alberti's ideas [indicating espe-

cially the perspective] as to constitute, in a sense, a programmatic exposition of the full resources of Albertian theory" (Hartt, p. 231). The door panel *Jacob and Esau* (c. 1425–1452) is the earliest space construction that does not use the double scale (one for figures, one for architecture) of the Middle Ages. Ghiberti used instead Alberti's ideas of actual visual unity.

Modern architects appreciate Alberti and still use his ideas. One, for example, is creating the optical illusion that a structure becomes lighter in weight vertically from the first to the third story. Architects, using Alberti's original idea, achieve this effect by heavily rusticating the façade's bottom level, light rustication in the middle, and slight or no rustication at the top. They also translate the idea into color using a dark color at the bottom level then increasing the lightness of the same color ascending the stories. This gives the building a less ponderous appearance. Alberti also adopted the ancient Roman idea of using a different architectural order for each story as seen in Rome's Colosseum (c. 80 A.D.). The Doric or Tuscan Order occupies the first story, the Ionic Order the second, the Corinthian the third. Most architects following Alberti chose this method to solidify and bring into unity the appearance of a Roman palazzi.

Alberti was the first architect after the fall of Rome to study seriously the Roman architectural theorist Vitruvius's treatise *De Architectura.* He gleaned from this work a system of ideal proportions and thereafter argued that the central plan, not the longitudinal design, was the most perfect form for a Christian church. The longitudinal Latin cross design used in the old (c.333) and the new seventeenth-century St. Peter's on the same site in Rome had become the norm. The central plan, however, did not find success.

One of Alberti's greatest attributes was that he never hesitated to make changes in the details of a structure. He never shrank from changing a structure completely if he felt the ideas had run their course or didn't harmonize well with the building's surroundings. In all but a few buildings he stopped using the medieval arcade, for example, a practice nearly anathema at the time. In the end his ideas gave the world of architecture a contemporary and scholarly application of classical (Greco-Roman) elements.

Ideas for numerous buildings derive from Alberti's theories and link him to not only High Renaissance Rome, but the period following, the Baroque. For example, after Alberti's death, several buildings designed in the 1470s and 1480 deviated little from his Santa Maria Novella form.

Alberti's artistic influence and reputation in fifteenth-century Italian architecture and city planning extended far beyond his buildings. He became an inspiration to younger artists. "A style, almost a way of life, becomes associated with Alberti's personality" (Hartt, p. 221). Throughout his life he worked toward decorum, dignity, and immaculate style. As a Florentine humanist, he studied and searched for *virtus,* that is, a certain humanity, a quality that separates individuals from beasts and lower animals. In this way he never lost sight of manners and grace. He never forgot propriety in a time when murder, robbery, deceit, and general disregard for human life lurked behind not only the coarse cloths of unmannered peasants, but also behind the silks and satins of polite nobles.

Alberti was the ideal Renaissance combination of intellectual and athlete. Architectural Historian Nikolaus Pevsner noted, "it is recorded that he could jump over a man's head with his two feet close together" (Pevsner, p. 188). At the same time he was an idealist in some ways. He felt that any individual could accomplish what he or she desired with little outside help. He evolved to his theories on his own. Although his father supported Alberti's education until he died, the artist never found the love and support his own extended family, the Alberti, denied him. They, to the end of his life, refused to treat him as a legitimate member of the family.

He became famous for a unique, unmatched versatility and a dedicated, unequaled originality. He won approbation, applause, and support from many powerful patrons and friends. His writing, as he intended, spread throughout Italy. Authors after him knowingly or unknowingly took the classical style to those northern European countries north of the Alps where Renaissance ideas trailed behind Italy. His work created a language studied by northern and Italian artists, a language that helped them appreciate and want to study and conserve ancient works of art.

Alberti worked his entire life. Only two years before he died at age 68, he created an interior for Sant' Andrea in Mantua using as a model huge barrel vaults he had studied in Rome. Possibly he used the Basilica Nova of Constantine in Rome (even though it was in ruins). He never favored the medieval colonnaded nave arcade used by most contemporary architects, and in fact, he omitted side aisles altogether. Alberti's pupil Luca Fancelli, Anton-Maria Viani (1636–1700), who worked with him on Sant'Andrea in Mantua, and the Bolognese architect Giuseppe Torri (1655–1713) continued to design and build using Alberti's ideas into the eighteenth century. Today scholars regard Alberti as one of the most important pioneers of modern architecture.

A person with wide interests, Alberti traveled in Germany, France, Belgium, and the Low Countries. He traveled the world at a time when people lived and died within the confines of the few miles surrounding their birthplace. His travels always provided him inspiration. He always returned to his native Italy a fountainhead of new ideas.

With unmatched brilliance and determination, Alberti designed for the most important and brilliant individuals of his day: the brutal soldier–prince Este of Ferrara, the tyrant Malatesta of Rimini, the Gonzaga of Mantua (all noble family rulers), and several cardinals. He advised two popes, Eugenius IV and Nicholas V, on the restoration of the city of Rome. Later he worked for the most accomplished of all fifteenth-century popes, Pius II. He also worked for the powerful Florentine merchant prince Giovanni Rucellai.

Alberti became a celebrity, but his high status and acceptance in society had come at a high price. He had worked his entire life to accomplish himself in the traditional arts of the courtier, the perfectly mannered, exquisitely educated squire. He had trained himself in all the modern arts of the Renaissance scholar. He had studied assiduously the best ways to converse with intellectuals, to ride horses, to walk with grace, and to never reveal the effort it took.

In 1472, when Alberti died in Rome at the age of 68, he had completed works that influenced followers for more than 400 years. His ideas lost favor only after architects and engineers began experimenting with iron in the early nineteenth century and later with steel.

Bibliography

Burckhardt, Jacob. *The Civilization of the Renaissance in Italy*. Vol. 1. New York: Harper & Row, 1958.

Earls, Irene. *Renaissance Art: A Topical Dictionary*. Westport, CT: Greenwood Press, 1987.

Gidion, Sigfried. *Space, Time and Architecture*. 5th ed. Cambridge, MA: Harvard University Press, 1970.

Hartt, Frederick. *History of Italian Renaissance Art*. Englewood Cliffs, NJ: Prentice Hall, Inc. and New York: Harry N. Abrams, Inc., 1987.

Holt, Elizabeth. Ed. *A Documentary History of Art*. Vol. 1. Garden City, NY: Doubleday & Co., Inc., 1957.

Murry, Peter. *The Architecture of the Italian Renaissance*. New York: Schocken Books, 1963.

Osborne, Harold. Ed. *The Oxford Companion to Art*. Oxford: The Clarendon Press, 1978.

Panofsky, Erwin. *Renaissance and Renascences in Western Art*. New York: Harper & Row, 1972.

Pevsner, Nikolaus. *An Outline of European Architecture*. New York: Penguin Books, 1981.

Summerson, John. *Heavenly Mansions and Other Essays on Architecture*. New York: W.W. Norton & Co., Inc., 1963.

———. *The Classical Language of Architecture*. Cambridge, MA: MIT Press, 1971.

CHAPTER 2

Filippo Brunelleschi, 1377–1446

Florentine goldsmith, clockmaker, and architect Filippo di Ser Brunelleschi, called Filippo Brunelleschi and "Pippo," is remembered for ideas so revolutionary they changed the course of architectural history. Such projects as his cupola, or dome, of Santa Maria del Fiore (the Florence Cathedral), a structural engineering miracle, made use of a double-shell construction for the first time. History knows him also for the unusual manner in which he creatively re-elaborated the classic forms of Roman architecture. So new and revolutionary was his work that historians credit him with the creation of the Renaissance style in architecture. Begun in 1421, the first building in Renaissance form is Filippo Brunelleschi's Foundling Hospital.

Brunelleschi's Life

In 1377 Filippo Brunelleschi was born in Florence. Except for a brief stay in Rome, he remained in Florence until he died at the age of 69. From a highly respected family of scholars and physicians going back several generations (at a time when few individuals received education), his parents named him after his paternal grandfather, Lippo. His great-grandfather, known as Cambio, lived a productive life as a highly educated, articulate man. Brunelleschi quite naturally followed the lofty educational traditions of his family.

Filippo's father, Ser Brunellescho di Lippo Lapi, taught Filippo, a child prodigy who learned to read, write, and compute the most complex math problems as a small boy. He revealed unusually remarkable talent for the arts and even rudimentary problems dealing with mechanics and engineering. He fre-

quently worked at an adult level to solve difficult problems involving machinery and art. Scientific linear perspective, for example, and problems considering recession into depth on a flat surface, fascinated him. Moreover, it appears he found challenges wherever he looked. When he looked at a clock, for example, he wanted to know how it kept time. His father, with a mind for legal matters, did not share his son's inclinations.

Filippo's father was an esteemed, wealthy, and well-traveled notary—or public official authorized by law to certify, attest, or declare genuine legal documents and take depositions and affidavits—directed the legal affairs of military personnel. His mother belonged to the well-known, famous aristocratic family the Spini. As part of her dowry she bought her husband a house, and the family lived in this same location all their lives. (One can still see the house located in Florence on a corner across from San Michele Berteldi.)

No doubt exists that Filippo, from the time of his birth, found himself surrounded by and catered to virtue, scholarship, dignity, respectability, fine manners, and high principles. His parents taught him the best of all personal characteristics for noble bearing "including such a kind nature that there was never anyone more gentle or lovable" (Vasari, p. 133). It appears he always kept in mind the poor and the homeless, and throughout his life he remained ready to help the less fortunate either indirectly or directly. He despised cruelty of any sort. He also disliked individuals without honor and decency and, believing that every person bore responsibility for his or her actions, never befriended anyone with corrupt morals or lazy or parasitic inclinations.

Brunelleschi, however, worried his father. Some biographers reveal Ser Brunellescho as the resigned parent who, against the prospects for any career he might have planned for his son's future, respected Brunelleschi's talents and reluctantly allowed the boy to learn the arts of sculpture and jewelry. This must have been a difficult decision when one considers that from the day of his son's birth it was assumed that the boy would become a notary or a physician. As a doctor his son would have followed the greatly respected profession of his great-grandfather. His disappointment mounted, however, as the child Brunelleschi rapidly excelled far beyond ordinary at both sculpture and jewelry making.

Yet, another problem existed. Because young Brunelleschi showed not only extremely high intelligence but also an unusually rare common sense, his father thought he deliberately shunned other lessons like the mathematics his tutors taught him. Actually the small boy found himself drawn irrepressibly to the arts. Late-fourteenth-century Italian individuals who did not expect to become doctors, lawyers, or priests received no education. Since young Brunelleschi had been educated by tutors from an early age, one understands his father's concern that his son revealed no inclination to enter the professional world.

Resigned, however, to his son's obvious genius, understanding and recognizing brilliance, Brunelleschi's father apprenticed him at the age of 15 under the tutorship of a dear friend, a goldsmith named Benincasa Lotti, so that he would be taught the rudiments of design. But this small conciliatory gesture wasn't as drastic as one might believe. Learning the art of jewelry was not uncommon at

the time, although individuals who wished to pursue a career in the arts more often took art classes. Not only did Donatello, Ghiberti, Uccello, and many other Renaissance artists begin their work in a goldsmith's workshop, so too did Brunelleschi (Hauser, p. 53).

Successful in his new environment, inordinately talented Brunelleschi drew and painted beyond common facility. After extensive training, he decided he loved the goldsmith's profession. In fact, he learned the goldsmith trade with such ease and perfection that at the age of 24 the Silk Guild, in an unusual decision, allowed his entrance in 1396. So rapidly did he learn that only eight years later, in 1404, he became a master. In his *Lives of the Artists,* Giorgio Vasari says that after only a few years Brunelleschi set precious stones more expertly than older, more experienced craftsmen and began work in engraving on that branch of the goldsmith's trade known as niello (Vasari, p. 134). His main enjoyment became the art of working on figures in bas (low) relief (a type of sculpture with low projection).

In record time Brunelleschi became expert in every detail of all aspects of the goldsmith's repertoire, especially in the most difficult aspect, the goldsmith's creative elements of composition and design. Here, he displayed exceptional gifts. In a short time he became a master of niello, enamel (glassy, colored, opaque substance fused to surfaces of metals, glass, and pottery to ornament or protect), and colored or gilded ornaments in relief, as well as an expert in cutting, splitting, and setting diamonds, emeralds, rubies, and other precious gems. It seemed that in any work to which he applied himself, he found immediate success far beyond his years.

Indeed, so deep were the roots of Brunelleschi's talent that after a brief period of study he soared past his classmates and easily became accomplished in every aspect of the goldsmith's art. His work drew such praise from mature, experienced artists that he, according to Hauser, had his life written by a contemporary. This distinction had previously been enjoyed only by princes, heroes, and saints (Hauser, p. 65). One is surprised when studying Brunelleschi's later works in architecture and sees his buildings. All are so ahead of other masters in design and workmanship that it's nearly impossible to believe he began his career as a goldsmith and a metal worker, a master setter of precious gems.

Before turning to architecture, Brunelleschi worked with several silver pieces, including two half-length prophets designed for the city commissioners and later placed at the head of the altar of San Jacopo in Pistoia.

While working as a goldsmith he became fascinated with problems of time and motion, of wheels and weights. His ever-inquisitive mind wondered what caused them to revolve and what kept them in motion. Not too long after this fascination overcame him, he constructed his own clocks. Several magnificent clocks came from his hand that are very different from ordinary Renaissance clocks. "Filippo's clocks . . . used springs instead of weights to drive their gear trains . . . spring-loaded clocks are not known to have been invented for almost another hundred years" (King, p. 64).

After making clocks, Brunelleschi again became intrigued with sculpture, for which he had been trained from a very young age, and thus became nearly in-

separable friends with Florentine sculptor Donato Donatello (c. 1386–1466). After working at several different crafts, he found that architecture interested him most. He had noted for several years that even the newest buildings of his time were crude and possessed no design or style. In his mind, very few had truly aesthetically pleasing points. In fact, Florentine-born Antonio Averlino Filarete (1400?–1465?), the Renaissance theoretician known as Il Filarete, states in his *Treatise on Architecture* (Book VIII) that "the term 'modern' refers to the contemporary style" (Holt, p. 247) which was, in the early fifteenth century, Gothic. He added, "I urge everyone who builds . . . to follow the ancient [the ancient or the Roman system] of building and abandon these [Gothic] styles which are used almost everywhere today" (Holt, p. 247). He added further, "Brunelleschi . . . has revived in . . . Florence this ancient [Roman] style of building in such a way that today in churches as in public and private buildings no other style is used" (Holt, p. 247).

Some of Brunelleschi's earliest architectural ideas centered on the problems inherent in the lack of a definite early fifteenth-century architectural style. A strict revival of Greek and Roman architecture did not interest him. Instead, his most creative thoughts moved to problems of construction in relation to engineering design and the practical management and construction of space.

With his unique and, at the time, progressive ideas, Brunelleschi brought to building a light, airy feel, a new rhetoric that stood in direct contrast to the ponderous medieval structures with which he found himself surrounded. He created a cultured, intellectual taste in design, a new space and perspective of light, seemingly floating loggias and rectangular windows with panes of glass carefully measured and mullioned (divided) to blend in quiet, perfect harmony with the façade. The world had never seen delicate, simple designs like Brunelleschi's. He persevered and became not only the earliest modern architect, using ideas never tried in the history of architecture, but also one of the primary initiators of the Renaissance. His architectural works stand firmly beside early fifteenth-century geniuses such as his friend sculptor Donato Donatello and Florentine painter Masaccio (1401–1428?). These three form the perfect Early Renaissance triangle of architecture, sculpture, and painting.

Brunelleschi visited Rome on several occasions, and the result is that the trained eye can observe his newly learned Roman engineering principles transformed into innovative concepts for construction. Peter Murry believes Brunelleschi, before any other architect, understood the engineering principles behind classical architecture and adapted these principles to Renaissance buildings (Murry, p. 25). Because of this, even in his own time, he became famous as the man who brought back the ideas of Roman masonry work. For example, Brunelleschi and Donatello ordered excavations on buildings so they could understand the joinings of the parts of the structures (Holt, p. 178). Also, "he [Brunelleschi] found in the decoration . . . of [Roman] buildings many differences in the finish of the building blocks as well as in the columns, bases, capitals, architraves, friezes, cornices and pediments" (Holt, p. 179). Today, historians identify the ideas Brunelleschi uncovered in Rome with the Renaissance in architecture.

Throughout his life friends described Brunelleschi as a kind and sincere man. He treated every person with a genuine courtesy unusual at the time when politeness and manners were close to completely lacking in even the noblest individuals living in the most refined societies and situations. However, his friend, Antonio Manetti (1423–1491, who wrote Brunelleschi's first biography, *Filippo di Ser Brunellesco,* knew him as "irascible, sarcastic, and self-centered" (Prager and Scaglia, p. vii). Because of differing and sometimes unbelievably conflicting accounts, scholars usually judge Brunelleschi, as they do most artists, by his accomplishments. Some unusual accomplishments in Brunelleschi's life are in fields other than art and architecture.

Brunelleschi's Machines

Brunelleschi investigated early fifteenth-century problems of the day in engineering, especially the planning of mechanical devices; a few are among the most important machines of the Renaissance. More specifically he found most interest in those used in construction for lifting loads of unmanageable, tremendous weight (e.g., lifting 70 million pounds hundreds of feet up to workmen on his own especially designed platforms). As a student his early interests had frequently diverted to mechanics. He had spent many spare hours studying the few examples of the then-existing machinery for carrying, pulling, and especially lifting great loads. After careful study, he usually found inspiration and ideas to make a new design. As Giorgio Vasari wrote of the young genius, "Filippo . . . was always, on the slightest excuse, making designs and models of scaffolds for the builders and of machines for lifting weights" (Vasari, p. 155).

No doubt Brunelleschi's wide range of talents helped him solve problems in engineering. So useful were his creations that he won the approbation and admiration of his most critical contemporaries. He was fascinated by machinery needed to hoist and move blocks and stones necessary for high places on buildings. Most always, after quick investigation, he invented new concepts and changes for the machines, drawing, building, and working out advanced structural engineering devices for new ones. In this manner he invented the reversible hoist, the elevated crane, the elevated load positioner, and many others that assisted builders immeasurably for decades after his death.

From the thirteenth to the fifteenth century, Gothic construction before Brunelleschi had reached unheard-of heights, building higher with every new construction. Upon studying their buildings, Brunelleschi concluded that his Gothic predecessors must have used machines more advanced than simple winches. Unfortunately, historians know nothing today about medieval lifting machines beyond a man-powered hoisting wheel, a *rota magna* or great wheel placed in the ceiling of the cathedral in progress. (One or several men walked inside a large wheel like hamsters in order to turn it.) Also, biographers do not know how Brunelleschi designed his advanced elevated crane structures, as he always worked alone and in secret. Only suggestions for his designs found in

the *Zilbaldone*, or Notebook, of Buonaccorso Ghiberti (1451–1516) still exist. The *Zilbaldone* has especially articulate drawings of architecture, sculpture, and machinery. Historians believe that one of these, a load-positioning machine standing on a roller platform, inspired Brunelleschi. It is a "rotary crane similar to a merry-go-round. . . . At its top there is a grooved horizontal beam structure wherein a screw-engaging block can slide. The block is shifted along a groove by a horizontal screw. There is also a vertical screw passing through the block, and this latter screw can support three hangers" (Prager and Scaglia, p. 74). Engineers and builders learned enough to help them with other machines when they studied Brunelleschi's load-positioning machine, and over time made small repairs and improvements so that workers used it successfully for decades.

The reversible hoist, or ox-hoist, another of Brunelleschi's practical inventions, has an extraordinarily large and formidable framework. The machine's great size allows a horse, or even several horses or oxen, as the load requires, to walk around a powerful vertical shaft that is pivoted in the center. Rugged, nearly indestructible, this remarkable hoist lifted the monstrous stone beams Brunelleschi needed to raise the dome he designed for the apse end of Santa Maria del Fiore, the Florence Cathedral.

Similarly, Brunelleschi also designed a load positioner for lifting and putting into place stones and other building materials of enormous weight. No one knows where Brunelleschi found ideas for the load positioner and his other schemes. "The exact inspiration for this remarkable machine remains as mysterious as that behind Filippo's other inventions. The specialist theoretical knowledge needed for constructing such a hoist was largely unavailable in 1420" (King, p. 63). During the first months of Brunelleschi's work on the dome for the Florence Cathedral (built from 1421 through 1430), workers needed equipment to carry extraordinarily massive, cumbersome heavy loads. They had to move, for example, gigantic stone blocks for the tie rings to the eight corners of the octagonal-shaped drum (lower vertical section of a dome). When the stones arrived in an upper central location, workers (even the entire workforce together) found it impossible to move the unwieldy masses over the drum's scaffold. Compounding the problem was the fact that it was necessary to interlock the blocks with the already cut and set blocks. In order to lift such unmanageable materials, workers needed a powerful central mechanism. For this task Brunelleschi designed the load positioner.

Brunelleschi's load positioner has two horizontal, screw-actuated slideways designed to manipulate the load and a counterweight. The capabilities of the new machine fascinated even the great inventor Leonardo da Vinci (1452–1519). "The apparatus, like most of the Brunelleschian machines, is shown in Leonardo's notebook . . . contributors to the Leonardo literature have been inclined to use exclamatory statements (when referring to Brunelleschi's work) and have been unduly impressed by the progress that they believed to find in this device" (Prager and Scaglia, p. 78). Also, one must know the other side of this information, that Leonardo, "fascinated by Filippo's machines . . . made a series of sketches of them and, as a result, is often given credit for their invention" (King, p. 69).

Several of Brunelleschi's machines became famous. One, mentioned by Georgio Vasari in his *Lives of the Artists,* was an auxiliary tool, a pair of screw-acting mechanisms historians believe builders used as load hangers.

Unfortunately, most of Brunelleschi's machines no longer exist. As the need for them eventually lessened, they were placed in storage; constructed of wood, they fell apart over time. On the other hand, some, like the sturdy reversible hoisting machine, operated for longer than 10 years with no improvement and a minimum of maintenance. Brunelleschi himself made a few minor changes. He replaced the elevated scaffolds (areas receiving constant wear) and a few of the crane elements due to hard, unavoidable wear on certain sections.

Only a few machines survived the test of time, hard, steady use, and storage. Several of Brunelleschi's machines survived until recently because the interest of engineers and scholars afforded them the care they needed. Today their whereabouts cannot be reported (Prager and Scaglia, p. 97). Mostly, though, Brunelleschi's machines disappeared because they belonged to a world rapidly moving away from the Renaissance and toward the future.

Brunelleschi's Sculpture

In 1401, when Brunelleschi was 24, the Wool Merchants' Guild approved a project to replace the doors on the east side of *Battistero* or Baptistery of Florence. The doors faced, as they still do today, the west entrance to Santa Maria del Fiore, the Cathedral of Florence. Most historians believe a committee arranged a contest so that the east baptistery doors would be made by the most talented hand the world had to offer:

> The committee which the *Calimala* had put in charge of the Baptistery, the *Officiali del Musaico* or as it was popularly called the *Operai* or *Governatori,* very likely set up the general conditions of the contest, presumably with the approval of the consuls of the guild, and allotted the funds necessary for the occasion. (Spencer, p. 20)

Brunelleschi participated in this contest. As it turned out, the contest became one of the most famous sculptural projects of the Early Renaissance. Andrea Pisano (c. 1290–1348) had already sculpted one pair of doors, showing the Life of John the Baptist. Two more doors (four long panels for the Baptistery's east side) had yet to be made. These doors became the subject of the contest. They were to illustrate both the Old and New Testaments. In 1401 the *Operai,* or Board of Works representing the Baptistery, officially opened the competition.

"[The Board of Works asked] each contestant to submit a relief panel depicting [an Old Testament scene] 'The Sacrifice of Isaac' (Kleiner, Mamiya, and Tansey, p. 592). The story the Board members had decided upon for the competition would illustrate "[t]he story of Abraham's offering of his son, Isaac, to God [as] told in Genesis 22:1–19. God tested Abraham's faith by commanding him to offer his only son, Isaac, as a sacrifice to him" (Earls, *Renaissance Art,* p. 254).

Brunelleschi entered the competition as a goldsmith. He followed the exact guidelines, as did every other contestant. Rules stated that entrants' illustration panels had to include Abraham, Isaac, an angel, a lamb, servants, and a donkey. The scene depicted was to be the moment Abraham took the knife to his son's throat with the intention of sacrificing him. Brunelleschi's entry, in a quatrefoil (a four-lobed shape similar to a four-leaf clover), which included all necessary ingredients (and has since become famous) did not win. Frederick Hartt says "Brunelleschi's relief [sculpture] was a brilliantly original creation full of daring poses . . . [however] the qualities of harmony and balance . . . are absent" (Hartt, p. 158).

In fact, Brunelleschi's figures' movements are stiff and jagged and not at all graceful. It is surprising, almost shocking that Brunelleschi depicts Abraham standing in an old stiff Gothic S-curve pose. Abraham's body does not appear supple, graceful, or well made. All contestants depicted the same scene and in nearly the same way: "Abraham with his knife held high . . . Isaac either kneels or lies, usually naked, on a type of low altar. . . . An angel is in the act of taking Abraham's hand and at the same time pointing towards the lamb in the brush" (Earls, *Baroque Art,* p. 261).

Nevertheless, with Brunelleschi's best efforts, he became one of the seven semifinalists but was defeated by the younger Florentine sculptor Lorenzo di Cione Ghiberti (1378–1455). He won the competition with an extremely classical, graceful Isaac. Unlike Brunelleschi, his entry exhibited soft, curving rhythms and harmonious lines derived directly from classical antiquity. Frederick Hartt says, "Throughout Ghiberti's entire composition—in every figure, every drapery form, even in the far more complex rocks of the landscape—runs a beautiful flow of soft, curving rhythm" (Hartt, p. 159). Within his prescribed quatrefoil (four-lobed shape) Ghiberti created the first Renaissance classical nude figure, a figure that could have come from classical Greece, so balanced and harmonious were the lines. Brunelleschi's figures, on the other hand, appeared boardlike and not at all supple. As a result of winning the contest, Ghiberti received the commission in 1403 and a renewal in 1407. Both Ghiberti's and Brunelleschi's panel can be seen in the Bargello Museum. When viewed side by side one sees why Brunelleschi lost the contest. While Brunelleschi's figures are sturdy and stiff, Ghiberti's are graceful and flowing. Where Brunelleschi emphasized hard, dramatic emotion, Ghiberti gave his figures grace and elegance. Abraham, in Ghiberti's panel, stands in the Gothic S-curve pose and pauses to think about the act he is about to perform, even as he holds the knife ready to strike. Here, Isaac, far more realistic than Brunelleschi's, reminds one of the perfections seen in Greco-Roman statuary. Some historians regard it as the first true nude in the classical style since antiquity. Brunelleschi's Isaac, on the other hand, reveals only a rudimentary understanding of anatomy.

As painful as the loss must have been for Brunelleschi, the contest became a major turning point in his life. After his defeat he turned from sculpture to architecture, and as a result he found, with little effort, the curving rhythms and flowing lines in architecture he had been unable to capture in sculpture.

Despite his talent and broad education, losing the contest left Brunelleschi unreasonably despondent beyond rapid or even normal recovery. In fact, so great was his depression and disbelief (he had never before produced work of lesser quality than other artists), he turned away from sculpture completely and forever.

Many historians agree the history of the Early Renaissance in sculpture begins with the competition for the design for the Florence baptistery's doors. They further agree that the sculpture competition, which Brunelleschi expected without any doubt to win, probably caused him to become an architect.

Brunelleschi's Architecture

After losing the competition to sculpt the east doors of the Baptistery of Florence to Lorenzo Ghiberti, a greatly defeated and depressed Brunelleschi left for Rome. He traveled with his friend Donatello, who went on to become the greatest Florentine sculptor before Michelangelo (1475–1564). Donatello was also a young man at that time and regarded by Florentines as showing great promise. (He went on to become the most influential individual artist of the fifteenth century, confirming the fact that Brunelleschi kept company with some of the greatest artists who ever lived.)

After the Consuls announced the winner of the sculpture competition, they learned that Brunelleschi planned to leave Florence. Recognizing his genius, they requested he remain with Ghiberti and assist with work on the Baptistery doors. With some anger and without hesitation, he refused. His strong determination to be the world's best in an art other than sculpture overcame any possibility of being another artist's helper.

Accordingly, after this, Brunelleschi chose architecture "as being more useful to mankind than either sculpture or painting" (Vasari, p. 139). Without a glance back he sold the farm where he lived and with Donatello moved to Rome to study Roman architectural monuments. Vasari says that as "he walked through Rome seeing for the first time the grandeur of the buildings and the perfect construction of the churches he kept stopping short in amazement, as if thunderstruck" (Vasari, p. 139). In this way, he began several years of study of the architecture of the Romans so intensive that at times he forgot to eat or sleep. He drew in detail every building he saw: aqueducts, Roman baths, triumphal arches, coliseums, amphitheaters, basilicas, and octagonal, square, circular, and rectangular temples. He noted the Roman engineers' unique methods for binding stones together. He studied the Roman system for piecing together or dovetailing (a wedge shape that fits into a corresponding indentation to form a joint) stones and balancing them. He made himself, as a result of long and extensive study and openness to new ideas, an architect of colossal creative power.

As it turned out, Brunelleschi had chosen the best course. In the end, he found architecture more useful and satisfying than any art or subject he had ever studied. He recognized too that his analyses of Roman buildings were prepar-

ing him to design with ideas the world had never seen. A highly competitive person, as he investigated and drew buildings, he privately hoped that eventually his architecture would elevate him higher than Ghiberti and Donatello, who had moved far beyond him in their sculpture (Vasari, p. 139).

For this purpose, he studied church construction. He drew ground plans of ruined Roman buildings on every street in Rome he traveled. He recorded measurements of every building worthy of consideration. So driven was he that he worked all day and many times into the night without stopping. He concentrated only on architecture of the past, studying especially the Roman aspects of reinforced concrete and engineering. He studied in detail that most famous of all feats of Roman engineering, the Pantheon (c. 118–125). If he found any remains, such as ruins of capitals or bases of buildings, he would have them completely dug out, which explains why he became known as a treasure hunter. He studied Roman methods for clamping vaulting with ties and the methods for binding stones for linking and balancing them.

As a result, using the findings of his Roman explorations, Brunelleschi moved architecture out of the seemingly hopeless Gothic trench into which it had become mired. Gothic masons had purposely and totally ignored Roman engineering techniques (considering them, as did early Christian builders, pagan and therefore not suitable for housing Christian worshipers). French historian Jules Michelet (1798–1874), who in his *Histoire de la France* coined the slogan "*découverte du monde et de l'homme*," or "discovery of the world and man," credits Brunelleschi as the destroyer of the Gothic. He did not design with flying buttresses, stained glass windows, or pointed arches. He did not use pinnacles (spires) or any of the myriad Gothic techniques and designs. The building with which he opened the gates to the Renaissance in architecture was the Foundling Hospital in Florence.

Foundling Hospital, *Ospedale degli Innocenti*, Florence, 1421–1445

Most architectural historians agree that the first building to exhibit true Renaissance characteristics, that is, forms not Gothic, is Brunelleschi's Foundling Hospital, or *Ospedale degli Innocenti*, a structure in Florence designed to house orphans from infancy to age 18. The hospital is the most exact embodiment of not only the architect's style but also of the Renaissance.

Unlike its Gothic predecessors, and in fact unlike any building ever built before, this first Renaissance building, begun in 1421, has a delicately, perfectly balanced loggia façade. The design, so aesthetically pleasing, harmonious, and balanced, quickly became an important, much-imitated prototype. So lovely was the loggia that architects who saw or heard about it copied its parts from the columns to the cornices.

Because of the hospital's influence, Brunelleschi's buildings became so recognized that, in unusual gestures, celebrated authors mentioned his genius while he was still alive. Renaissance painter–author Giorgio Vasari said "his genius was

View of the courtyard of *Ospedale degli Innocenti,* Florence, designed by Brunelleschi. © Scala / Art Resource, New York.

so commanding that we can surely say he was sent by heaven to renew the art of architecture" (Vasari, p. 133). Vasari's book *Lives of the Artists* is certainly to be taken seriously as it "is perhaps the most important book on the history of art ever written, both as a source-book and as an example for all the later Italian historiographers" (Murry and Murry, p. 460).

Indeed, Brunelleschi's hospital's exterior loggia is the most aesthetically pleasing part of the entire design. (Brunelleschi's followers completed the hospital section of the building out of necessity because by 1425 he had become busy with the dome for Santa Maria del Fiore.) Architects find a prototype for the Foundling Hospital's loggia at another hospital in Lastra a Signa near Florence, built in 1411. This building has a vaulted loggia outside, and upon cursory glance only a few differences exist between the two. Brunelleschi's details, however, present several important new elements, ideas he derived from the Romans.

For instance, when studying Brunelleschi's hospital loggia in detail, one sees a stately row of round arches surmounted by a delicate horizontal entablature (a horizontal member directly above the columns). Between the wall and the outside columns, vaults made up of small domes carried on the slender columns of the loggia and on corbels (bracket-like braces) attach to the hospital wall. And, more importantly, unlike the hospital at Lastra a Signa, the area between the columns and wall and space between two columns forms a perfectly balanced square—top, bottom, and sides. No Gothic builder had considered such harmonious measurements.

Brunelleschi built the Foundling Hospital loggia at one side of a piazza ending on a newly opened street, the Via dei Servi. No one knows the design of the

structure city fathers intended to have built across from the hospital as a balance on the other side of the piazza, or large, open place, "but it is probably that the present harmonious series of arcades—the first of the great, unified squares of modern urban design—was planned from the first" (Hartt, p. 146).

Balancing the piazza, Brunelleschi's famous arcade with its wide semicircular arches has spandrels (the triangular space between the curves of adjacent arches) accented with medallions by Andrea della Robbia (1435–1525). His medallions (using the vitrified lead glazing technique pioneered by his uncle Luca della Robbia, 1400–1482) with the famous foundling children, babies in swaddling clothes, came to be greatly admired. At the time of their installation souvenir dealers sold inexpensive copies throughout Florence.

On the whole one can conclude that Brunelleschi's architecture set a precedent throughout not only Renaissance Italy, but eventually throughout Europe. His Foundling Hospital, however, seemed but an architectural exercise in all that is aesthetically pleasing when one considers his dome for the Cathedral of Florence.

Dome of the Florence Cathedral—Santa Maria del Fiore, 1420–1436

In 1418 Brunelleschi won the commission to place a dome on the cathedral of Florence, Santa Maria del Fiore, an unfinished Gothic cathedral placed on the site of the ancient, deteriorating seventh-century church of Santa Repartata. The Florence Cathedral was a frequently used building that served not only religious needs but benefited Florentines as a meeting place for voting into law proposals that authorities put before them.

Indeed, for decades Florentines had dreamed of a dome for their cathedral. However, their constantly conflicting ideas concerning what would be the best kind of dome for the existing building caused argument to the point of total inertia. "Even before Filippo's birth a controversy about the Florentine cathedral had come to the attention of his father, Ser Brunellescho di Lippo Lapi [who lived from 1331 to a time between 1397 and 1404]" (Prager and Scaglia, p. 2).

In the early fourteenth century, proposals for continued renovation of the cathedral included an unusually large dome, not the usual small semicircular apses or radiating chapels prevalent throughout Italy. If built, the dome would be the widest and highest ever constructed; it would appear to rise to the heavens without any visible support. "Many experts considered its erection an impossible feat. Even the original planners of the dome had been unable to advise how their project might be completed: they merely expressed a touching faith that at some point in the future God might provide a solution" (King, p. 5).

The wardens in the *Opera del Duomo* voted to construct the dome but then lapsed into irresolvable arguments concerning details. For 50 years no one in Florence had even a hint of an idea for construction. But construction wasn't the argument that kept the authorities immobile. The outer shape of the dome, the silhouette with which it would grace the skyline, caused the greatest consternation. The commune of Florence could come to no agreement as to whether

View of Florence with the dome Santa Maria del Fiore designed by Brunelleschi. The Art Archive / Album / J. Enrique Molina.

it should be pointed or semicircular. Because the opening already in place was gigantic—with a diameter exceeding even the Roman Pantheon, which for more than 1,000 years was the largest dome in the world—the dome would be an impossible feat using engineering principles known to even the most advanced architects of that time. The proposed dome had to not only cover a space 138.5 feet across, but also fit an octagon shape that could not be changed. The number eight was important in Christian iconography as the number symbolizing Christ's Resurrection: "It was on the eighth day after His Entry into Jerusalem that Christ rose from the grave. Many baptismal fonts are octagonal in shape" (Ferguson, p. 92). Thus, for two reasons wardens would entertain no arguments toward changing the octagonal shape: It was already in place, and its symbolism meant more than a problem of engineering.

Furthermore, the octagonal space ready by 1412 or 1413 was an unusual area in that it did not begin at ground level. "The walls of the cathedral were already 140 feet high, above which a tambour (or drum) on which the dome was to rest would rise another 30 feet . . . vaulting for the cupola would therefore begin at . . . 170 feet" (King, p. 9). Even the Cathedral of Saint-Pierre at Beauvais (the highest Gothic vault ever built) rose only to 157 feet (and collapsed a little more than a decade later), 13 feet below where the vaulting for Santa Maria del Fiore's dome was to begin.

The largest problem, however, was not the height. It was that the dome had to fit on top of the octagonal shape already in place. Problems never imagined surfaced. For example, trees necessary for constructing the centering (temporary support necessary for a dome or arch during construction) for a dome of such size to bridge the gap did not exist. (A dome is a series of arches in a circle and requires timber for centering.)

The problem, once brought to light, surprisingly brought forth a plethora of curious solutions. The suggestion that seemed the most viable and seriously considered was a construction method used by Egyptian architects nearly 4,000 years previous: to have the workers fill the area within the octagonal space with dirt as the shell of the dome rose so that the dome walls could be supported on the dirt within. Hypothetically, when the dome reached completion, children could be brought to the site to dig out the dirt in an effort to find coins (of sufficient number to entice them) builders had dropped into the dirt as the dome progressed.

Brunelleschi found this idea absurd. He had already completed his model demonstrating the idea of a double-shell dome built without centering he knew would work. In 1417, the city planners (the *Operai*) of Florence agreed with him and paid for his drawings. In addition to his plans, he had shown them his small-scale wooden model. In 1420, the Florentine *Operai,* impressed by his ideas and convinced of their ultimate success (and also weary of arguing), gave Brunelleschi the commission for building the dome. At the same time they appointed Ghiberti (his old rival), along with a master mason, to act as building supervisors. The plan was to construct the dome according to Brunelleschi's drawings, which consisted of two domes—an inner, nearly vertical dome for support and a second thin outer shell for height and the impressive silhouette the Florentines desired.

The architectural plans were Brunelleschi's, and the builders used no others even in part. This should have pleased him. But it did not because Brunelleschi could not work with Ghiberti. According to Peter Murry, "[t]he construction of the dome was begun on the 7 August, 1420, and was finished as far as the base of the lantern on 1 August 1436. . . . Ghiberti and Brunelleschi did not get on at all well together, and there are later stories of how Brunelleschi pretended to be ill at critical moments so as to expose Ghiberti's incompetence" (Murry, p. 27). Also, since all machinery used for building and hoisting came from Brunelleschi's designs, he resented Ghiberti's tendency to take credit for his inventions and ideas. As the work progressed, he guarded his ideas from Ghiberti in a way that slowed the workers. During these times he felt less than appreciated.

Many architects, however, recognized Brunelleschi more than he imagined. A document written in 1423 rightly uses the terms "inventor and governor" to describe Brunelleschi in association with all work on the dome. The Building Consul fired Ghiberti in 1425 after the construction had become so difficult his incompetence as supervisor could not be covered. They discovered he depended on Brunelleschi and offered few ideas of his own. One must remember that while

assisting work on the dome, he worked on the commission for the Baptistery doors—a fact he never let Brunelleschi forget.

From the start, rather than using dirt to fill in the space under construction, then remove it (as the other architects had advocated), Brunelleschi went ahead with his idea (though still controversial) of a dome with two shells. He used neither pendentives (curved, triangular features enabling a circular dome to be placed on a square surface) nor squinches (an arch built diagonally across the corner of a square building to support a circular dome). Both methods had been used frequently and successfully since the fifth century in the early Christian structure in Ravenna, Italy, Galla Placidia (very small-scale pendentives), and in the sixth century in Ravenna's San Vitale, where builders constructed squinches to support a small dome. No architect had conceived of a dome springing from an octagonal shape without pendentives or squinches, except Brunelleschi. He derived his ideas from studies of the Pantheon in Rome. It was thus that Brunelleschi designed and helped build the first known double-shell dome in the history of world architecture. Unfortunately, he had to argue with every person involved with the project before he persuaded them his idea would work. He convinced them that it was the only way a dome could be placed on the space provided.

It was finally accepted—although still scorned and ridiculed. However, the construction of the double shell, once under way, was not as easy as it had appeared on paper. Brunelleschi, even after thorough studies, came across unforeseen problems in the octagonal base. In discussing the octagonal opening (and rightly believing he was the only architect who could construct the dome), he said, "[I]f the cupola could be round it would be possible to follow the method the Romans used when they vaulted the Pantheon . . . whereas in this case we have to follow the eight sides, using ties and dovetailing the stones" (Vasari, p. 143).

For the inner shell he had derived, from studies of ancient Roman architecture, a nearly vertical construction. (Vertical sections of architecture are always the strongest.) He proposed for this "vertical cone" light bricks to form a tightly knit herringbone pattern similar to those he had investigated in ancient Rome. When he had first presented ideas involving an inner shell, the wardens of the Cathedral and other citizens present laughed at him, remarking that his ideas were as mad as he was. All the while he stressed his idea that two domes rather than only one was the only way the space could be covered. At first they had "dismissed him as an ass and a babbler. Several times he was told to leave, but he absolutely refused to go, and then he was carried out bodily by the ushers leaving all the people at the audience convinced that he was deranged" (Vasari, p. 145).

With determination Brunelleschi finally convinced the wardens there was no way the dome could be made round or built other than the way he proposed. When he wrote out his ideas, "they were incapable of grasping what he had written, yet considering how ready and willing Filippo seemed and that none of the

other architects stood on better ground . . . after they had gone into a huddle they showed themselves inclined to give him the work" (Vasari, p. 148).

After the project got under way, problems of every size and complexity plagued Brunelleschi's progress. Many Florentine citizens resented Brunelleschi being chosen to build the dome. They believed too much responsibility had been given to one man. They also had convinced themselves that no one could solve the problem of the octagonal shape. Also, during the course of construction, Brunelleschi had spent too much time trying to figure ways to rid himself of Ghiberti (who drew the same salary). Another unforeseen, drastic problem was that the dome, even at its octagonal base, was so high that workmen feared working on it.

In the end, when construction neared completion, Brunelleschi saw for himself that the final shape of the dome was not the hemisphere he had hoped for. It was (and still is today) pointed and far more vertical than he desired. But, at the time, there was no other shape that would cover the octagonal drum (and remain standing). Buttresses would have allowed a more aesthetically pleasing hemispherical shape, but he knew that Italians would not tolerate them and, even more complicated, with the dome's drum or base so high above the street, there was nowhere to place them.

Brunelleschi's dome for Santa Maria del Fiore (c. 1420) stands in Florence today as a major landmark for the city. Tourists climb to the top using stairs Brunelleschi provided between the two shells. They walk to the edge of the oculus (central opening in the top of the drum) and enjoy the Florence Brunelleschi knew.

Brunelleschi's Scientific Linear Perspective, c. 1420

Not only did he excel at architecture, Brunelleschi also made a serious study of linear one-point perspective. Peter Murry says Brunelleschi found linear perspective to be "[a] quasi-mathematical system for the representation of three-dimensional objects in spatial recession on a two-dimensional surface, i.e. for the creation of an independent pictorial space as a microcosm of nature" (Murry, p. 337).

Because of various artists' errors in design experiments, the advance of perspective after the fall of Rome collapsed and did not find favor until the early fifteenth century. Greek artists had demonstrated a knowledge of simple single vanishing point perspective, using it first in stage sets. Roman artists had used aerial and herringbone perspective systems. Aerial perspective shows objects in the distance less distinct or veiled in haze. Herringbone has lines that do not converge on a single vanishing point on the horizon. Instead, several vanishing points are found on axes that run vertically through the picture. Knowing that parallel lines never meet, Renaissance artists before Brunelleschi never grasped the fact that parallel lines might only *appear* to meet. On a flat picture plane, parallel lines going in one direction will meet at one point on the horizon, a fact

not realized after antiquity until the early fifteenth century. Brunelleschi, fasci-
nated by the problem, studied the principals. According to Vasari, "[Perspec-
tive] gave him so much satisfaction that he went to the trouble of drawing the
Piazza San Giovanni and showing all the squares in black-and-white marble re-
ceding beautifully, and he also drew in the same way the house of the Miseri-
cordia" (Vasari, p. 136).

Brunelleschi's discovery made giant steps forward in the art of design. Art his-
torian Friedrick Hartt noted, "The invention of perspective was credited to
Brunelleschi by his anonymous biographer and by [Giorgio] Vasari, although
the question remains one of the most vexing and intricate in the entire history
of ideas" (Hartt, p. 173).

Giorgio Vasari wrote, "Filippo made a careful study of perspective, which be-
cause of all the errors of practice was in a deplorable state at that time, and . . . he
discovered for himself a technique by which to render it truthfully and accu-
rately, namely by tracing it with the ground-plan and profile and by using in-
tersecting lines" (Vasari, p. 136).

Brunelleschi's studies of perspective made a contribution to the art of com-
position and design so immense it cannot be measured. Today scientific linear
perspective can be learned by most students in a few hours with a minimum of
good instruction. Paradoxically, it may be the relative simplicity of the system
(it is taught to grammar school students) that causes artists of the twentieth and
twenty-first centuries to have no interest in the depiction of illusions of space,
a street, for example, receding into the distance on a flat surface. They ignore
the representation of the third dimension, especially twentieth-century abstract
expressionists, and create a system of space—for example Cubism, in which all
sides of an object are laid out on one flat nonreceding plane painted in mono-
chromatic hues. No recession into depth is considered, a fact Brunelleschi would
not have enjoyed.

Beyond all his other accomplishments, Brunelleschi spent a lot of time teach-
ing his concept of perspective to the young painter nicknamed Masaccio or
"Hulking Tom" (1401–1428?). Masaccio's real name was Tommaso di Ser Gio-
vanni de Mone. He became a close friend who did his teacher, Brunelleschi,
credit, as can be seen from the buildings painted in proper perspective in his
now-famous early fifteenth century frescoes—*Tribute Money,* to name one.

Brunelleschi also taught perspective to those who worked in intarsia, a sur-
face decoration made by inlaying small pieces of colored wood in patterns, a
kind of mosaic in wood. His influence on expert craftsmen is immeasurable. He
can be given credit for the results achieved then and even many years later, and
for the many works which over the years have brought praise to Florence.

Even before building the dome for the Florence Cathedral and furthering the
principles of scientific perspective, Brunelleschi had became friends with famous
Italian cosmographer and mathematician Paolo dal Pozzo Toscanelli (1397–
1482), known as Paul the Physician. (It is said Columbus used Toscanelli's map
of the world in 1492 for the voyage to America.) According to Giorgio Vasari,

Brunelleschi "struck up a close friendship with [Paolo] and started to take lessons from him in geometry" (Vasari, p. 136). From Paolo Brunelleschi learned the math he would need later when he built the dome for Santa Maria del Fiore and when he did the mathematical calculations needed for scientific linear one-point perspective.

Other Interests

Besides studying math, Brunelleschi read the works of the profoundly erudite Florentine poet Dante Alighieri (1265–1321), author of *The Divine Comedy*. (He called the work his "comedy," and later admirers added the adjective "divine.") A gifted reader, Brunelleschi admired Dante's elaborate narrative poem of his imaginary journey through Hell, Purgatory, and Paradise (certainly no comedy in the ordinary sense). Dante called it a comedy (beginning in despair and ending in bliss, in contrast to tragedy) because he wrote the manuscript in the vulgar—that is, Italian rather than Latin, the language then recognized as scholarly. Also, the work has a realistic view of human nature and includes a variety of unsavory human types. The places Dante described (e.g., The Dark Wood of Error, The Vestibule of Hell) so influenced Brunelleschi that he mentioned Dante in conversations and work whenever he could. Everything he read led him to consider how to devise and solve ingenious and difficult problems, although he never found anyone whose view of art agreed more with his own than his friend, fifteenth-century Florentine sculptor Donato Donatello (c. 1386–1466).

Most historians agree Donatello was the most influential individual artist of the fifteenth century before Michelangelo. Admiring Brunelleschi's intelligence and wide education, Donatello always listened to Brunelleschi's opinion of what Donatello considered one of his finished works. After he carved a wooden crucifix for Santa Croce in Florence, for example, he showed it to Brunelleschi for a candid opinion. Brunelleschi told him (in his usual honest manner) he had carved nothing more than a peasant hanging on a cross. This provoked Donatello's famous, "Get some wood and do it yourself" (Vasari, p. 137). Later, Brunelleschi carved a crucifixion and Donatello admitted Brunelleschi's work surpassed his to the point that he knew no less than the hand of a genius could have created such a miracle.

All during his life Brunelleschi aimed for the highest ambitions. One was to practice good architecture. He believed that if he continued with his best, his name would be regarded by posterity as highly as Giotto's, a thought he never overcame. He knew also that if architecture failed him and he needed money, he had only to return to work setting jewels for friends in the goldsmith business. Never one to limit his attention, he branched in different directions, including ecclesiastic or religious architecture.

Brunelleschi's other interests include two large basilican churches in Florence. One was San Lorenzo, the parish church of the Medici family. Another was Sto

Spirito. In addition, one of his most famous works is the Chapter House of the Convent attached to Sta Croce, an exquisite, perfectly balanced little building in the cloister known as the Pazzi Chapel. For 40 years the building remained unfinished. Today, although historians consider the building a "little jewel," most agree the façade, altered by others, is not as Brunelleschi planned.

Historians consider Brunelleschi the first Renaissance architect. He found his place in history by accident after working in different media. As a designer–builder with an artist's eye, Rome's architectural masterpieces fascinated him not for aesthetics but for practical reasons. He studied Roman engineering and gave himself a foundation with which to base his many innovations. An experimenter by nature, an eclectic gatherer of ideas, he moved in the directions his training and instincts took him.

Brunelleschi's ideas, so perfect for the age in which he lived, were to find ever fuller development, however, under his successors' pens. Without doubt he saved fifteenth-century architecture from the real threat of Gothic redundancy. Some scholars remind us that he saved Early Renaissance architecture not only from Gothic profusion, but also from unimaginative and exact copies of Roman ruins.

Brunelleschi had a genius so brilliant that many believed his gift had come directly from heaven. Truly a Florentine hero, his work, sweepingly innovative and revolutionary by the strictest standard, became the example by which historians measured most Renaissance architecture that followed.

Though many of his works remained unfinished at his death, imitators in great numbers copied Brunelleschi's ideas. It is interesting to note that of all artists who copied his works, not one mastered the strict mathematical severity he never omitted; not one conquered the creative sculptural richness seen in his columns and capitals.

When he died at age 69, friends buried him in Santa Maria del Fiore. Surprisingly, his tomb remained unknown for over 500 years, until "in 1972, [his] bones were exhumed from where, for over five hundred years, they had lain beneath a simple tomb slab" (King, p. 156).

Bibliography

Earls, Irene. *Renaissance Art: A Topical Dictionary.* Westport, CT: Greenwood Press, 1987.
————. *Baroque Art: A Topical Dictionary.* Westport, CT: Greenwood Press, 1996.
Ferguson, George. *Signs & Symbols in Christian Art.* New York: Oxford University Press, 1959.
Hartt, Frederick. *Italian Renaissance Art.* 3rd ed. Englewood Cliffs and New York: Prentice-Hall., Inc., and Harry N. Abrams.,1987.
Hauser, Arnold. *The Social History of Art.* Vol.2 New York: Vintage Books, nd.
Holt, Elizabeth. Ed. *A Documentary History of Art.* Vol. I. Garden City, NY: Doubleday Anchor Books, 1957.
King, Ross. *Brunelleschi's Dome.* New York: Penguin Books, 2000.
Kleiner, Fred, Mamiya, Chistin. *Gardner's Art through the Ages.* 11th ed. New York: Harcourt College Publishers, 2001.

Murry, Peter, *The Architecture of the Italian Renaissance.* New York: Schocken Books, 1970.

Murry, Peter and Murry, Linda. *A Dictionary of Art and Artists.* New York: Penguin Books, 1977.

Pevsner, Nikolaus. *An Outline of European Architecture.* New York: Penguin Books, 1981.

Prager, Frank D. and Scaglia, Gustina. *Brunelleschi: Studies of His Technology and Inventions.* Cambridge, MA: MIT Press, 1970.

Spencer, Harold. Ed. *Readings in Art History.* Vol. II. 2d ed. New York: Charles Scribner's Sons, 1976.

Vasari, Giorgio. *Lives of the Artists.* Trans. by George Bull. Baltimore: Penguin Classics, 1965.

CHAPTER 3

Donatello (Donato di Niccolò di Betto Bardi), 1386–1466

Italian Renaissance master of sculpture Donatello is sometimes considered the most original and comprehensive genius of a remarkable group of sculptors, architects, and painters who created a veritable artistic revolution in Florence during the first quarter of the fifteenth century. Murry and Murry believe that "[Donatello] was not only the greatest Florentine sculptor before Michelangelo; he was the most influential individual artist of the 15th century" (Murry and Murry, p. 132). Likewise, Panofsky gave him the most supreme compliment when he called him "the rival of the ancient sculptors" (Panofsky, p. 32).

Donatello's Life

Donatello (Donato di Niccolò di Betto Bardi) was born in Florence, Italy, according to most sources, c. 1386. To the dismay of many historians, "Donatello's birthdate is uncertain, but not because of a lack of records, rather because of the man himself. On his successive tax declarations (*portate al Catasto*) for 1427, 1431, 1433, and 1458, he listed his age, respectively as 41, 42, 47, and 75" (Bennett and Wilkins, p. 35). By 1458, when his tax declarations yield a birth date of 1383 or 1384, Donatello may have forgotten his age, possibly because it was unimportant to him. Earliest documents identify Donatello as "Donatus filius Niccolo Bardi de Florentia" and "Donato filio Niccolò Betti Bvardi, de Florentia" (Bennett and Wilkins, p. 36).

The nickname "Donatello" appears in 1411, when he accepted the commission for the statue of St. Mark. "It does not reappear until 1426, and then in two Pisan, not Florentine, documents" (Bennett and Wilkins, p. 36). He was the son of Nic-

colò di Betto Bardi (or di Bardo), a Florentine wool carder who made a modest living by brushing wool to untangle the fibers and prepare it for spinning. Niccolò, who died before 1415, did not live to witness most of his son's achievements. Certainly a man with drive who would stand up for himself, Niccolò perhaps participated in the Ciompi Revolt of 1378, which turned craftsmen and skilled workers against the governing aristocracy. His past was so checkered that it is not surprising to learn that at one time in Niccolò's life authorities purportedly sentenced him to death for a murder in 1380. Later, finding him innocent, they let him go (Bennett and Wilkins, p. 36). Donatello's father's activities apparently had no effect on the artist's mind and artistic inclinations.

Donatello's mother, Mona Orsa, according to one of her son's tax declarations, was around 40 when he was born. Still, this is only guesswork: In both 1431 and 1433 Donatello listed his mother's age as 84 (Bennett and Wilkins, p. 35). In 1427, after he had created several masterpieces, she was probably 80. Historians know she had given birth to a girl, Tita, about five years before Donatello. (Tita was widowed and had a paralyzed son, Giuliano.) Although it is extremely remotely possible that Donatello's family descended from the great and successful Bardi family, who had become wealthy from banking, it seems unlikely considering the young man's spare and frugal early upbringing tended toward bare necessities rather than extravagant indulgences.

Accordingly, one can understand that even after his fame and word of his accomplishments had reached beyond Florence, Donatello chose a serene, unpretentious life. It seemed he found happiness within himself and never sought notoriety or even the smallest unwise excess. Apparently, he remained throughout his life thoroughly absorbed by his art.

Since Donatello's lineage has not yet been traced back beyond his father, not only are historians unable to link him to the riches of the Bardi (in which case the family chose, despite wealth, to live a modest life), they also do not know where his genius originated. Furthermore, historians do not know what he looked like, amazing because he lived at the dawn of the portrait, the dawn of the beauty of the Renaissance and the celebration of man.

Remarkably, no portrait upon which historians agree as being absolutely authentic has been located—that is, possibly a coin, marble bust, or painting. Bennett and Wilkins indicate that

> [w]e have no certain portrait that represents the features of Donatello, but the traditional type used by Vasari as an illustration for his *Life of Donato* in the *Vite* [*Lives of the Artists*] is based on a famous, if ruined, fifteenth-century painting in the Louvre, which depicts the Founders of Florentine Art (Giotto, Uccello, Donatello, Manetti, and Brunelleschi). Donatello is supposedly represented among several other portraits (including that of Masaccio as John the Evangelist on the far right) in Masaccio and Masolino's *St Peter Healing with his Shadow*. (Bennett and Wilkins, p. 34)

Vasari, in his *Lives of the Artists*, says, "[Donatello's] portrait was done by Paolo Uccello [1396/7–1475]" (Vasari, p. 188). Likewise, Christoph Lederer's wood

engraving "Portrait of Donatello" (Bennett and Wilkins, p. 64) may also be a portrait. Donatello's *Reliquary Bust of San Rossore* might be a self-portrait from the 1420s.

With no guaranteed portrait, historians find it impossible to put a face on the man whose accomplishments we enjoy today. Nonetheless, whatever his appearance, surprised patrons discovered an inordinately stubborn man when they attempted to curtail his artistic ideas, or (sometimes cleverly) maneuver them to match their own. He adamantly demanded and received complete artistic freedom because he would never begin a work without unequivocal liberty. Contract negotiations ultimately and without exception ended in his favor. So involved was he that he would never relent and, once set on an idea, could become nearly impossible to negotiate with. "A letter of 1458 implies that it was difficult to negotiate with Donatello: he is described as being 'molto intricato' [excessively involved]" (Bennett and Wilkins, p. 32).

Donatello was able to carry out his ideas because he knew what he wanted. He had studied, for example, Roman art, and it is quite possible no contemporary artist understood the Roman style better. Vasari is correct in saying that "in the good times of the ancient Greeks and Romans sculpture was brought to a state of perfection by many hands. . . . [Donatello] alone by his many works restored its magnificence and perfection in our own age" (Vasari, p. 189). At the same time, surprisingly, his contemporaries did not consider Donatello a cultured, well-educated intellectual. On the other hand, to his credit, he never assumed airs to cause artists or historian to think otherwise. His clothes, for example, revealed no taste, for he cared not about his appearance, most of the time presenting himself shabby and unkempt. In fact, "Cosimo de'Medici, evidently embarrassed by Donatello's usual manner of dress, gave him a new cloak, cowl, and red mantle. After a day or two Donatello 'put them aside, saying that he would not wear them again as they were too fine for him'" (Bennett and Wilkins, p. 32). Even so he did study Roman art seriously enough to make it his inspiration and never overlooked even the most minute details during his studies. In fact, one notes unusual signatures on his works. These stand out because they are among the first examples of the revival of classical Roman lettering. All are well made and exact because he had practiced each letter relentlessly and, as with all his art, became meticulous concerning even the most detailed nuance.

Donatello did not live in the household with his mother and father, which might explain the reason his father's activities had no impact on his life. Vasari says, "Donatello was brought up from early childhood in the household of Ruberto Martelli. His fine character and the way he applied his talents won him the affection of Ruberto and all his noble family" (Vasari, p. 174). (During the Renaissance it was not unusual for an especially gifted child to be raised by a noble family.) While still a young boy with the Martelli, he created so many works that eventually his art went unheeded. Soon, however, his experiments would become more than the efforts of a child. His talent emerged early when he began instruction as a goldsmith and after the most minimal training created

a work worthy of display. However, Vasari says, between 1428 and 1433 "he made his name . . . when he carved an *Annunciation* [the angel Gabriel announcing to Mary she would be the mother of Jesus] in gray-stone, which was put in Santa Croce at Florence near the altar of the Cavalcanti Chapel" (Vasari, p. 174).

At age 17, Donatello learned the rudiments of carving stone as an apprentice from Florentine sculptor Lorenzo Ghiberti (1378–1455). A famous, inordinately talented sculptor, Ghiberti had in 1402 been awarded a commission sponsored by the *Arte di Calimala* (Wool Merchants' Guild). The commission was to cast a set of doors for the east side of the Florentine Baptistery, which was located directly in front of the façade of the Florence Cathedral. (Recall from chapter 2 that this is the competition Filippo Brunelleschi lost, which caused him to turn away from his career as goldsmith and work in architecture.)

Along with learning to cut stone, Donatello also worked in Ghiberti's bronze foundry. The foundry "became a veritable academy and among his assistants were his son, Vittorio, Donatello [and others]" (Holt, p. 151). Under Ghiberti's tutelage, Donatello developed into a strong and effective master. He learned to reveal deep psychological intensities. This is rare and outstanding, even astonishing, considering the Gothic milieu in which he lived: At this time, Jesus, the Virgin Mary, saints, and other holy figures never revealed emotion, age, or rank, and artists never depicted them as worldly or military.

Significantly, only the rarest sculptor has ever been able to portray a range of various figure types. According to Hartt, "Donatello could, with ease, depict figures of diverse ages, ranks, and human conditions, such as childhood, the idealized human nude, practical men of the world, military despots, holy men, derelict prelates, and ascetic old age" (Hartt, p. 593). Only a few masters in the history of art, such as the northern baroque artist Rembrandt (1606–1669), have matched Donatello's range of human emotion and age.

However, some historians saw displays of true emotion and advanced age differently and commented on his penchant for the ordinary, sometimes the ugly. According to Wölfflin, "the master who created the bronze *David* . . . [Donatello] had an insatiable appetite for ugliness: he ventured even to make his saints repulsive, because a convincing living individuality was everything" (Wölfflin, p. 224).

Donatello advanced classical idealism and naturalistic illusion, along with a strong diversity and range of emotion, in sculpture. His work beacons all the more brightly when one considers that early fifteenth-century Florence, with the exception of architect Filippo Brunelleschi's (1377–1446) work, would have remained medieval for many more decades. In this light, Donatello's levels of accomplishment made him worthy of being the third of the great Masaccio–Brunelleschi–Donatello triumvirate, which moved medieval Florence toward the early sixteenth-century High Renaissance.

A generous, happy man throughout his entire life, Donatello never, even during his advanced years, found wealth important. Vasari says, "[H]e kept [money] in a basket suspended by a cord from the ceiling, and all his workmen and

friends could take what they wanted without asking. He was very happy in his old age, but when he became senile and was no longer able to work he had to be assisted by . . . his friends" (Vasari, p. 186). Shortly before he died, relatives came to see him. They insisted he must give them a farm he owned at Prato. According to Vasari, he told them,

> I am afraid I cannot satisfy you, because it seems only right to me to leave it to the peasant who has always worked it, and who has toiled there, rather than to you, who have not given anything to it but always thought that it would be yours, and now hope to make it so just by this visit. Now go away, and God bless you. (Vasari, p. 187)

Raised in a spare environment, preferring a frugal existence his entire life, Donatello never married. Except for his infancy, during the 80 years of his long, peaceful, and productive life he spent his time even into advanced age in all endeavors concerning art. However, by the time he reached 80, Vasari tells us "he became so palsied that he could no longer work at all, and he had to keep to his bed in a poor little house . . . [where] he grew worse from day to day and gradually wasted away until he died on 13 December 1466" (Vasari, p. 187).

Looking at a few of his accomplishments, Donatello carved his marble *David* (he later cast a bronze *David*) after leaving Ghiberti's workshop to work at the Cathedral of Florence. He carved the David for a buttress on the north transept of the cathedral.

The Early Marble *David*, 1408

In 1408, when he was 22 years old, Donatello carved a six-foot, three-inch marble *David*. One of his earliest known works (of which there is positive knowledge), the *David* is now in the Bargello (Italian National Museum) in Florence. It is by all accounts exceptional. Donatello does owe a small debt to Lorenzo Ghiberti, Donatello's teacher, who worked in bronze.

It is no drawback that Donatello's rather stiff drapery reveals the influence of late Gothic statues (with which he was surrounded), and does not reach the level of virtuosity that would come to his hand a few years later. Art historian Hartt describes the statue:

> The boy [David] stands proudly yet awkwardly, his left hand bent upward on his hip, his right (which once held the sling) hanging loose, his head tilted. The lines of the drapery, now momentarily free, now tied to the figure and to each other, oscillate back and forth in sharp curves, from his right foot upward toward the head. This head is perhaps the strangest part of the statue. Instead of the pride of the victor . . . we see a mouth half open . . . and eyes widened in a detached stare. (Hartt, p. 165)

In this first marble *David* Donatello reveals human emotions previously only fleetingly glimpsed (if at all) in the patron-restricted imaginations of medieval sculptors. Church patrons considered only symbolic faces and straight bodies

set by guidelines hundreds of years old appropriate for religious works depicting saints, the Virgin Mary, Jesus, or God himself. Medieval worshippers did not demand emotion and they expected standards, strict and proper, to be followed. It is thus that the marble *David,* with his bright and inordinately human eyes and turned head, looked toward the future and, breaking all contemporary rules, became an inspiration for other sculptors to follow.

Donatello carved the *David* as civic statuary for a buttress of the north transept of Santa Maria del Fiore, the Cathedral of Florence. Installation there would have placed it high above ground level, where viewers saw it only from below. For this reason he kept details minimal, although the right hand at one time held a strap of bronze meant to be David's slingshot. "On this strap were inscribed in Latin the words (no one could read yet everyone knew the meaning): 'To those who bravely fight for the *patria* [homeland] the gods will lend aid even against the most terrible foes'" (Hartt, p. 164). Today only the marble piece holding the stone has survived.

In the early fifteenth-century Florentine republic, the triumph of brave over strong appealed to the people. This was the idea embodied in Donatello's young David, whose story as successor of Saul everyone knew and who, author of the psalms and a noted musician, became king of the ancient Hebrews (c. 1012– c. 972 B.C.) (Earls, p. 81). More importantly, with this statue "a new conception of David was developed by Renaissance sculptors [Donatello being the first], who [in the 1430s] represented him as a handsome youth standing proudly over Goliath's severed head" (Earls, p. 82).

Accordingly, Donatello adorns the second king of Israel and Judah with a crown of leaves and flowers known as amaranth. This plant, a purplish-red imaginary flower that never fades or dies, lived only in the imagination of poets and symbolized the eternal fame of Greek and Roman heroes.

So important was Donatello's work that after he completed the statue, Florentines gave more significance to the story of David, and they made the religious figure the symbol of Florence. As David moved into position as the symbol of Florence, Donatello added the bronze strap and even slightly reshaped the marble statue to conform it to its new meaning. One must recall that "in 1416 Florence was just emerging from a long period of war and of threatened republican freedom, and the city's identification with the hero must have been particularly strong" (Bennett and Wilkins, p. 66). Undoubtedly, in Renaissance Florence, David, the shepherd boy who became king of the ancient Hebrews, stood for the most noble, righteous, honest human beings and in this role promoted security and peace.

Even in his early marble *David,* Donatello used projections and hollows to emphasize light and cast shadows. No sculptor before him had used these techniques. With optical accomplishments, that is, carefully manipulated deeply cut furrows and protrusions never imagined by Gothic, Roman, or Greek sculptors, he created areas in stone that appeared alive and breathing. Expertly planned and executed shadows beamed from what would have been, under an ordinary hand, insignificant dark depressions. As his art progressed, Donatello improved

upon and mastered ideas concerning shadows, shaping light, and purposely focusing and placing it to change a stone's color,. His revolutionary carving techniques mature in statues such as his larger-than-life *St. Mark.*

The Statue of St. Mark, c. 1411–c. 1414

Donatello's maturity and full power are first seen in his statue of St. Mark, carved when he was 25. In this seven-foot, 10-inch marble, the old Gothic "sword blade" drapery no longer exists.

The *St. Mark* is Donatello's first contribution to the guilds' common program to decorate the exterior niches of Orsanmichele in Florence. A stark, enormous three-story structure located in the center of the city, Orsanmichele was a combined grain exchange and shrine. It was the center of the food supply of the Republic and thus immensely important during a time when many people did not have enough to eat. The old ogives, or pointed Gothic arches, which surmounted the deep exterior aediculae (tabernacles or niches for statues) were open to the streets. In each tabernacle or niche, every guild of Florence was responsible to place a statue of its patron saint.

St. Mark the Evangelist was the patron saint for the linen drapers and peddlers, or the *Arte dei Linaioli e Rigattieri.* Donatello had taken the commission for the St. Mark with a partner, Filippo Brunelleschi (1377–1446). Both men agreed, however, that Donatello would finish the statue alone. The linen drapers placed Donatello's statue in a typical Gothic tabernacle designed and executed by Perfetto di Giovanni and Albizzo di Pietro. Here, it became one of a sequence of statues produced by Florence's leading sculptors between 1406 and the late 1420s. As per agreement, every statue had been designed to stand on the exterior of Orsanmichele, and by the late 1420s every guild tabernacle had been filled with a statue.

Originally partially gilded (overlaid with a thin layer of gold), Donatello's St. Mark statue, identified by Mark's symbol, the lion (the four Evangelists are even today recognized by the following winged symbols: Matthew—angel, Mark—lion, Luke—ox, and John—eagle [Hall, p.128]), located below on the base or plinth, displays the saint standing on a flat, decorative cushion, as required by his patrons because the *Rigattieri* sold cushions.

Because his patrons sold cloth, Donatello purposely carved drapery in a manner not equaled since the Greek style of Phidias used on fifth-century B.C. sculpture found on the Acropolis, known today as the Elgin Marbles. His drapery, however, is quite different from that of Phidias' "wet drapery" technique. He brought to stone translated into cloth a pliable, gliding movement never before rendered. Historians have questioned why Florentines, whose livelihood depended upon the sale of cloth, had never noticed the stiff, blade-like Gothic cloth used on earlier statues.

Similarly, just as in the earlier marble *David,* Donatello knotted Mark's cloak over his shoulders. This knot produces deep folds of cloth that fall, in a manner entirely different from all preceding statues, to the saint's feet. The left leg protrudes through malleable, voluminous furrows. Donatello cleverly designed

the statue to be seen from below, from the street, where its audience would always be. He knew the statue would never be seen from a straight-on traditional point of view. Thus he carved the legs short and the torso long, producing a distortion in perspective that looked absurd, even misshapen from the standard point of view. But it appeared normal from street level, where the observer looked up at it. The consuls of the guild, however, disliked the statue. Thinking it distorted, they raised serious objections and decided they did not want to put the statue in their niche.

According to Vasari, "Donatello urged them [the guild consuls] to let him set it up on high, saying that he would work on it and show them an altogether different statue. When they agreed, he merely covered it up for a fortnight [fourteen nights] and then, having done nothing to it, he uncovered it and amazed them all" (Vasari, p. 178).

Yet there is more. Beyond all Donatello's new optical realism, the sculptor rendered a power in Mark's features no Gothic sculptor had even remotely approached. Gothic sculptors had rendered mostly symbols of saints. No facial expressions existed, no eye looked at any earthly object. Every face stared ahead in mute rapture. Donatello departed from all Gothic ideas. Hartt sums up his new approach:

> St. Mark seems, on the one hand, to assess the outer world and its dangers and, on the other, to summon up the inner resources of the self, which must be marshaled against them. This noble face—*terribile* would be the Renaissance word for it—can be thought of as a symbolic portrait of the ideal Florentine under stress. (Hartt, p. 165)

Florentines felt security in the turned head, the focused eyes, the relaxed posture, the comfortable, graceful drapery of a sort they had never encountered.

The details of the *St. Mark* show an attention to realism, something new after hundreds of years of stylized hair, schematic drapery, and no facial expression, that reveals individuality. Even St. Mark's eye is revolutionary. Donatello does not use the ordinary incised cornea edge and a standard drilled-out hole to form the pupil. He dilates Mark's pupil by cutting a very deep hole so that the outer shape forms shadows that actually appear to present a widely dilated black pupil. All this is surrounded by what miraculously appears to be a white eyeball, though the entire eye is stone. Although many earlier statues, even as far back as the Egyptians, have inset stones to color the eye and make it more realistic, Donatello did not choose this method. His new approach ran so counter to all sculpture before him that "it has been rightly claimed that this statue represents so abrupt a break from tradition that it is to be considered a mutation" (Hartt, p. 165).

As if that weren't enough, with his *St. Mark* Donatello "took a fundamental step toward depicting motion in the human figure by recognizing the principle of weight shift . . . [he] grasped the essential principle that the human body is not rigid" (Kleiner, Mamiya, and Tansey, pp. 599, 600). In other words, Donatello, after assiduous study of Greek and Roman sculpture, rediscovered *con-*

trapposto (also known as ponderation), or weight shift (a pose in which one part of the body is twisted in the opposite direction from the other). This concept had been lost during the last years of the Roman Empire after having been discovered by the Greeks in a statue, the *Kritios Boy* found at the Acropolis in Athens, Greece c. 480 B.C.

The contraposition of posture, the body at rest on one leg, completely separates *St. Mark* from all sculpture since Rome. *Contrapposto* had vanished in Roman art by 305, as one can see in the porphyry (purple marble) body portraits of *The Four Tetrarchs* at St. Mark's in Venice, Italy.

In contrast, earlier Gothic statues found at the entrance of cathedrals, known as jamb statues and sometimes statue-columns, are affixed to a wall or a column. (Examples from the late twelfth century can be found on Laon Cathedral at Laon, France.) Also, when in a niche or tabernacle, Gothic statues are permanently fixed and give no indication of any part existing except those portions that can be seen. Sometimes little more than decorative vertical accents, the statues were meant to be viewed from the front only. *St. Mark* is the first statue in 1,000 years to accentuate the legs, hips, arms, and shoulders, suggesting that it did not wear an invisible straitjacket, that it could walk out of the niche. With this achievement Donatello created a turning point in sculpture. His statue was human. It had a kind face. It seemed to be on the verge of moving—a miraculous sight after years of stiff, straight, rigidly upright saints staring straight ahead.

The Statue of St. George, c. 1415–1417

In addition to the *St. Mark* statue, Donatello's power as a mature sculptor appears in his marble statue of St. George, although it has been dated by some art historians as early as 1410. Donatello created *St. George* for an exterior tabernacle facing the street at Orsanmichele just as he had created the *St. Mark.*

Likewise, Donatello carved the statue in marble because the *Arte dei Corazzai e Spadai,* the Florentine guild of armorers and sword makers, whose patron saint was St. George, could not afford the expense of a bronze statue. (The marble statue, when removed from its tabernacle at the end of the nineteenth century, was replaced by a bronze copy.) Donatello's original marble is in the Bargello, the thirteenth century palace in Florence that houses Italy's national museum.

The original marble statue's right hand at one time held a sword, which probably protruded into the street. One can still see traces of corroded metal on the hand. St. George's head once had a helmet so that he wore the manufactured products of the guild he protected. Both sword and helmet have disappeared, and only drill holes indicating their placement remain. Undoubtedly, the helmet must have covered the unusual profusion of St. George's deeply carved curls. Helmet and sword identified both the figure (a warrior–knight) and the guild, maker of both items used in battle.

Leaving the stiff, staring-straight-ahead Gothic head position and the blank, otherworldly eye, the head of St. George turns slightly to the left. He stands straight

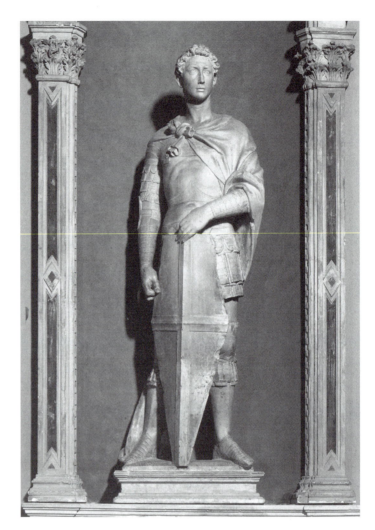

Donatello's *St. George*. Museo Nazionale del Bargello, Florence. © Scala / Art Resource, New York.

and tall, and appears human, even sensitive. Because of *St. George* and other of Donatello's statues, gentle, soft features came to characterize the Early Renaissance in Italy. St. George's pose is in complete contrast to late medieval statues. All that is left of medieval characteristics is an extremely popular subject.

Depictions of St. George as a warrior–knight and legendary knight–saint were common before 1400. However, "his popularity in the West dates only from the 13th cent. [sic] . . . As a devotional image St. George tramples the dragon under his foot, an allusion to the victory of the Christian faith" (Hall, pp. 136, 137). Yet, however successful the *St. George* statue was, "the most startling innovation of the *St. George* composition in Orsanmichele is the little marble relief representing the young hero's conquest of the dragon that adorns the base of the niche" (Hartt, p. 167).

The St. George Slaying the Dragon Relief, 1417

In the oeuvre (body of works) of Donatello's sculpture, the most important contribution to the history of art is the little marble relief illustrating St. George killing the dragon. This small masterpiece (15 1/8″ × 47 1/4″) is found directly below the tabernacle that holds the St. George marble on the exterior of Orsanmichele. The tiny rectangle spans a little more than the width of St. George's feet spread directly above. The relief was ordered in 1417, a date that has come to be regarded as crucial in art history. Until 1417 all artists—Egyptian, Greek, Roman, Gothic, Early Renaissance—carved figures of all reliefs on a completely flat background. Little indication of atmosphere had ever been depicted. Even a few years earlier, such masters as Ghiberti and Brunelleschi left a sky devoid of clouds or atmosphere.

Specifically, a cross section of bas-reliefs before Donatello would show the background slab as a straight line. On the other hand, a cross-section of Donatello's 1417 *St. George and the Dragon* relief would be impossible to "read" because it consists only of bumps and depressions. No flat areas exist. Donatello's experiments and studies came to fruition in this little relief. His hills and valleys create a light not unlike painting with chiaroscuro or shadows. His carefully calculated inclines and depressions create subtle shadows like no others in the history of sculpture. "Donatello's relief sculpture no longer corresponds to the idea of the object, nor to the object as we know it, but exclusively to the image of the object that light casts upon the retina. There could be no more crucial distinction, for in it is manifest the division between medieval and modern

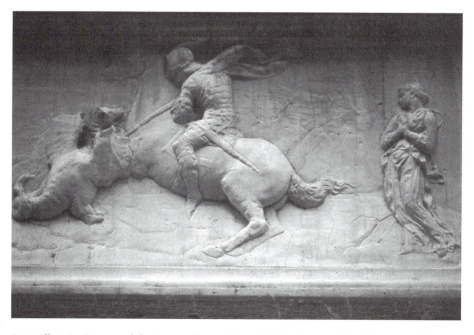

Donatello's *St. George and the Dragon*, bas-relief ca. 1416. Orsanmichele, Florence. ©Timothy McCarthy /Art Resource, New York.

art. The eye is now supreme" (Hartt, p. 168). This new relief treatment is known by the Italian expression *schiacciato* or *rilievo stiacciato,* a type of relief sometimes barely more than scratched in some places. Actually, the term *schiacciato* only partially describes Donatello's relief. He does more than flatten or scratch out the forms. He abandons totally the old bas-relief artists practiced for thousands of years and replaces it with new ideas of optical illusion.

Furthermore, as a result of an unusual study, Donatello calculated his new technique to fit the placement of his relief on the north side of Orsanmichele. This location illustrates a cleverly thought-out solar orientation. He knew the relief would never receive the direct, strong light of an east or west position. The sun's rays would be slanted every hour of every day, every month, always casting (in different places according to the time of year) scattered, subtle shadows, always bouncing back diffused from stone building façades across the street. With calculated shadows, light, and atmosphere, the St. George relief points the Renaissance directly toward the future.

The St. George relief is, even in its present blurred (from dirt and decomposition) state, striking. The warrior–saint's horse (always white for purity) rears back, his tail blown askew by unseen breezes, as St. George, dressed in Roman armor, plunges his long lance through the dragon's breast. Behind George (a symbol of good), the princess (traditional symbol of an ancient region of Asia Minor, Cappadocia, and—in Donatello's time—Florence) watches, wringing her hands while her dress blows in the breeze. The loggia and rocky opening take (with nearly correct one-point perspective) the viewer's eye back to the new background of sfumato, or haze. Florentines saw St. George as a devotional image killing the dragon, indicating victory of the Christian faith and triumph over evil politics.

Donatello's atmospheric relief sculpture no longer adhered to ordinary rules and conventions. It is the image of an object that light casts upon the retina. Here, science began its invasion into art's territory as Donatello carved stone as no sculptor before him to manipulate light. This little marble is the artistic divide between medieval and modern art. His technique, so subtle the untutored eye misses it, dissolves entirely any perceived line between the background and any objects—St. George, his horse, the maiden, the dragon. He turned stone into airy trees, drifting clouds, hills that for the first time in history hover in an atmospheric veil. He seemed to use the sculptor's chisel as a paintbrush.

The Meaning of St. George

With power shifting frequently, with constant changes in Italy's economic and political systems, social unrest became an important factor in art patronage and contributed to the subject choices patrons made when purchasing a work of art.

At the beginning of the fifteenth century, Florence's economy was threatened. Understandably, the legendary Roman tribune or warrior–saint and martyr St. George provided a perfect subject. Those who could afford art knew he was patron saint of all soldiers and armorers. They knew and appreciated the fact that

he was born in Cappadocia in Asia Minor of Christian parents before the reign of Constantine and martyred in Lydia in Palestine near the end of the third century.

St. George became an important Renaissance subject because his story contains a dragon or serpent. According to Ferguson, "The dragon, or serpent, was selected by the painters of the Renaissance to symbolize the Devil. The dragon as the enemy of God is vividly portrayed in revelation 12:7–9)" (Ferguson, p. 4). A dragon symbolized evil to the early Christian. "Armor [worn by St. George] also suggests the Christian faith as protection against evil" (Ferguson, p. 104). "The conversion of a heathen country to Christianity by a saint would thus be depicted in symbolic form, as the slaying of a dragon with a spear. St George was shown in this manner to signify the winning of Cappadocia for the faith, the place itself being personified by a maiden" (Hall, p. 136). St. George, in the Early Renaissance, signified the victory of the Florentine republic over the numerous evils (the serpent) that threatened its stability.

The Feast of Herod, 1423–1427

Shortly after completing the St. George statue and the small base or plinth relief, Donatello began work on a non-Florentine project, a bronze panel for the base of a baptismal font commissioned by the Siena Cathedral in Siena, Italy. The subject is *The Feast* or *The Banquet of Herod*. This tiny masterpiece, on a gilded bronze panel 23 1/2 inches square is also sometimes known as *Salome* or *The Dance of Salome.*

Here, Donatello's perspective comes in sharp contrast to the flat backgrounds and backdrops of medieval works. *The Feast of Herod* is one of the major innovations of not only the Early Renaissance, but also of art itself. "[Donatello's perspective] is certainly closer to a consistent statement of one-point perspective than any earlier work in Western art" (Hartt, p. 173). Yet, closer inspection reveals that Donatello did not achieve harmony through perspective but through a reconstruction of the entire space using light and shade in a shallow relief. At a time when artists used set aesthetic conventions to accomplish their goals, Donatello's work stands alone.

The biblical story of the feast of Herod, found in Mark 6:21–28, is also a chapter in the life of John the Baptist, or Giovanni Battista. Knowing the story is important to understanding Donatello's relief. Donatello tells the story using continuous narrative; that is, he shows the characters in different rooms at different stages in the story.

To begin, Herod held a great feast at which his stepdaughter, the beautiful Salome, danced. Her beauty and the grace of her dance moved him to such extremes that he granted her any favor she chose. Salome's mother, Herodias, told Salome to request John the Baptist's head on a platter in order to take revenge on the saint, whom she hated. Herod granted her wish. This was handily carried out because Herod had already jailed John after the saint rebuked Herod for having married Herodias, the wife of his brother, Philip. Therefore, he

granted Salome's wish to see John's head on a platter., To illustrate the story ac-
curately, Donatello used his newly invented technique *rilievo schiacciato*, in which
he achieved seemingly infinite layers of spatial depth. He revealed room after
room appearing to run back almost infinitely into the picture plane. He controls
the inward recession with linear perspective. Indeed, he creates open, airy rooms
and seemingly colored floor tiles with his Early Renaissance perspectival sys-
tem.

Donatello projected into the relief surface an entirely imaginary architecture,
a floor space that invites the spectator to enter. All of this has no relation to the
relief's surroundings or to the precise position of the observer. "He constructed
his architecture by using the device that Alberti was later to describe as the vi-
sual pyramid in the systematic formulation published in his *Della Pittura*" (Hartt,
p. 174). Indeed, the viewer easily recognizes this imaginary visual pyramid in
the composition.

Donatello chose a conglomerate of perfectly arranged arched courtyards with
background groups of attendants (properly diminishing in size), which made
the perfect setting for the biblical story of passion and intrigue culminating in
John the Baptist's beheading. He organizes his composition in an entirely new
way—by its centrifugal force, all forces obviously moving, with gesture and fig-
ure, away from the center.

The perspective in Donatello's relief is uncomplicated. Floor lines, mold-
ings, and the recession of arches—all form a cross section of a visual pyra-
mid culminating in one vanishing point. (Although controversy exists, Vasari
gives credit for the culmination of correct recession into depth to Filippo
Brunelleschi c. 1420.) Scientifically, Donatello interrelated the diamond-
shaped slabs of the inlaid floor in diagonals so that the extended diagonal of
the one becomes the diagonal of the diamond shape above in the next row.
Herod receiving John the Baptist's head on a platter is depicted in the third
room back from the main platter presentation, in a form of continuous nar-
rative. It seems far away, beyond the main action, though in reality the dis-
tance on the relief is millimeters.

Nonetheless, John the Baptist's severed head, presented as it is at Herod's table,
creates the effect of a scattering, an outward strewing of truly horrified specta-
tors. The banquet guests agonize in postures and demonstrations of repulsion
and fear. Donatello purposely placed the banquet closer to the front and showed
it in a higher relief to emphasize the actor's roles in the drama (and also to form
the base of the visual pyramid).

With this drama, Donatello's manipulation of panel surface by spatial illusion
replaced the redundant flat grounds and backdrop areas of Gothic and even the
earliest Renaissance artists. Earlier Roman illusion or aerial perspective (as seen
on the Ara Pacis [c. 9]) had been lost around the fourth century. (Masaccio
[1401–1428?] reintroduced aerial perspective in his 1427 fresco *Tribute Money*,
located in the Brancacci Chapel of Sta Maria del Carmine in Florence.)

Donatello's scene from one event in the life of John the Baptist later influ-
enced the best Italian artists, including Leonardo da Vinci, whose famous *Last*

Supper uses and perfects the perspectival principle on which Donatello based his innovative relief.

It is true that no one work can be taken as typical of Donatello's œuvre, but no doubt exists that his famous *David* in bronze continues in furthering the artistic trends of the Early Renaissance.

The Bronze *David*, 1440

The most specifically classical of Donatello's works, his bronze biblical hero *David,* 5 feet, 2.25 inches high, created for the Palazzo Medici courtyard, belongs to the decade after the artist's visit to Rome in 1430. Of various dates given, historians prefer 1440. The statue precedes Michelangelo's famous marble *David,* carved between 1501 and 1504.

As the slayer of Goliath, David the biblical shepherd represents the independent Florentine republic. The bronze is probably the first freestanding nude statue in the round (capable of being seen from all sides) since the fall of Rome. In contrast to all sculpture after Rome, the early Christian and Gothic church considered displaying the naked body improper, even vulgar. Only Adam and Eve or figures depicted as sinners suffering in Hell appeared without clothes from the early Christian period until the middle of the fifteenth century.

Donatello's statue, revolutionary technically and culturally, "contradicted the medieval conviction that nakedness was a case for shame; and although the subject is the biblical slayer of Goliath . . . Donatello makes him more like a Greek god than a Hebrew shepherd" (Harris, p. 14). After Donatello's courageous breakthrough " . . . the body, nude or otherwise, was seen again as a beautiful work of art. The face was viewed again as individual and lovely" (Earls, p. xii). In true Renaissance fashion, Donatello led the way toward the future. Though his subject is not a god or a goddess, a saint or a martyr, he dared place an undressed male body before viewers accustomed only to clothed, rigid religious figures.

David, with Goliath's head at his feet, does not consider his nude body inappropriate. Quite the opposite, he is proud of its harmonious, perfect beauty and he stands arrogantly to display it. David, contrary to medieval statues, is swaggering and proud. The laurel crown atop his hat and the laurel wreath at his feet symbolically allude to the Medici. He wears the laurel to symbolize triumph and victory (Sill, p. 51). When the statue was completed, the Medici displayed it in their palace in 1469.

"The bronze *David* was first mentioned in 1469 in the description of the wedding of Lorenzo il Magnifico; it was then on a column in the centre of the palace courtyard" (Bennett and Wilkins, p. 92). Giorgio Vasari says:

> In the courtyard on the palace of the Signoria [The Palazzo Vecchio] stands a bronze statue of David, a nude figure, life-size; having cut off the head of Goliath, David is raising his foot and placing it on him, and he has a sword in his right hand. This figure is so natural in its vivacity and softness that artists find it hardly possible to believe it was not molded on the living form. (Vasari, 179)

Donatello's *David* is a technical masterpiece. In the first decades of the fifteenth century, technology for bronze casting had developed only enough to cast cannons for military purposes. Cannon casting was crude and massive. Results, thick and bulky, allowed no detail. Not until the middle of the fifteenth century did technology exist for creating aesthetically pleasing life-size works of art such as the *David*. Donatello had proved with the *David* that he could handle large casts, that he could go far beyond cannon casting. He could mold bronze in the form of fingers, laurel leaves, eyes, and lips.

However, he went beyond even the *David* with his *Gattamelata*. "Indeed, he proved himself such a master in proportions and excellence of this huge cast [of *Gattamelata*] that he challenges comparison with any of the ancient craftsmen in expressing movement, in design, skill, diligence, and proportion" (Vasari, p. 182).

The *Equestrian Monument of Gattamelata* (Erasmo da Narni), c. 1445–1450

The large 11 foot by 13 foot bronze equestrian statue, which required the most advanced technology of the fifteenth century, took Donatello to Padua. The statue was a memorial to the Venetian condottiere, or leader of mercenary professional soldiers, Erasmo da Narni, who had died January 16, 1443. Looking like a cat on his horse, his nickname, Gattamelata, means honeyed cat or calico cat, a wordplay on his mother's name, Melania Gattelli.

Under commission by city officials of the Republic of Venice, Donatello, chosen by Gattamelata's heirs, made this equestrian statue a few years after the leader's death. He knew that Gattamelata, as all other condottiere before him, went to war with great numbers of troops at his command and played a primary role in the endless struggle for power (Kleiner, Mamiya, and Tansey, p. 590). Donatello kept this in mind for both the man and his horse as he fashioned his cast.

Oddly, the honor given Erasmo da Narni with the completion of the statue has baffled historians. It seems Gattamelata was neither a military genius nor often victorious in battle. Possibly there were other reasons behind the monument's creation, such as Gattamelata's loyalty and honesty (both exceedingly rare at the time). When finished, the statue would be erected in the Piazza del Santo, in the square in front of the Basilica of Sant'Antonio in Padua.

Donatello's project was unprecedented, even scandalous. During the days of the Roman Empire bronze equestrian monuments had been the privilege only of emperors. Gattamelata, no more than an ordinary military leader, became the first equestrian to be distinguished in bronze after the fall of Rome.

But the statue moved beyond the barrier of privilege. Earlier sculptors had fashioned statues in the medieval period made to fit against walls or in niches. For example, the equestrian portrait the *Bamberg Rider*, a nearly eight-foot sandstone statue, stands in the east choir at Bamberg Cathedral in Germany (c.1235,

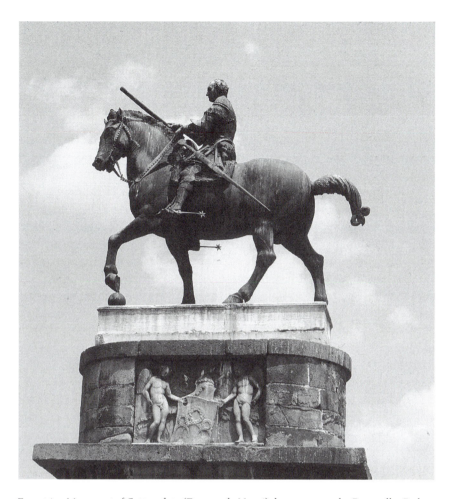

Equestrian Monument of Gattamelata (Erasmo da Narni), bronze statue by Donatello, Padua, Italy. The Art Archive / Dagli Orti (A).

1240). Possibly a true portrait of German emperor Frederick II (r. 1220–1250), this statue has been mounted solidly against a pier.

In 1453, to emphasize the condottiere's image, the councilmen of Venice did not mount the Gattamelata against a pier; they placed it on a high pedestal and set it completely apart from its surroundings. Even the plinth, or pedestal, assumed importance. "The pedestal cannot be ignored. It is a sort of building in itself, complete with architectural orders and even a door (which leads nowhere) . . . this 'architecture' demonstrat[es] the new supremacy of sculpture" (Sedgwick, p. 19).

A statue on such a high plinth is an unprecedented idea for fifteenth-century artists. Completely alone in the open, the statue celebrates sculpture's liberation from architecture after the fall of Rome and becomes the prototype of all equestrian monuments erected in town squares and other places thereafter.

[Gattamelata's] horse and rider are over life-size, monumentalizing the proportion and identity of man. Two separate phenomena distinguish the change in relationship between architecture and sculpture from the Gothic to the Renaissance equestrian figures. First, the Renaissance figure is free from architecture. It stands near to surrounding buildings but is completely independent of them. (Sedgwick, p. 10)

Location of the statue became a primary consideration in a quest to emphasize military strength. "Whatever the circumstances of the commissioning [and placing] of the *Equestrian Monument of Gattamelata,* the sculpture was intended to convey a political message, above and beyond being a memorial to Erasmo da Narni. [It is] an assertion of military power" (Bennett and Wilkins, p. 94).

Donatello's *Gattamelata* also is the first statue to rival the mounted portraits of antiquity such as the Roman larger-than-life-size (11.5 feet tall) gilded-bronze Marcus Aurelius (c. 175 A.D.). Donatello must have seen the Aurelius statue in Rome and, inspired, endeavored to take his work beyond it. The *Gattamelata* surpasses even the Roman ideal. "Indeed, he proved himself such a master in the proportions and excellence of this huge [bronze] cast that he challenges comparison with any of the ancient craftsmen in expressing movement in design, skill, diligence, and proportion" (Vasari, p. 182).

Although Donatello had never seen the man Gattamelata, he did not listen to the multitudinous descriptions offered him to properly reproduce the condotteriere's features. He chose instead to create his own portrait of the man's face, a portrait of power and strength. To do this, he compressed the general's lips to emanate courage. He molded a powerful jaw under fixed facial muscles to give the impression of a stern military man. He kept the hair extremely short, close to the skull, in order to suggest an austere soldier. The heavy, arched brows and the fiercely hard eyes reveal an uncompromising, intelligent, undaunted individual. In the end, Donatello fashioned the ideal conception of a valiant, intrepid general, bold and unafraid to face any adversary. He created a man who seemed the epitome of firm, indomitable, unbending heroism. At the same time, he did not depict the general as superhuman and larger than life. In addition to the portrait, the image included Gattamelata's horse. The snorting, quivering animal, with his bulging veins and purposeful, intelligent eyes matches perfectly the general's military mien, even his confidant, rigid stance in the saddle. Seldom in the history of portraiture will one find so mighty and formidable an image of control and authority as one observes in Donatello's Gattamelata.

As a result of Donatello's work, those who lived in Padua did all they could to keep the artist with them. They recognized the importance of his art, that the 11 years he spent there "changed the entire course not only of sculpture but also of painting in North Italy. A whole school of painting grew up in Padua around the personality of Donatello" (Hartt, p. 238).

Besides carving marble and casting bronze, Donatello also carved statues in wood. His Mary Magdalene is one of his finest examples.

Mary Magdalene, 1453–1455

Many individuals identify Mary Magdalene as the repentant sinner absolved of sin through her belief in Christ. However, several views exist. "John (11:2) identifies her with Mary the sister of Martha and Lazarus of Bethany. . . . [I]t is only tradition that identifies her with the person named Mary Magdalene" (Hall, p. 202). Also, Mary Magdalene is important in history because she was one of three women (along with Mary, Jesus' mother, and Mary, mother of St. James the Less) who walked with Jesus on his last journey to Calvary. She was present at Christ's crucifixion along with Mary his mother and John the Beloved. Likewise, she witnessed the burial. On the third day after the crucifixion, she, along with the other two Marys, appeared at the tomb. Finally, she was the first to bring the news of Christ's Resurrection to his disciples, having seen him herself in the garden.

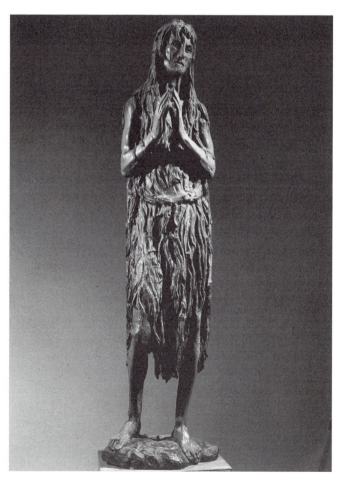

Donatello's *Mary Magdalene,* wooden sculpture, 1453–1455. The Art Archive / Duomo, Florence / Dagli Orti (A).

To help the viewer recognize Mary Magdalene, most artists (sculptors and painters) who represent her include her jar of ointment for anointing Christ's feet when he was at supper with Simon the Pharisee (Luke 7:36–50). Her second most important attribute is her untied long hair (used to wipe Jesus' feet after anointing them), which sometimes, as in Donatello's statue, covers her entire body. Her inscriptions, sometimes found on the plinths of statues, include "'Do not despair, you who have fallen into the way of sin; restore yourselves through my example and through God'" (Hall, p. 202). Knowing that her long hair would identify her, Donatello chose not to include an inscription or a jar.

Carved for the Florentine Baptistery by the aged Donatello, Mary Magdalene, 74 inches high, or over six feet tall, reveals an entirely new psychological intensity, a different and harsh reality not seen before in Renaissance art. Unlike his marble and bronze *Davids,* the figures on the baptistery font, or the *Gattamelata,* she is gaunt and haggard, even scrawny beyond what any artist of the time, including Donatello, would be expected of carving. At the same time she appears as a strange and haunting apparition, a wraith with exaggerated, sunken eyes, withered cheeks and a mouth with missing teeth. Her neck, corded and pulled, seems damaged.

Strangely, Donatello clothed the Magdalene only in the long tangled mass of her own hair that falls in rivers to below her knees. Disturbingly, she runs directly counter to the lofty blue-blooded noble religious figures created by earlier and contemporary Florentine masters. Even beyond this, she appears as a sculptural regression, especially for Donatello, being little more than a vertical wooden shaft with scrawny legs. Straight and column-like, she seems made for a Gothic portal.

Donatello used poplar wood for the statue and gilded her hair with gold. He painted her with a color to indicate the darker skin she would have acquired while spending her days in the desert. Historians discovered this color when they removed the brown paint added in the seventeenth century. In reality, she would have been dark as Donatello depicted her. After converting many people to Christianity, she lived in the desert near Marseilles, France, for several years close to the end of her life. "She had nothing to eat or drink, but, legend relates, she was refreshed by angels with celestial food" (Ferguson, p. 80).

Although Donatello made other statues in wood—St. Sebastian, St. John the Baptist, and St. Jerome, to name a few—he never reached the peak of reality one observes in Mary Magdalene.

Donatello's Achievements

Donatello is responsible for such innovations as rediscovering *contrapposto.* In addition, he created entirely new, remarkably innovative sculptural optical accomplishments in atmospheric perspective known as *rilievo schiacciato.* He also created *David,* the first large, free-standing nude bronze statue after the fall of Rome (c. 1440). This statue blatantly contradicted the medieval doctrine of

the nude body as disgraceful and scandalous. No nudes, with the exception of Adam and Eve, had been shown for nearly 1,000 years. With the bronze *David* and his *Gattamelata*, Donatello reintroduced the freestanding statue, away from niches, walls, or buildings.

Also, beyond the field of sculpture, one notes that important fifteenth-century Florentine painters felt Donatello's influence. Specifically, Donatello inspired the entire Paduan School of Art and resulting Paduan Style founded by Francesco Squarcione (1394–c. 1468). In addition, some of the most significant Italian painters, such as Andrea Mantegna (1431–1506), inspired by Donatello's work, took steps forward beyond the sculptor's achievements and created the first exaggerated perspective. Mantegna experimented with *in scurto*, or extreme foreshortening, and *di sotto in sù* (meaning "from below upwards"), or figures seen from below by a spectator looking up and viewing, for example, the underside of a person's chin. Mantegna probably would not have achieved this accomplishment without the step provided by Donatello. Even Venetian artists felt Donatello's influence, notably the Bellini, a Venetian family of three painters: Jacopo (c. 1400–1470/1) and his sons Gentile (c. 1429/30–1507) and Giovanni (c. 1430–1516). Recognized art history texts such as *Gardner's Art through the Ages* usually include Giovanni's early sixteenth-century *San Zaccaria Altarpiece* in Venice, Italy, and his *Feast of the Gods* (in the National Gallery in Washington). Historians agree that Donatello, a man who led a simple, uncomplicated life, created an artistic revolution in early fifteenth-century Florence and affected its evolution.

Donatello, unlike other artists, depicted figures of all ages and ranks. He understood the world of children. He knew the male and female nude; he studied practical men of the world, military despots, holy men, derelict prelates. Like Rembrandt, he understood old age. Few artists in the history of art have matched this wide range. That Donatello advanced both naturalistic illusion and classical idealism in sculpture remains a remarkable achievement.

Donatello became a sculptor of the most original and highest accomplishment as well as a competent, skilled worker in stucco (wall and ceiling decoration). Other achievements include architecture and scientific perspective, at which he worked carefully trying to achieve perfection in depicting recession into depth as well as beauty.

Although he created many works in bronze and in stone, he did not "think as a metal worker thinks; neither can it be said that he was bound by the conventions of stoneworkers. He saw things in his own vivid and revolutionary way . . . he worked directly with the materials, seeing their possibilities almost as if he were painting in them" (Hartt, p. 164).

Donatello devoted his entire life to art. Nearly every sculptor who followed him, even Michelangelo, owed him enormous debt. The spectacular, confident heroic types he created affected all fifteenth-century Florentine artists.

Despite years of the unappreciative handling of Donatello's works, years of being carted from one place to another, his work survives. For example, "after the flight of the Medici in 1494 the bronze group of Donatello—*Judith with the*

Dead Holofernes—was taken from their collection and placed before the Palazzo della Signoria [moved later to the Loggia de' Lanzi, then the Palazzo Vecchio]" (Burckhardt, p. 79). That they remained intact reveals the respect and care with which handlers treated them.

Donatello spent the last few years of his life designing twin bronze pulpits for San Lorenzo. Adorned with reliefs illustrating the passion of Christ, both pulpits reveal powerful spiritual depth and intricacy. He died, still working for the Medici, before the pulpits reached completion, and both works had to be completed by lesser artists.

At his own request Donatello was buried in Filippo Brunelleschi's church of San Lorenzo. Nearly the entire art community of Florence attended his funeral—painters, sculptors, architects, and goldsmiths. A highly respected, well-loved individual, "for a long time afterwards various verses in different languages were continually composed in his praise" (Vasari, p. 187).

Historians of the twentieth century saw the significance of Donatello's work as precursor to new techniques, intuitions, and insights that helped to shape the course of future art. In the light of new critiques, exposing the nature of the artist's spiritual fountainhead, today one sees a stronger than ever appreciation of Donatello's position as one of the founders and forceful protagonists of Renaissance art.

Bibliography

Bennett, Bonnie A. and Wilkins, David G. *Donatello*. New York: Moyer Bell Limited, 1984.

Burckhardt, Jacob. *The Civilization of the Renaissance in Italy*. New York: Harper & Row, 1958.

Earls, Irene. *Renaissance Art: A Topical Dictionary*. Westport, CT: Greenwood Press, 1987.

Ferguson, George. *Signs & Symbols in Christian Art*. New York: Oxford University Press, 1959.

Hall, James. *Dictionary of Subjects and Symbols in Art*. Boulder, CO: Westview Press, 1979.

Harris, Nathaniel. *The Art of the Renaissance*. Avonmouth Bristol: Parragon Book Service Ltd., 1995.

Hartt, Frederick. *Italian Renaissance Art*. 3rd ed. Englewood Cliffs, NJ: Prentice-Hall, Inc., and New York: Harry N. Abrams, Inc., 1987.

Kleiner, Fred, Mamiya, Christin. *Gardner's Art through the Ages*. 11th ed. New York: Harcourt College Publishers, 2001.

Murry, Peter and Murry, Linda. *A Dictionary of Art and Artists*. New York: Penguin Books, 1977.

Panofsky, Erwin. *Renaissance and Renascences in Western Art*. New York: Harper & Row, 1972.

Sill, Gertrude Grace. *Symbols in Christian Art*. New York: Collier Books, 1975.

Vasari, Giorgio. *Lives of the Artists*. Trans. by George Bull. New York: Penguin Classics, 1972.

Wölfflin, Heinrich. *The Art of the Italian Renaissance*. New York: Schocken Books, 1968.

CHAPTER 4

Fra Filippo di Tommaso Lippi, c. 1406–1469

The giant strides in painting taken from the Gothic era to the Early Renaissance can be seen in the works of one of the most important Florentine painters of the early fifteenth century, Fra Filippo Lippi. (*Fra* means brother, a title given to a friar or monk.) Fra Filippo understood and communicated the informal humanity of his subjects before other Early Renaissance painters. He also understood the line and color of composition and the sciences of linear perspective on a higher, more complex level than his fellow contemporary painters. One of the greatest draftsmen who ever lived, he developed, along with an extraordinary use of rich, exquisite hues, an elegant, aristocratic, humanistic, and graceful style, a style that still today exudes all that is Renaissance. These features are a significant accomplishment at a time when patrons still demanded and saw beauty in stiff Gothic figures intended only to represent religious characters and inspire awe and even fear in worshipers.

Fra Filippo's early fifteenth-century *Annunciation* (c. 1438), for example, was, with its balance and perspective and especially its new humanity of the Virgin Mary, one of the most innovative and astutely designed works of the Early Renaissance. In addition, at a time when other artists still floundered in experiments, both in color and composition, Fra Filippo used with perfection the principles of perspective. Finally, according to Wölfflin, Fra Filippo mastered the inordinately difficult fresco color, surpassing "all the Florentines of his century in charm of colour" (Wölfflin, p. 16).

Fra Filippo's Life

Fra Filippo di Tommaso Lippi, a Carmelite monk, a quattrocento (1400s) Italian painter of the Florentine School, was born in Florence, Italy, behind the

Carmelite Convent. This monastery would one day be his home. Concerning his birth, Strutt says "[he was born on] a shabby little by-street of Florence, known as Ardiglione, near the 'Canto alla Cuculia,' or Cuckoo's Corner" (Strutt, p. 12). Historians have not agreed upon an exact birth date. Most sources agree with Hartt, who states, "He was born about 1406 . . . into a large family of an impoverished butcher [Tommaso di Lippi], in the poor quarter surrounding the monastery of the Carmine in Florence" (Hartt, p. 214). However, research has not yet determined the exact date of his birth (Strutt, p. 12).

Life's most unfortunate and cruel events assaulted Filippo early in his life. Some sources indicate that his mother, Mona Antonia Sernigi (Tommaso di Lippi's second wife), the daughter of Ser Bindo Sernigi, died shortly after his birth. Historians, however, have never agreed on the identity of his real mother. They only know he didn't have one shortly after he was born. Therefore, various ideas have surfaced; for example, Strutt tells us "he was the son of Tommaso's first wife . . . but there is nothing to prove this supposition" (Strutt, p. 14).

After Filippo's second birthday his father died and left him, and his equally unwanted brother, orphans. Subsequently, with no one to care for the young Filippo, his father's sister, his aunt Mona Lapaccia, fed and clothed him for six years. Mona Lapaccia sacrificed greatly to care for the child, as she had barely enough resources to feed and clothe herself. Yet not only ungrateful but also incorrigibly disobedient, Filippo would not listen to Mona Lapaccia's admonishments to behave and to fulfill his religious duties. In fact, as he grew older, she lost control of him. Also, her limited income could neither feed nor clothe an older child. Consequently, by the time Filippo reached his eighth year, completely unmanageable and thanklessly defiant, she decided that if he were to make anything of himself, he needed strict discipline.

Accordingly, she took the only option open to her at the time. She sent him to the Carmelite Convent, a monastery adjacent to the church of Santa Maria del Carmine, where she knew he would live under the strict restraints and regulations of religion and the tight restrictions of monks. No one knows how Filippo reacted. It is possible he regretted his unrestrained behavior and missed Mona Lapaccia's home, meals, and clothes she provided for him, however humble. Whatever his thoughts, he could never have imagined life behind the walls of a monastery. A sympathetic Strutt says, "thus we find Filippo, at an age when other children romp and play in blissful ignorance of all that is sad and serious in life, already shut out from the beautiful happy world" (Strutt, p. 14). In total seclusion, behind thick walls, the small child lived in conditions of the most harsh and unimaginable severity. Rather than hearing the laughter of other children and twittering birds and enjoying warm sunlight, he lived out his childhood years behind cold, damp stone walls. Instead of playing, carefree and happy, he roamed empty corridors and heard endless muffled chants, unceasing prayers, and, above all else, church bells symbolically "call[ing] the faithful to worship. . . . [Bells were] the voice of God" (Sill, p. 128).

Despite a rigorous routine that left no room for individual thought or laughter or loud voice, Filippo apparently suffered not in the least. Neither did he feel stifled, either in his creative tendencies or in his fervent exuberance to live life, a joy that increased as he grew older and in fact never disappeared. And despite what must have been a merciless, cruel lack of love or closeness to another person, he must not have found life at the Carmine unpleasant, at least not beyond bearing. Historians assume this from the later lovely colors, lines, and designs of his paintings and also from the close relationships he formed easily with both men and women.

Apparently he loved art from an early age (drawing on every surface he could find). He never enjoyed learning from books. As biographer Giorgio Vasari says, "he showed himself dexterous and ingenious in any work he had to do with his hands, but equally dull and incapable of learning when it came to his books" (Vasari, p. 214). His genius for drawing, his eye for beauty stirred noticeably at an early age and could not be quelled even by his tedious, stultifying surroundings.

In time, his fellow monks discovered his talent. They saw that although he was an inordinately lazy student (he despised and never studied his math or grammar) and in fact loathed school, he had the gift of genius for drawing.

At the same time, Filippo must have been a loveable but extremely worrisome student, in fact, at times an incorrigible, ornery mischief-maker. Devilish beyond acceptance (he scribbled all over other monks' books), he had just the opposite personality needed for a bland monotonous monastic life based on silence, total and immediate obedience, and numbing hours of prayer.

Searching for a situation that would encourage him to learn, the monks grouped Filippo and other new monks with their best grammar teacher. This ploy, for a mind as brilliant as Filippo's, failed. He did not do the prescribed exercises. Vasari has noted that "instead of studying, he spent all his time scrawling pictures on his own books and those of others, and so eventually the prior decided to give him every chance and opportunity of learning to paint" (Vasari, p. 214). Fortunately for Filippo and for later generations, the fifteenth-century church, the greatest patron of the arts, always admired, protected, and respected drawings and paintings, and by extension, those who produced them.

Subsequently, seven years later, at the age of 15, in an enigmatic move entirely out of character, Filippo took religious vows and became Fra Filippo, or Brother Filippo, a Carmelite monk. Strutt says, "[H]e made his solemn profession in [1421] . . . [and this] is further proved by a document *rogato* or drawn up by a notary, Ser Filippo di Cristofano, stating that the ceremony took place on June 8, 1421" (Strutt, p. 19).

In brief, historians believe Filippo became a monk not because he had become a holy man, a devout believer, as one might assume would be possible in his religion-saturated environment. He took the vows because he owned nothing. He had no clothes, no shoes, no means with which to feed himself. Furthermore, he possibly hated this great step life had compelled him to take. Strutt agrees "that Filippo was forced to become a monk by his poverty and helpless

position, and that the step, however unavoidable, was repugnant to him, is certain" (Strutt, p. 18). Testimony to Filippo's extreme poverty is the subsidy he received from the convent to purchase the habit all monks wore. Hauser says that in fact his poverty was so great "he could not buy himself a pair of stockings" (Hauser, p. 57).

After becoming a monk, between 1424 and 1426, Fra Filippo traveled often to offer religious services in Siena, Pistoia, and Prato. Apparently he found success and admiration because in 1428 the monks nominated him deputy prior in the Carmelite monastery in Siena. Thereafter, in 1430 public records show him for the first time as *dipintore*, or painter.

As destiny would seem to favor him after a bleak and luckless childhood, Fra Filippo had access at the monastery, Sta Maria del Carmine in Florence, to some of the greatest frescoes the world has ever known. Vasari tells us that "at that time the chapel of the Carmine [the Brancacci] had been freshly painted by Masaccio [1401–1428?], and its great beauty attracted Fra Filippo so much that he used to go there every day in his spare time and practise" (Vasari, p. 214). The beauty of the figures apparently inspired Fra Filippo as nothing else ever had. Practicing his drawing and painting daily, he became so superior to all other artists working in the chapel that they knew he soon would paint as well as any master before him.

Most historians assume Masaccio played a great role in Fra Filippo's development as a painter. Kleiner and Mamiya agree that although "Fra Filippo's early work survives only in fragments . . . these [paintings] show he tried to work with Masaccio's massive forms" (Kleiner and Mamiya, p. 623). Also, according to Murry and Murry, "the hypothesis that he was Masaccio's pupil is much strengthened by the fresco fragments, datable c. 1432, of the *Relaxation of the Carmelite Rule* which are his earliest works: they reflect the influence of Masaccio to the exclusion of almost everything else" (Murry and Murry, p. 262).

Shortly after this (and one is not surprised to learn) Fra Filippo left the monastery. No one knows his age, but he could not have been more than 24 years old. Unfortunately, following his break from monastic life, his childish escapades became misdemeanors that included more adult crimes, including forgery and embezzlement. In 1450 he had to go on trial and eventually suffered torture on the rack.

In 1456, after being appointed to the chaplaincy in the nunnery of Santa Margherita in Prato, the course of Fra Filippo's life changed dramatically. In Prato he saw, while he celebrated the Mass, a nun to whom he became irreversibly and irresistibly attracted. Accounts differ on the entrance of Lucrezia Buti into Fra Filippo's life. Hartt says,

> [It was in the church that] Filippo's attention was deflected from the Mass he was celebrating by the charms of a young nun named Lucrezia Buti, whose religious dedication seems to have been no stronger than his own. We know from an anonymous denunciation, made to the Office of the Monasteries and of the Night, that from 1456 to 1458, Lucrezia, her sister Spinetta, and five other nuns were living in Filippo's house. (Hartt, p. 214)

According to biographer Giorgio Vasari, Fra Filippo met Lucrezia when "he was asked by the nuns to paint the altarpiece for the high altar of Santa Margherita, and it was when he was working on this that he one day caught sight of the daughter of Francesco Buti of Florence" (Vasari, p. 218). Records reveal that Lucrezia Buti lived at the nunnery as a novice and had reached the stage of taking her final vows.

Fra Filippo, infatuated beyond good sense, persuaded the nuns to let Lucrezia model for the Virgin Mary. They agreed to let the girl sit for him, knowing she would indeed make a lovely Madonna. Studying Lucrezia as a model every day left Fra Filippo in such a frenzy and without intelligent reason that one day he captured her as she was on her way to view the Girdle of Our Lady, a relic of Prato Cathedral. (The girdle, or cincture, was one of several symbols of the Virgin Mary's chastity) (Ferguson, p. 107). Thereafter, the nuns and the girl's father never succeeded in getting Lucrezia home. The fact remains that Lucrezia never left Fra Filippo. Subsequently, she became the mother of his son, successful Florentine painter Filippino Lippi (1457/8–1504) and, even after she returned to the convent, she continued to see Filippo. At length, his daughter, Alessandra was born, and a most unpleasant scandal ensued. Fortunately, Fra Filippo's faithful patrons and friends, the Medici family, rescued him from dreadful and eternal shame. The Italian merchant prince and first of the Medicis to rule Florence, Cosimo de' Medici (1389–1464), grandfather of Lorenzo the Magnificent, intervened for the artist with all his power. So successful were his efforts that he even obtained a release for Fra Filippo to marry Lucrezia. After both had their religious vows rescinded, they married in 1461, and the church legitimized their children. Although both Filippo and Lucrezia left the monastery and never returned, for some reason known only to him, Fra Filippo continued to wear his monastic habit and always signed himself Frater (Brother or Friar) Philippus.

Some historians believe that the capricious nature of Fra Filippo's life corresponds to an uncommitted, frivolous attitude that he reflects in his works. His paintings, with their far too human, far too lovely Virgin Mary, their overly playful, impish angels and often unidealized Jesus, seem to many of his contemporaries lightsome, even in some cases close to sacrilege. One has only to view his *Tarquinia Madonna* panel to know that few of the criticisms the painter received stand up to scrutiny.

Madonna and Child (*Tarquinia Madonna*), 1437

Fra Filippo painted the *Tarquinia Madonna,* a Madonna and Child panel, his first dated painting, for the ancient Etruscan city of Tarquinia northwest of Rome known as Corneto. (After the ninth century A.D. Tarquinia was superseded by nearby Corneto and called Corneto during the Renaissance.)

One of Fra Filippo's earliest works (1437), the *Tarquinia Madonna,* reveals the influence of the first great master of the Renaissance, Masaccio (1401–1428?), who perfected a commanding, solid, three-dimensional style with correct perspective. Masaccio had an uncanny ability to elevate figures to the highest lev-

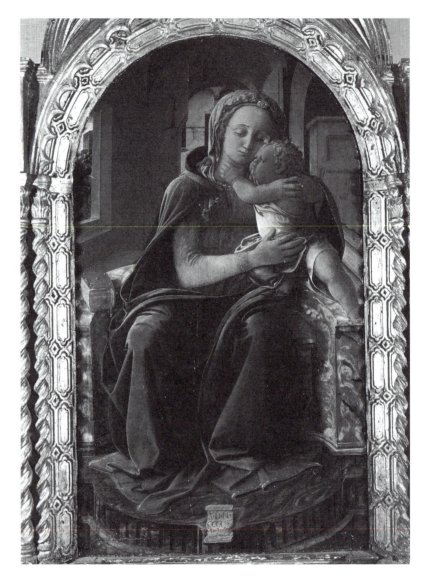

Fra Filippo's *Tarquinia Madonna*. The Art Archive / Palazzo Barberini, Rome / Dagli Orti.

els of human dignity and authority without placing them in heaven on gilded thrones. Not only did Fra Filippo understand this, he took the master's work further into the realms of an even higher dignity, an even more gracious beauty.

Under Masaccio's influence, Fra Filippo rendered his figures solid and strong. He gave them the same elevated, patrician aura. Yet, he took his figures beyond Masaccio. He rendered them in ordinary settings as even more princely while giving them a delightful demeanor, and he colored them in hues Masaccio had never found. Fra Filippo's soft Madonna, more human than any Mother of God ever painted, is a gentle, merciful mother, not a reigning queen in bejeweled, royal robes enthroned in a golden heaven. Her sad but compassion-

ate features and the simple refinement of her robes and her room, including a plain, formal bed, reflect an interest in her as a person. She is not a mere symbol of the Mother of God. To further imbue the idea of the Madonna's life on earth, Fra Filippo painted the fragment of a landscape seen on the left through an open window. To further reiterate the Madonna's life on earth, he also included a view into a courtyard. The only features reminiscent of Masaccio are the tenebrous shadows.

Fra Filippo's Madonna is fragile, even though solidly seated and well-placed within the picture plane. With the Madonna seated on earth (after medieval sculptors and painters for several hundred years had displayed her reigning in heaven), the marble throne on which she sits appears as a slight remnant of the Gothic and not what one would expect of an earthly mother. Fra Filippo's contemporaries might have wondered why a mother and her small child would sit (although Mary does not reign as a queen) on a large throne in an undecorated bedroom. However, the throne is left over from medieval depictions of Mary. Fra Filippo shows her on earth but doesn't go so far as to take away her throne. Also, nearby, to Mary's right, Janson has pointed out important details: "The vividly patterned marble throne displays a prayer book and [below her feet] the scroll inscribed with the date" (Janson, p. 396).

Equally important, and a large step into the future, Fra Filippo purposely omits the typical halo for both Mary and her child (who previously wore a cruciform halo, i.e., a halo with a cross within the circle). With the omission of a halo (Northern Renaissance painter Robert Campin, [1378/9–1444] had already disposed of the halo), Fra Filippo brings the Early Italian Renaissance to naturalism, straight to the mother of God as a real mother.

Furthermore, the placement of the Child Jesus is not on his mother's lap, as had been *de rigueur* earlier. Moreover, the baby reaches for his mother to embrace her in the gesture of an earthly baby, not an infant who is the son of God blessing the world, sitting stiffly on his heavenly mother's knee. He is not the child of angel-inhabited, celestial regions seen in artists' earlier works.

Altogether the most innovative feature of Fra Filippo's style is the reappearance of the contour or the line delineating figures and objects. Apparently, Masaccio's influence did not include line. Masaccio and other early quattrocento painters used chiaroscuro or light and dark to delineate figures and objects. Fra Filippo preferred line, and he produced some of the most calligraphic the world has seen. Specifically, he drew lines around every figure and piece of furniture and door. As if this weren't enough, he drew edges and accented them by graduation of tone to give them the appearance of lines.

Historians agree the *Tarquinia Madonna* presents a new use of line. His Madonna seems truly human. She is a mother with her child. No longer is she a standard symbol for the Mother of God. She seems wistful and pensive, sorrowfully and grievously aware of the sacrifice for which her Son was born. This contemplative, melancholy Madonna is typical of many of Filippo's works. Furthermore, as his work matured, the painter carried the Madonna's reflective appearance beyond the work of other artists to an even higher, an even more

gracious and motherly elevation, which can be observed in his Barbadori altar-piece.

Madonna and Child with Saints and Angels, 1437

Fra Filippo painted an impressive tripartite altarpiece (the old Gothic three-part triptych modified into a new unified three-part composition) of the Madonna and Child. One of the largest of his works, seven by eight feet, Filippo designed the panel for the chapel of the Barbadori family in the church of Santo Spirito in Florence. Today it is in the Louvre in Paris. So complex, so packed with figures was the work that other artists predicted it would take Fra Filippo seven years to complete. With this 1437 work, no trace of either Masaccio's influence or the Gothic remains.

The panel depicts, using a new *sacra conversazione* type of composition (religious figures from different time periods conversing within the same room), a graceful young Madonna holding her rather large and extraordinarily real, chubby-faced Child. She stands in a Renaissance courtyard before a large, elaborate throne. Numerous, very lifelike angels cluster about her, all of whom hold a single stem with several blooming and budding lilies, "symbol[s] of purity, associated particularly with the Virgin Mary" (Hall, p. 192).

It is no coincidence that above the cornice at the top of the walls behind the Madonna, Fra Filippo painted blue sky. "Blue, the color of the sky, symbolizes Heaven and heavenly love. It is [also] the color of truth because blue always appears in the sky after the clouds are dispelled, suggesting the unveiling of truth" (Ferguson, p. 91).

Besides the cornice, the architecture appearing in the panel is no longer Gothic. It is Renaissance, as one observes in its harmony, balance, and symmetry. The ogive, or pointed Gothic arch, does not appear. Fra Filippo uses the more modern arcade or series of three round arches. He does not use the Gothic triptych or three-paneled altarpiece composition. Three, an important number in Christian iconography, signifies the Trinity, the doctrine taken from Matthew (28:19) that God is of one nature but at the same time is three persons, Father, Son and Holy Ghost.

Furthermore, in the manner of Italian mothers even today, the Madonna holds her Child in a cloth sling which slides over her left shoulder. This detail underscores Fra Filippo's success in bringing the Mother of God to a truly human plateau. Little-known St. Frediano and one of the Four Latin (western) Fathers of the Church, fifth century St. Augustine, both with halos, kneel before her, one on the right, one on the left.

Equally important, in the Barbadori altarpiece Fra Filippo reveals his virtuosity with line and color when delineating his figures as both elegant and sublime. Strutt writes: "The angels are among the most graceful and dignified that Fra Filippo ever painted" (Strutt, p. 58). They hold white lilies for purity, and several flank either side of the Madonna's throne, conversing and gazing about in a man-

ner most human. The entire panel is bathed in a soft chiaroscuro (light and dark shadows) that is more diffused and of a lower intensity than one finds in his *Tarquinia Madonna*. The colors, warm and somber, are characteristic of the hues of Fra Filippo's early work and become, in time, characteristic of the Renaissance. One sees soothing strong greens, vibrant lustrous reds, and tasteful blue-reds. One little angel to the Virgin's left wears yellow. The Virgin's tunic surprises spectators with its orange-red. Artists usually show her in white to indicate her purity or blue to indicate her truthfulness or red to indicate her extreme sacrifice and suffering. All artists before and after Fra Filippo used red for the Virgin's tunic. Iconographically red is "the color of love . . . and suffering. . . . [For example] [r]ubies or other red tones set in the four terminals of an ornamental cross and at the center signify Christ's wounds" (Sill, p. 29). Orange-red might seem nearly sacrilegious to a color-conscious observer. Also, discreet touches of gold can be observed here and there. Likewise, for the first time in Italian painting, the haloes of Mary and Jesus, are a transparent color and appear as fine glass sprinkled with gold dust. According to Heinrich Wölfflin, concerning Fra Filippo's unusual color, "every one indeed . . . will acknowledge that it has no parallel" (Wölfflin, p. 16).

For the purpose of earthly representation, Fra Filippo rounded the faces. They are sensuous, cheeks and chins are powerfully projected with expertly applied chiaroscuro. Beyond this, Fra Filippo formed a pyramidal composition of the central figures that forms a balanced and typically Renaissance composition. Never one to be redundant or boring, he deviated considerably from this composition so copied by other artists when he painted his famous *Annunciation*.

The Annunciation, c. 1440

The Annunciation, one of Fra Filippo's finest early panel paintings, still remains in place not only in San Lorenzo but also in its original Corinthian-deeply fluted pilastered frame. Inside the frame, Fra Filippo painted two side-by-side flattened, catenary arches (*catenary* is the curve made by a flexible cord when it is suspended between two points at the same level). He painted a support for the two arches in the form of a high central unfluted, undecorated pier. The pier divides the Annunciation scene into two sections (an unusual and innovative design) and seems wider than necessary. The result is that the scene appears as a diptych (an altarpiece divided into two panels) and yet it is not.

In addition, Fra Filippo gives the viewer a background of nearly infinite perspective that moves thorough a long, rectangular monastery garden bordered on both sides by monastic buildings. Significantly, "[t]he idea of an enclosure, walled or fenced, the *hortus conclusus* [closed garden], within which is fruitfulness, was used as a symbol of the Immaculate conception" (Hall, 135). Furthermore, "[t]he symbol is borrowed from the Song of Solomon 4:12 [which says] 'A garden inclosed is my sister, my spouse; a spring shut up, a fountain sealed'" (Ferguson, p. 23).

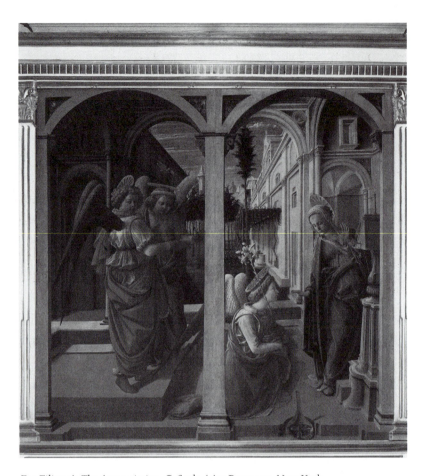

Fra Filippo's *The Annunciation.* © Scala / Art Resource, New York.

Quattrocento viewers knew that Mary's garden of the Temple, was the Closed Garden of the Song of Songs, an ancient symbol of her chastity. Within the garden, Mary, in the right panel, stands before her Bible open to the prophecy of Isaiah: "A young woman is with child and she will bear a son (7:14)" (Hall, p. 163). Mary stands in an unusual pose. Her foot touches the ground as a symbol of humility, and she looks down at the Annunciation angel Gabriel, who holds a stem of lilies and reveals a quiet, although somewhat ill-at-ease astonishment.

However, yet to be explained are the two angels, one with inordinately curly hair, and both with round, cherub-like faces in the left panel. They seem an anomaly since neither angel was required by the text. One, in the back, lifts both hands in either wonder or mild horror (emotions previously unseen in an angel). He looks either down or, more probably, at the pointing finger of his companion who, with his head completely turned, mischievously looks directly at the viewer over his shoulder. In this position, in a manner that is close to sacrilege,

he points toward the right to Mary and Gabriel. The pointing angel's finger could be a device included to lead the viewer's eye to Mary, although the hand is dark and obscure. Remotely, it could be the angel telling the viewer, in an extremely earthly manner, to "check this out," indicating the angel telling Mary she will be the Mother of God.

Another unusual feature of the picture is the transparent glass vase in the immediate foreground of the right panel. It is meant to hold a white lily, a symbol of Mary's chastity. Fra Filippo chose to have Gabriel hold the lily whereas, it would be just as proper to have the lily in the vase (especially a glass vase in which one can see the stem). "A vase holding a lily is one of the most frequently depicted objects in paintings of the Annunciation. The vase is very often of transparent glass; for glass, being clear and translucent, symbolizes the perfect purity of the Virgin" (Ferguson, p. 113). Likewise, "the lily is a symbol of purity and has become the flower of the Virgin . . . In many scenes of the Annunciation painted during the Renaissance, the Archangel Gabriel holds a lily, or a lily is placed in a vase between the Virgin and the Announcing Angel" (Ferguson, p. 17). A vase placed on the floor would have detracted from the figures of Mary and Gabriel. Cleverly, Fra Filippo painted a false niche and the transparent vase rests inconspicuously, although certainly importantly, on a lower step. Its transparency with realistic shadows produces its purpose, "[the] glass being clear and translucent, symboliz[ing] the perfect purity of the Virgin" (Ferguson, p. 113). The smaller kingdom within the vase contrasts with the larger garden behind the figures. The Virgin's blue dress contrasts with the strange and improbable orange building at the end of the garden. According to Sill, "orange and the orange tree are a symbol of chastity, generosity, and purity, because of the tree's white blossoms" (Sill, p. 55).

Fra Filippo uses same kind of playful angel that appears in this Annunciation scene in a later Madonna and Child with Angels, a panel that reveals the artist's full maturity.

Madonna and Child with Angels, c. 1455

Madonna and Child with Angels, painted when Fra Filippo was 50 years old, reveals his fully developed gift, his virtuoso for controlling and handling line that surpassed all his contemporaries. A gracefully flowing, light-as-a-feather line organizes perfectly the composition's completely faultless design and structures the meticulously accurate and fluent depiction of figures and layout, including the background.

Certainly few masters in the history of art have outperformed Fra Filippo's skill in drafting, telling his story with line and using it to create beauty. His calligraphic line, its flexible swirls, curves, spirals, and orderly winding hands, fingers, and faces have remained inimitable.

Again, he painted the Madonna as an astonishing, unexpected mother of this world. A truly lovely young mother, no longer depicted as a saint, Mary is neither unearthly nor frail. Her child, the baby Jesus held to her face by two an-

gels, is chubby and unpretentious. He does not bless the world; he reaches only for his mother.

At the same time, in a fact of design typically Fra Filippo, the angel closest to the viewer looks out of the picture with an impish, nearly naughty grin. He represents a child possibly as incorrigible as the artist himself, refusing to settle down even in such close proximity to the Madonna, even when lifting the son of God.

Undoubtedly Fra Filippo openly enjoyed the allure, bloom, and vigor of youth, the intrigue of elegance as he studied it wherever he went. Even landscape fascinated him. One can see in the painting a well-planned, well-executed background, seen through a typically Renaissance window composition. It integrates, albeit with some little distortion, identifiable details of the Arno River valley.

When studying early fourteenth-century Madonnas by Duccio and Giotto, stiff and straight and without background or perspective, for example, one realizes how far into the Renaissance Fra Filippo moved. He made Mary human and humble. He made her child unassuming and worldly.

Madonna and Child, 1452

Fra Filippo's *Madonna and Child* tondo (circular picture) of 1452 appears more tranquil, more human than even his previous Madonnas. Although far from sacrilegious, Mary seems unconcerned with her lofty station in life, with the promises of heaven. Probably painted for the prosperous fifteenth-century merchant Leonardo Bartolini, the panel exudes the worldliness and humanistic qualities the Renaissance came to represent. Historians have questioned the purpose of the tondo shape without success; yet it was employed frequently. In the quattrocento of the 1400s, the tondo became a desired shape for domestic religious images, although its precise meaning and origin continue to evade even recent investigation (Hartt, p. 218). The shape possibly derived from the mirror, which was most often circular, not only in the Middle Ages but also in the Renaissance. Moreover, mirrors had their own symbolic meaning: "The spotless mirror is a symbol of the Virgin Mary (Ferguson, p. 109). On the other hand, it could be related to birth-salvers, or painted wooden trays, sometimes given to noble ladies on the delivery of a child. During the Renaissance Mary was depicted as a lady of the nobility, and in this position she would have received a birth-salver.

Specifically, in the tondo the architecture consists of several elegant rooms of an aristocrat's fifteenth-century home. To Mary's left, and a little behind her, Fra Filippo painted a small scene depicting Mary's birth, known to history as the *Birth of the Virgin*. He depicts her birth as if it had occurred in the decorous Renaissance house of a wealthy Florentine family. Servants carrying gifts wait on Anne (sometimes Anna), Mary's mother. Likewise, to Mary's right, on a high staircase, a small scene depicts Mary's mother receiving her husband Joachim.

(The story of Anne and Joachim, parents of the Virgin Mary, is told in Jacobus de Voragine's thirteenth-century *The Golden Legend*.)

Fra Filippo created planes and volumes with stark wall surfaces. He painted large and small marble squares in the tessellated floor (constructed with small pieces of stone or marble) and barely discernible coffered ceilings (ceilings with recessed panels). Stairs of all breadth, height, and degree of slope create the most perfect spatial composition of Early Renaissance painting. While Fra Filippo had reached perfection, many Early Renaissance painters were barely grasping the complexities of scientific linear one-point perspective.

Equally important, to emphasize his astonishing achievement, Fra Filippo seats his lovely young Madonna at the focal point of perspective—which follows the strict rules necessary to make the illusion appear correct. However, within the tondo he seats her to the left somewhat for a more aesthetically pleasing presentation. The casual viewer may not note her composition placement and the superlative design it creates. With her child balanced on her lap, Mary and Jesus form a perfect triangle—the preeminent balanced geometric form most favored by later Renaissance artists.

Fra Filippo's Madonna was possibly drawn from the same model as the *Uffizi Madonna* and might be a portrait of his beloved Lucrezia who must have possessed a wistful, melancholy, dreamy grace. As the Mother of God, she is extremely beautiful, flawless, absorbed, contemplative, reflective. She looks shyly yet meaningfully out at the viewer who has, if only for a moment, glimpsed her with her Child.

In the painting, Jesus holds an opened pomegranate, its numerous seeds exposed, with one hand, and lifts one of its seeds with the other. Symbolically, the pomegranate is "the Christian symbol of the Resurrection. . . . [T]he many seeds contained in its tough case made it also a symbol of the unity of the many under one authority (either the Church or a secular monarch), and of chastity" (Hall, p. 249). The pomegranate has many meanings. "Like Masaccio's grapes [indicating the Eucharist], this realistic motive [motif] has a religious meaning; the pomegranate is red like the blood of Christ, and its seeds are held with its shell like individual souls within the encompassing Church" (Hartt, p. 218). In the elegance and contemplative melancholy of this painting, one of the high points of Filippo's style, the sources of Botticelli's art can be discerned.

In the Cathedral at Prato, Fra Filippo left a fresco cycle of the Life of St. John the Baptist. The most magnificent, and also the latest of the many episodes is the *Feast of Herod*.

Feast of Herod, 1452–1466

Fra Filippo's *Feast of Herod* (1452–1466) is sometimes known as the *Banquet of Herod* and *The Dancing of the Daughter of Herodias and Its Result*. It is an unusually original fresco (a painting made on wet plaster) located in the chancel (space reserved for clergy) of the Cathedral at Prato, Italy. The scene of the Feast

or Banquet of Herod is from the story of the life of St. John the Baptist (his beheading) and is found in the Bible in Mark 6:21–28.

In brief, Herod, King of Judea (73?–4 B.C.; reigned 37–4 B.C.), called Herod the Great, presides over his feast and celebration at a grand and very long U-shaped table located in a wide, figure-filled garden courtyard. A complicated diamond-square-triangle-patterned tesselated marble floor defines with well-delineated orthogonals (lines receding to a single horizon line) the scientific perspective Fra Filippo understood so well. Inner walls, emphasized by sharply receding perspective, move to the back of the room. Fra Filippo accents the room's shape by openings such as windows and a bipartite arch section (similar to the one in his *Annunciation*). All are rendered in perfect perspective. Garden plants and trees rise above parapets (low walls) garlanded in the Roman style (like the bottom half of a wreath) or are placed against high walls. The long orthogonals move one's perspective rapidly toward a single vanishing point. They run to the banquet table where Herod sits directly below the Datini family's coat of arms. Fra Filippo placed the coat of arms, the donors of the cycle (those who paid for the fresco), prominently and conspicuously in the center at the level of the fresco's highest windows (darkened for obscurity). Lower windows directly below the coat of arms and behind Herod open to a lighted view of somewhat blurred rocky hills and the buildings of a city.

On this spacious stage, the drama of Salome takes place in three episodes. Beginning at the left, Salome receives, with her face obviously averted, the decapitated head of St. John the Baptist on a platter. She is rendered extremely small by an inordinately large foreground figure, a man-at-arms—guard, herald, or, according to Strutt, the executioner of St. John. The viewer does not see the entire story of the beheading in the feast scene. Hartt reveals where Fra Filippo painted the execution scene. "The actual decapitation, impossible to photograph, is painted around the corner of the chancel, in the semi-darkness next [to] the window" (Hartt, p. 218).

Furthermore, Fra Filippo paints Salome dancing to the left of Herod, depicted, again inexplicably, in a peculiar, "cemented" position as she glides to the music of a group of minstrels. Both her right leg and her right hand (with the palm completely open and even bent back) along with her swirling, billowing dress, extend enticingly into the air. Details here are new to the world of art. Fra Filippo began the vogue of alluring motifs, or what Aby Warburg called "'bewegtes Beiwerk' . . . that is, windblown hair, billowing drapery, fluttering ribbons" (Panofsky, p. 175). She does, however, seem entirely real, perfectly placed within the setting. Again, the use of perfect perspective and a more human figure combine to form some of the first "real" figures of the Early Renaissance. In contrast, even Masaccio's figures appear heavy, ponderous, weighted to the ground and too voluminous. According to Strutt, "throughout [Fra Filippo's] painting we are struck with the masterly manner in which the artist has contrived to draw out his figures in such strong relief that they seem to be almost entirely detached from the background, and actually appear to live and move—well-rounded, solid figures of flesh and blood" (Strutt, p. 136).

To the right, Salome, shown again, kneels before Herodias, her mother, her face still obviously averted, and she offers up the ghastly platter. Herodias, perfectly calm, lifts her hand in praise of her daughter. At the far right two servants clutch each other, and unable to restrain their curiosity, turn to look at the dreadful head.

Fra Filippo's composition is one of the most perfect of the Early Renaissance. The figures, very human and well rendered, appear weightless. This same mature style appears in *Madonna Adoring Her Child,* a subject new to Renaissance artists.

Madonna Adoring Her Child, 1450s

With this Madonna and her Child painted for the altar of the chapel in the Medici Palace, Fra Filippo gives the world of Christian art and religion a subject never painted or sculpted before. No Christian, Gothic, or Early Renaissance painter had painted the Madonna adoring her Child. Indeed, the subject opens new thoughts and feelings and a new phase of fifteenth-century painting.

At 50 x nearly 46 inches, this is one of Fra Filippo's smaller panels. At first one might believe the subject is a Nativity; indeed, a few historians use this reference. Yet upon closer inspection, one sees that Fra Filippo has included none of the usual accoutrements for a Nativity. For example, the scene does not include a stable or cave. Joseph, Mary's earthly husband, and angels announcing the birth to shepherds are not present. Neither do an ox, representing those who believed Jesus was the son of God, and an ass, representing those who did not believe respectively, appear.

Moreover, in a setting most unusual, Fra Filippo places the Madonna in a dark wooded area, a rock landscape, a forest with numerous trees already cut down, their stumps flat and polished by the elements. God the Father, a little to the left of center, hovers in divine solicitude above the Mother and Child with arms outstretched, with stars and rays of heavenly light forming for him a celestial backdrop. Suspended directly below him is a white dove, "symbol of the Holy Ghost or Holy Spirit (John 1:32)" (Sill, p. 18) directing God's blessed light to the new baby. Far to the left of Jesus stands (in an unbalanced leaning-forward position) John the Baptist, a rather large child of five or six years old. The child's age is inexplicably incorrect (Fra Filippo did not always follow protocol) because Jesus was only six months younger than his cousin John. This furthers the argument that the painting is not a Nativity, as John the Baptist does not appear in Nativity scenes.

Below the scene, in the left corner, an ax stands upright in a fallen piece of a tree with the following inscription:

FRATER PHILIPPUS P (THE 'P' IS FOR PINXIT—'painted') [appears] on its handle. . . . [T]his image was derived from the Baptist's own words (Matthew 3:10): 'And now also the ax is laid unto the root of the trees: therefore every tree which bringeth not forth good fruit is hewn down, and cast into the fire.' (Hartt, p. 220)

For personal reasons, unknown by historians, Fra Filippo could have included the hatchet, which can also be a symbol of destruction (Ferguson, p. 108), as a mark of penance for his own sinful soul. On the other hand, every day the Camaldolese monks living at the monastery of Camoldi in Italy's Apennine Mountains near Arezzo chopped down trees with hatchets. It is well known that all monks lived a frugal life with every day from sun to dark filled with hard work. They built huts (each monk had to build his own separate hut) in the forest where they had chopped down the trees. Each monk celebrated Mass alone and fed himself from his own private garden. He used a hatchet every day, and it became an important part of his life.

St. Antonine, inspired by the Camaldolites, encouraged penitents to live within religious meditation and nourish what he called "'the little garden of the soul,' very like the garden plot in which we see Mary kneeling to adore her Child" (Hartt, p. 220). Directions for Camaldoli religious meditation included cutting the trees. Mary and her child are shown in a forest where trees have been cut. Flower blossoms, white to indicate purity, bloom about the mother and her son. Chopped-down and uprooted trees are visible in the background. In the blue-green forest, Mary is accompanied by the Benedictine monk Romuald (c. 952–1027), who founded the Camaldolite Order, communities bound by vow to solitude and silence. According to Hall, "Romuald is old and white-bearded and is dressed in the habit of the Camaldolese Order, a striking, loose-flowing white garment with wide sleeves" (Hall, p. 267). He, along with Mary, adores the Child.

In many ways Fra Filippo's work was ahead of his contemporaries. "[His] easel-pictures treat subjects like the twilit forest depths, which do not appear again in art till the time of Correggio [1489–1534]" (Wölfflin, p. 16).

Fra Filippo's Work

Altogether, when considering beauty, grace, and line, Fra Filippo's oeuvre takes precedence within the wide range of outstanding masterpieces of Early Renaissance painting. In an era moving slowly away from the stiff, formula-following Gothic, Fra Filippo produced panels and frescoes of uncommon refinement and tasteful elegance. His work strongly influenced not only his students, such as Florentine Renaissance painter Sandro Botticelli (c. 1445–1510), but also numerous other artists.

In particular, unusual beauty is evident in his predellas—those areas, usually rectangular, located below the main altarpiece or retable reredos or *pala d'altare*. Giorgio Vasari said of the beauty he created, "[Fra Filippo's] stature as a painter was such that none of his contemporaries and few modern painters have surpassed him. Michelangelo himself has always sung his praises and in many particulars has even imitated him" (Vasari, p. 220).

Other paintings include a panel done for the high altar of the church of San Domenico Vecchio at Perugia. It features a Madonna, St. Peter, St. Paul, St. Louis, and St. Anthony Abbot. Subsequently, for the church at Vincigliata, he

painted the knight Allesandro degli Alessandra and two of his sons with St. Laurence and other saints.

In 1452 the wardens of the Prato parish church commissioned Fra Filippo to paint frescoes to fill the chancel because they wanted to have a memory of this man they knew was a great painter. In a grand gesture, Fra Filippo made his chancel figures larger than life. Then, in a bold move, he dressed his figures in clothes not at all contemporary. Here, again, he became a leader. Other artists imitated his idea of not using the same clothes and colors that had been used to excess and that patrons had come to expect.

Painted in 1452–c. 1465, the subject of the work is the life of St. Stephen (told in the Acts of the Apostles), the patron saint of the church. The frescoes that cover the right-hand wall are the *Disputation, The Stoning of Stephen*, and *The Death of Stephen,* the first martyr of the Christian faith.

Fra Filippo revealed passion in St. Stephen's face as he argued with his accusers, an emotion no artist before him had captured. So too he revealed hatred and anger in the faces of Stephen's accusers, emotions totally alien to Gothic and earlier Renaissance masters. The savage brutality of St. Stephen's executioners remains unsurpassed. Preparing to stone him, they take up rocks of all sizes. Stephen maintains peace and courage in the pain of his death. He lifts his calm face to God and prays for those who stone him.

Despite his childhood years in the Carmelite monastery, even in old age Fra Filippo was an extraordinarily happy person with a multitude of friends. He lived life with extreme freedom, doing all he desired and apparently disciplined himself only in his work. He spent money that he earned from painting on love affairs, entanglements he pursued all his life.

Altogether Fra Filippo Lippi was a first-rate Renaissance draftsman, as can be seen in any example of his work. He learned to draw at an early age and understood line and color on a level few artists ever reach. Although as a young man he began as a follower of Masaccio, in time he evolved a style that served as a major source for other artists, especially the nineteenth-century Pre-Raphaelites. The PRB or Pre-Raphaelite Brotherhood first appeared in 1849. They were painters like Dante Gabriel Rossetti (1828–1882), who sought to emulate artists earlier than Raphael, painters such as Fra Filippo. Filippo's skill in the use of line, however, has never been surpassed.

Fra Filippo relished the charm of youth and beauty, and he captured their details in his work. One of the first artists to paint landscape as he saw it, he sometimes included features of the Arno River valley in Italy that can be recognized today. Also, he took the humanization of the theme of the Madonna to its furthest extreme. Whatever the ideals of spiritual perfection may have meant to artists in past centuries, Fra Filippo appreciated and captured the sensuous, colorful beauty of this world. His exclusion of otherworldly considerations exerted a strong influence on later Florentine art. His influence can be seen in such details as the settings in Leonardo da Vinci's *Madonna of the Rocks* (two versions: 1483?–1486, Louvre, Paris; ?1508, National Gallery, London). One of his major contributions to the Renaissance world was seeing holy

figures with a new humanity. According to Longaker, "his Madonnas are like the Florentine girls he so admired; his saints look like the people he saw every day; and his angels resemble the street urchins he encountered" (Longaker, p. 134).

Painter of the most tasteful, refined, and truly beautiful Madonna and Child, it is difficult to believe Fra Filippo was a disgraced monk. He had taken his vows when an orphan, seeing the church only as an escape from poverty that possibly would have killed him. By the 1450s he had scandalized himself, having fathered children with a nun. Besides that, he faced trial and torture because of financial dishonesty.

Fortunately, the Italian merchant prince Cosimo de'Medici (1389–1464), first of the Medicis to rule Florence, recognized his talents and rescued him. Fra Filippo's nearly complete lack of devotion to the Roman Catholic church is apparent in more than a few of his paintings. Only the Medicis' intervention on his behalf at the papal court preserved Fra Filippo from the severest punishment and ultimately the most final and complete disgrace.

In the end, through the mediation of Cosimo de' Medici, Fra Filippo was asked by the commune of Spoleto to decorate the chapel in their main church dedicated to the Virgin Mary. Unfortunately, he died at the age of 57, before he could finish. "They say that in one of those sublime love affairs he was always having, the relations of the woman concerned had him poisoned" (Vasari, p. 221).

With a clause in his will he left his son Filippino, who was then 10 years old, to the care of Fra Diamante, who brought the boy back to Florence and taught him the art of painting. The people of Spoleto buried Fra Filippo in a tomb of red and white marble in the church he had painted. He will always be remembered for colors and lines no one else could achieve, and he will always be praised for his quiet, lovely Madonnas and his realistic landscapes.

Bibliography

Ferguson, George. *Signs & Symbols in Christian Art.* New York: Oxford University Press, 1959.

Hall, James. *Dictionary of Subjects and Symbols in Art.* Revised ed. Oxford: Westview Press, 1979.

Hartt, Frederick. *History of Italian Renaissance Art.* Englewood Cliffs, NJ: Prentice-Hall, 1987.

Hauser, Arnold. *The Social History of Art.* Vol 2. New York: Vintage Books, nd.

Janson, H.W. *History of Art.* 2d ed. Englewood Cliffs, NJ: Prentice Hall, Inc., and New York: Harry N. Abrams, Inc., 1978.

Kleiner, Fred S. and Mamiya, Christin J. *Gardner's Art through the Ages.* 11th ed. New York: Harcourt College Publishers, 2001.

Longaker, Jon D. *Art, Style and History.* Glenview, IL: Scott, Foresman and Company, 1970.

Murry, Peter and Murry, Linda. *A Dictionary of Art and Artists.* 4th ed. New York: Penguin Books, 1976.

Panofsky, Erwin. *Renaissance and Renascences in Western Art.* New York: Harper & Row, 1972.

Sill, Gertrude Grace. *A Handbook of Symbols in Christian Art.* New York: Macmillan Publishing Company, 1975.

Vasari, Giorgio. *Lives of the Artists.* Trans. by George Bull. New York: Penguin Classics, 1972.

Wölfflin, Heinrich. *The Art of the Italian Renaissance.* New York: Schocken Books, 1968.

CHAPTER 5

Giotto di Bondone, c. 1266/7–1337

During the first decades of the fourteenth century, Giotto di Bondone was the most innovative and revolutionary painter in Italy. A model of the genuine Renaissance artist, he was also a sculptor and an architect. Even the most severe trecento (1300s) critics recognized him as the first genius of naturalistic art in the Italian Renaissance. "The whole Trecento is dominated by this naturalistic style of Giotto's" (Hauser, p. 27). They also recognized him as an intrepid painter of unusual insight who bravely turned from established standards and gave painters the impetus they needed to abandon the redundant ideas of an inflexible medieval world and move toward the future. According to Murry, "Giotto . . . is generally regarded as the founder of modern painting, since he broke away from the stereotyped forms of Italo-Byzantine art" (Murry, p. 187).

Specifically, Giotto lived and worked at a time when artists' talents first began to strain against the shackles of medieval constraints. Although he painted traditional religious subjects, he gave his holy figures the first breaths of earthly life, movement, and force. After several hundred years of stiff and stultifying symbolic saints and other unreachable, blatantly unreal celestial beings, Giotto's figures stepped off the old stage and walked into a new, unheard-of world.

Giotto's Life

Historians do not know when Giotto, was born, reporting his birth variously as 1266, 1267, 1276, or even 1277. They do know he was born in Vespignano, Italy, and he died c. 1337 in Firenze, Italy. Concerning his life, even today an

enigma, Girardi says, "there is no documentary evidence to provide us with any certain information about the chronology and events of his [Giotto's] life" (Girardi, p. 8).

Regardless of the lack of most factual material, it is known that Giotto's mother and father were poor peasants who lived in Colle di Vespignano, a small village about 14 miles north of Florence in the Mugello Valley. The area is a flat section of Italy where farmers cultivate olives and various vines. His father, Bondone, a poor peasant farmer, named him Giotto and raised him the same as any other peasant boy (Vasari, p. 57).

According to Giorgio Vasari (1511–1574), the author of the first biography (written in the mid-sixteenth century) on Giotto, it was Cenni di Pepi, known as Cimabue (c. 1240–1302?), a great Italian painter of the Florentine School, who accidentally discovered Giotto's talent. According to Vasari, Cimabue happened to see the 12-year old child dressed as a shepherd in the act of painting one of his father's sheep. "Cimabue . . . came across Giotto . . . drawing [a sheep] by scratching with a slightly pointed stone on a smooth clean piece of rock" (Vasari, p. 57). In 1845 artist Déveria illustrated this meeting. The drawing shows Cimabue standing over the young Giotto who, with immense concentration, draws (scratches) on his stone. Cimabue, immediately recognizing the boy's enormous gift, took him to Florence. At the time Cimabue worked on the frescos in the Florentine church, St. Francis of Assisi. Before long, the great artist became Giotto's teacher. He probably did not suspect that the 12-year-old child would not only surpass him, but would go on to become one of the most important artists in the history of western art.

Some historians, however, dispute Vasari's account. Another story, less frequently heard, says that Giotto apprenticed to a wool merchant in Florence at an unknown early age. Whenever he could, he watched student artists in Cimabue's studio by the hour until the master, seeing his unflagging interest, finally allowed him to study painting.

Beyond the aforementioned, few facts concerning Giotto are on record. Among the few are that Giotto owned a house in Florence in 1305 and joined the local painters' guild in 1311 while in his forties. Two years later, still in Florence, he laid claim to household goods from his landlady in Rome—which implies that he must have visited Rome or lived there at some previous date—and he was in Florence from 1318 to 1320. From 1329 to 1333 he was in Naples as court painter to Robert of Anjou and painted several murals (of which only traces remain) for the king's private rooms and chapel. In 1334 he was named to the important position as overseer, or *capomaestro*, of works for the cathedral and the fortifications of Florence.

Afterward, according to Italian historian Giovanni Villani (c. 1275–1348), whose 12 books historians consider reliable, the foundations for Giotto's Bell Tower or Campanile for the Cathedral of Florence were put down in 1334. Also, Villani states that during 1335 and 1336 Giotto worked in Milan for Azzone Visconti (1302–1339), of the Italian family that ruled Milan from the thirteenth century until 1447, and that he died in January 1337. Furthermore, Antonio

Pucci (c. 1310–?1388), writing in 1373, says that Giotto was in his seventieth year when he died.

Although critics proclaimed Giotto's success and fame in his own lifetime, documents pertaining to extant paintings ascribed to him are yet to be discovered. Scholars do, however, mention various paintings as executed by him. It is important to note that the only work universally accepted as Giotto's is the fresco cycle covering the interior walls of the Arena Chapel in Padua, Italy. Historians generally consider the Arena Chapel works the "School of Giotto."

Giotto was sharp-witted, "always ready with a joke or a witty response" (Vasari, p. 69). Italian poet and author of moral discourses Franco Sacchetti (c. 1330–1400), in his *Novelle* (c. 1378–c. 1395), a collection of stories, records many of Giotto's most remembered clever remarks and equally clever pranks. Vasari recorded one of his pranks:

> When Giotto was still young and in Cimabue's workshop, he once painted on the nose of one of the figures Cimabue had executed a fly that was so lifelike that when Cimabue returned to carry on with his work he tried several times to brush it off with his hand, under the impression that it was real (Vasari, p. 80).

Although a clever and fun-loving prankster, a man of inordinately keen and subtle humor, and also an architect, Giotto excelled at painting. We now turn to his masterpiece, the fresco cycle in the Arena Chapel in Padua, Italy.

The Arena Chapel—Cappella dell'Arena, Consecrated c. 1305

The early fourteenth-century paintings in the Arena form an impressive display. The chapel, a surprisingly small building, was constructed in the early fourteenth century just east of Venice in the university city of Padua, in the northeastern corner of Italy. The religious frescoes (paintings on fresh wet plaster) in the building not only form Giotto's greatest preserved achievement in painting but also make up one of the most beautiful, perfectly balanced, and well-preserved fresco cycles anywhere in the world. They comprise one of the most important chapters in the history of Italian painting.

The Arena Chapel in Padua had its origins in the first decade of the fourteenth century. In 1300, wealthy Paduan merchant Enrico Scrovegni, son of the infamous Reginaldo, the usurer so notorious Dante mentioned him in Canto XVII of the *Inferno,* purchased a large piece of land within an old Roman arena in Padua. Only a small church dedicated to the Virgin still stood on the property. Scrovegni had a chapel built next to the church. He used it as a family oratory—a chapel or small room set apart for private devotions. He hoped to expiate the sins of his father, whose soul he sincerely believed would never find its way to heaven without serious intervention.

Work began in 1303, and in 1306 the chapel was consecrated, or declared sacred. Since Scrovegni built the chapel on the ruins of the ancient Roman arena, he named his new building the Arena Chapel.

He intended the Arena Chapel only for the Scrovegni family and the several individuals attached to the household. It eventually also housed the tomb of Enrico Scrovegni and his wife.

Today, as then, the building consists of a single nave or central aisle with a wide barrel vaulted ceiling and a presbytery (office of the presbyter or official who oversees the local congregation in the church). Some historians believe Giotto designed the building. They cite its harmonious simplicity, its Giottoesque balance and perfection. According to Girardi, Giotto, possibly responsible for the design of the entire chapel, is said to have built the presbytery between 1317 and 1320.

The family dedicated the chapel to one of the holiest of stories, the Annunciation of the Virgin Mary, which can be found in Luke 1:26–38. It tells of "the announcement by the angel Gabriel to the Virgin Mary: 'You shall conceive and bear a son, and you shall give him the name Jesus'" (Hall, p. 19). Scrovegni may have chosen the Annunciation to further his father's remote chances for a place in heaven.

Within the chapel visitors find Giotto's frescoes in perfectly measured and repeated square designs. The chapel's ceilings, floors, and walls, flawlessly framed and fitted together, greet the viewer in perfectly proportioned horizontal bands of fresco paintings. Although Giotto did not understand scientific linear one-point perspective, his paintings' surfaces seem to recede into space (albeit not perfectly) behind a distinctly defined picture plane (in this case, the outer, flat surface). This narrow, flat space provides a horizontal surface on which Giotto's figures enact their dramas, much like actors on the proscenium area of a stage.

At the same time, within this outer plane, with chiaroscuro (light and dark), Giotto gives volume to every figure so that it forms its own space, an accomplishment destined to influence painters for many years. With volume and a slight recession into depth, Vasari termed the accomplishment "very creditable and should be valued highly and [it is] reasonably successful" (Vasari, p. 70). Panofsky tells us that "here [in Giotto's frescoes] we witness the birth of 'modern space'" (Panofsky, p. 136). One observes also that Giotto kept the number of figures in each fresco to the barest minimum to ensure the quiet elegance the chapel demands.

Equally important is the landscape behind Giotto's figures. His trees and rocks are the most advanced known in the early fourteenth century, although admittedly not lifelike to a twenty-first century eye. Giotto formed his trees using several shades of green and in the process brought his foliage to a point of reality beyond any leaves painted after the fall of Rome. Unlike other artists, he used more than one flat green color. Equally important, his rocky backgrounds, although limited (sometimes severely) in space, form the perfect setting for the serious religious drama of each scene.

Likewise, instead of the usual, and typically expected, Byzantine gold sky, Giotto moved beyond all precedent and painted his sky blue, the color of the new and, at the time, revolutionary Renaissance heaven. However, although the

sky is blue, not one part of it in the chapel contains a cloud. And never does a sun cast even the suggestion of a shadow. Leaves neither rustle in a breeze nor twinkle in sunlight. Several hundred years would pass before artists scientifically recorded cloud formations, storms, fog, and other phenomena of the physical world.

Giotto paints his figures in entirely new ways. For example, he paints figures in profile, and even one-quarter view. Similarly, he reveals back views instead of the traditional three-quarter positions of figures in Dugento (1200s) painting. Furthermore, instead of flat, nonshadowed faces and forms, he used chiaroscuro (even though he painted no source for light) and created a fullness far beyond the achievements of his contemporaries, even the work of his teacher Cimabue.

In the Arena Chapel, Giotto tells the stories of the Lives of the Virgin and Christ in three superimposed tiers or rows of scenes. These rows cover all the Chapel's interior walls side-by-side nearly in the manner of motion picture strips. They are set above the high dado, or lower section of the interior wall. Although builders kept the windows as small as structurally possible in order to provide Giotto as much wall space as he needed, the frescoes are smaller than one might expect. However, even though the figures are only half life-size, they appear nearly life-size.

Accordingly, in the manner for which he is known, Giotto enclosed each scene in geometric-styled architectural motifs, or recurrent themes, that form a continuous vertical frame of wide simulated or false piers. One also finds small scenes populated with the same half life-size individuals, framed by French Gothic quatrefoils (four-lobed shapes), that serve as details on the larger ones.

Above, Giotto painted the barrel vault or rounded ceiling, referred to as *il cielo* or "the sky," in a blue previously not used, a lapis-lazuli or dark blue. As mentioned previously, Gothic artists preferred the gold background to indicate the heavenly domain or paradise of God and all other religious figures. Giotto ignored this. He included gold stars in his cosmos for a worldly effect. He also included portraits of Christ; Matthew, Mark, Luke, and John, the Four Evangelists; Jesus' mother the Virgin Mary; and four prophets, Isaiah, Malachi, Daniel, and Baruch—all set in tondos or round frames. From the blue sky they hover above worshipers.

The narrative 38 scenes, divided into six sections and painted on three horizontal levels, tell the Life of the Virgin and the Life of Christ (Hartt, p. 63). In this manner, Giotto placed the discreet emphasis upon the Virgin Mary his patron required. He found his stories of biblical characters, among other references, in a thirteenth-century book, *The Golden Legend* (known previously as *Legenda Sanctorum* or the *Legend of the Saints*) written by thirteenth-century Genoese bishop Jacobus de Voragine (1228/1230–1298). Written originally in Latin and still a viable reference today, the manuscript was "translated [from Latin] about 1450. [William] Caxton translated it . . . using the older English version and a French translation, with little or no reference to the Latin original; he printed and published his text in 1483" (Voragine, p. vii).

Arena Chapel—*Joachim Takes Refuge in the Wilderness,* 1305

For the purpose of illustrating an important event in the life of Joachim, the father of the Virgin Mary, Giotto chose an incident from Joachim's life after he discovered he was not accepted in the Temple in Jerusalem. Voragine tells the story of the parents of the Virgin Mary. According to Hall, "Joachim, a rich man, and Anne his wife were without child after twenty years of marriage. When Joachim came to the Temple in Jerusalem on a feast day to make offering he was rebuked and turned away by the high priest because he was childless" (Hall, p. 170). After this, Joachim, embarrassed to go home, went to the desert and stayed with shepherds. Giotto depicts Joachim's first meeting with the shepherds, suspicious of him as a stranger.

In brief, Giotto uses this story not only to focus attention on the Virgin Mary, but also as the focus of the design. The intense psychological nuances between

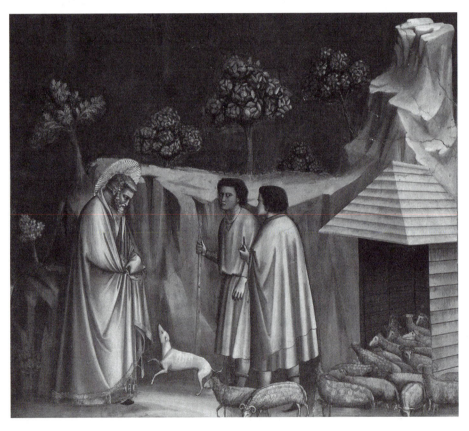

Joachim Takes Refuge in the Wilderness, fresco by Giotto. The Art Archive / Scrovegni Chapel, Padua / Dagli Orti (A).

the figures form a bond that becomes the principal design held together by clever gestures and glances. He depicts Joachim as an embarrassed man, head down, humbled and humiliated because he had not given the world sons. In his shame he looks at the ground. The shepherds, seeing his extreme self-renunciation, accept him with reluctance. Making eye contact, the two shepherds glance at each other, hoping to understand the problem of the man before them, judging whether they should help him. In addition, Giotto places the trees and rocks so accurately in the composition, they call attention to and heighten Joachim's critical moment.

Moreover, the sheep, included as symbols of the Christian flock become the subplot. They move conspicuously from their undersized sheepfold. The dog, on the other hand, intuitively recognizes Joachim's sacred role and jumps toward him. According to Sill, "the dog was probably the first domesticated animal . . . [and became] a symbol of fidelity . . . [it also] symbolizes the priest who guards, guides, and protects his human flock" (Sill, p. 19).

Equally important is the landscape behind Joachim and the shepherds. As previously mentioned, Giotto paints the most advanced trees and rocks known at the time. He makes trees an important part of the composition. Unfortunately, the scope of the landscape is restricted because of his lack of knowledge of linear perspective. In other scenes that occur in the same location, he did not place the rocks and trees in the same place, although the recession into depth with all his frescoes stops where they stand. With this very slight horizontal stage he successfully focuses attention on the precise moment of the action the spectator views. Also, the rocks seem to surround a special place, creating a limited space. He uses this same backdrop, trees and rocks, for all his Arena Chapel scenes.

Giotto used muted, faint, subtle light (without a source) to give volume to the drapery, Joachim and the shepherd's faces, even the rocks and trees. He applied his subdued pastel-like fresco hues with an accuracy beyond the work of any of his contemporaries. Despite his innovations, Giotto painted the light in all the Chapel frescoes as a standard luminosity that bathes every scene in the same way, with no attention paid to the time of day. One cannot tell if Joachim stands in the dawn, the noon hour, or the twilight. With no sun to furnish it, this consistent illumination helps hold all the compositions to a firm unity.

Furthermore, Giotto's light, with neither sun nor moon, casts no shadows and causes no reflections around either Joachim or the shepherds. In fact, shadows do not appear (with a few exceptions) in paintings until the early fifteenth century. Still, historians do not believe that trecento artists did not consider shadows. A medieval literature on light, and even the behavior of light, exists. However, painters did not use light, either sun or moon, to illuminate their subjects.

Finally, in an effort to suggest a greater recession into depth, Giotto cuts off some trees with rock formations so that the viewer sees them as growing on the other side of the rock; thus they appear deeper into space.

We now turn to the stories Giotto painted concerning the Virgin Mary's mother, Anna or Anne.

Arena Chapel—*Vision of Anna* or *The Annunciation to St. Anne,* 1305

The mother of the Virgin Mary, Anna or Anne, has her own story, which Giotto took from Voragine's *The Golden Legend* and depicted it as he imagined it would have been.

In the beginning, Anna has a vision that takes place in Jerusalem. In the vision, an angel from heaven visits her, entering her window to tell her that she will conceive and bear a child. In Giotto's version, on the back porch, one sees a servant spinning cloth who seems to be unaware of the miraculous event occurring in the next room. Because Mary became a Virgin of the Temple and spent her days spinning wool for the veil of the Temple (torn during the Crucifixion), the spinner may be symbolic. The stairway in close proximity symbolizes Mary as the Stairway to Heaven, the primary reason Scrovegni chose her to help his father reach the celestial realms. In fact, Scrovegni may have asked Giotto to include the stairway.

On the whole, Anna's Annunciation occurs in a typically Giottoesque setting, a quaint, small building. Giotto adorned the building's small pediment with a medallion containing a bust portrait supported by two angels, an idea taken from a Roman sarcophagus, or coffin. The building's door jambs and thin lintel are decorated with Greco-Roman acanthus-leafed (a type of serrated Mediterranean thistle) scrolls. Furthermore, it is roofed with marble shingles rather than the typical Italian roof tiles. This exterior also could be symbolic, Giotto's idea of a shrine for the Immaculate Conception of Mary.

When painting the building, Giotto omitted the front wall, revealing the inside of the room. Also, he used the opportunity presented by a three-sided room to paint a view of a trecento Florentine room with curtains, a bed, shelves, a clothing chest, and objects hanging on the wall. He turned the space at an angle and presented the viewer with two sides. He foreshortened (perspective used to depict an object that extends back in space) the angel's head and painted it as seen from above. Vasari, amazed at the new point of view, says, "Giotto's use of foreshortening . . . is very creditable and should be valued very highly by all artists since it marked a new departure" (Vasari, p. 70).

Another convention probably derived from Giotto is related by Italian artist and writer Cennino Cennini (c.1370–?). He writes that objects seen in a distance should be painted darker than those up close. The architectural frames seen in Giotto's work are notably lighter than those spaces within the interior. The same holds true for his leaves. Giotto's foreground trees always have leaves lighter than those do in the background. Furthermore, according to Osborne, "from Giotto's school [Cennini] may also have derived his precept that 'nature' is the artist's best master" (Osborne, p. 214).

Later, after Anna's vision or her Annunciation, the mother of the Virgin Mary met her husband, Joachim, at the Golden Gate in Jerusalem. Giotto painted this scene as well.

Arena Chapel, *Meeting at the Golden Gate,* after 1305

The story of Anna meeting Joachim at the Golden Gate in Jerusalem is told in the Apocrypha. At this time Anna was already with child. Hall asserts, "Anne conceived, like the Virgin Mary herself, *sine macula*—that is, 'without concupiscence'—[this] was taught by the Church in the doctrine of the Immaculate Conception" (Hall, p. 170). Before these teachings, the embrace of Joachim and Anne at the Gate in Jerusalem was used to symbolize her conception and, according to Hall, "this was therefore the first redemptive act of God. The Golden Gate was compared to the 'porta clausa,' the closed gate (Ezek. 44:1–2) which was the symbol of Mary's virginity" (Hall, p. 170). True to the story, Giotto depicts the pair outside the Golden Gate during their embrace.

In brief, for the purpose of meeting Anna, after he received a message from the angel Gabriel, Joachim returned to tell her the good news, that an angel had told him she would conceive and that the child would be the mother of Jesus. Meanwhile, an angel had already visited Anna and had told her the same news.

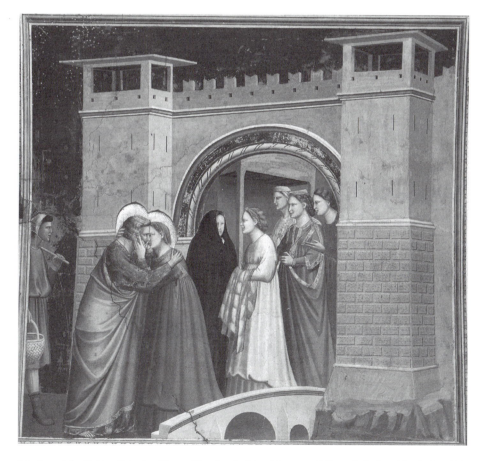

Meeting at the Golden Gate, by Giotto. The Art Archive / Scrovegni Chapel, Padua / Dagli Orti (A).

Giotto painted this meeting of Mary's parents. In his version, Joachim and Anna meet on a small, white bridge outside the Golden Gate of Jerusalem. The scale of Giotto's architecture is noticeably small compared to the figures. But one must realize that to use the same scale for architecture and figures would result either in scaling down the figures to such a small size that the story could be read only from close up, or in showing only the lower sections of the buildings. For this reason, Giotto and painters that followed him (until nearly mid-fifteenth century) painted a double scale—one for figures and one for architecture. In this way, they told their stories with the strongest possible force.

As a result, throughout the Arena Chapel, Giotto's architecture plays a subordinate role. For example, the arch of the Golden Gate of Jerusalem above the figures coming out of the crenellated gate flanked by two security towers seems to embrace those who accompany Anna. Also, Giotto painted the arched entrance a light gray so that it would not detract from the drama.

On the whole, this reunion of husband and wife—even in the fresco medium, which can give faces and features a dull, bland look—is one of the most beautiful portraits ever painted. Anna's left hand tenderly holds her husband's face and her right hand holds the back of his head and draws his face close to hers. Giotto keeps his drawing simple. He omits all details that do not clarify the message of the human emotions.

Equally important are subordinate characters who play smaller, albeit important, roles. For example, the shepherd who carries a sack full of belongings (like a suitcase) and accompanies Joachim (standing behind him) is cut in half by the picture frame. This device is a traditional fourteenth-century convention to indicate that he and Joachim have traveled a long distance.

Finally, the figure cloaked in black with her face partially covered represents the servant who refused to believe that Anna or Anne, so old in years, would ever have a child.

We now turn to Giotto's Annunciation, which depicts Mary receiving word from the angel Gabriel that she will be the mother of God.

The Arena Chapel, *The Annunciation,* after 1305

One finds the story of the angel Gabriel's announcement to the Virgin Mary that she will be the Mother of God in Luke 1:26–38. Following the words of Luke and story of the vision of Ezekiel, Giotto divided his Annunciation fresco into two sections. He painted them in the spandrels (triangular sections on either side of the top of the arch) flanking the Arena Chapel's sanctuary arch, the traditionally designated placement for the Annunciation, as indicated in earlier Byzantine art. Within the space designated by tradition, both figures genuflect or kneel on a narrow stage. Interestingly, Hartt says it has recently been discovered that

> the two little stages on which Giotto has placed the two participants of the Annunciation are derived . . . from constructions used in the dramatizations of the An-

nunciation that actually took place during the Trecento in Padua. These started at the Cathedral and culminated in performances in the Arena Chapel. (Hartt, p. 68)

Curiously, the idea of the placement of the Annunciation flanking the Chapel's sanctuary comes from the prophet Ezekiel. He had a vision of the sanctuary of the Temple, whose gate, at the time, was closed. "This gate shall remain shut; it shall not be opened, and no one shall enter by it" (Ezekiel 44:2–3).

To Christian theologians, the *porta clausa,* or closed gate, of the sanctuary, open only to God, represented Mary's virginity. She sits before her prie-dieu, or small reading desk with a ledge for kneeling, her Bible in her hand, her finger marking the prophecy of one of the four greater prophets, Isaiah, who said, "a young woman is with child and she will bear a son" (Hall, p. 163). Gabriel, facing Mary, says, "'You shall conceive and bear a son, and you shall give him the name Jesus'" (Hall, p. 19).

Giotto painted his Annunciation more intimately than had previous artists. He emphasized the moment when Mary, shown in profile looking directly at Gabriel, accepted her enormous responsibility, genuflecting and placing her hands over her bosom with her Bible in her right hand.

Both Mary and Gabriel genuflect, a practice of kneeling, then standing that involves one or both knees. Giotto's figures are in a mid-kneeling position. Giotto knew about genuflection, which had already been introduced in the eleventh century as an act of adoration of the Eucharist or thankfulness standing for the Holy Communion or the Lord's Last Supper. And although the Eucharist was not required at Mass until the early sixteenth century, Giotto chose to use the genuflection position for both Mary and Gabriel.

In both sections, Giotto painted light not in the older, traditional way, using gold leaf to form a solid gold background, but in mysterious, dimmed orange-yellow rays that cover and surround Mary. He did not use the same light over every figure as did Medieval artists. And although no source for the heavenly light coming from the upper left exists, those who saw the fresco knew only heaven could have produced it. Traditionally, light has been identified with the second person of the Trinity, the Son. Ferguson says that "light is symbolic of Christ, in reference to His words in John 8:12, 'Then spake Jesus' words in John 8:12, "Again unto them, saying, I am the light of the world: he that followeth me shall not walk in darkness, but shall have the light of life'" (Ferguson, p. 23). Gabriel, too, in the left panel, genuflects in a radiance of Divine Light.

Giotto also painted scenes from the life of Christ. One of the better known is *The Raising of Lazarus.*

Arena Chapel—*The Raising of Lazarus,* after 1305

Giotto's *The Raising of Lazarus* makes a forceful statement in the Arena Chapel. Rather than paint the favored Byzantine type used by Cimabue, he paints, in fresco, a strong, stoic earthly Christ with a short beard who stands directly on the ground in bare feet.

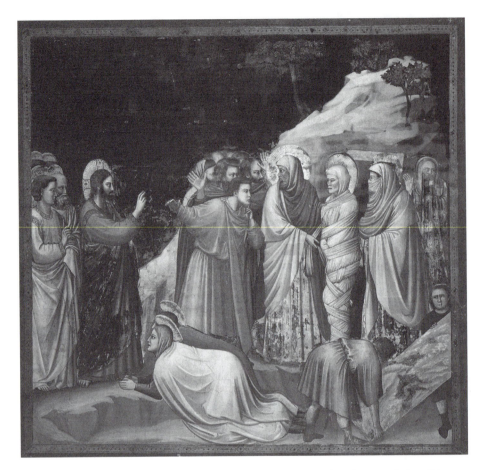

Giotto's *The Raising of Lazarus*. The Art Archive / Scrovegni Chapel, Padua / Dagli Orti (A).

For the figure of Christ, Giotto chose the Gothic tradition. He used as a model *Christ Treading on the Lion and the Basilisk* or the *Beau Dieu* which is the central portal trumeau, or supporting post, from the portal of the Cathedral of Notre Dame at Amiens in France. Giotto used only the figure of Christ. In a modern vein, he omitted the symbolic references, which carried deep and enormous meaning to earlier worshipers. For example, "in early symbolism, the basilisk [half rooster and half snake] was commonly accepted as the symbol of the Devil or the Antichrist" (Ferguson, p. 1). On the other hand, the lion has several symbolic interpretations, depending on its presentation. When under the feet of Christ "the lion . . . was used as a symbol of the Prince of Darkness, this interpretation being supported by Psalm 91:13; 'Thou shalt tread upon the lion . . . '" (Ferguson, p. 8).

Giotto's Christ stands confident with his feet firmly planted on the ground and, considering that this is the early fourteenth century, appears inordinately human. Giotto silhouetted him against the new, blue sky, his right hand ex-

tended toward Lazarus palm out, in blessing. With calm assurance he calls the dead Lazarus from his stone burial place. Miraculously, Lazarus, still wrapped in his grave clothes, stands and walks out. Mary and Martha, Lazarus's sisters, kneel before Christ in supplication, pleading with him to bring Lazarus back to life. Behind Lazarus, Giotto includes two biblical women covering their noses with a cloth who seem to repeat the words written by John the Evangelist, "by this time he stinketh" (John 11:39).

Again, Giotto depicts a figure from the back, a bent-over man who lifts the stone that opens the cave of Lazarus. Giotto's color, even in the dull fresco shades, is remarkably vivid. He uses iridescent hues, for example, and he dressed the bent-over man in a soft pea green shadowed with rust colors. Giotto recorded the formula for these new shades in Cennini's *Libro dell' arte* or *Craftsman's Handbook*. Because the book offered detailed advice about the established technique of painting, following the tradition of Giotto, Giotto's ideas persisted into later Renaissance painting. Inordinately impressive is the freedom Giotto used in coloring the tomb slab's veined marble. Later Renaissance painters copied these marbled effects for many years.

The blue color Giotto chose for Christ's garment was mixed with pigments that could not be painted on the wet plaster in true fresco. Therefore, he painted the blues in fresco secco or directly on the dry plaster. No one at the time considered that fresco secco flakes off. They considered the color and the use of imagination more important. The result was that much of Giotto's fresco secco paint has peeled, and the brushstrokes of the base drawing are exposed.

In the adjacent border, Giotto painted a quatrefoil, or four-lobed motif, with a *Creation of Adam*. The triune God, being three in one (the Father, the Son and the Holy Spirit) wears the cruciform halo. This halo with a cross on its interior designates Christ as being in the form of the Son or the Second Person of the Trinity.

Not long after he completed the Arena Chapel, Giotto painted a panel, *Madonna Enthroned* or the *Ognissanti Madonna*. It is believed to have been painted about 1310.

Madonna Enthroned, 1310

From the Church of the Ognissanti in Florence, this large tempera panel (10 feet 8 inches x 6 feet 8 1/4 inches) in the Uffizi Gallery in Florence, one of Giotto's most important, is sometimes known as the *Madonna Enthroned* or the *Ognissanti Madonna*. It dates 1310 or sometimes as late as 1320. Painted in Giotto's middle years, it is neither signed nor documented. Undisputed, however, is the dramatic power that, in the early fourteenth century, belonged only to Giotto.

Accordingly, the panel is filled with the humanity that only Giotto, in 1310, recognized. One of the primary panels in the development of his style, the Ognissanti Madonna emphasizes the artist's revival in traditional iconography. In contrast to earlier frontal Madonnas with stiff torsos and nonmoving necks, in

the *Ognissanti* panel Giotto turns Mary's body so subtly as to be nearly imperceptible. He echoes her slight turn with the position of her child held in her left arm. The Child is not a little old man of earlier Gothic works; he is a real baby with fat, rounded cheeks.

The Virgin's perfectly oval face, its more human characteristics, her eyes looking directly at the viewer, and the direct position of her body are far from the Gothic realm. At the same time, Mary is quite large in relation to the angels who flank her on both the right and the left. Here, Giotto breaks only slightly with medieval hierarchy. Mary isn't quite as large as she would have been compared to other figures in earlier works. (Gothic masters painted religious figures in size according to importance.) Two kneeling angels, each holding a vase of the Virgin's flowers, roses and lilies, flanking Mary's throne in the foreground, appear fragile. Their gowns seem illuminated, and they look at the Madonna in total adoration.

On the left, a crown held by an angel and meant for Mary is exquisitely adorned with jewels. According to Ferguson, "The crown . . . indicates that she [Mary] is the Queen of Heaven" (Ferguson, p. 101). The crown also indicates the Madonna's majesty, her glory as the Mother of God.

The Madonna's throne recedes into depth somewhat, although it is evident Giotto did not understand scientific linear perspective, and it balances perfectly in relation to Mary's body. Although he based his throne on Italian Gothic architecture, with one large central arch and two outer small arches, Giotto depicts it as an aediculae, or niche, that surrounds the Madonna on three sides. This new placement separates her totally from the old Gothic gold background. In addition, she sits as a person would on the throne, not stiff and straight as earlier Madonnas had done. The base rests on a platform detailed with Giotto's typical geometric motifs or patterns. Also, Giotto brings about a reappearance of trompe l'oeil, a surface painted to emulate a texture well enough to make it appear real. In this case, Giotto emulated polychromatic or colored marble. "Make-believe" marble and other stone textures had been used by ancient painters, but Early Christian painters did not use them. According to Janson, "[Their] sudden reappearance here offers concrete evidence of Giotto's familiarity with whatever ancient murals could still be seen in medieval Rome" (Janson, p. 327).

Giotto's scheme was the culmination of a revival in long, large narrative paintings earlier initiated by the Cavallini circle in Rome and in Assisi at the end of the thirteenth century. Pietro Cavallini (1273–1308) "was the great representative of the Roman School slightly before Giotto. He painted fresco cycles and designed mosaics in a purely classical [Roman] style" (Murry, p. 89).

In contrast to earlier works, Giotto draws his figures from personal observation. They are revolutionary because they break with all medieval formulas. They are not the stiff, straight bodies of earlier centuries. The effect is to produce figures that are didactic, principled, and proper. At the same time, divine magnificence, so important in medieval art, no longer plays a role. He purposely gives up the spectacular color and ornamental line of both Byzantine and early fourteenth-century Sienese painters.

Giotto the Architect

Giotto's biographer, Giorgio Vasari, described him as painter, sculptor, and architect.

Giotto's appointment in 1334 as *magister e gubernator*, or chief architect (or *Magnus Magister*, Great Master), of the workshop of Florence Cathedral offers supportive evidence that he worked not only as city architect but also as superintendent of public works. Giotto's accomplishments in problems involving space in drawing and painting revealed strong and original solutions. The Arena Chapel paintings, for example, provided spatial problems because of their carefully drawn outlines and classical proportions for the many buildings Giotto painted. Besides painting buildings, Giotto may have been involved in several architectural projects.

In particular, Giotto may have been the chief architect on a later project, the Carraia Bridge in Florence. Made up of simple arches, the bridge, a structure typical of Giotto's proportions, rises gracefully and only slightly toward the center. Open since 1337, unfortunate enemy action destroyed Carraia Bridge in 1944 during World War II. Today it exists only in photographs.

More evidence of Giotto's work as architect can be found in the Campanile or Bell Tower still standing in Florence beside Santa Maria del Fiore or the Cathedral of Florence.

The Campanile or Bell Tower for the Cathedral of Florence, c. 1334

Giotto's primary surviving architectural work is the Campanile on the south side of the Cathedral of Florence, Santa Maria del Fiore. This structure came to be known as Giotto's tower and is known also as the Florence campanile. So perfectly designed is the structure that, according to Kleiner and Mamiya, "it could stand anywhere else in Florence without looking out of place; it is essentially self-sufficient" (Kleiner and Mamiya, p. 547). Giotto's campanile, so faultless in design, so unequaled in balance and structure, would be complete without the Cathedral beside it.

Giotto designed Santa Maria's bell tower as a tall, square structure. On each corner he placed an octagonal column running the length of the edifice, giving the bell tower the effect of being solidly held together. The geometric precision (in which Giotto excelled) and the elegant, ornamented style make the painter's architectural effort the natural extension of his fresco cycles.

As mentioned earlier, in January 1334 Giotto was appointed as *magister e gubernator, capomaestro* or architect in chief of the workshop of the Cathedral of Florence. The position, however, was not free of controversy. Several artists complained that Giotto was no architect, as some historians have also claimed. According to Murry, "The painter Giotto, who was appointed *Capomaestro* in 1334 simply because he was the most famous Florentine artist of the day, had no ar-

chitectural knowledge and confined himself to designing the separate Campanile" (Murry, p. 22).

Despite criticism and controversy, on July 9, 1334, Giotto began work on the campanile. After the water and gravel had been excavated and the ground settled, builders laid a strong stone foundation to a depth of around 40 feet. On this base they put down about 24 feet of ballast or filling as stabilizer and then had the remaining 16 feet filled with stone.

After this, builders constructed the first story of the building following Giotto's design drawn on a large parchment. Today officials preserve this drawing in the *Museo dell'Opera del Duomo* or Cathedral Museum in Siena. The drawing's authenticity, however, stems only from the fact that most historians agree that the design's perfection would eliminate the possibility of a copy.

Indeed, the design, involving some rote repetition of identical elements and motifs, was possibly executed by Giotto's assistants, under his supervision, using his calculations and sketches. One concedes that Giotto's method did not reflect on him as an artist; the practice is not uncommon, and architects today still use assistants for preliminary drawings.

In addition, according to Giotto's model, he intended the campanile to be topped by a four-sided pyramid about 100 feet high. Although the design was Giotto's, because of its style, the spire was never built.

Giotto's bell tower is fundamentally not completely original. He designed the Campanile in the traditional design of an ordinary Tuscan bell tower, in which the fenestration (arrangement of all windows in a building) multiply in number as the stories increase. The four sides of the tower represent the Gospels of Matthew, Mark, Luke and John. He purposely topped the tower with an octagonal bell chamber, eight being one of the most important numbers of Christian iconography and used frequently in painting and in architecture. At the time everyone understood its several meanings. According to Sills, "eight is the number of regeneration, its spiraling shape, eternally in motion. It is the number emblem for baptism, and baptismal fonts are often octagonal. Eight represents Resurrection, for on the eighth day after his entry into Jerusalem, Christ arose from the grave" (Sills, pp. 137–138).

In contrast, the Campanile's lower story can be understood only in relation to the entire design. The hexagons of white marble appear suspended against pink marble panels. For emphasis, Giotto purposely placed the hexagons off-axis with each other from panel to panel. The effect, therefore, viewed from street level, would have scintillating white hexagons wavering against pink in the sunlight. One is amazed when considering that this spectacular sunny vacillation occurred for 200 feet and is reminded that the designer thought as a painter rather than an architect.

Giotto, in his desire for arithmetical simplicity, planned 75 hexagons on each face of the Campanile. Three hundred exist for the entire bell tower.

In addition to Christian symbolism, Giotto considered wind pressure. He planned iron tie-rods running from the pinnacles (Gothic-shaped cones) through

the oculi at the corner windows. However, attention to wind pressure waned when he decided on certain embellishments. Hartt states:

> It is the more surprising that he decided to set enormous marble baskets of fruit on the three gables of his sixth story, crown his slender pinnacles with marble angels with widespread wings, and poise a colossal Archangel Michael, with wings and a banner, on the very tip of his spire, some three hundred feet above the ground, all of them exposed not only to wind but also to the disintegrative action of the rain, ice and snow of Florentine winters, worse then than now. (Hartt, p. 80)

Unfortunately, Giotto's successors mostly despoiled his design. And, added to their desecrations, after he died, builders discovered that the walls of the bell tower's first story were too thin and fragile and had to be doubled.

Giotto divided his bell tower into harmonious, symmetrical sections. The Florentine tower is the sum of its lucidly delineated sections. An aesthetically pleasing effect exists because each of the parts—neatly separated from each other by running moldings—exists independently, each a section of perfect beauty. Although this compartmentalization reminds one of the earlier Romanesque churches (c. 1000), it also predicts the balance and harmony of sixteenth century Renaissance architecture. Artists like Giotto designed in a clear and logical way. They did not use the old Gothic vocabulary. As a result they produced self-sufficient works that could stand alone or beside other structures.

Altogether, for all these works, Giotto was not only given Florentine citizenship but also granted by the commune the large sum of 100 gold florins a year. Taddeo Gaddi (d. 1366), Giotto's godson and one of his most faithful followers (he worked for Giotto for 24 years), took over the position as overseer of the work after the Giotto's death.

Giotto and Italian Art

Most historians regard Giotto as the founder of modern painting. In the early fourteenth century he broke from both Italian and Byzantine stereotyped art forms. He gave his figures solidity with volume and a naturalism that appeared substantial and lifelike after several hundred years of flat, unnatural figures. Besides this, he infused passion and psychological subtleties such as glances between two people into his scenes.

Giotto probably designed the fresco cycle of the Legend of St. Francis in the Upper Church at Assisi, although many critics deny his authorship on stylistic grounds. Here, in the Upper Church, Giotto imbued the Assisi frescoes with the kindness and goodness St. Francis had brought into the thirteenth-century religious experience. In changing religious life "St. Francis of Assisi . . . appeared seemingly at the right moment and made religion a matter of intense personal experience" (Earls, p. xii).

Both St. Francis and Giotto helped change medieval thinking. But where did Giotto find his ideas? Certainly new elements in French art provided Giotto with a great deal of inspiration. The early thirteenth-century jamb figures (statues framing a portal) of the south portal at Chartres, for example, reveal a new naturalism and movement. The head turns slightly, the body no longer stands stiff and locked at the knees. The drapery falls more softly. Also, one no longer sees the old knife-edged stylized folds. The jamb figures known as *The Visitation* on the west portal of Notre Dame de Reims stand free of the column, rotate their bodies in space, and reveal a psychological mood unrecorded by medieval sculptors. Giotto translated these depictions of religious drama, derived from the observation of faces and bodies, movements and gestures, onto the walls and panels of churches and chapels. Although he worked under French inspiration, he inspired a movement toward classical realism in the arts that ultimately left French artists behind.

Giotto's work bears up well under critical scrutiny because of both the formal qualities of his art and the vastness of the pictorial world he created. Giotto surpassed earlier artists in revealing the beauty of natural forms, as witnessed by his plants drawn with close botanical observation and his depictions of the behavior of dogs and other animals. He created a pictorial language equal in vigor to the work of Nicola Pisano (c. 1220/5–1294), who had created an earlier rebirth of the arts. He developed further the ideas of Italian architect, sculptor, and designer of Florence Cathedral (c. 1300) Arnolfo di Cambio (d. probably 1302) in the creation of balanced architectural forms. Finally, he transformed the sacred stories from the Bible, treating them as they actually existed in the imagination of his contemporaries. He situated them in a three-dimensional space (although limited) with psychological nuances painted into each action.

For a public accustomed to the figurative ideals of the thirteenth century, Giotto's art was revolutionary in its realism. Even today his work stands as an encyclopedia of the fourteenth century in the same sense in which *The Divine Comedy* stands as an encyclopedia of the mentality of the period. Like Dante, Giotto not only brought together the elements of his own artistic culture, he also influenced its subsequent development. He created models for the painters who followed him. He gave form to ideal, human figures in which men of the early fourteenth century found inspiration.

Giotto was able to influence painters of his day because they did not think as he did. They thought of a wall surface as a flat, solid, impenetrable plane. They were unable to give the illusion of recession into depth. Giotto's paintings have different planes and volumes, characteristics they had never before seen. His architectural settings within nature surround small but defined spaces almost like openings in the wall.

Although he was a brilliant and influential master, in the early fourteenth century, Giotto was far from using the paint, color, line, light, and shade one associates with later Renaissance art of fifteenth- and sixteenth-century Florence. His paintings reveal a limited knowledge of scientific linear perspective, and his

landscapes are stylized. Still, Giotto expanded greatly the means of pictorial representation. The human figure depicted with real human emotion and the analytical exposition of the visible world became the central themes of Florentine painting. Giotto began this great tradition and remained a source of its inspiration for many years. He is considered the pioneer of pictorial realism and the initiator of the process which led to the rebirth, the Renaissance, in art.

Bibliography

Earls, Irene. *Renaissance Art: A Topical Dictionary.* Westport, CT: Greenwood Press, 1987.

Ferguson, George. *Signs & Symbols in Christian Art.* New York: Oxford University Press, 1959.

Girardi, Monica. *Giotto.* Trans. By Anna Bennett. London: Dorling Kindersley Ltd., 1999.

Hall, James. *Dictionary of Subjects and Symbols in Art.* Revised Ed. Oxford: Westview Press, 1979.

Hartt, Frederick. *History of Italian Renaissance Art.* Englewood Cliffs, NJ: Prentice-Hall, Inc., and New York: Harry N. Abrams: 1987.

Hauser, Arnold. *The Social History of Art.* Vol. 2. New York: Vintage Books, 1951.

Janson, H.W. *History of Art.* 2d ed. Englewood Cliffs, NJ: and New York: Harry N Abrams, Inc., 1978.

Kleiner, Fred S. and Mamiya, Christin J. *Gardner's Art through the Ages.* 11th ed. New York: Harcourt College Publishers. 2001.

Murry, Peter. *The Architecture of the Italian Renaissance.* New York: Schocken Books, 1970.

Murry, Peter and Murry, Linda. *A Dictionary of Art and Artists.* 4th ed. Middlesex, England: Penguin Books, 1977.

Osborne, Harold. *The Oxford Companion to Art.* Oxford: Clarendon Press, 1970.

Panofsky, Erwin. *Renaissance and Renascences in Western Art.* New York: Harper & Row, 1972.

Sill, Gertrude Grace. *A Handbook of Symbols in Christian Art.* New York: Macmillan Publishing Co., 1975.

Vasari, Giorgio. *Lives of the Artists.* Trans. by George Bull. New York: Penguin Classics, 1972.

Voragine, Jacobus de. *The Golden Legend.* Trans. by Granger Ryan and Helmut Ripperger, 1941. Reprint, New York: Arno Press, 1969.

CHAPTER 6

Leonardo da Vinci, 1452–1519

A major figure of the fifteenth-century Italian High Renaissance, Leonardo da Vinci became one of the most eminent painters and most variously accomplished geniuses the world has ever seen. Besides being one of the greatest Italian masters of painting, sculpture, and architecture who ever lived, he was a talented engineer and a pioneer investigator in the natural sciences. His portrait *Mona Lisa* and his religious scene *Last Supper* rank among the most significant and influential masterpieces in the history of painting.

Trained as a painter, Leonardo's interests and achievements extended into several areas, including the scientific. Not only did he study astronomy, geology, optics, anatomy, and botany, he also drew plans and designed machines for hundreds of inventions.

Because Leonardo excelled in an astonishing number of areas of human knowledge, critics label him a universal genius. Yet, as broad as his kaleidoscopic interest spectrum was, he had little interest in literature, religion, or history; and although he formulated a few scientific laws, he seldom developed his ideas systematically.

Of all his achievements, Leonardo was most astute in observation. Rather than spend time with abstract concepts, he concerned himself with what the eye actually viewed in nature. Hauser states, for example, that "the replacing of the imitation of the masters by the study of nature is first accomplished theoretically by Leonardo da Vinci" (Hauser, p. 63). With his new techniques and perceptions Leonardo rid painting of many old medieval, traditionalist thoughts. This is an enormous victory of intelligence and rationalism over redundant and staid convention. He changed attitudes and resurrected beauty in a time and place of mostly traditional minds bereft of visual stimulation.

Moreover, the sign of artistic genius stays so strong throughout his life that important artists from the north—Albrecht Dürer, to name one—came under his influence. Panofsky states, "revival of . . . [equestrian monuments] in the French Renaissance is largely due to the influence of Dürer's engraving which, as far as the movement of the horse is concerned, goes back to Leonardo da Vinci" (Panofsky, p. 102).

Finally, one notes the unmistakable sign of the artist–genius when viewing his famous inverse writing, or *scrittura sinistra*, with which one must use a mirror (Scaglia, p. 32).

Leonardo's figures, man or animal; his botanical illustrations, flowers or trees; and his innovative methods of chiaroscuro, or shading, influenced the most important artists for years after his death.

Leonardo's Life

Historians are not sure where Leonardo was born. Most agree his birth in 1452 occurred at Anchiano, close to the village of Vinci, near Florence in the Tuscan countryside of central Italy.

Historians agree, however, that Leonardo was the illegitimate son of Ser Piero da Vinci, a legal specialist (notary), and a peasant girl named Caterina. Presumably Ser Piero's family raised the child in their home and trained him as a painter. It is believed he developed his lifelong interests in nature as a child while with his father's family.

In addition, little is known of Leonardo's childhood. Various historians describe him as being a beautiful child who had a charming manner and an inordinate, nearly otherworldly artistic talent. It is well known that around 1465 (dates differ with accounts), when he was about 13, he became an apprentice at the Fraternity of St. Luke in Florence to Florentine painter, goldsmith, and sculptor Andrea del Verrocchio (c. 1435–1488). Verrocchio, a resourceful, well-known quattrocento (1400s) sculptor and painter in Florence, evidently never dictated the directions of Leonardo's brush. As a result, to Leonardo's good fortune, his apprenticeship and genius never suffered under any other artist's heavy hand or dictatorial ideas. Luckily for him, "his [Verrocchio's] *atelier* [studio] was clearly the most versatile in Florence" (Wölfflin, p. 22).

Although accounts vary as to Leonardo's guidance, Ser Piero, his father, probably made the arrangements for his education. According to biographer Giorgio Vasari, "Piero one day took some of Leonardo's drawings along to Andrea del Verrocchio (who was a close friend of his) and earnestly begged him to say whether it would' be profitable for the boy to study design. Andrea was amazed . . . and urged Piero to make him study the subject" (Vasari, p. 256). While working in the studio Leonardo met Florentine painter Sandro Botticelli (c. 1445–1510) and fresco painter Domenico Ghirlandaio (1449–1494), who had at one time Michelangelo as an apprentice. Both Botticelli and Ghirlandaio became great masters of the Italian Renaissance.

At that time Verrocchio worked with tempera (pigment mixed with egg yolk, glue, or casein) on a wood panel of the *Baptism of Christ by St. John.* In an unusual gesture, he allowed Leonardo to paint on the panel. Leonardo painted an angel on the far left holding some clothes. No doubt exists that his angel, beside the mature painter Verrocchio's angel, reveals the unmistakable bud of genius. Wölfflin says "the Angel in Verrocchio's Baptism moves us indeed, like a voice from another world. . . . everything in it is significant and new . . . the freedom of movement in the details . . . the new pictorial value given to light and shadow" (Wölfflin, p. 22). Leonardo's angel's head is the first statement of the paradox—combined frailty and power in one figure, that became prominent in his work. Despite his inexperience and youth, Leonardo's brush produced such beauty and sensitivity that his angel cast unheard, unseen aspersions on Verrocchio's figures. Fortunately Verrocchio did not cast him out. Leonardo is also given credit for the painting's misty landscape, the sfumato (light and shadow blended in the manner of smoke) he later perfected. Some historians also claim Leonardo's brush is evident in the depiction of the soft and gentle Christ, subdued and delicate beside the master Verrocchio's more rigid, ungraceful John the Baptist.

One finds a hint of the same lovely and fragile feeling in Leonardo's *Annunciation,* now generally accepted as painted by the young boy before his twentieth birthday. This tempera on wood, painted in Verrocchio's studio around 1472, reveals an exquisite, beautifully balanced composition. Some painters of the time believed Leonardo's drawings and paintings were the reason Verrocchio stopped drawing and painting. He was embarrassed that a boy so young could paint figures with such deep sensitivity and understanding, that his brush could create dignity and grace so much more elegant than his. On stylistic grounds most historians accept the information as true. On the other hand, Verrocchio may have believed that he could devote all his energy to sculpture, which he preferred and which gives him his prominent place in art history, if he could have in his studio a painter with genius such as Leonardo's.

Leonardo also painted the *Benois Madonna* and the *Madonna Litta.* These early paintings have been repainted (possibly because of experimental pigments he often tried), and many critics consider them ruined. They are nevertheless associated with preliminary drawings that are without doubt by Leonardo's young hand.

Equally important, while still in his early teens, Leonardo modeled in clay several heads of women and children. So well done were they one might believe the modeling could have been from the hand of a mature, well-trained artist. He made plaster casts of each one. He also executed numerous architectural drawings both of ground plans and of other elevations. Moreover, while still very young, his engineering propensities surfaced. He proposed, for example, reducing the Arno River to a navigable canal between Pisa and Florence. No one before him had thought of this. Continuing interest in engineering, he drew designs for mills and engines that could be driven by water power.

Leonardo's talent spread into many areas. He was commissioned to make a cartoon (drawing for a tapestry) for a silk tapestry to be made, that is, sewn and embroidered with gold thread, in Flanders. The finished tapestry was to be sent

to the king of Portugal. For the subject, Leonardo illustrated Adam and Eve in the Garden of Eden. His cartoon revealed the fine, unmistakable chiaroscuro, the blended shadows for which he became known, and he painted highlights in lead-white in a way painters had never before seen. For background he painted a spacious meadow with various animals. A botanist can recognize every leaf, flower, and blade of grass, so perfectly did he render each one. He created an astonishing fig tree with all the leaves foreshortened and its branches drawn from several different points of view, a feat unheard of at the time. The tree, according to Italian painter, architect, and biographer, Giorgio Vasari (1511–1574), is "depicted with such loving care that the brain reels at the thought that a man could have such patience" (Vasari, p. 258). He drew a palm tree in the same manner. Today only the cartoons or preliminary sketches exist.

No doubt exists that from the time he was a young boy in Verrocchio's studio until he died, "the world lay open to him [Leonardo], as perhaps to no other mortal of that day" (Burckhardt, p. 59).

We now discuss one of the works that survives in good condition from the wondrous intelligence of the youthful Leonardo, the fascinating *Annunciation*.

The *Annunciation*, c. 1470s

Leonardo's *Annunciation* is a panel from his Florentine period (one of the few remaining), painted for the monastery of Monte Oliveto, just southwest of Florence. It measures 38 1/4 feet by 85 1/2 feet.

Here, he posed the Virgin to the far right seated quietly in her garden at the door of a magnificent Italian villa. He balanced the smooth stone walls with pietra serena (a dark, clear stone) quoins or stones marked to appear as if they wrap around a corner.

Mary's Bible, open to the prophecy of Isaiah, who predicted her coming motherhood, rests before her on a podium in the form of a squat Roman garlanded urn. Her right arm reaches toward her Bible, and her delicate fingers appear to point to the prophecy indicating she does not wish to lose her place in the text. Her elegant little podium has two lion's feet, surmounted by two balanced acanthus leaves that ascend and blossom into Ionic-styled volutes or swirls. A shell rests delicately between them on the typically Roman garland or swag.

Mary acknowledges Gabriel's salutation by lifting her left hand. Neither surprise nor fright registers on her truly perfect and lovely features. Gabriel, the Annunciation angel, is a small and graceful child, who kneels before her surrounded by the rich multitude of her flowers, each petal painted botanically perfect.

A perfectly straight and low garden wall looms to Mary's right. The wall encloses one of the symbols of Mary's virginity or "the *hortus conclusus*, the 'enclosed garden'—a fence or wall surrounding the young woman" (Hall, p. 328). Beyond the garden, Leonardo painted dark cedar and cypress trees. According to Ferguson "the cedar tree . . . is a symbol of Christ:' . . . his countenance is as Lebanon, excellent as the cedars' (Song of Solomon 5:15)" (Ferguson, p. 14). Ferguson also writes, "The cypress, even in pagan times, was associated with

death . . . it has dark foliage and, once cut, it never springs up again from its roots" (Ferguson, p. 15). The cypress tree prefigures the death of Christ. Beyond the cedar and cypress trees, if one looks closely enough, a port can be discerned, with towers, lighthouses, and ships to emphasize Mary's title "Star of the Sea." According to Hall, a port "derives from her title 'Star of the Sea' (Lat. *Stella Maris*), the meaning of the Jewish form of her name, Miriam" (Hall, p. 330).

In addition, between Mary and the viewer Leonardo painted an invisible haze. So effective is this thin, gossamer atmospheric veil that, despite numerous attempts, not one of Leonardo's contemporaries could duplicate it, even though he discussed the process at length in his writings. The veil begins at the surface as nearly nonexistent, then gradually, so subtly that even the most acute eye cannot measure it, the air shimmers, becomes denser, glows in a blue and radiant sfumato. The veil is an entirely new method of painting. Osborne says the veil was "the capacity to mellow the over-precise and harsh outlines characteristic of earlier quattrocento masters [that became] a distinguishing mark of the perfect manner of painting ushered in by Leonardo da Vinci" (Osborne, p. 1060).

In the same way the Virgin's dress, occupying real volume and depth, reveals a new method of study and application. Giorgio Vasari recorded it. "Sometimes he [Leonardo] made clay models, draping the figures with rags dipped in plaster, and then drawing them painstakingly on fine Rheims cloth or prepared linen. These drawings were done in black and white with the point of the brush" (Vasari, p. 256).

Both faces, Gabriel's and Mary's, appear bathed in an incandescent ethereal light. They glow mysteriously as if lit from behind the canvas by some unearthly source. Not the slightest chiaroscuro or shadow appears on either face, so fully glowing did he render each one. The viewer notices, however, that strange light comes into the painting from the left behind Gabriel (who kneels in profile) and a dark, prominent shadow spreads over the ground before him. This otherworldly light creates deep, penetrating shadows in the folds of Mary's dress. It lights the building's quoining in a soft yet forceful way.

Leonardo da Vinci gave the world of painting new illumination. He continued his quest for light in *Virgin of the Rocks*.

Virgin of the Rocks, 1483

Two versions of *Virgin of the Rocks*, also known as *Madonna of the Rocks,* survive, one in the Louvre in Paris and the other in the National Gallery in London. Possibly both were painted as a panel for an altarpiece for the Confraternity of the Immaculate Conception, which had a chapel in San Francesco Grande in Milan. Leonardo painted the second or London version as a replacement panel with the help of a sculptor and two of his pupils after the first panel was sent to France. He used to advantage the discovery made by one of Italy's greatest fifteenth-century masters, Masaccio (1401–1428?)—chiaroscuro, or light and dark. Creating volume with light and dark and using chiaroscuro to depict emotion and movement became one of Leonardo's main experiments. He became

the master of gesture to convey emotion and in the process a great painter. According to Blunt, "A good painter has two chief objects to paint—man and the intention of his soul. The former is easy, the latter hard, for it must be expressed by gestures and the movement of the limbs" (Blunt, p. 34).

Specifically, Leonardo depicted the figures in *Virgin of the Rocks* using the typically High Renaissance perfect pyramid composition, placing all figures in the same environment. This unified representation of objects in a misted gauzy setting with curiously filtered light was an enormous and particularly original achievement. The work was also a painted treatise of his scientific curiosity concerning vapors and hazes affecting objects in space. The Madonna, Jesus, and John the Baptist—the latter two as infants—and an angel repose in subtle, softened light and shadows, and quiet clear fogs of color emerge as the glassy pales of a meticulously rendered craggy background. Miraculously, paradoxically, light veils and reveals the figures at the same time. Strangely, this light appears to immerse them in a mildly defocused sphere that exists invisibly, a curtain, between them and the spectator. Leonardo used aerial or atmospheric perspective, and he used it originally and skillfully. Vague, fluctuating lights and darks, those observed at certain moments of twilight, bathe all figures and flowers.

The figures, as seated in their diaphanous glen, defy explanation. The figures' hands—Mary's hand covering her son's head, Jesus blessing, John praying, the angel pointing, unite the composition so that it forms a pleasing circular unit. To the right, with a bright red mantle, an angel, one of the loveliest ever painted, points to John the Baptist, who wears his baby camel skin, and at the same time looks directly out at the spectator. This intimate gesture brings the viewer into the drama. Looking at Jesus, John, on one knee, prays. At the same time Jesus blesses him using two fingers (the index and middle). Mary, the central figure, her head the top of the triangle, holds the gestures together. Her inordinately long right arm embraces John to her right, while her left hand hovers over her son's head. The gestures bring together a gentle, warm mood amplified by the vaporous light that illuminates arms, legs, and faces strangely, as if in warning of Jesus' death.

Simultaneously, plants and flowers emerge from rocks both before the scene and behind it. They, too, grow in light that seems to be a harbinger of what is to come. Behind the figures, the cavernous, cragged landscape too appears melting and diffused, translucent, yet in detail. And although Leonardo had experimented with light as veil in earlier works, in *Virgin of the Rocks,* he matures the process, adding even another dimension—light as fleeting, as impermanent. Leonardo perfected light before he moved into the completeness of the emotional focus made concrete with both light and gestures of his *Last Supper.*

Last Supper, 1498

Leonardo also painted for the Dominican monks of the convent of Santa Maria delle Grazie in Milan. On the wall in the convent's refectory or dining room he began the immense and famous *Last Supper* (30 feet by 15 feet). When finished,

so perfect was the illusion he created that the paint of the cloth on the table, so brilliantly applied, could not be discerned from real linen.

Unfortunately, Leonardo had achieved the illusion he sought with outlandish experimentation. Brashly, especially for such a large undertaking, Leonardo used oil paint and tempera on wet plaster. The mixture had never before been tried. Indeed, he had formed a new kind of fresco that, when first applied, produced unbelievable and extraordinary results. This mixture was an unfortunate choice, however, for as the pigments dried, so did they peel away from the wall.

In addition to problems of peeling, the Prior of Santa Marie delle Grazie harassed Leonardo every day to complete the project. Leonardo's habit of spending slow hours looking at and contemplating what he had already done was beyond the Prior's patience. If the Prior could have made him work at the speed he desired, Leonardo would have worked nearly round the clock with speed and certainly beyond his capacity. The Prior lamented his problems to the duke and pled his case so convincingly that the duke called Leonardo in and questioned him about his work. At the same time he let it be known that he had Leonardo before him only because of the Prior's insistence. Leonardo confiding his plans in detail, told the duke he had finished all but two of the heads—that of Christ and that of Judas. He wondered, too, if he were capable of painting these two heads. For Judas, he could not imagine the eyes and lips of the man who, despite all the love and goodness he had received, could forsake his master. He decided to search for a model for Judas and he had actually made up his mind that if he could not find one, he might use the Prior's head. Before long, however, he finished the head of Judas and somehow painted it the exact epitome of treachery and deceit.

For Leonardo, the story of the Last Supper, as found in the gospels, was one of the most powerful chapters in Christ's life. To understand the painting, one must understand the story, which begins when Jesus and his apostles went to Jerusalem to celebrate Passover. As Jesus ate with them, he had a foreshadowing of his approaching arrest and death. With this in mind, Leonardo placed Christ and his 12 disciples at a long, white linen–covered table precisely parallel to the picture plane. The room, wide and spacious, opens in the back in perfect one-point perspective, directly behind Christ, to an atmospheric landscape. Leonardo's room, purposely solemn, exaggerates well the painting's quiet, albeit forceful, action. Leonardo depicted Christ with his arms open, spread before him on the table, his demeanor calmly effective. He has just said, "Verily I say unto you, that one of you shall betray me" (Matthew 26:21). Obvious and tantalizing ripples of consternation wave over the disciples as each asks himself or his neighbor, "Is it I?" (Matthew 26:22). Leonardo created a worldly juxtaposition of the words "One of you shall betray me" with the beginning celebration of the Eucharist, or the Holy Communion. Christ blessing bread and wine said, "This is my body, which is given for you. Do this in remembrance of me. . . . This cup which is poured out for you is the new covenant in my blood." But behold the hand of him who betrays me is with me on the table" (Luke 22:19–22).

Furthermore, to emphasize the action, Leonardo purposely seated Christ in the center of the table, in the most perfect tranquility, an island of repose in a position that isolated him from his apostles even though he sits among them. He is the perfect, quiet center of the storming, gesticulating passion both to his right and his left. A central window at the back strongly highlights his head as it is superimposed over a nearly white sky. A segmental pediment (barely discernible) forms the only curve in the room's strictly trabeated or vertical–horizontal architecture with no arches. It forms a half-halo above Christ's head, the intense focal point of all orthogonals or converging perspective lines in the composition. Consequently, the center, calm and motionless, and paradoxically at the same time the cause of the buzzing, close to hysterical activity, is also the focus of Leonardo's perfect one-point perspective. And it might be some time before one realizes that Christ becomes the perspectival, the serene, psychological center and the cause of a flurry of rapid gestures, quiet questions, lovely heads tilted proportionately and perfectly.

Leonardo depicted Christ's disturbed, nearly frenzied disciples in four groups of three, placed and held in flawless design and unity by hand and body movements and attitudes and positions. Moreover, he did not rely on old established iconography, even though traditional, to maintain the story and expression he desired. Rather than place Judas on the opposite side of the table, as had been the custom for hundreds of years, he placed Judas on the same side of the table with Jesus and his apostles. However, he painted the traitor's face dark, in deep shadow. At the same time Judas, leaning perceptibly away from Jesus in horror, grips almost desperately in his right hand a bulging purse. And he lifts his left hand forward in fulfillment of the Master's announcement as found in Luke: "But yet behold, the hand of him that betrayeth me is with me on the table" (Luke 22:21).

While the action boils from both sides of Jesus, both apostles at the end of the table do not display as much agitation as those who sit closest to him. This, a clever compositional device, holds together the whirling energy of the composition.

Leonardo's *Last Supper* drew the admiration of the King of France, who requested permission to take the entire refectory wall from Italy. He even tried to find architects to make cross-stays of wood and iron with which the painting could be transported to France. He had no regard for expense, so overwhelming was his desire to have the work. In the end, besides the fact that Leonardo had painted the *Last Supper* on an extraordinarily thick wall, the Milanese would not let France have it.

Unfortunately, the paint (completely experimental) early began to show signs of flaking. "[Giorgio] Vasari [1511–1574], in 1556 described it as a 'muddle of blots' . . . [a] ruin, pitted and rubbed, [however] it still retains immense authority, and before it there can be no doubt that one is in the presence of a masterpiece" (Osborne, p. 654). Although Leonardo worked at a slower pace than most other artists, endlessly experimenting with colors and pigments, he completed his *Last Supper* just before Duke Lodovico Sforza, his patron, died in 1499.

On August 16, 1943, Leonardo's *Last Supper* came close to destruction. A bomb hit Santa Maria delle Grazie and a side wall of the refectory crumbled. The painting, safe behind a protective barricade, survived. Over the years the *Last Supper* has received extensive repair. The most extensive and successful restoration occurred in the latter part of the twentieth century and caused numerous complaints.

As popular as the world has made Leonardo's *Last Supper,* his portrait *Mona Lisa* has accumulated an even greater aura of admiration and respect over the years.

Mona Lisa or *La Gioconda*, c. 1503–c. 1505

Although some controversy concerning the date exists, Murry says Leonardo painted Mona Lisa between c. 1500 and c. 1504 (Murry, p. 257); yet, according to Kleiner and Mamiya, he completed the portrait between c. 1503 and 1505 (Kleiner and Mamiya, p. 641).

Leonardo spent three months painting the portrait of Lisa di Antonio Maria Gherardini (wife of the prominent Florentine citizen Francesco del Giocondo), whom he called Mona Lisa. When she sat for Leonardo she was 24 years old. The result of her several sittings was an oil painting on a wood panel, universally known as the *Mona Lisa,* which measures a small 31 1/4 inches by 21 inches. Equally important as the famous subject is the fact that the panel is one of the artist's few finished works.

In contrast to earlier Renaissance portraits, Leonardo chose a totally new portrait style. Several compositional devices dominate. To begin, Mona Lisa's head divides a craggy mountain landscape. Also, earlier Italian portraits, such as Piero della Francesca's Battista Sforza and his Federico da Montefeltro (c. 1474), reveal only the head and shoulders. They cut the body at mid-chest. Leonardo includes the body well below the waist, and both arms, bent at the elbow, folded in front. The left forearm rests on the arm of her chair and runs nearly parallel to the picture plane. The right arm, in a perfectly natural position, falls across it. Both hands appear softly comfortable. The body, presented in three-quarter view, allows for a barely discernible turn of the head. The viewer feels that the entire woman sits before him. This is because she is not just a bust, as had been previously shown; she comes close to being a full-length portrait.

With an unusual landscape and a nearly full-length pose, Leonardo's depiction of Mona Lisa paves a new road into painting that later artists copied. He uses his new format so successfully that both Northern and Italian Renaissance artists followed it for several hundred years. Lasting success resulted from this truly magnificent portrait, a pose more astonishing than anyone had seen before. Indeed, Italian models emerged thereafter and loomed so impressive they became the ideal of the face and body. One has only to view the three-quarter portrait of *Isabella d'Este* (1534–1536) by Venetian painter Titian (c. 1487/90–1576), the somewhat later *Portrait of a Young Man* (c. 1530s) by Florentine Mannerist painter Bronzino (1503–1572), and the seventeenth-century

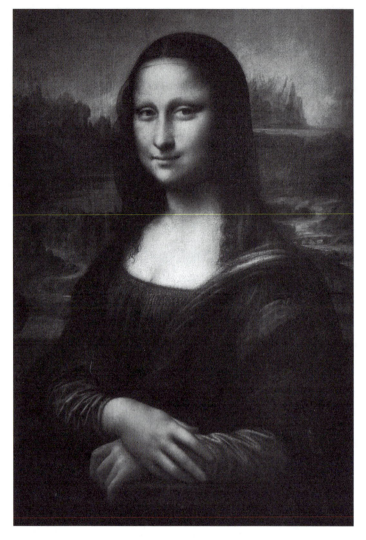

Leonardo's the *Mona Lisa* or *La Gioconda,* c. 1503–1506. The Art Archive /
Musée du Louvre, Paris / Dagli Orti (A).

Self-Portrait (c. 1659–1660) by Dutch painter Rembrandt (1606–1669) to know
that Leonardo's ideas spread not only through Italy but into lands north of the
Alps as well.

Not only did Leonardo change the dignity and grandeur of the portrait, and
the facial expression, he changed the attitude, the placement of the arms and
hands as well. Artists who studied the quiet enigma of Mona Lisa's smile and her
calm, well-placed hands felt that she exemplified the finest manners and the
highest dignity a person could achieve.

However, deeper levels of content in Mona have loosed a plethora of dis-
agreements. One can discern, searching somewhat more carefully, those confi-
dent, dark, bottomless eyes that Leonardo's feelings toward women teetered

between uncertain and indecisive, as if he could not make her either smile or smirk. Curiously, too, Mona Lisa is not beautiful, even when measured by late quattrocento (1400s) or even twenty-first century standards. One has only to note any one of Leonardo's depictions of the Virgin Mary to view a face as lovely and soft as any ever put on paper or canvas, the shadows perfectly rendered toward the most classic beauty. One looks to the progress of Renaissance phases to note this. "The first phase . . . was ushered in by Cimabue and Giotto in painting . . . the second, received its imprint [in painting] from Masaccio . . . and the third, began with Leonardo" (Panofsky, p. 31).

Despite attempts at explanations, the portrait has, even from the beginning, been cloaked in mystery. It is tempting to assume that the woman held some puzzling hypnotic power over the artist, her distant and aloof manner, her terribly confident, powerful position. Most historians believe, however, she held no romantic attraction for Leonardo.

Strangely too, one cannot disassociate her distant personality with the mountains with which she seems personally connected. As it is, like ideas are matched in her figure and in the landscape. Her dark hair, falling over her right shoulder, blends into the misted background so perfectly that one cannot tell where one begins and the other ends. Through a valley behind this wife of a Florentine burgher a thin road snakes. Over her left shoulder rests a gauzy scarf, the lines of which Leonardo continued from her shoulder with a bridge in the far distance.

Leonardo's selections of light and atmosphere ranged from dusk to nearly dark. In his treatise on the *Perspective of Color and Aerial Perspective*, he wrote, "'[W]hen you want to take a portrait, do it in dull weather, or as evening falls . . . Note in the streets, as evening falls, the faces of the men and women, and when the weather is dull, what softness and delicacy you may perceive in them'" (Holt, pp. 283–284). Because of this special technique, the longer the viewer looks at Mona Lisa, the more roles she assumes, and the more they range from melancholy sadness to arrogance to threatening.

With an emphasis on nature, as was Leonardo's inclination, the only man-made accomplishments added to the landscape are the bridge over her left shoulder and the road over her right. Leonardo purposely painted these to take the viewer's eye to sheer cliffs and craggy rocks that as they ascend and regress become impossibly inaccessible, as is the enigmatic woman who sits before them.

Leonardo was 50 years old when he painted Mona Lisa. One wonders if she was at the time the epitome of beauty for him. Was she, to him, as inaccessible as the rocky cliffs against which she is superimposed? Noting that the highest horizontal level of mist points to her eyes, emphasizing the carefully calculated narrowed lids, one is inclined to think possibly yes. Note too the tactics Leonardo used to make his model smile. Vasari tells us that "while he was painting Mona Lisa . . . he employed singers and musicians or jesters to keep her full of merriment and so chase away the melancholy that painters usually give to portraits" (Vasari, p. 267). Such a gesture was uncommon for quattrocento painters.

In particular, critics might question why an artist of Leonardo's genius would choose to spend valuable time painting what ordinarily would have been just an-

other picture of a woman on a piece of wood. Observations indicate that indeed, the *Mona Lisa* is no more than another portrait of a lovely woman commissioned by a wealthy man. Burckhardt indicates it is, however, understandable that even one of the greatest artists, "for example, Leonardo—should paint the mistresses of their patrons [as] no more than a matter of course" (Burckhardt, p. 74).

On the whole, Leonardo painted many impressive portraits. However, in the end, in accessing his oeuvre, one notes that the artist studied the beauty of humanity in a more sensitive, tender way when painting religious figures, especially the Virgin Mary.

The Madonna and St. Anne, 1508–1513

The exact date for Leonardo's panel *The Madonna and St. Anne* remains uncertain, although historians believe that between 1508 and 1513 is close to accurate. Taken from a lost cartoon, the purpose of the work also remains unknown. Evidently a painting important to the artist, it was one of three works, the other two being his *St. John the Baptist* and the *Mona Lisa,* that he took to France and kept with him until he died at Cloux in 1519.

If the first wall painting of the High Renaissance is Leonardo's *Last Supper, The Madonna and St. Anne* is the first painting of the High Renaissance to use the new principles of scale and compression to panel painting. Leonardo's *Last Supper* features four groups of three figures that rely on the emotions and actions of the moment. *The Madonna and St. Anne* builds figures in a single large compressed group tied together not with gestures and actions, but with contours or outer lines that ultimately form a nearly perfect pyramid. With this painting, the Renaissance pyramidal composition reached its High Renaissance summit.

The pyramidal design began, although did not reach perfection, with Italian painter, sculptor, engraver, goldsmith, and designer in embroidery Antonio Pollaiuolo (c. 1441–1496). His *Martyrdom of St. Sebastian* has seven figures that form a high, loose perfect pyramid with St. Sebastian's head at the apex. In Leonardo's work the pyramidal composition reaches a symmetrical, large-scale, compressed, classical conclusion—classical because one witnesses the same large-scale compression in the Parthenon's pedimental sculptures (the Elgin Marbles) produced c. 432 B.C. Here, sculptors carved figures specifically to fit the triangular form of the pediment. Leonardo could not have known the Parthenon's pedimental sculptures and probably came on the idea on his own thorough intuitive experiment.

Note that Leonardo's pyramidal composition cuts the mountain landscape in half. The landscape does not, as one might expect, evoke the picturesque, the bucolic, or a poetic mood involving sunny valleys and hills, or even a certain time and place. His view exists only to a fleeting moment of vision. Cliffs, crags, streams, and lakes rush forward and recede into a opalescent, shimmering distance. Through this landscape, with its mysterious mists and pearly fogs, ripples movement, a kind of worldly natural wild disorder, as if nature's elements, ordinarily so harmonious, do battle.

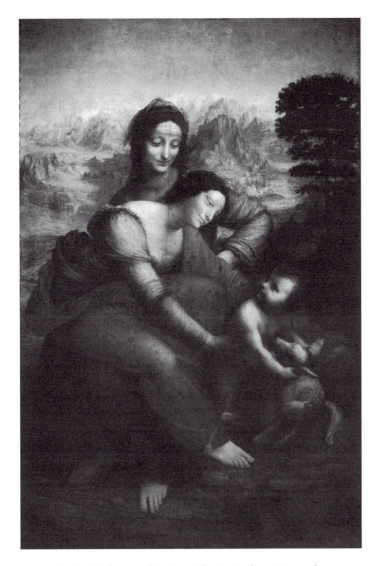

Leonardo's *The Madonna and St. Anne*. The Art Archive / Musée du Louvre, Paris / Dagli Orti (A).

Finally, one great, dark tree looms large and impressive in the distance on the right as a necessary balance or *repoussoir* to the carefully rendered pyramidal composition. And like the lamb situated as a lower corner of the pyramid, it brings calm against the turbulent, rugged mountains.

Further Accomplishments

In spite of painting and drawing and being busy simultaneously with several different projects, Leonardo made plans for numerous supporting devices, mod-

els, and even directions for parting gold from silver. He kept notes on architecture, specifically columns and capitals, and on making aquafortis (nitric acid). According to Vasari, "he used to make models and plans showing how to excavate and tunnel through mountains . . . and he demonstrated how to lift and draw great weights by means of levers, hoists, and winches and ways of cleansing harbours and using pumps to suck up water from great depths" (Vasari, p. 257).

In addition, he planned an ideal city. Crowded and horribly unclean, fifteenth-century Italian cities bred some of the world's most dangerous diseases. Modern in its consideration of hygiene and attention to population density, conceived on two levels connected by ramps and stairs, Leonardo's ideal city was ultramodern for its time. Within the city, living areas occupy the top, and lower levels not only serve traffic but also include canals for sewage disposal. His innovations included plans to solve health problems such as cholera suffered by crowded cities. His awareness of the necessity of clean water and sun-exposed areas surpassed any planners of the day.

Leonardo went beyond city planning and revealed his skills as a military engineer. Among innumerable battle necessities, he designed portable bridges and cannons (some of which resemble the machine gun), armored cars, and battleships. His ideas for a fort set low to the ground (for a minimal profile) reveal his knowledge and acceptance of immense changes in warfare and the advanced lethal uses of gunpowder. He included thicker, stronger, battered or gradually sloping walls and designed new curved angles and surfaces to counter artillery shot.

Equally important, the scope of his scientific investigations remains unparalleled. His explorations include paleontology, botany, geology, zoology, physiology, anatomy, mechanics, mathematics, and optics. All fields inspired him to create. After researching the flights of birds, for example, he considered a flying machine. Not only that, according to Murry, "he projected several aircraft and helicopters and anticipated the submarine. [Unfortunately,] not one of these discoveries was completed; and in the same way he left thousands of notes and drawings but only a handful of paintings, and still fewer completed ones" (Murry, p. 255).

Furthermore, with an interest in the human body, he studied the processes of reproduction, digestion, breathing, and all the internal organs. Studying the heart, he became aware of the circulation of the blood, although he never concluded his investigation to understand it completely. He also studied the development of the fetus in the womb and the birth of an infant. Using red chalk and pen and ink, he made meticulously detailed sketches of legs showing bones and tendons. He always carried such experiments to the furthest extremes. For example, according to Frederick Hartt, "Leonardo compared the behavior of the muscles overlying the bones of the human leg to that of ropes, as if, in his combined scientific and creative studies, he could make a machine that would function like a human being" (Hartt, p. 435).

Leonardo loved birds. He would buy birds from vendors just to turn them loose and let them fly away. Furthermore, he investigated the properties of plants

and observed the motion of the heavens, the path of the moon, and the course of the sun. Always with an interest toward nature, it seems appropriate that the earliest datable work that can be found and positively attributed to Leonardo is a drawing of an Arno River Italian landscape in 1473 executed when he was 21. The drawing shows his avid interest in rock formations and the structure of mountains and hills, all of which over the years he developed to perfection. Some of his later paintings and drawings reveal exquisitely detailed rocks and pebbles—wet, dry, in water, and in sun.

Along with interests in nature and geology, a few drapery studies exist, made in the 1470s while Leonardo was in his teens. These studies show the artist using new techniques never considered by other painters. Earlier painters had used the same traditional formula for drapery and all through their life spans they neither experimented nor changed. On the whole painters (especially northern Renaissance artists) created ungraceful figures draped in wood- or stone-like cloth. It is typical of Leonardo's universal mind that he made detailed studies of cloth fold structures and, in the process, created a new way to present chiaroscuro or shadows and thus invent a more elegant, more human figure. Arnold Hauser, noting Leonardo's accomplishments in this area, states that "in the whole of Italian painting before Leonardo there is no human figure which, compared with the [later] figures of Raphael . . . [or] Michelangelo, has not something clumsy, stiff, constricted about it" (Hauser, p. 88).

One of the most unusual aspects of Leonardo's genius was the extreme attempt he made to examine perfect modeling. He searched endlessly for the flawless inky shadow, for example. To achieve the darkest possible contrasts, he performed bizarre experiments mixing unusual concoctions of paint. At a time when all artists had to grind stones and make their own paint, he mixed black pigments with other materials such as bitumen (tar) that made darker, deeper shadows and shone blacker than any other artists' mixtures. Curiously, he made his lighter shades more brilliant and more radiant by sharply delineated colors meant purposely to contrast as much as possible. One detects "patches" of this technique in his late 1470s *Annunciation*. (This new method of chiaroscuro or shading, known as tenebrism, does not appear in its maturity until the seventeenth century, when one sees sharp contrasts of light and dark in the work of Caravaggio c. 1571–1610.) However, in the process of investigation Leonardo continued until he eventually carried projects to such an extreme that his paintings became wholly without light. The figures looked ghostly, as if they floated in twilight, and did not exist substantially.

Despite a few failures with pigments, when commissioned to execute a painting by the Pope, Leonardo began, even before completing the work, to condense oils and work with different plants to invent a new glaze or transparent coating for the finished work. The Pope supposedly commented that Leonardo, who changed courses in too many directions at once, would never get anything finished.

Because a desire for beauty possessed him, a drive that lasted until he could no longer paint, as a young man and throughout his life, Leonardo sought out

men of uncommon appearance. An odd, flamboyant head of hair or a wild, unusual beard always called him closer for further examination. Any person, man or woman, who attracted him he would follow around, observe, and in the end memorize every detail so clearly that when he returned to his studio he could draw the individual as if he or she stood before him as a model. He drew several male and female heads using this approach. Besides this, Leonardo did many unusual and detailed drawings on paper. One, a "study of drapery 1470s [is in] silverpoint, ink, wash, and white on red prepared paper" (Hartt, p. 439). Silver point (or metal point) is an indelible drawing with a sterling silver wire on a sheet of lightly colored paper prepared with an opaque paint such as Chinese white. The silver leaves a fine grey line that cannot be erased and therefore demands perfection.

In contrast to his youth, as he grew older, Leonardo's profound mind became so ambitious that it became an impediment. He labored to pile excellence on excellence and perfection on perfection. In the end his endeavors took him to more than a few failures. One of his constant problems was that his brain ordinarily raced ahead of his performance. For example, "[t]he Sforza Monument, never completed, is known only in preliminary drawings, for the full-size model of the horse was used as a target by French soldiery in Milan in 1499 and eventually, having been moved to Ferrara, crumbled to pieces" (Osborne, p. 654). Also, a small wax model which critics considered perfect, and a reference book Leonardo wrote and illustrated delineating the anatomy of horses disappeared.

Leonardo, a good and warm-hearted person, comforted the most troubled soul. A kind, though adamant philosopher, he frequently persuaded people to embrace his ideas. Physically strong, he could bend the iron ring of a horseshoe with his right hand as if it were no more than soft lead. He was generous to a fault. He fed and took care of all his friends, rich or poor, provided they had talent or attracted him with their looks.

Throughout his life Leonardo made copious notes on painting. As early as 1651 his followers published a treatise from his notes. Also, in 1965 historians discovered two of his lost notebooks in the National Library of Spain in Madrid. The first notebook treats technological principles. The second is an intellectual diary written over a period of 14 years. In 1974 both notebooks were published as *The Madrid Codices*.

Today one sees the finest collection of Leonardo's drawings in the Royal Library in Windsor Castle, England. Other important paintings by Leonardo are located in St. Petersburg, Russia; Milan (Ambrosiana), Italy; the Vatican in Rome; and the Louvre in Paris.

Finally, in old age, sick for a long time, knowing he would die, Leonardo turned to the Catholic church. For the first time in his life, having painted the Madonna and her Child numerous times, he wanted to learn all he could about the Catholic religion. After this, he confessed and repented. Although too weak to stand up, supported by friends, a priest gave him the Blessed Sacrament. In the end he believed he had offended God by not using his gift. He felt he could have used his genius to better advantage; he should have worked harder when

he was a young man; he should have accomplished more. He wished he hadn't played so many pranks. Leonardo da Vinci, age 67, died at Cloux, near Ambroise, Italy, on May 2, 1519.

Bibliography

Blunt, Anthony. *Artistic Theory in Italy, 1450–1600*. London: Oxford University Press, 1964.

Burckhardt, Jacob. *The Civilization of the Renaissance in Italy*. New York: Harper & Row, 1958.

Hall, James. *Dictionary of Subjects and Symbols in Art*. Revised Ed. Oxford: Westview Press, 1979.

Hauser, Arnold. *The Social History of Art*. Vol. 2. New York: Vintage Books, 1951.

Holt, Elizabeth. *A Documentary History of Art*. Vol. 1. Garden City, NY: Doubleday Anchor Books, 1957.

Kleiner, Fred S. and Mamiya, Christin J. *Gardner's Art through the Ages*. 11th ed. New York: Harcourt College Publishers, 2001.

Murry, Peter and Murry, Linda. *A Dictionary of Art and Artists*. 4th ed. Middlesex, England: Penguin Books, 1977.

Osborne, Harold. Ed. *The Oxford Companion to Art*. Oxford: Clarendon Press, 1978.

Panofsky, Ervin. *Renaissance and Renascences in Western Art*. New York: Harper and Row, 1972.

Scaglia, Gustina. "Leonardo's Non-inverted Writing and Verrocchio's Measured Drawings of a Horse." *The Art Bulletin,* 64 (March 1982): 32–44.

Vasari, Giorgio. *Lives of the Artists*. Baltimore: Penguin, 1972.

Wölfflin, Heinrich. *The Art of the Italian Renaissance*. New York: Schocken Books, 1968.

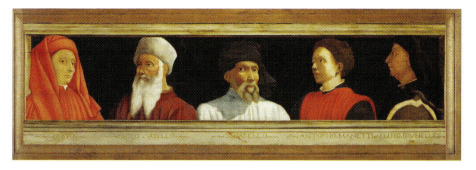

Five masters of Renaissance painting: Giotto, Uccello, Donatello, Manetti, and Brunelleschi. Fifteenth century. © Erich Lessing / Art Resource, New York.

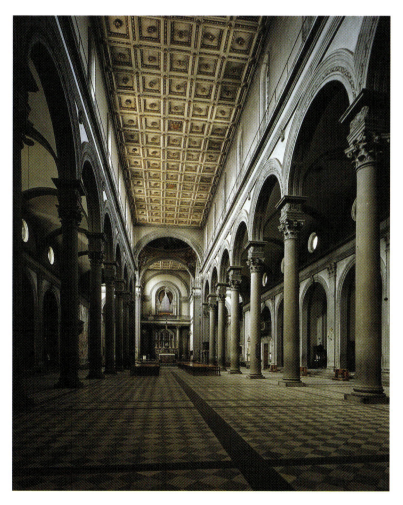

Interior of San Lorenzo church in Florence, Italy, designed by Brunelleschi, built between the 1420s and the 1460s. The Art Archive / Dagli Orti.

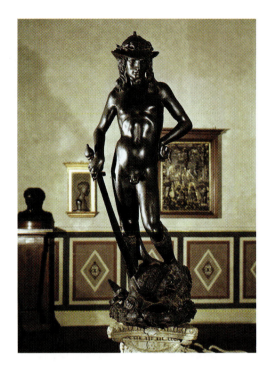

David, in bronze, by Donatello. Florence. The Art Archive / Bargello Museum, Florence / Dagli Orti.

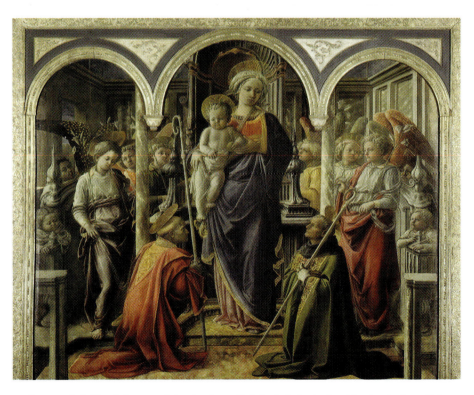

Madonna and Child with Saints and Angels, also called the *Pala Barbadori*. The Art Archive / Musée du Louvre, Paris / Dagli Orti.

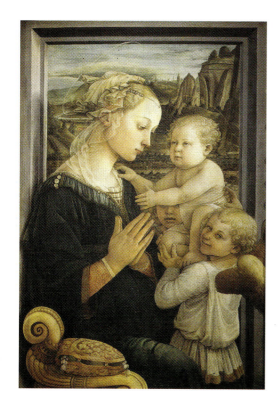

Fra Filippo's *Madonna and Child with Angels*. The Art Archive / Galleria degli Uffizi, Florence / Dagli Orti.

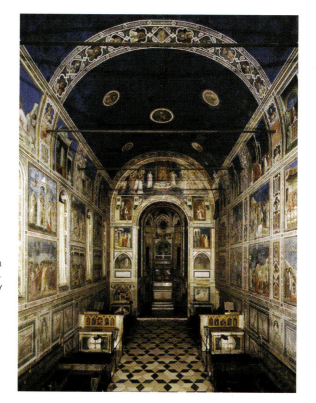

Interior of Scrovegni Chapel with frescoes by Giotto. The Art Archive / Scrovegni Chapel / Padua / Dagli Orti (A).

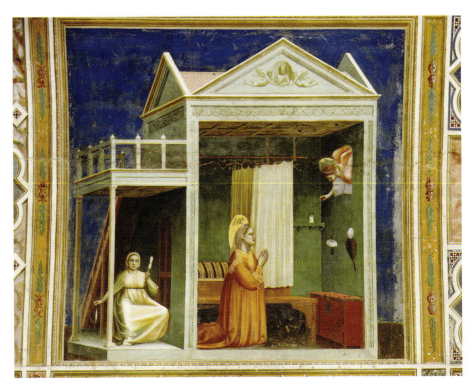

The Vision of Anna, in which the angel appears to Anna, mother of the Virgin, to announce that she will bear a daughter, in Giotto's fresco. The Art Archive / Scrovegni Chapel, Padua / Dagli Orti (A).

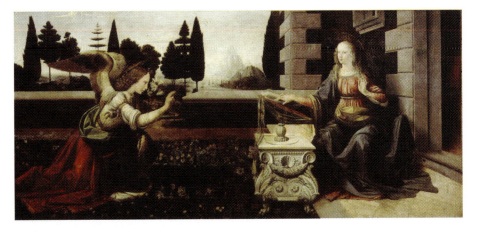

Leonardo's *Annunciation.* The Art Archive / Galleria degli Uffizi, Florence / Dagli Orti.

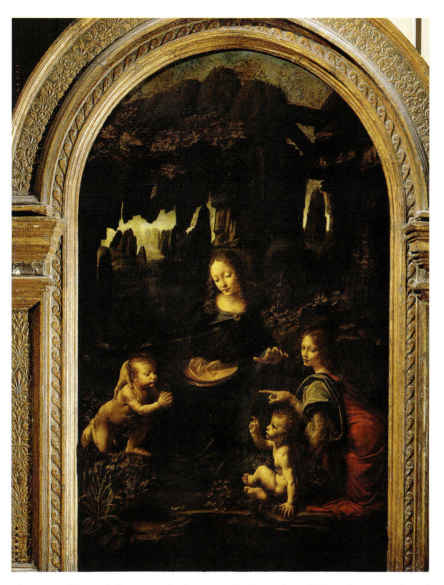

The *Virgin of the Rocks* by Leonardo da Vinci. The Art Archive / Musée du Louvre Paris / Dagli Orti (A).

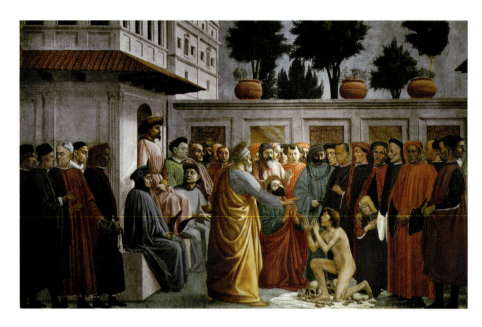

Above: Resurrection of son of
Theophilus, King of Antioch, from
Brancacci Chapel, fresco by
Masaccio. The Art Archive / Santa
Maria del Carmine, Florence / Dagli
Orti (A).

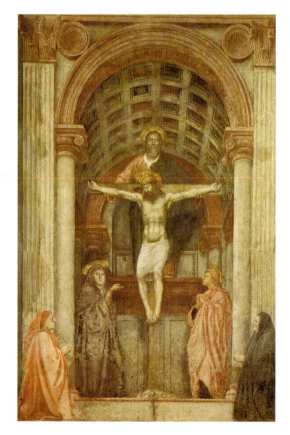

Right: *Holy Trinity*, fresco by
Masaccio. The Art Archive / Santa
Maria Novella Church, Florence /
Dagli Orti.

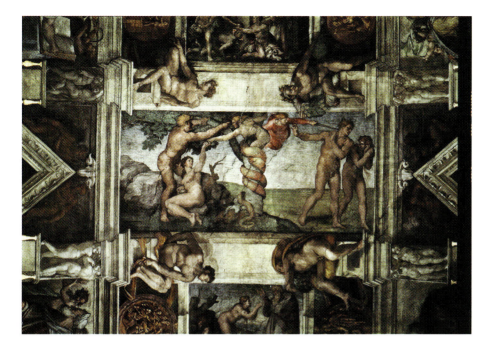

Above: *The Expulsion of Adam and Eve from the Garden of Eden*, Sistine Chapel ceiling, fresco, by Michelangelo, Vatican, Rome, 1508–1512. The Art Archive / Album / Joseph Martin.

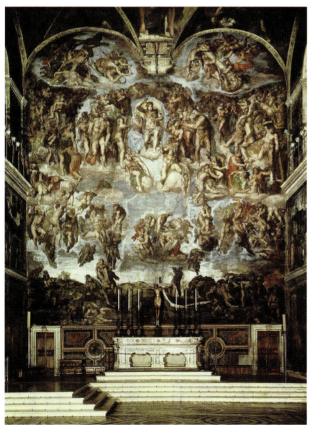

Left: Michelangelo's *Last Judgment*, 1536–1541, fresco, Sistine Chapel, Vatican, Rome. The Art Archive/ Album/ Joseph Martin.

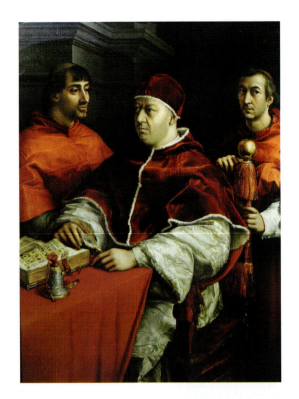

Raphael's *Pope Leo X with Cardinals Giulio de' Medici and Luigi de' Rossi*, c. 1517. The Art Archive / Galleria degli Uffizi, Florence / Dagli Orti (A).

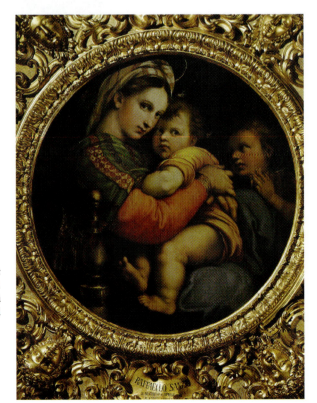

Raphael's *The Madonna of the Chair*, c. 1516, with infant St. John. The Art Archive / Galleria degli Uffizi, Florence / Dagli Orti (A).

CHAPTER 7

Andrea Mantegna, c. 1431–1506

Andrea Mantegna, the leading Italian quattrocento (fifteenth century) painter and engraver of the North Italian mainland, numbers among the greatest masters of the Italian Renaissance. Although especially interested in solving the most complex problems of scientific linear perspective, he never let perspectival organization of space either become the main ingredient of his compositions or cause his designs to appear contrived.

Mantegna discovered never-before imagined illusions of space with viewpoints from unusual perspectives. In the *Camera degli Sposi*, or Room of the Newlyweds, in Mantua's Palazzo Ducale, he performed a truly innovative feat of pictorial illusionism. He was the first artist to produce a completely consistent illusionistic decoration of an entire room, including the walls and the ceiling, seemingly painting away the room's walls, integrating in an astonishing new way painting and architecture. His unusual trompe l'oeil ("fool the eye") technique went beyond any illusionism ever painted, yet at the same time "it recalls the efforts of Italian painters more than fifteen centuries earlier at Pompeii and elsewhere to integrate mural painting and actual architecture " (Kleiner and Mamiya, p. 627). Murry and Murry, noting Mantegna's figures' stonelike appearance, add, "his forms appear to be made of tinted stone or bronze" (Murry and Murry, p. 276).

One sees in Mantegna's work, primarily religious, the influence of both ancient Roman sculpture and the contemporary Florentine sculptor Donatello (c. 1386–1466) in his presentations of the human figure, both of which had great impact on Mantegna's statuelike forms. Even from the beginning, he distinguished his human forms with an unusually forceful solidity, a particularly earthy expressiveness, and an exact anatomical correctness displaying an advanced knowledge of the correct placement of bones and muscles.

One of his several innovations completed in the *Camera degli Sposi* (1465–1474) is the first *di sotto in sù* ("seen from below upward") perspective of a ceiling. This entirely new perspectival system, executed in fresco, inspired and greatly influenced seventeenth-century Italian baroque illusionistic ceiling painters. As a result of Mantegna's ceiling, *di sotto in sù* quickly became one of the most important innovations in the history of Renaissance and Baroque decoration. Here, figures look down upon the viewers in a way they had never before encountered, and the results were shocking. Even the painted oculus or round window of the ceiling appears as an eye staring straight down, startling all who had never before seen it. Mantegna's cloud illusions make the sky appear to move into an infinite space never before placed on a flat surface.

He also mastered the art of extreme foreshortening, or *in scurto*, as seen in his *Dead Christ*. Until the advent of Mantegna's new ideas concerning space in the last decades of the fifteenth century, Renaissance artists had never manipulated perspective beyond Filippo Brunelleschi's (1377–1446) one-point linear perspective.

Mantegna's Life

Andrea Mantegna, Italian painter of the Paduan school, was born of peasant stock in the most humble, though honorable, circumstances in Isola di Carturo (now named Mantegna), which is near Piazzola between Vicenza and Padua and at the time belonged to the territory of Vicenza. Known as the painter of Mantua, Mantegna worked persistently and rose to the rank of knight before his death in 1506 at the age of 75.

As is the case with some other Renaissance painters, controversy exists concerning his birth date. Some sources say he was born in 1431. Historians take his birth date not from written documents, but rather from an inscription on a 1448 altarpiece, now lost, which he painted in Padua for the Church of Sta Sofia. "His date of birth has been deduced from an inscription on a lost painting of 1448 in which he declared himself to be seventeen years old" (Camesasca, p. 3). Also, it should be noted that early documents use variations of his name, impeding research; he is called Andrea de Vicentia in some of the documents of his Paduan period.

Unfortunately, no information concerning his youth exists; however, his work reveals that his education in painting began early. He worked on masterpieces at an age when most painters were still students.

As the second son of the woodworker or carpenter Biagio, Mantegna farmed in the fields as a young boy. He owed little of what he learned to his father, who, by one account, possessed only average ability as a worker of wood. Only through the most extreme perseverance and tenacity from an early age, did Mantegna rise to the high-ranking status of knight.

Sometime between 1441 and 1445, Mantegna's father, recognizing the young boy's astonishing talent, enrolled him in the guild of Paduan painters, an im-

portant, necessary step toward his future. Here, for six years, he became the pupil of the ambiguous tailor and embroiderer turned painter, collector, art dealer, and entrepreneur (among other professions) Jacopo Squarcione (1394–1468), a Paduan. Squarcione became an art teacher possibly because of an unusually fine collection of antique statues and classical casts—all perfect for art students to use in classes.

Actually, Squarcione produced only one known work in 1449: a polyptych, or many-paneled altarpiece, that still retained old Gothic ideas (Batterberry, p. 114). Now in the civic museum of Padua, it draws little attention. Squarcione's teaching methods, impeded by his own lack of talent, included having his students copy various pieces from his collection of antique works. Mantegna learned to draw from stone rather than the flesh of a live model. Many historians believe "this early training explains to a certain extent the dry, stony texture of Mantegna's drawing and his tendency to crowd his paintings with classical details" (Batterberry, p. 115).

After a while, noticing Mantegna's remarkable gift, his extraordinary intelligence, and also the possibilities for acquiring large money-making commissions, the mediocre master Squarcione legally adopted the child Mantegna. Squarcione kept in his house more than a few young boys, all handpicked because of uncommon talent. After he had guided them toward maturity in drawing and painting, he sent the young boys out to art patrons in exchange for large sums of money.

As time went by and Mantegna matured and compared his work and superiority to Master Squarcione, he found the master lacking. However, he came upon problems when he tried to dissolve his legal apprenticeship with the man. Eventually, desiring to be free of Squarcione, Mantegna took what had become a legal dispute to the Paduan judges. He told them how his work and that of his fellow students had brought enormous profits to Squarcione. On January 2, 1456, the *Quarantia Criminale* of Venice recognized Mantegna's situation and, after some hassle, nullified Squarcione's legal papers. It is thus that no legal papers exist as evidence of Mantegna's apprenticeship as a young boy under Squarcione.

By the 1450s, Mantegna, working hard on his own, had become the most important painter of the Paduan school. Later, the well-known Venetian painter Jacopo Bellini (c. 1400–1470/71), whose daughter, Nicolosia Bellini, Mantegna married in 1454, saw Mantegna's genius right away and let him know how large his gift was. Giorgio Vasari says that " when Squarcione heard of this [the marriage] he was so angry with Andrea that they were enemies from then on; and just as before he was always praising Andrea's paintings, so now he spent all his time criticizing them" (Vasari, p. 242).

Mantegna did not fret and try to win Squarcione's forgiveness. His marriage to Nicolosia catapulted him into the most important family of Venetian artists of the day.

Accordingly, Mantegna's first work after leaving the Squarcione *atelier*, or workshop, depicted Mary with other religious images. Masters recognized the

young man as one of the important talents of the day, and thus he encountered no problems finding work. In fact Vasari says, " [B]efore he was seventeen Andrea painted the panel for the high altar of Santa Sofia in Padua, producing a picture worthy of a mature and experienced craftsman" (Vasari, p. 242). Mantegna included an inscription on the painting expressing his enormous pride in his own artistic accomplishment. At this time, his gift for painting matured to the point that he had gained attention and appreciation from the highest and most severe critics, the citizens of Padua, the first Italian city to embrace humanism.

For the first 12 years of his career in art (1448–1460), Mantegna worked in Padua. During this time, the sculptor Donatello worked there as well, on sculptural projects for the Basilica del Santo. Influenced by Donatello, Mantegna's painting became more sculptural. As if to emphasize this style, he used more correct archaeological details, studying the extant classical ruins in northern Italy. Some artists at the time, such as Antonio Pollaiuolo (c. 1432–1498) in his 1475 *Martyrdom of St. Sebastian*, included a ruined monument, complete with trees growing from great cracks and broken areas. Pollaiuolo also revealed great knowledge of anatomy and the new technique of oil painting. Mantegna's studies of Roman ruins gave him a mastery over foreshortening, especially emphasized in his *Dead Christ*.

In 1448, purportedly at age 17, Mantegna painted the *Madonna in Glory* (no longer in existence) for the church of Sta. Sofia at Padua. The painting exhibited the early development of a miraculous talent, judging from the maturity of his later, mature 1454 frescoes. One of the most famous is *St. James Led to Martyrdom* (1455), painted for the Ovetari Chapel in the Eremitani Church in Padua. Aerial bombing in 1944 destroyed most of the Church's frescoes. Consequently, only pre–World War II photographs (albeit poor) of the frescoes exist.

When most likely only 18, Mantegna began, with fellow student Niccolò Pizzolo, a section in the Ovetari Chapel of a fresco series for the Church of the Eremitani in Padua. Because of his age, Mantegna could not sign the contract for the frescoes, dated May 16, 1448; it had to be signed for him by his older brother Tommaso. No doubt the success of his chapel frescoes, reflecting the strength and force of Donatello, established his reputation. "Eleven years later he had finished six frescoes in which the figures, looking as if they were made of bronze or tinted tone, reflect Donatello's powerful influence" (Batterberry, p. 115).

Most of Mantegna's frescoes, destroyed during World War II, no longer exist. "It is tragic to record that the Ovetari Chapel with all Mantegna's frescoes save two badly damaged scenes removed for restoration, was blown to dust in the spring of 1944 . . . only a few pathetic fragments have been recovered" (Hartt, p. 626). Only the 1459 fresco cycle's four scenes from the *Life of Saint James,* an *Assumption*, and *Saint Christopher* escaped complete destruction.

In Mantua, Mantegna painted for the Gonzaga, a powerful Italian princely house that ruled Mantua between 1328 and 1708, Montferrat between 1536 and 1708, and Guastalla from 1539 until 1746. The Gonzaga name, important

in its day, derived from the castle of Gonzaga, a village not far from Mantua. Holy Roman Emperor Charles V (1519–1558) made Federico or Federigo Gonzaga (1500–1540) duke in 1530. Mantua, already a center of thriving humanism before Federigo, prospered under his rule. In the continuing prosperity of the arts, Mantegna painted for the Gonzaga, among other works, an interior in the Palazzo Ducale, a palazzo that since became known for its unusual and extreme illusionistic walls and ceiling, the paintings he executed.

Ovetari Chapel, 1454–1457

Mantegna's work in the Ovetari Chapel begins with three saints, Peter, Paul, and Christopher. He painted their figures in the segments of the vault of the apse, or area, usually at the east end of the church. As early as 1450 he finished the frescoes of the *Calling of St. James and St. John*. He also completed the *Preaching of St. James* in the lunette or half-circle shape (second row above the floor) at the top of the left wall of the narrow chapel, an area that had been set aside for him. Both frescoes, it should be noted, had been originally commissioned to Pizzolo, died in 1453. The lack of boldness seen in *St. James Led to Martyrdom* might be because Mantegna finished what Pizzolo started and did not change the composition.

Working on his own, in an unusual design composition, he joined the frescoes by a common perspective. He cleverly concealed the vanishing point behind the frame between the *Saint James Before Herod Agrippa* and the *Baptism of Hermogenes*. His figures and architecture are thus extremely foreshortened, an innovation attributable to the one perspectival point between the two pictures. To be noted also are the areas in which Mantegna applied full, thick paint, which gives frescoes the appearance of embedded precious stones.

Winged putti or chubby children playfully hang long fruited Roman-like garlands replete with large and colorful blossoms and buds and lush foliage (strung from one fresco in a continuous line to the next). Mantegna placed these in the chapel seemingly from outside the corners of the frames and also above the frames. The garlands meet at the Ovetari coat of arms at the center of the pilaster between the frescoes, both of which, because of the extreme illusionism, cause the viewer to believe he or she peers deep inside two rooms.

In these first mid-century mature works, Mantegna reveals interest in the compositional designs of Bellini (whom he had seen in Venice in 1453). He also reveals his interest in the perspectival principles of Alberti. Indeed, problems of extreme perspective occupied him every day he painted.

In the *Baptism of Hermogenes*, Hermogenes kneels on a marble pavement sectioned into squares. Because the painting is one with its neighbor (separated by a painted pilaster), the pavement appears to be continuous with that of the area directly before Herod Agrippa. Linear perspective between the two works features perfect receding orthogonals (lines that recede into the distance). It also features correctly diminishing transversals (lines that intersect other lines), which establish the size of the figures that become smaller as they recede into space.

The contract called for Mantegna's work to be finished by 1450; but even though he worked with dependable, well-established masters, he encountered problems. It happened that in 1443 Antonio Ovetari had drawn up his will and in it provided money for scenes from the lives of St. James and St. Christopher. However, in 1454 Mantegna had to sign a new contract. Curiously, the new contract had to be drawn because Mantegna's technique, so apparently strong and overwhelming to the other painters, glared so obviously from the start, that the Ovetari program agreed upon in the beginning had to be changed. None of the painters who had begun the project with him continued. In a strange coincidence, Giovanni d'Alemagna died in 1450, Antonio Vivarini withdrew in 1451, and a third, the Paduan painter Niccolò Pizzolo, died in a quarrel in 1453. However, the 1454 contract allotted Mantegna but a few subjects, and all other assignments went to painters with minor masters such as Bono da Ferrara and Ansulino da Forlì. Fortunately, the second round of painters left the job and the chapel to Mantegna. Vasari wrote that "left to finish the work by himself, Andrea did a fresco painting of the four evangelists, which was very highly regarded" (Vasari, p. 242). He also spent the next eight years painting the Ovetari chapel and during this time, alone, left to his own talent and intuition, he evolved a completely new and mature style. He completed the chapel in February 1457 when he was probably only 26 years old.

The Ovetari Chapel frescoes exhibit preoccupation with illusionism and the perfected principles of perspective (from which he never tired). The frescoes also highlight the scope of his literary and archaeological training. He painted frescoes from the life of the apostle James the Greater, or the Great or the Elder (meaning Son of Thunder), the brother of John the Evangelist. The name in Italian, which Mantegna understood, is Giacomo Maggiore. James the Greater, son of Zebedee, was a man in the circle closest to Christ and was present with Peter and John the Evangelist at the Transfiguration and again at the Agony in the Garden. Most people called him Son of Thunder because of the thunderous tones of his preaching, which converted many sinners. Mantegna painted him on his way to his martyrdom.

Saint James Led to Martyrdom, 1454–1457

After being put on trial in Jerusalem in the year 44 by Herod Agrippa, the Roman soldiers executed James by beheading. Artists depict James as mature in years, with dark hair parted and falling on either side. Mantegna painted him with darker than usual hair. He depicts the saint–apostle, though walking to the place of his own death by beheading, taking time to bless a paralytic, who lay by the roadside but crawled from the crowd to kneel at James's feet and look up at his face. As James blessed him and cured him, a Roman soldier prevents others from reaching the condemned saint, using a long pole to hold back a woman who strains against it. In *The Golden Legend,* Voragine indicates that the martyrdom took place March 25, the day of the Annunciation (Voragine, p. 371).

The fresco shows the story of James the Greater taking place upon a stage

seen somewhat from below, with a Roman triumphal arch in the background. The historical authenticity of the Roman barrel-vaulted arch order's correct classical architectural vocabulary is immaculate. Inside the arch, as it is seen from below, Mantegna reproduced typical Roman coffering or recessed panels in the ceiling. He painted the deeply cut, fleurated (or flowered) coffers to appear as if they are being viewed from a low vantage point. The illusion is so extreme, in fact, that it is as if the viewer is nearly under the vault looking up at it. Because the fresco is nearly 11 feet wide, the impact of Mantegna's new perspectival system, *di sotto in sù*, the impact when one stands before it is enormous. His narrow Roman triumphal arch, interpreted through Renaissance eyes, with its straight and parallel storied construction, contrasts with the medieval citadel and the wall, crenellated—or notched or indented—along the top to the right of the action. In addition, as if in a final flourish, Mantegna dresses his Roman soldiers in historically correct attire.

The final fresco in the cycle of St. James the Greater illustrates the saint's martyrdom.

The *Martyrdom of St. James,* 1454–1457

After being tried in Jerusalem in the year 44 by Herod Agrippa and found guilty for preaching the Christian doctrine and converting many who saw and heard him, and being condemned to be beheaded, the Romans executed James the Greater. "Some accounts say Herod Agrippa himself killed the saint" (Earls, p. 147). Frescoes in the Eremitani church in Padua, destroyed in 1944, told the story.

More important to historians than the narrative are the influences the artist felt when he painted his frescoes. Mantegna's Ovetari Chapel's *Martyrdom of St. James* reveals the artist's second perspectival discovery: *in scurto* or extreme foreshortening. To accent the perspective Mantegna stretched St. James' body, hands tied behind him, on an angle into the picture plane. His head, placed straight out toward the viewer, on an angle to the right, breaks the flat picture plane and moves into the viewer's space. On two posts stuck in the ground on either side of James' neck, a sharp blade rests above the saint's neck. An executioner holds a large mallet above James' haloed head, both arms high above his own head, ready to strike, it appears, with furious force. A tree to the left of James has a broken limb hanging high over his head. On a hill to the left above James, a deep crack splinters a castle from the basement to the top, widening as it runs the wall. A great disquiet moves between the broken bough, the sharp blade about to sever James' neck and the splitting castle. All three contrast with the disinterested, unexcited Roman soldiers who, seeming almost bored, look in the direction of the execution. Mantegna has created such an astonishing and believable perspectival space that it seems James' head will roll into the chapel, directly onto the floor before a worshiper, after the executioner's mallet hits the blade and cuts it off. Mantegna painted a person to James' left standing before him looking down with a kind face. Although there is already space in the far hills, Mantegna increased the illusion by including a pole fence that appears to

exist outside the painted frame. He shattered the picture plane even more by including the soldier who leans over the fence, probably for a close view of the beheading. Furthermore, "[a] powerful tension in depth is established by the rise of the hill—its classical ruins brilliantly illuminated against the slaty, dark-green sky" (Hartt, p. 387).

As might have been expected from the beginning, Squarcione, Mantegna's former master, criticized Mantegna's paintings in the Saint Christopher chapel. He claimed the work stiff and hard and not up to standard because it appeared Andrea had used marble statues for models. Further, he added that the figures looked like something Montegna had taken from antique statues with no feeling of skin and bone and muscle.

Mantegna and the Palazzo Ducale in Mantua, 1465–1474

In 1460 Mantuan officials appointed Mantegna court painter. This mid-fifteenth-century point in history was propitious for the painter because at this time Mantua was a city on the cusp of leading Europe as a center of humanist culture. Mantegna gave Mantuans the art they hoped for in the palace of the Gonzaga, the ruling family. Between 1465 and 1474 he painted for Ludovico Gonzaga in one of the towers of the Gonzaga castle, high in the hills overlooking the lakes that then made up the landscape of Mantua. In the palace Mantegna completed decoration for the now famous *Camera degli Sposi* or Room of the Bride and Groom (originally the *Camera Picta* or Painted Room, whose theme was the grand glorification of the Marquis Lodovico II Gonzaga. In 1474 the Marquis dedicated the extraordinary room to the petty prince Lodovico II Gonzaga and his wife. According to Kleiner and Mamiya, "Mantegna performed a triumphant feat of pictorial illusionism, producing the first completely consistent illusionistic decoration of an entire room" (Kleiner and Mamiya, p. 627).

Specifically, on the walls, in order as narrative representations, are group portraits of the Gonzaga family members. The corners of the irregular ceiling contained bust medallions of Roman emperors within highly ornate garlands, each one held aloft by a putto resting against a gold background of entwined ivory ribbons and calligraphic leaves. This arrangement indicated that the Gonzaga family found itself on a par with the powerful Roman Empire. Finally, pilasters (flat columns against the wall) with ivory classical motifs or designs such as Greek acanthus leaves and small fleurettes on a gold background, designate the three arched bays, or spaces, between the paintings. Around the base of the room runs a painted dado or lower part of the wall decorated with circles.

Furthermore, on 12 lunettes, or half circles, above the paintings hang fruit-laden garlands bearing the emblems of the Gonzaga family. In addition, Mantegna painted curtain rods between pilasters, from which hang clothlike leather curtains embroidered with gold designs and lined in light blue, others in gold lined with a rusty magenta.

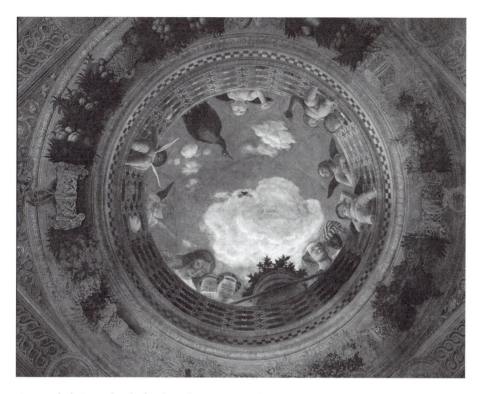

Camera degli Sposi, detail of ceiling showing open sky, by Mantegna, The Art Archive / Palazzo Ducale, Mantua / Dagli Orti (A).

Mantegna's composition style with fresco, hard-edged with unusual muted color and thick, luscious cloth, was just as significant as the content of his works. "'Here for the first time in modern art the different subjects are not applied to the wall like single pictures side by side or over one another; they seem to be actually happening in and outside the space in the room, as if the walls had disappeared'" (Osborne, p. 690).

Mantegna continued the illusion in the ceiling. Here, he opened the center of the painting with a faux oculus, or round window, to such an extent that the ceiling appears to open to the sky. Finalizing the view, swirling white puffy clouds in diminishing perspective appear to zoom into space. On the outer rim, he framed the whole painting with a circular balustrade and placed exceedingly convincing figures leaning over it looking down. All this he accomplished with his exaggerated, perfectly rendered perspective.

A new commission came to Mantegna in 1484 given to him by Lodovico's grandson Francesco, who had succeeded to the marquisate (the status, rank, or territory of a marquis, which ranks directly below duke). The subject of the new commission was a Triumph of Caesar. In 1627 Charles I bought the results of this commission: nine-foot-square canvases. Mantegna also painted a private room for Francesco's well-educated wife.

In 1497 Mantegna painted the *Parnassus* and in 1500 the *Triumph of Virtue*. Both works are of a more sophisticated, private nature. Both have a complex allegorical meaning. Mantegna handled the *Parnassus* in a new way, fresh, charming, and with a new feeling for movement completely different from anything in Mantegna's work.

Besides a plethora of other subjects, Mantegna worked with literary sources. He sought and found inspiration for subjects in the Bible as well as from Roman artifacts such as coins, medals, and statues. When painting religious themes, or even classical themes, his work went from architecturally correct depictions, revealing his early training, to allegorical moralization. He fortunately found a "common denominator . . . between the motifs freshly assimilated from the Antique and the traditional vocabulary . . . what [Johann] Winckelmann was to call 'noble simplicity and quiet grandeur'" (Panofsky, p. 201). His figures, albeit sometimes wooden and stiff, have immense dignity and grace.

As the years passed and Mantegna moved from accomplished artist to one who had paved new highways into perspective, the artist became intellectual. His work no longer exuded the earlier élan and brilliant color. "In his old age the princely artist, working in isolation from other Italian schools, living in considerable splendor in the classical house he had designed for himself in Mantua, had become unmistakably if brilliantly reactionary" (Hartt, 395). The painting that best exemplifies his later years is *Madonna of the Victory*.

Agony in the Garden, 1460

In his panel *Agony in the Garden* (24 3/4 inches by 31 1/2 inches), Mantegna depicts the Biblical scene found in Matthew 26:36–46, Mark 14:32–42, and Luke 22:39–46, when Christ went to the Mount of Olives to pray. *Agony* indicates the spiritual struggle between the two sides of his nature—the human, which feared the inevitable suffering ahead, in conflict with the divine, which gave him the strength to endure it.

Mantegna reiterates with considerable force the marblelike appearance of the sculptured form. He restates a glossy, bright, and shining color, especially the road upon which Judas leads the endless line of Roman soldiers to Jesus praying in the garden at the Mount of Olives. The moment is the scene after the Last Supper and immediately before his arrest. Certain rock formations nearly glow from within; one placed directly behind Judas' head highlights the traitor's dark hair.

Mantegna duplicates the exquisitely clear atmosphere seen in the San Zeno altarpiece. Not a speck of dusk pollutes subject or sky. Similarly, as in previous paintings, he takes perception to it maximal frontiers. He depicts the gently curving road (complete with wild rabbits) with unflawed, hard, stony, striated accuracy. Even the smallest stones, many of which he scattered on the road, and the weathered, cragged cliff and figure have been captured by Mantegna's relentless brush in a drive toward total definition.

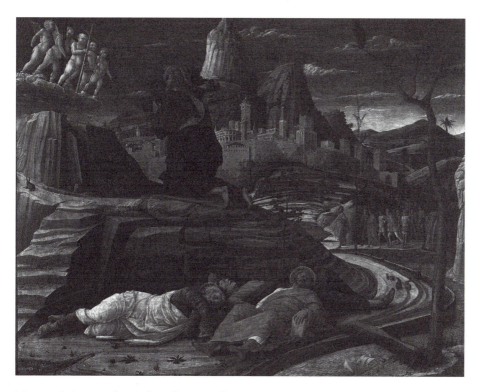

Mantegna's *Agony in the Garden*. The Art Archive / National Gallery, London / Eileen Tweedy.

Beyond the scene, in the background behind the figure of Jesus, the city of Jerusalem looms nearly white as an eclectic pastiche of the North Italian medieval cities Mantegna had seen and studied. He included buildings from Rome, including a triumphal arch, though he had never traveled there; he must have seen drawings and heard descriptions of it. Behind the medieval Roman buildings, he painted tall cragged cliffs of a kind that looked like stone smoothed by water. Few trees interrupt the desertlike landscape. Three thin trunks punctuate the foreground but have sparse foliage. Several small weedlike plants sprout from flat rocks.

To the left, and above his disciples, Mantegna's reverent Christ kneels on hard stone, his hands together in prayer. A small legion of six angels floats on a flat cloud directly before him, meant to give him strength for the coming ordeal, each one holding one of the symbols of his Passion (the crown of thorns, the cross, the column, the whip, the nails, and the spear).

Directly below Christ, in an arrangement that forms the bottom of a compositional triangle, sleep the three apostles Christ brought with him. On the left reclines Peter, gray-haired and bearded with a rock for a pillow. John, with dark hair and a beard, sleeps directly behind Peter, whose head is on the same rock, and James the Greater, forming the right side of the triangle's base, with gray-

ing hair and a beard. His head rests on John's leg. Curiously, James is so fore-shortened the body nearly reaches the point Mantegna achieved in his later *Dead Christ*, painted after 1466, in which he used *in scurto*. One of John's feet sticks into the road and acts as an arrow to point the viewer down the road, beyond the rabbits, toward Judas, who leads Roman soldiers to the garden, where they will arrest Christ. Judas points with his right arm so the soldiers, armed with shields, might see Jesus praying in the garden.

Dead Christ, after 1466

Mantegna painted the *Dead Christ* on a piece of canvas 26 1/4 inches by 31 7/8 inches. No one is certain of the date. "Even modern critics are disconcerted by this work, and uncertainty about the date—a span of nearly half a century divides opinion" (Camesasca, p. 54). One of his later paintings, Mantegna depicted Christ after the crucifixion, lying on a thick, veined marble slab, with a wrinkled white cloth over his lower body and his legs. He placed Christ's head on a heavy, nearly vertical pillow so that the viewer can see his dead, closed eyes, which, though shut, still appear as if the body lives in pain. The lips, somewhat apart, reveal the agony he suffered. The open wounds in the feet, directly at the viewer's level, remind one of the work of German monk and scholar Thomas à Kempis (1380–1471), who asked his readers to dwell on the wounds of Christ. Kempis, a skeptical man, said "those who often go on pilgrimages . . . rarely become saints" (Huizinga, p. 162). Kempis, in his c. 1425 *The Imitation of Jesus Christ*, a Christian devotional book that originated among the Brothers of the Common Life in the Netherlands, leads humanity back to everyday life after the medieval period in which Christians were encouraged to live a life of mystical devotion to Christ and a distrust of the human intellect. By placing Christ in a horizontal position facing the viewer, it seems Mantegna, too, has asked his observers to meditate on Christ's wounds, to come back to prayer and find its consolations. In fact the viewer is nearly forced to discover the wounds by following the folds of Mantegna's stone-like drapery which folds point arrow-like to them.

Mantegna's marble-like sculptural figure provides the entire body, and at the same time also the open wounds, with a most persuasive three-dimensional view. Only decades after its discovery, Mantegna had perfected the perspectival recession technique. It causes a heaving forward of the body, with its open wounds, out past the painting's space and into the viewer's mind. When viewing the canvas, one cannot seem to escape. Mantegna painted Christ's feet so that they follow all viewers wherever they stand before the canvas. Consequently, the wounds on the bottoms of the feet always appear more open and glaring, an atypical depiction for an Italian artist.

Despite the painting's perspectival innovation and success, the figure is not perfect, according to some critics. They argue the head is too big and the feet are too small. Scientifically, however, no other position is possible when draw-

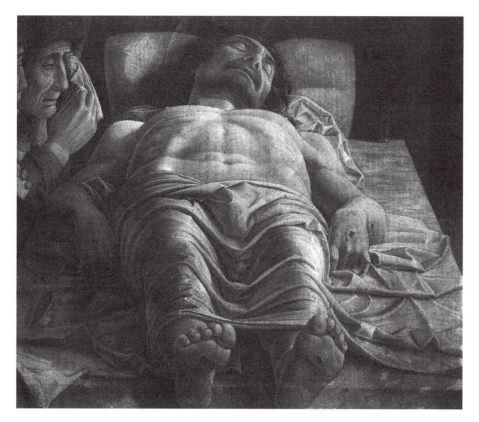

Mantegna's *Dead Christ*. The Art Archive / Galleria Brera, Milan / Dagli Orti (A).

ing a single figure on a flat vertical surface. The projection is, in fact, one that would be seen with only one eye. According to Hartt,

> the perspective we actually experience in daily life is monocular, of course, not binocular. We see two slightly variant views separated by the distance between our eyes, and as a result the feet of a recumbent figure pointing toward us, seen from both sides at once, loom larger. But an experiment—looking at a figure or a statue in this position with one eye—will show that Mantegna's perspective and proportions are correct. (Hartt, pp. 392–393)

Mantegna painted the *Dead Christ* with tempera. This reveals a science rarely found in painting. Canvas grays down and dulls the colors of tempera paint. Some historians think the canvas may have been painted for use as a processional banner for a special society or a confraternity dedicated to the Corpus Christi (Latin for "body of Christ"), a feast of the Western Church to commemorate the founding of the sacrament of the Eucharist established in 1264.

Regardless of who used it, in 1537 Federigo Gonzaga, first duke of Mantua, placed this tempera on canvas work, this persistent reminder of death and its inevitability, directly outside his bride's room.

Reproductions of Mantegna's painting exist without the two awkward figures at the left of Christ's body. In the original they appear as if painted later, possibly by a student.

Camera degli Sposi (Room of the Bride and Groom), 1465–1474

Possibly the most surprising and astonishing example of Andrea Mantegna's illusionism is the *Camera degli Sposi,* or Room of the Bride and Groom, located in the Palazzo Ducale in Mantua. Done in fresco and painted over a long period of time, between 1465 and 1474, Mantegna did the work for Ludovico Gonzaga and his family. He painted the room in one of the towers of their castle situated in a position meant to overlook the many lakes that then surrounded Mantua.

Above the low, wide fireplace, Mantegna painted the Marquis and the Marchioness, Barbara von Hohenzollern of Brandenburg, dressed in a sumptuous gold embroidered gown, with their children placed before a decorated wall. He did not flatter the Marchioness or her children, one of whom offers her a piece of fruit, which she ignores. Standing directly behind her is Rodolfo, the fourth son of the Marchese. He also included their favorite dwarf and courtiers. Mantegna depicted them gathered on a terrace enclosed by a wall. The wall is decorated with colored circles of white marble filled with round disks of various colored veined marble. The top of the wall carries an elaborately presented row of white Greek palmettes. Swags of fruit hang above. The viewer must note especially that the mantelpiece at the bottom is not an illusion, so realistically painted is the rest of the fresco. The mantelpiece appears, however, to support the foot of a courtier who seems to stand rather arrogantly with his left hand on his hip in front of one of the frescoes' separating pilasters. To the far left of the family and emerging from under a curtain that seems to actually be pulled aside from a painted pole, a messenger brings a letter to the Marquis. Since his feet stand on the room's molding, as he bends forward listening to the Marquis' instructions he seems to come from outside the painting.

Overall, Mantegna's composition is one of extraordinary simplicity. The artist has grouped the figures in a simple, uncomplicated composition, some figures seated in front of others who stand in different, calm, and appropriate attitudes. His figural arrangements, especially between the mother and her sons, reveals a relaxed sincerity simple in presentation. He has drawn a display of elegant forms and colors. Mantegna presented the portraits, of which only a few can be confidently identified, with a practiced, mature style. This 1474 style, however, is not the style of his early work. Here he does not project the forms as powerfully. Here colors meld gently, softly; textures appear solid and touchable. All harshness, such as one views in the Eremitani frescoes, or brilliance one notes in the San Zeno altarpiece, has disappeared.

To complete the room's decoration, Mantegna continued the frescoes on two of the four walls. The scene on the adjoining wall still eludes identification with

any known family event and waits for research to clarify its meaning. Mantegna painted Ludovico standing to the left. On the right he painted the older Gonzaga son and successor, Federigo. In the center he depicted the second Gonzaga son, the Cardinal Francesco, made titular (a bishop holding the title of a no longer functioning see or center of authority) of Sant'Andrea in Mantua in 1472. In the foreground two younger brothers greet Ludovico, a prothonotary or one of the seven members of the College of Prothonotaries Apostolic, who recorded important pontifical events. Possibly symbolic of Rome, Mantegna painted a city in the background with statues and Roman ruins outside its high walls, all below a castle. He dressed the Gonzaga in costumes—two-colored hose emphasized by strong, long legs, and flared, cone-shaped doublets or close-fitting jackets. These provided him opportunity for color and geometrical elements to balance an already geometric composition. One of the greatest pleasures of Mantegna's *Camera degli Sposi* is the subdued yet pervading radiance of color. A noteworthy difference exists, however, between the walls and the frescoed ceiling.

Ceiling of the *Camera degli Sposi*, 1465–1474

Mantegna's frescoed ceiling of the *Camera degli Sposi* is a circle 8 feet 9 inches in diameter. He used an approach to ceiling painting never before imagined. "The Renaissance painter's daring experimentalism led him to complete the room's decoration with the first *di sotto in sù* (from below upwards) perspective of a ceiling" (Kleiner and Mamiya, p. 628). Here, his trompe l'oeil appears so realistic, it went far beyond any painting ever seen in Italy.

Mantegna painted the ceiling to resemble relief sculpture in marble. In the center of the room, the viewer looks straight up through a round balustrade—all painted but appearing as if it is real and receding into depth—and into the infinity of sky above. Putti, or cupids (the sons of Venus) or little babies, chubby and amazingly foreshortened as seen from below, balance precariously just inside the balustrade's rim. Others poke their baby faces through the balustrade's circles. Grinning spectators (unidentified) peer over the balustrade at the viewer far below. The peacock, an attribute of Juno, Jupiter's wife, perches on the balustrade. The peacock is "also [the attribute] of pride personified" (Hall, p. 238). In a final and successful attempt at illusion, Mantegna painted a large and heavy pot of plants and balanced it "trembling in the balance" on the edge of the balustrade. It is held in place only by a too-thin pole that could break or roll aside.

Madonna of the Victory, 1493–1496

During the latter part of the fifteenth century, Mantegna painted the finest painting of his later years, the *Madonna of the Victory*, a large rectangular altarpiece measuring 9 feet by 5 feet 10 inches, commissioned by Francesco Il Gonzaga to celebrate his inconclusive military victory over the French at Fornovo July 6, 1495.

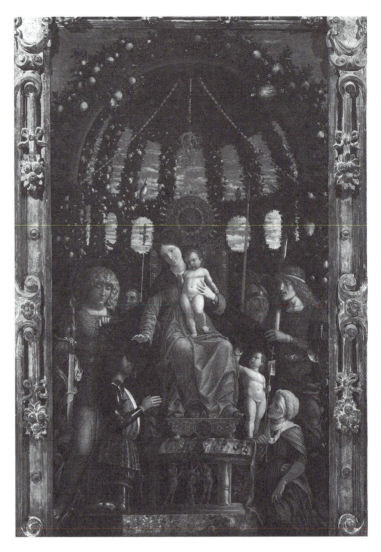

Mantegna's *Madonna of the Victory.* The Art Archive / Musée du Louvre, Paris / Dagli Orti (A).

In 1496, the day of the battle's first anniversary, the altarpiece was installed, in a chapel especially designed by Mantegna, with excessive ceremony. Critics have objected to the miniature, obsessively meticulous style compared to the size of the painting. Along with this, Mantegna uses traditional perspectival space as the ideal measure of figures and forms and at the same time employs his well-practiced *di sotto in sù.*

To the right of the Virgin, St. George, legendary warrior and saint, holds his signature heavy broken lance. According to Hall, the reason for this is that "he [George] holds . . . sometimes a broken lance (which helps to distinguish him

from other saints in armour)" (Hall, p. 137). St. Longinus, the Roman soldier who was present at the crucifixion and who stabbed Christ's side with a lance, stands beside George as the patron saint of Mantua. St. Andrew, brother of Peter, the Galilean fisherman first to follow Christ, stands there also. They stand to protect the marquis, in full armor, who kneels with his hands lifted in a praying position to the left of the Virgin. St. John the Baptist as a baby appears at the right on the pedestal of the throne looking up at baby Jesus, who stands on his mother's lap, his right hand blessing Francisco. Kneeling to his right is an old woman, her head bound, who might be St. Elizabeth, his mother and also patron saint of Isabella d'Este.

In addition, one sees on the pedestal of the Virgin's throne directly below her feet a painted relief depicting the *Temptation of Adam and Eve*. Adam and Eve stand beside a tree, around which long trunk is wrapped the symbolic snake. The theme reminds viewers of the sin from which Christ and the Virgin have redeemed mankind.

Immediately above, all the figures are set within the Virgin's regal fruit- and leaf-covered pergola, orange trees resting upon a carved wooden arch decorated with Mantegna's special Greek palmettes along with entwined vines thick with leaves and tiny white flowers and gourds. From the center of the pergola, a large piece of rose-colored coral hangs from a string of beads, an early form of the rosary. It has six coral beads that alternate with one in crystal. According to Hall, coral had "the power of averting the attentions of the 'evil eye.' It was often hung round children's necks as a protection. It is seen in this sense usually as a string of beads, in pictures of the Virgin and Child" (Hall, p. 74). Behind and above the virgin, in the "windows" of the pergola, one sees the sky with white fluffy clouds sailing by. Directly behind and slightly above the Virgin's head, one of the Gonzaga family symbols, a 16-pointed bejeweled wind rose decorates the top of her throne.

The picture is replete with a other devices. Mantegna placed the Virgin's footstool slightly off center. This compensates compositionally for her extended right arm and hand as she reaches toward and nearly touches Francesco. Mantegna painted the details, of which there are many, with more attention than he did in earlier works. His linear accuracy is more exact. However, the trade-off is that his figures have lost their élan, and his colors are so muted one does not see the brightness so apparent in earlier works. In addition, he shows no hint of the brilliant Venetian color that he had used in the past.

Parnassus, 1490s

Mantegna painted the Parnassus in the 1490s on canvas for Isabella d'Este, and in 1497 the painting was in place. Actually a mountain (a little over 8,000 feet) in southern Greece, in antiquity Apollo, Dionysus, and the Muses called Mt. Parnassus sacred. Also, the fountain or spring of Castalia, named for a nymph and said to give poetic inspiration to those who bathed in it, was on its slopes. Traditionally, it was the place of music and poetry. According to Hall,

[Parnassus] is depicted as a hilltop rather than a mountain, with a grove perhaps of laurels, beneath which sits Apollo playing a lyre or other instrument and surrounded by the Muses. The stream runs at their feet. . . . The winged horse Pegasus, symbol of Fame, especially of poetic genius, may be present though in that role he strictly belongs on Mount Helicon. . . . Mantegna (Louvre) crowns the scene with the figures of Mars and Venus who symbolize Strife conquered by love. The birth of their offspring, Harmony, is being celebrated by Apollo and the Muses with song and dance. (Hall, p. 234)

Specifically, in Mantegna's *Parnassus,* Mars embraces a Venus not at all beautiful and innocent, as she is depicted in *Birth of Venus* (painted a good 20 years earlier) by Florentine painter Sandro Botticelli (c. 1445–1510). She stands at the apex of a compositional pyramid, in the middle and at the top of the composition, and at the top of Parnassus, before a bed complete with two small pillows. Mantegna set the entire scene upon a land formation much like a natural bridge.

Venus's son Cupid, mischievous as usual, blows a long object that looks like a glassblower at Vulcan, the god of fire and Venus' cuckolded husband. According to legend, Vulcan was crippled from birth; accordingly, he springs in great disorder from his cavern, the home of his forge, and waves an arm at the faithless pair. His position is awkward because of his deformity. A large bunch of grapes hangs to his right at about the level of his head and possibly symbolizes intemperance and strength.

To the left and just below Vulcan, a seated Apollo plays his lyre, making music for nine Muses, who dance quietly and gracefully, although a few leap in frenzied running steps. "The dancing Muses are easily identifiable, both on account of their number and the presence of the crumbling mountains in the top left of the picture" (Camesasca, p. 75).

On the right, one of the 12 gods of Olympus, Mercury, messenger of the gods, stands beside Pegasus the winged horse. One recognizes Mercury by his winged sandals, winged hat, and winged caduceus, or magic wand with two snakes entwining it.

Mantegna painted the *Parnassus* to celebrate the wedding of Gianfrancesco and Isabella February 11, 1490. For the occasion he included numerous references to ancient sculpture he had studied. It is interesting to note that the golden color of the scarf blown by breezes held in Venus' left hand and the gold, blue, and red colors of Mars' clothes and the gold and red coverings of the bed are the intermixed colors of the Este and Gonzaga families.

Isabella possibly specified the elements of the painting. She wanted an allegory of martial harmony under which the arts, led by music, would blossom. Mantegna followed her directions and at the same time maintained a smooth finish to the surface, probably conceding to her tastes also. It was her desire to create a unity between her jewel-like treasure room and the jewels she kept in it. Nevertheless, even though Isabella may have dictated directions to the artist, "the Parnassus . . . is handled with a freshness, charm, and feeling for movement unique in Mantegna's *oeuvre* " (Osborne, p. 690).

Mantegna's Influence

Mantegna's perspectival discoveries were adopted by several artists in Mantua, Venice, and Ferrara. Such an impact did his influence have that his ideas traveled far beyond Italy. He made engravings; probably the hard, stonelike lines in his *Dead Christ* reveal this more than any of his other works. Artists carried his prints over the Alps and into Germany. Here, the leading engraver in sixteenth century German art, Albrecht Dürer (1471–1528), saw them. However, when Dürer visited Italy a second time to see Mantegna, he found that the painter had died.

When Mantegna died in 1506 the High Renaissance was at its peak. Since he had worked for the Gonzaga family for nearly 50 years, they felt his death as a real personal tragedy. Artists in northern Italy felt the effects of his death also, not only in Mantua but also in Ferrara and Venice.

One of the foremost north Italian painters of the fifteenth century, Mantegna was a virtuoso of foreshortening and perspective; as such he made indelible contributions to the perspectival approaches and techniques of Italian Renaissance painting.

Artists in Mantua and other parts of northern Italy—Ferrara and Venice—found inspiration in Mantegna's experiments in perspective. During his career he forged new roads into perspective such as artists had never seen. His different views, such as a type of illusionistic perspective known as *sotto in sù,* or seen from below, were so radical that they did not surface until around 1500. Further, no artist developed the concept completely before the Baroque era in the seventeenth century. Also, throughout his career Mantegna continued to develop ideas involving *in scruto* or extreme foreshortening, a perspectival system that had puzzled artists for centuries.

Although from the humblest beginnings, Mantegna worked his way through a lifetime in which he ultimately not only created masterpieces for generations to enjoy, but also contributed new and daring ideas that helped move art toward the twenty-first century.

Bibliography

Batterberry, Michael. *Art of the Early Renaissance.* New York: McGraw-Hill, 1968.

Camesasca, Ettore. *Mantegna.* New York: SCALA/Riverside, 1992.

Hall, James. *Dictionary of Subjects and Symbols in Art.* Revised ed. Oxford, England: Westview Press.

Hartt, Frederick. *Art, A History of Painting, Sculpture, Architecture.* Vol. II. 4th ed. Englewood Cliffs, NJ: Prentice Hall, Inc., and New York: Harry N. Abrams, Inc., 1992.

Huizinga, Johan A. *The Waning of the Middle Ages.* New York: St. Martin's Press, Inc., 1924 (reprinted 1954).

Kleiner, Fred S. and Mamiya, Christin J. *Gardner's Art through the Ages.* 11th ed. New York: Harcourt College Publishers, 2001.

Murry, Peter and Murry, Linda. *A Dictionary of Art and Artists.* New York: Penguin Books, 1977.

Osborne, Harold. Ed. *The Oxford Companion to Art.* Oxford: The Clarendon Press, 1978.

Panofsky, Erwin. *Renaissance and Renascences in Western Art.* New York: Harper & Row, 1972.

Vasari, Giorgio. *Lives of the Artists.* Trans. by George Bull. Baltimore: Penguin Books, 1965.

Voragine, Jacobus de. *The Golden Legend.* Trans. by Granger Ryan and Helmut Ripperger. New York: Longmans Green and Co., 1969.

CHAPTER 8

Masaccio, 1401–1428

Masaccio, or Tommaso, is the first painter of the Italian Renaissance whose scientific linear one-point perspective and aerial perspective began a new era in painting. He is the first Renaissance artist to have transferred the deep passions and feelings of individual beings to his figures. After Masaccio, painting and the entire history of art set out in new directions.

Masaccio, aware at a young age of new Renaissance ideas, especially in the science of perspective, wielded a lasting impact on the works of later Italian artists, particularly in Florence, where artists copied his Brancacci Chapel frescoes. Along with the importance of architect Filippo Brunelleschi (1377–1446) and sculptor Donato Donatello (1386–1466), historians agree he helped shape fifteenth-century art. Howard Hibbard says, "That tradition, beginning with Cimabue and Giotto before 1300, came to flower in the serene architecture of Brunelleschi, the expressive sculpture of Donatello, and the weighty painting of Masaccio" (Hibbard, p. 11).

In the early years of the fifteenth century, Masaccio moved to Florence, where a cultural revolution was taking place. Masaccio gleaned from Brunelleschi's and Donatello's work what he needed to form his new style. Brunelleschi's work in linear perspective helped him with the mathematical proportions necessary for his understanding and use of perspective. Donatello's work introduced him to the best of classical art and took him forward at a time when all artists surrounding him worked their Gothic figures and ideas into redundancy. Forming a pastiche of his ideas gleaned from the innovations Florence had to offer, Masaccio began a new painting style and developed ideas no longer concerned with what had already happened. He moved toward extreme simplicity and away from ornamentation and flat figures, both hallmarks of me-

dieval painting. He painted full volume and a convincing illusion of three dimensions. He shunned the "light with no source," uniform, coming from nowhere, and focused his figures into a single soft light. More importantly, he lighted his figures from one source, as if sunny rays poured in from an actual chapel window. In this way he developed the first truly realistic chiaroscuro, or light and shadow.

During the Italian rebirth, patrons for whom Masaccio painted wanted to be included beside holy figures. He used linear perspective for the fresco *Trinità* or *Trinity* (c. 1425) in Santa Maria Novella in Florence. He also reinvented atmospheric or aerial perspective, used by the Greeks and the Romans to suggest recession and later lost during Rome's decline. Furthermore, he used chiaroscuro to define figures in his fresco series for the Brancacci Chapel in Santa Maria del Carmine in Florence c. 1427. His work influenced Leonardo da Vinci, Michelangelo, and Raphael. These artists took his work beyond what he ever imagined and created a point in the history of painting that headed artists into the modern era.

Masaccio's Life

Masaccio, whose full name was Maso di Ser Giovanni di Mone Cassai, was born December 21, 1401, in the village of San Giovanni in Altura, Italy, in the Valdarno, today known as San Giovanni Valdarno, in the middle of Italy. Tourists and historians still study figures kept near his birthplace, sketches he made in early childhood. His parents named him after St. Thomas the apostle, sometimes known as Doubting Thomas (Tommaso in Italian), and baptized him on the saint's day, December 21.

His father, Giovanni di Mone Cassai, was a notary. His family name, Cassai, comes from the trade of his father's family—carpenters or cabinet makers. His mother, Monna Jacopa di Martinozzo, became a widow when Tommaso was only five, and in the same year she gave birth to another boy, Giovanni. He too became a painter under the nickname Scheggia. Soon after this, the boys' mother married a wealthy spice merchant, a widower much older than herself, Tedesco del Maestro Feo. This union guaranteed her and her family a comfortable life.

Masaccio spent his early years in San Giovanni; when he was 16 he moved with his mother and brother to Florence. His mother had again become a widow; therefore they lived in the parish of San Niccolò Oltrarno, where the young boy, inordinately talented, painted with the already established master Masolino da Panicale (c. 1383–1477?), 20 years his senior.

Masaccio began painting at the time when this Italian master was working in the Brancacci Chapel of Santa Maria del Carmine in Florence. Almost from the beginning of the relationship, instead of teaching the young student, Masolino came under the influence of the young Masaccio's style. By 1420, however, Masaccio had enrolled in the Arte dei Medici e degli Speziali, one of the seven Florentine craft guilds. At this time he settled into serious work as a painter. In 1427 he still lived with his mother and brother.

On the whole, all sources describe Masaccio as a thoughtless eccentric who used all his time and energy on art. Nothing else concerned him. He did not take care of himself and paid little attention to other people. He spent no time with material possessions, worldly considerations, or even with his clothes or appearance. So engrossed in art did he become that he never tried to recover possessions he loaned to anyone unless he found himself in desperate need of whatever had been borrowed. Rather than call him by his proper name Tommaso, those who knew him changed his name to Silly Billy, Sloppy Tom, or Tom the Slob. Sources say he was not a bad person; he was good in every way, although he was interested only in developing his immense gift.

Masaccio lived in Florence at a time when the greatest Florentine architecture was being constructed: the dome of the Cathedral of Florence, the Baptistery of the Florence Cathedral, and the churches of Orsanmichele, Santa Maria Novella, and Santa Croce. These structures impressed and influenced him. He found himself highly motivated by Brunelleschi's dome (c. 1420) and the innovative sculpture of Donatello. And though inspired by the most modern architecture the world had ever seen, he always inclined toward painting.

Although Masaccio witnessed great innovations in architecture and sculpture, he saw that nothing had changed in painting. He found himself surrounded by stiff, flat figures, and he knew he wanted animated, real human figures painted directly from nature. Working with this in mind, it wasn't long before his figures and painting became completely original and far beyond what other painters created in both design and color. He was meticulous in his work and made problem studies of linear perspective, a science that few painters at the time understood. Sometimes he even chose points of view not directly from the front as did other artists. He chose various angles, none of which had been painted before. Besides using different points of view, he used the elusive, difficult–to–compose foreshortened figure, which had rarely ever been painted. Even Giotto (c. 1267–1337), the most competent, innovative artist of his time, had attempted foreshortening in the 1305 Arena Chapel in his *Lamentation* but, having no knowledge of linear perspective, did not succeed. In addition to his perfect line in drawing, Masaccio revealed his perspective expertise by using chiaroscuro or shading in such a way as to cause his architecture to gradually disappear into space.

Specifically, Masaccio painted, below the choir in Santa Maria Novella, the fresco *La Trinità (The Trinity)*, which is over the altar of St. Ignatius. The Virgin stands to the left and St. John the Evangelist on the right. Both contemplate the crucified Christ. At each side Masaccio painted two kneeling figures, portraits of those who paid for the work. The man kneels to the left below the Virgin and the woman to the right below St. John the Evangelist. After the figures, most impressive of all is the deeply coffered Roman barrel vault serving as a ceiling. Into each coffer, or indentation in the ceiling, Masaccio painted a rosette receding into space so accurately that the surface appears as if it is actually indented.

During a stay in Rome in 1423, Masaccio also decorated a chapel for Cardinal San Clemente in the church of San Clemente. And although the work is commendable, historians see Masaccio's mature work as his best in the frescoes of the Cappella Brancacci or Brancacci Chapel in Santa Maria del Carmine in Florence, painted between 1424 and 1425. He continued the scenes of St. Peter's life, which his master Masolino had begun. Works he completed were: *St. Peter Enthroned*, *The Healing of the Sick*, *Raising of the Dead*, and the *Restoring of the Cripples as St. Peter's Shadow Falls on Them*. The most remarkable among them, however, is the c. 1425 fresco *Tribute Money*.

In the summer or fall of 1428 Masaccio went to Rome, where he died. Consternation and incredulity followed his death. According to Hartt, "If, as is generally claimed, this event took place in November 1428, the artist did not reach his twenty-seventh birthday. Complete proof of this date has never been brought forward, however, and it is possible that Masaccio succumbed during the malaria season of 1429" (Hartt, p. 182). The summer and fall of 1428 remain a mystery.

No one knows where Masaccio's work would have gone had he lived out a normal life span. His biographer, Giorgio Vasari says,

> There are many who insist, that he would have produced even more impressive results if his life had not ended prematurely when he was twenty-six. He died in Rome in 1427 or 1428. However, because of the envy of fortune, or because good things rarely last for long, he was cut off in the flower of his youth, his death being so sudden that there were some who even suspected that he had been poisoned. (Vasari, p. 131)

"It is said that when he heard the news Filippo Brunelleschi, who had been at great pains to teach Masaccio many of the finer points of perspective and architecture, was plunged into grief and cried, 'We have suffered a terrible loss in the death of Masaccio'" (Vasari, p. 131).

In 1443 townspeople buried Masaccio in the Carmelite Church. Since he had made only a modest name for himself and important people did not know him during his life, they provided no memorial. "But there were some to honor him when he died at age twenty-seven with the following epitaphs. Annibal Cardo wrote:

> I painted, and my picture was like life;
> I gave my figures movement, passion, soul:
> They breathed. Thus, all others
> Buonarroti [Michelangelo] taught;
> he learnt from me
>
> <div align="center">(Vasari, p. 132)</div>

Of all Masaccio's work, the most exceptional fresco is his acknowledged masterpiece *Tribute Money*. Matchless in its innovative properties, imposing in its subject and unparalleled in its influence on the world of Renaissance painting, *Tribute Money* remains overwhelming with its innovative forces.

Tribute Money, 1425

Masaccio took his subject for *Tribute Money* from Matthew 17:24–27. In Christian art artists have seldom represented this scene. In Florence in the Brancacci Chapel, Santa Maria del Carmine, Masaccio's 1425 fresco dominates the room. The fresco tells the story well. When Christ and the apostles arrived at Capernaum, a Roman tax collector asked for the usual half-drachma tax. "When they came to Caper'na-um, the collectors of the half-shekel tax went up to Peter and said, 'Does not your teacher pay the tax?' He said, 'Yes.'" Masaccio depicted the apostles gathered around Jesus, who stands in their midst as a peaceful beacon. According to the Bible, he tells Peter where to find the money for the tax. "Go to the sea and cast a hook, and take the first fish that comes up, and when you open its mouth you will find a shekel; take that and give it to them for me and for yourself" (Matthew 17:27).

Cleverly, Masaccio used continuous representation or narrative (painting the same figure more than one time) to illustrate the scene. In the center of the painting Christ tells Peter to find the money in the mouth of the fish. To the left Masaccio shows Peter kneeling at the edge of the sea of Galilee taking the coin from a fish's mouth. On the right, Peter pays the tax collector.

Masaccio, however, revised the story. "The tax-gatherer comes directly before Christ and the apostles, who are not represented 'at home,' as in the text, but before a wide Arno Valley landscape culminating in the mass of the Pratomagno; the house relegated to one side" (Hartt, p. 187).

Although the date of *Tribute Money* is not known conclusively, historians consider 1425 most likely. This date is historically one of the most dangerous in the Florentine Republic's history. The Republic had just been defeated by the duke of Milan, Filippo Maria Visconti. In order to pay for the war in a fair manner, Florentines decided on a new tax, the *Catasto*, which provided deductions and exemptions. The *Catasto* also based its collection on an ability to pay.

Although Masaccio painted Christ's blessing of a tax, the subject may not have been chosen for strictly religious purposes. In fact, it may have been painted to bolster a tax needed in Florence. And for this reason he depicted the scene on the banks of the Arno River in Tuscany, Italy. He also painted into his scene the needed solemnity, the needed seriousness for raising taxes on citizens, many of whom had very little.

Specifically, Masaccio distributed his apostles within the painting in a semicircle around the main figure, Christ. It is possible he took this figural arrangement from Nanni di Banco's (c. 1380–1421) *Quattro Santi Coronati* (*Four Crowned Saints*), completed in 1414. The subject, martyrs, promoted the theme of sacrifice and also featured the four saints in a tight semicircle. Masaccio may have noted the statue during installation in its niche at Orsanmichele in Florence. Light on Nanni di Banco's martyrs, especially the heavy, deeply cut drapery and the solid, firmly standing figures may have intrigued Masaccio, causing him to think of representing figures in a new way.

Moving away from Florentine medieval ideas (even Nanni di Banco's statues existed in a deep, Gothic-decorated niche) Masaccio adopted a low point of view and hazy landscape, an indication of Donatello's influence. He painted a landscape that no artist before him had produced or even come close to. He dissolved the flat medieval wall that had existed as background. He has the viewer's eye moving into the picture easily from the foreground and figures, to an open plain with several trees and a riverbank, over hills, to the mountains, and beyond to the sky and clouds. After studying Donatello's new optics in sculpture, Masaccio developed his own optics in painting. He left behind all traces of fourteenth-century hard line and obsessive attention to detail. On his new figures, trees, and mountains, he painted light that gave them correct volume and set them in space securely and believably. He used bright, clear color, an unexpected surprise discovered by workers after a recent restoration.

Also, the restoration revealed a background hazy with mists and spots of open plain that seem to dissolve under light fogs. He did, not paint with the hard, tight stroke of earlier artists; rather, his brush moved loosely, freely, as did the masters' brushes in ancient Rome.

Masaccio painted *Tribute Money* shortly before his early death. He shows the tax collector confronting Christ outside the Roman town of Capernaum. Then, he returns to the right side of the painting to pay the Roman tax collector the money. Masaccio showed Peter three times: once in the center, once at the left, and once at the right.

Christ tells Peter to go to the shore of the sea of Galilee. After catching a fish, as foreseen by Christ, Peter kneels down, reaches into the fish's mouth, and takes the half drachma out. On the far left at the edge of the sea that laps to shore, Peter takes money from the mouth of a fish to pay the Roman tribute who stands before Christ. Both Christ's right hand and Peter's right hand point to the sea to the left of the group. The tax collector points to Peter, who, on the far right, pays him the money. Thus the story is told in one long narrative. According to Vasari, Masaccio painted himself as one of the Christ's apostles (the last one on the right) standing firm and straight staring at Christ. It is interesting to note that around 1489 Michelangelo revealed more than a passing interest in Masaccio's figure of Peter. He made a copy of it, using the cross-hatch technique with a pen. His drawing is "a version of the Apostle Peter handing over a coin in Masaccio's famous fresco *Tribute Money*. Vasari tells us that Michelangelo studied Masaccio's frescoes for many months" (Hibbard, p. 19)

Masaccio told his story in three parts within the same fresco rather than paint a triptych, which would have told the story in three sections. Christ occupies the center of the fresco, and his apostles form a circle around him, except on the viewer's side, which is open. Masaccio's sturdy figures of Christ and the apostles remotely recall Giotto's (c. 1267–1337) figures in the 1305 Arena Chapel in Padua. They are plain and noble, dignified and elegant. Masaccio's figures, however, convey a heavier emotional weight, a thicker, more convincing volume, a more credible physical stature.

Masaccio modeled his figures in a new way. He did not rely on the light Giotto used, a general illumination with no source. He painted light as if it shone in from outside the picture. Therefore, light hits the figures at an angle and creates shadows (not seen in Giotto). Masaccio's new chiaroscuro creates an illusion similar to sculpture. Beyond an ordinary light spotlight effect, Masaccio paints a light that fluctuates, that highlights brightly here, dimly there, and not always on the figures. Shadows, for example, fall in horizontal stripes across the ground. Moreover, parts of the ground appear dappled. Giotto merely modeled the figures using a darker color to indicate a sunken bit of drapery and used no shadows on the ground. Masaccio's light has its own life. The figures and buildings would be invisible if this light did not exist. Their movement depends on its direction and intensity. For the first time viewers see light playing over drapery, heightening in one place, hiding in another, rippling over water and land, highlighting clouds in the heavens beyond the mountains.

Masaccio painted individual figures in *Tribute Money* grave and substantial. At the same time they show, because of light and shadow, the structure of their bodies. Their drapery reveals newly rediscovered (by Donatello) *contrapposto*, or ponderation (weight shift). Masaccio's figures reveal his understanding of anatomy, the muscles and bones and the movements of joints, all contrived to convey the energy a figure would really have. Masaccio's figures live and breath, they actually stand or sit.

Beyond all this, Masaccio's compositional arrangement of Christ and the apostles goes beyond ordinary medieval design. His figures do not form a flat screen parallel to the picture plane or even into the picture's receding planes. Rather than use the old formula, Masaccio placed his figures in a circular, convincing depth around Christ. He also painted a spacious landscape around them. This approach is in direct contrast to earlier frescoes, whose figures appear locked in place, confined to a proscenium (area on a stage in front of the curtain). Masaccio gives his figures their own space—room to point and gesture convincingly. He placed all their heads, even those in the back of the semicircle in *isocephaly*, or having all the heads at the same level, a method of balancing figures used by the Greeks. Using perspective, he placed his architecture within the scene and not on it.

Masaccio drew his building in perfect one-point perspective. To place a direct emphasis on Christ, he positioned his vanishing point, where all his orthogonals converge, right at Christ's head. This clever focusing using perspective orthogonals brings all attention to Christ. The building's bottom level floor, a window within a loggia and the second story roof lines all point towards Christ's head.

Masaccio also used aerial perspective, a phenomenon first seen on Roman monuments, the *Spoils of Jerusalem* relief panel on the interior of the *Arch of Titus* (c. 81), in Rome, to name one. Aerial perspective, in which objects blur as they recede into distance, seems to the casual twenty-first century spectator elementary, but although the Romans were the first to use it the concept disappeared when Rome fell. Medieval artists, focused on strictly religious presentations, did not rediscover it. It did not reappear until the early fifteenth century, when Masaccio rediscovered it. Furthermore, he evidently came across the concept on his own.

Because of Masaccio artists realized that air and light surrounding figures, buildings, and objects in a painting change and, in fact, blur as they move way into distance.

Expulsion of Adam and Eve from Eden, 1425

Probably in 1425, in a narrow rectangular place at the entrance to the Brancacci Chapel, Masaccio painted the *Expulsion of Adam and Eve from Eden,* a narrow fresco 7 feet high by nearly 3 feet wide. In this fresco he used the same innovations of perspective, both linear and aerial, he had so successfully focused on in *Tribute Money.*

Similarly, he used sharply slanted beams from an unknown source outside the picture to create a light that illuminates the figures' skin. He created luminosity and contrast by placing strong light beside strong dark. This placement forms a unity between the three figures: the angel, Adam, and Eve, who exit a tall, slender arch, admonished by an angel close above them wielding a long sword. Masaccio's figures reveal his mature knowledge of anatomy by giving Adam and Eve perfect bone and muscle structure. The viewer acknowledges the powerful weight of both, notices the substantial placement of feet as they exit paradise, their agony evident.

Equally important, Masaccio's light, coming from the right, illuminating the fronts of the figures, throws the shadows behind them. Aerial perspective develops an atmospheric space around all three figures building convincing space beyond them. Earlier artists could not do this; they settled for an impenetrable wall of sky and mountains. Solidly planted on the ground, Adam's feet designate the first human contact with earth. Similarly, Eve's suffering reveals the real, human anguish she suffers. Above them, the angel, although only somewhat threatening with sword in hand, does not actually force them from the garden. As a result of their sin they move from Eden to the open world with closed eyes driven by the knowledge of what they have done.

Finally, one notes that the design could not be more simple. Not even a flower sprig springs from the desertlike terrain both sinners stumble across. Masaccio's message, harsh and unforgettable, is curiously fluent.

St. Peter Distributing the Goods of the Church, c. 1425

In the Brancacci Chapel in Santa Maria del Carmine in Florence, Masaccio painted, c. 1425, *St. Peter Distributing the Goods of the Church.* The fresco is on the right side of the altar: the scene Masaccio chose, placed behind what could be a portal, could be in Florence. Four apostles accompany Peter, all wrapped in heavily draped mantles that reveal deep chiaroscuro or light and dark. He painted them in various attitudes, each one facing a different direction. They calmly, stoically distribute alms to poor people who gather round them, including a woman with a baby in her arms. The woman, whose child is dressed only in a short dress, has the same face as Masaccio's Madonnas, the large eye

sockets, the small eyes, the large nose, the small chin. A cripple moves forward on a cane behind her, and an old woman struggles toward Peter behind him.

Parallel to the picture plane and in front of Peter and the others who receive the goods of the Church is stretched the corpse of Ananias. According to Hall,

> The apostles, by their example and eloquence, persuaded men of property to sell their goods. The money was then distributed among the poor. One such man, Ananias, privately kept back half the proceeds for himself, with the knowledge of his wife. Lashed by Peter's tongue for his deceitfulness, he dropped dead on the spot . . . his wife suffered the same fate. (Hall, p. 241)

Ananias is meant to serve as a reminder of those who prefer greed to giving.

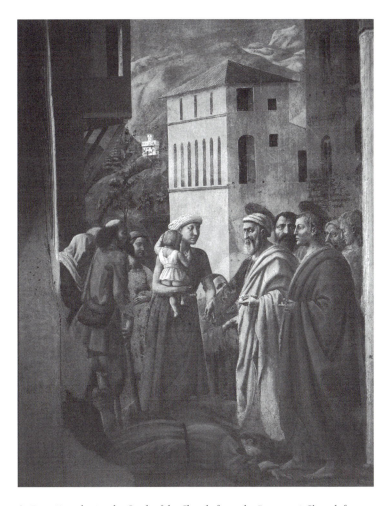

St. Peter Distributing the Goods of the Church, from the Brancacci Chapel, fresco. The Art Archive / Sta Maria del Carmine, Florence / Dagli Orti (A).

In the background, Masaccio painted a characteristically medieval town. With regard to perspective, the architecture moves correctly into space. To the left he depicted a room, painted dark, seen from below so that one must imagine its hidden front wall to move inward toward the altarpiece. The buildings frame Peter and his apostles and those who receive alms.

Although not one of Masaccio's most important works, here again the artist has represented a solidity of robed figures placed within the picture plane, highlighted by a light that reveals, a light that creates volume.

Raising of the Son of Theophilus, 1425

Masaccio painted *Raising of the Son of Theophilus* as one of two important frescoes of the lower tier in the Brancacci Chapel in Santa Maria del Carmine. The story tells how Peter

> raised a young boy who had been dead for fourteen years. . . . When Peter was preaching in Antioch he was accused by Theophilus [Bishop of Antioch] of corrupting the people there. Since Peter did not stop preaching, he was bound in chains and cast into prison without food or water . . . Christ sent St. Paul to him [he was nearly dead] . . . and told [Theophilus] of Peter's miraculous healings . . . Theophilus said "Go and tell him I shall set him free if he restores my son to life. . . . [Peter] was led to the tomb of Theophilus' son, ordered the door opened, and called the dead boy to life." (Earls, p. 226)

To depict the dead son alive before Peter, Masaccio used a composition in two parts in the shape of an S to show depth (different from the open semicircle of *Tribute Money*.) One part revolves around the miracle on the left, the child kneeling before Peter, while another scene on the right revolves around Peter on a throne in the midst of Carmelites. The S-curve moves in two directions—one toward the viewer, the second, away from the viewer. Masaccio crowded all the figures in the small courtyard of several buildings, one of which is the palace of Theophilus.

Although Florentine painter Fra Filippo Lippi (c. 1406–1469) completed the fresco, Masaccio painted the architecture and nearly all the figures. Fra Filippo's son, Filippino Lippi (c. 1457–150), trained by his father, painted the child.

Masaccio painted Theophilus' palace from his imagination. No structure like it is known to have existed in fifteenth-century Florence. Pedimented windows, however, in the upper left second story, appear to have been influenced by Brunelleschi's windows in *Ospedale degli Innocenti*, begun in 1419. Across the back and middle of the composition, Masaccio painted a wall made up of rectangular panels of inlaid marble across the back. It is close and pushes the figures a bit toward the front. The wall could symbolize death, as do the marble tombs behind the figures in Castagno's (c. 1423–1457) *Last Supper*. On the other side of the wall, trees grow and plants flourish in pots against a bright sky—all symbols of new life.

Masaccio's figures, so realistically rendered and set so convincingly in real depth and light, fit the patterns of the S-shaped composition the artist drew. It

appears that only Peter will move or act. All other figures seem frozen by the miracle they have just seen, especially the wicked Theophilus converted to Christianity on the spot. The story of Peter restoring the life of Theophilus's son has been explained as an allegory of papal and therefore Florentine power against the people of Milan (Hartt, p. 201).

Masaccio depicted Peter twice in a narrative of continuous representation. In both places, the center and to the right, he is the primary focus of the compositional S-plan. All other figures, including Theophilus, are but figures that make up the composition.

The Pisa Polyptych, 1426

From February to December of 1426 Masaccio worked in Pisa for Giuliano di Ser Colino degli Scarsi, a notary from San Giusto, who had commissioned him to paint a polyptych (a many-paneled altarpiece) for the Church of Santa Maria del Carmine. Vasari describes the altarpiece as follows:

> In the Carmelite Church at Pisa, inside a chapel in the transept, there is a panel painting by Masaccio showing the Virgin and Child with some little angels at her feet who are playing instruments. . . . Surrounding Our Lady are St. Peter, St. John the Baptist, St. Julian, and St. Nicholas. . . . On the predella below are some small figures illustrating scenes from the lives of those saints with the three Magi in the center offering their gifts to Christ, (Vasari, p. 127)

In the eighteenth century the panel was dismantled, and many sections disappeared. In fact, according to Casazza, "Only eleven pieces have so far come to light and they are not sufficient to enable a reliable reconstruction of the whole work. St. Peter and St. John the Baptist, St. Julian and St. Nicholas, who were on either side of the central part, are missing" (Casazza, p. 60). The one panel that remains, the *Enthroned Madonna and Child*, serves as a reminder of Masaccio's unequaled competence in exalting religious figures while giving them ordinary human characteristics.

Enthroned Madonna and Child for the Pisa Polyptych, 1426

The one surviving panel of the Pisa polyptych is the *Enthroned Madonna and Child,* 53 1/4 inches by 28 3/4 inches. Mary, a calm, monumental figure within a two-story throne seems almost like a giant and reflects Masaccio's superior ability to take the formal human figure to a magisterial level. Here, the artist elevates the Mother of God to importance far beyond other artists of his day. She reaches a new level of stateliness, a serious dignity no artist before Masaccio achieved.

Masaccio, to accomplish this unusual elevation of person, seats the Madonna on a throne based on architectural elements. The gold base, half the size of two angels who play musical instruments in devotion to her, rests on an elevated step. Above this, the throne, in perfect perspective, moves deeply inward and

is cast in shadow by the one strong light from the left—typical of Masaccio. The left is in dark shadow, the right shining and brilliant, as if the sun has just touched it. The Christ child catches the light too—his face, arms, and legs.

Masaccio decorated Mary's throne with correct architectural elements. On the first level (upon which she sits) he painted rosettes. He supported the second level with an unfluted Roman Composite column on each side. Above that, two unfluted Roman Composite columns are surmounted by an abacus, a fasciated architrave, and an overhanging cornice. An Ionic colonnade opens the throne behind her shoulders.

The Virgin reaches just above the top, her heavy blue mantle resting in deep folds about her shoulders. According to Hartt, to achieve such a successful effect with drapery "it is not impossible that Masaccio used in this case a clay figure with actual cloth imposed over it to chart the behavior of light and shade" (Hartt, p. 201). However, some historians believe Masaccio could have produced such accurate shadows on the throne and on the Virgin without a model.

Masaccio painted the same faces repeatedly, and the Madonna in this work is no exception. It is possible he used the same model, one with wide cheekbones and pronounced eye sockets into which he painted small eyes. Also, he used the same large nose and receding chin. In this work, Mary's child, resting on her left leg, is nude. He eats grapes his mother hands to him. Symbolically, grapes represent the Eucharist (a word meaning "thankfulness" and "gratitude," it is the consecration of bread and wine in Holy Communion).

Unfortunately, the panel has sustained damage. Entire passages of paint are gone. And beyond this, the Virgin's face has been over cleaned so vigorously the underpaint shows. Also, according to Hartt, "The architectural details, including the firm, hard rosettes and somewhat inconsistent strigil [wave like decorative fluting] ornament . . . of the pietra serena [dark stone] throne, as well as the lutes in the hands of the two little angels, are so brilliantly projected as to seem magically three-dimensional" (Hartt, p. 202).

The *Crucifixion* for the Pisa Polyptych, 1426

Masaccio intended his 1426 *Crucifixion* for the top of the Pisa polyptych for Santa Maria del Carmine. In this work he went beyond Donatello's optical perspective in that he determined the exact point where the viewer would stand to observe all the panels correctly. He depicted the cross from below and foreshortened the body of Christ, as he would actually appear if one stood below him on the ground and looked up. Christ's collarbones project to the extent that he has no neck, as the head, inclined forward, covers it. In this way, the worshiper's face is nearly parallel with Christ's—Christ looking down, the worshiper looking up.

For purposes of background, Masaccio used Gothic gold. Considering Masaccio's innovations, this difference from his earlier depictions of atmospheric landscape may have been ordered by Giuliani di Ser Colino, the patron. Nonetheless, in Masaccio's hands gold goes beyond ordinary medieval flat color. Under Masac-

cio's brush it miraculously creates its own sense of receding space and actually appears to move away from the figures surrounding the cross. It creates a new and powerful illusion of translucent air like spun gold through which the figures on Calvary silently suffer.

In addition, Masaccio painted INRI above Jesus' head. When the Romans crucified a prisoner, an explanation or titulus stating the condemned person's offense was hung around his neck as he was taken to execution. After the crucifixion, the titulus was fixed to the top of the cross. John (19:19–20) tells how Pilate wrote an inscription to be set on the cross of Jesus. It read "Jesus of Nazareth King of the Jews" in Hebrew, Latin, and Greek. Renaissance artists usually painted it in Latin only: *Iesus Nazarenus Rex Iudaeorum*, abbreviated to INRI. Once seen in earlier photographs, the INRI inscription is no longer there. Cleaning took off this titulus and revealed a plant growing from the upright part of the cross known as the *stipes* (the horizontal piece is the *patibulum*). Hartt suggests that "it must once have contained the pelican striking her breast to feed her young, which symbolized in medieval belief the Sacrifice of Christ for mankind" (Hartt, p. 202). Of the pelican Hall says, "The motif of the pelican piercing its breast to feed its young with its blood became a symbol of the sacrifice of Christ on the cross" (Hall, p. 238).

Notwithstanding the subject, Masaccio's theme is not the Crucifixion; it is Christ's sacrifice. To emphasize his subject, Masaccio used only four figures. He painted no gambling Roman soldiers at the foot of the cross, no St. Longinus with his spear ready to pierce Christ's side, no onlookers, no Joseph of Arimathaea ready to take Christ's body for burial. Significantly, he did not include the two thieves, no ladders or other accoutrements of crucifixion used by earlier artists, because they played no role in the sacrifice. Instead, at the bottom, he depicted Christ's mother Mary in a blue (for truth) mantle; at his feet Mary Magdalene, the image of the penitent in Christian art, cloaked in red (for sacrifice); and to his left John the Evangelist in blue and red. Christ, the fourth figure, the sacrifice itself, dominates the scene, his nailed feet directly above Mary Magdalene's head, brushing the edge of her halo.

To the left, Mary, Christ's mother, clasps her hands tightly before her, dramatically high at the level of her chin. She does not raise her left hand. According to Hall, "[Some artists] raised her left hand to her cheek, supporting the elbow with the other hand, a traditional gesture of sorrow that dates back to Hellenistic times [c. 200 B.C.]" (Hall, p. 84). She does not faint, overcome with anguish. Masaccio stands her according to John's words (19:25): "Standing by the cross of Jesus [was] his mother [Mary]."

Mary Magdalene kneels at Jesus' feet and throws her arms up, one on each side of the cross. Jesus' feet nearly meet at her head so that the cross appears to spring from her body. This fulfills the prophecy of Isaiah, one of the four greater prophets (11:1): "There shall come forth a shoot from the stump of Jesse, and a branch shall grow out of his roots." Mary Magdalene seems to sink below the figure of Christ on the cross. Her hair, long and flowing as usual, is untied (Hall, p. 202). Masaccio also painted a few minute plants growing

in dirt near Calvary or Golgotha, the Place of the Skull, so named because of its shape.

Christ, depicted dead and pale, has his eyes closed. A thin crown of thorns encircles his head. Even in death, his body rigid, his arms stretched long and perfectly straight, Christ suffers. Masaccio depicts him with a humanity never before painted. With the figures of the Virgin Mary, Mary Magdalene, John the Evangelist, and Christ, Masaccio presented a simple drama that achieves infinite power.

In this 1426 panel for the Pisa polyptych, Masaccio brought together perfectly rendered figures, revealing a mature knowledge of anatomy, a practiced knowledge of light and highlighted drapery, and a knowledge of iconography or symbols, including those for color. "And nowhere more than in this panel did Masaccio's style deserve the characterization given to it in the later Quattrocento [1400s]: 'puro, senza ornato' ('pure, without ornament')" (Hartt, p. 203).

Adoration of the Magi for the Predella of the Pisa Polyptych, 1426

The last surviving panel of the Pisa polyptych is Masaccio's painted *Adoration of the Magi* (8 1/4 inches by 24 inches) for the predella or narrow ledge on which an altarpiece rests.

In this 1426 predella Masaccio, for still unexplained reasons, used a traditional single eye-level point of view. Also, abandoning simplicity, he filled the foreground with figures—horses and people. He painted a landscape to the crowd's right that is bare yet receding into defined space. Hartt says, "the distant bay and promontories suggest the seacoast near Pisa; the barren land masses may be based on the strange eroded region called *Le Balze,* near the Pisan fortress-city of Volterra" (Hartt, p. 203).

Beginning at the left of the narrow predella, Masaccio painted the usual symbols, the ox (representing the believer) and the donkey (representing the nonbeliever), each painted from a different point of view. He painted an open stable, more like a lean-to (not within a cave), and it does not reveal iconographic features such as the falling down side to represent the Old Testament and the new side to represent the New Testament. In perspective foreshortening, he painted a saddle planted on the ground. He purposely turned all objects at various angles, as they would ordinarily be in reality, and each one presents a different problem of foreshortening.

An overall low point of view provides an opportunity for a different composition of lots of legs, human and horse, and space in between set off by shadows made by an unknown light source beaming from the left. Standing to the left of center are the patron Giuliano di Ser Colino and his son. Masaccio dressed them in contemporary attire and used the folds of their cloaks to bring them forward and to emphasize the composition. Four white horses also stand close by, all in positions, that provide problems in foreshortening.

It is interesting to note that Masaccio painted the Pisa polyptych during intervals in his work on the Brancacci Chapel in Santa Maria del Carmine in Florence. Scholars call it a splendid testimony to his maturity as a fresco painter. Viewers can observe the connection of the Pisa polyptych with the Carmine in the features of St. Paul and St. Andrew, who also appear in the Brancacci Chapel's *Tribute Money.*

Holy Trinity, c. 1427

The *Holy Trinity* fresco in Santa Maria Novella in Florence still remains without a solid date. Hartt asserts that "the fresco can be understood only when dated at the end of Masaccio's known development, after the Pisa altarpiece and the Brancacci Chapel, therefore in 1427 or 1428, shortly before the artist's departure for Rome" (Hartt, p. 203).

Holy Trinity is a large, tall rectangle, 21 feet high by 11 feet 5 inches long. Within its frescoed interior, Masaccio gave the world two main Renaissance precepts: human beings drawn after observation, not flat medieval figures with stony faces and no humanity, and the skillful use of mathematics to perfect Brunelleschi's (1377–1446) linear perspective.

Specifically, Masaccio painted the *Holy Trinity's* composition, set within a perfectly rendered Roman arch-order, on two levels of unequal height. Within the upper level, directly below a coffered Roman barrel vault much like the interior of a Roman triumphal arch, Mary, the mother of God and St. John the Evangelist stand on either side of Christ on the cross.

Mary does not look up at Christ. Instead, with no emotion, she holds her right hand toward him, indicating to the viewer his death. John the Evangelist is not grief stricken but rather lost in adoration as he stands to the right of the cross.

From behind Christ, God the Father leans forward somewhat, standing on a shelf toward the back of the chapel, calmly gazing out over his sacrificed son's head. His outstretched arms support both arms of the cross. The Holy Spirit, in the form of a white dove, hovers between God's and Christ's head, its head pointed down toward Christ.

At the same time, Masaccio painted those who paid for the fresco, Lorenzo Lenzi and his wife, members of a wealthy contemporary Florentine family. The man, possibly the occupant of the tomb below, wears the costume of a *gonfaloniere* or high official. Both donors kneel in the narrow space before the chapel in front of the pilasters that form the outer limits of the Roman arch-order used to frame the chapel.

Masaccio did not paint the tragedy of the Crucifixion. Again, he painted the sublimity of Christ's sacrificial death for mankind.

Below the scene Masaccio painted a tomb and a skeleton within it (discovered after World War II). Coming from the skeleton's mouth is Francesco Petrarca's (1304–1374) famous epitaph in Italian "*Io fu gia quel che vol siete e quel chio son voi anco sarete*" (Hartt, p. 204) or, "I was once what you are. You will be

what I am," reminding viewers that they too will one day be a skeleton within a tomb. These words run from the skeleton's mouth straight to its feet, paralleling the top of the body.

For all that, the subject of the *Holy Trinity* is not new. Masaccio's innovation is the perspective illusionism. He mastered completely the principals of scientific linear one-point. In fact, so well did he adhere to Brunelleschi's rules that some historians believe Brunelleschi may have instructed him.

Unexpectedly, Masaccio painted the vanishing point below Christ's feet, at the foot of the cross behind the lightly painted mound of Golgotha, rather than, as one might expect, having all orthogonals meet in one point at his head. Here, the vanishing point is exactly at eye level for viewers. In this way the composition could not be more closely controlled. Worshipers look up at the Father, the Son, and the Holy Spirit and down at the skeleton. Here, the vanishing point, about five feet above floor level, pulls the Trinity and the skeleton together. This creates a believable illusion of actual architecture that divides the wall's vertical plane. The illusion formed is a projecting tomb below and a receding chapel above that seems to be an extension of the viewer's space. Masaccio effectively adjusted the subject's space to the exact position of the viewer. This seemingly simple arrangement of the subject became the first step in the evolution of illusionistic painting that came to intrigue artists not only of the Renaissance but also of the seventeenth century baroque period. So exact was Masaccio in his measurements that today one can calculate the chapel's dimensions. The span of the Roman barrel vault is, for example, seven feet. The depth of the vault, with receding coffers, is nine feet. Indeed, Masaccio created a complete and exact illusion and also composed a mathematically measured whole that becomes the reason for the harmonious balance, symmetry, and perfection that make up the composition.

Masaccio created, in his *Holy Trinity* fresco, the setting for a grand Renaissance chapel. Its Corinthian pilasters conform to Brunelleschi's idea of perfection in architecture. He was mathematically accurate in his projection of the principles of perspective. His illusions dissolve the wall and establish what seems to be a real chapel within it. This precision in painting would have been inconceivable only a few years earlier, before Brunelleschi had perfected the mathematics involved in scientific linear perspective.

Within the perfectly balanced structure, single sections and parts are painted with Masaccio's knowledge of stereometry, or the study of determining the dimensions and volume of solids. Studies of parts of hands, arms, and different sections of architecture reveal interesting facts. For example, the nails that pierce Christ's hands, long and not sunken deeply, are painted along orthogonal lines that follow the perspective of the chapel.

Masaccio's *Holy Trinity* fresco, with its balanced illusionism, still moves worshipers with its images of the Trinity. Viewers begin at the bottom at the sarcophagus with the sadness of death, move up past the figures of the Virgin Mary and St. John the Evangelist to God, where they find hope of resurrection and immortality in heaven.

Masaccio's Influence

When Masaccio died in November 1428, Florence was the leader of a new style in painting. However, the artist's work did not have an immediate influence, nor one that was as far-reaching as, for example, Giotto's. In spite of Masaccio's innovations of light and space, both atmospheric and perspectival, the Gothic mind-set continued in Florence into the 1450s, long after Masaccio's death. Patrons continued to order altarpieces decorated with Gothic tracery, pointed arches, pinnacles, crockets, and flat gold backgrounds as if Masaccio's work did not exist.

Likewise, while most artists have students and a multitude of close followers, Masaccio did not, or those who did follow his work had not the talent to further his ideas. Only two Italian masters, who seem younger because they lived longer, found inspiration in his work and carried it forward—Fra Filippo Lippi (c. 1406–1469) and Fra Angelico (1387–1455).

Nevertheless, Masaccio was the first Italian Renaissance painter whose use of scientific linear one-point perspective in a variety of situations began the modern era in painting. One has to reach forward to the work of Michelangelo (1475–1564) in the sixteenth century to find the results of Masaccio's influence on later Florentine art.

Only four works definitely attributable to Masaccio survive, although other paintings have been attributed in part or wholly to him. All his works are religious, either church frescoes or altarpieces. His earliest painting, a panel depicting the *Madonna and Child with Saint Anne* (c. 1423), is in the Uffizi, Florence. It shows the influence of sculptor Donatello in its realistic flesh textures and sculptured forms. *The Trinity* (c. 1425), a fresco in Santa Maria Novella in Florence, used Brunelleschi's scientific linear one-point perspective. His *Trinity* figures reached a naturalism only seen in the work of Donatello, his contemporary. Also, his work for Santa Maria del Carmine in Pisa, the polyptych with the *Adoration of the Magi* (1426), became a simple theme after other painters had used the subject as an opportunity for ornament and decoration.

In the same way, Masaccio's (c. 1427) Brancacci Chapel fresco series in Santa Maria del Carmine in Florence reveals the innovative use of light to interpret the human body and drapery. Here, he did not light his figures and landscapes with the medieval method of flat, and uniform light. He placed light on them as if they had a single source of light, which seemed to be the chapel window. In this way, he created figures bathed in light, giving them a naturalism unknown to painting at that time. Contemporary artists could not duplicate his light. Later High Renaissance artists such as Raphael (1483–1520) found inspiration in his works. Of his six frescoes, historians consider *Tribute Money* and *Expulsion of Adam and Eve from Eden* masterpieces.

Vasari says, "Although Masaccio's works have always had a high reputation, there are those who believe . . . that he would have produced even more impressive results if his life had not ended prematurely when he was twenty-six.

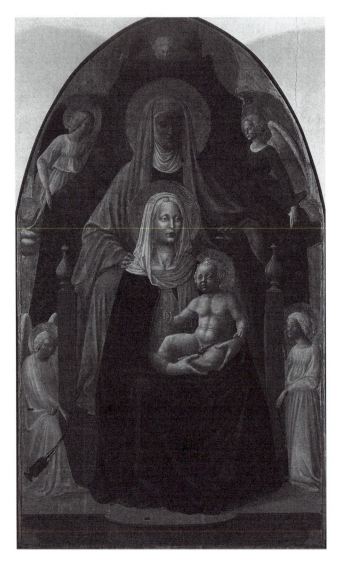

Massacio's *Madonna and Child with Saint Anne*. The Art Archive / Galleria degli Uffizi Florence / Dagli Orti.

However, because of the envy of fortune or because good things rarely last for long, he was cut off in the flower of his youth" (Vasari, p. 131). On the other hand, "the public at large, charmed by Gothic-influenced painters such as Gentile da Fabriano [c. 1370–1427], for a long time found Masaccio's heroic realism too austerely grand to cope with" (Batterberry, p. 71). Although the work he started did not progress immediately after his death, later artists such as Michelangelo and Raphael finally caught up with his ideas.

Florentines buried Masaccio in the now famous Santa Maria del Carmine in 1443. Curiously, while he lived, he had made only a modest name and there-

fore no one put up a memorial or marked his accomplishments in some way. His work, however, lives and his influence on the history of art remains.

Bibliography

Batterberry, Michael. *Art of the Early Renaissance.* New York: McGraw-Hill Book Co., 1968.

Casazza, Ornella. *Masaccio and the Brancacci Chapel.* Milan: Scala, 1993.

Earls, Irene. *Renaissance Art: A Topical Dictionary.* Westport, CT: Greenwood Press, 1987.

Hall, James. *Dictionary of Subjects and Symbols in Art.* Revised ed. Oxford: Westview Press, 1979.

Hartt, Frederick. *History of Italian Renaissance Art.* 3rd ed. Englewood Cliffs, NJ : Prentice-Hall, Inc., and New York: Harry N. Abrams, Inc., 1987.

Hibbard, Howard. *Michelangelo.* New York: Harper & Row, 1977.

Vasari, Giorgio. *Lives of the Artists.* Middlesex, England: Penguin Books, 1972.

CHAPTER 9

Michelangelo Buonarroti, 1475–1564

Many scholars consider Michelangelo the greatest draftsman and sculptor ever born. A prodigy from birth, he ranks among the most brilliant architects, sculptors, and painters in the entire history of art. Even during his life scholars and critics considered him the greatest and elevated him to the status of divine.

For all that he accomplished, it seems impossible that in the beginning the youth Michelangelo disliked school. In fact, he left his classes to watch artists work and, to the consternation of his teachers, drew in his books. Despite this dislike, throughout his life he wrote in an exceptionally elegant hand and communicated easily and fluently with the most erudite. From youth he possessed a natural magnificence. Unrelenting and indomitable, he did not hide his formidable and fierce personality in his art. With no explanation for his extremes and bursts of intensity, Hibbard says, "psychoanalysts have tried to explain Michelangelo's personality and art by calling attention to his supposed rejection by his mother, but we know nothing about their relationship" (Hibbard, p. 15).

In the history of art, Michelangelo's painting, sculpture, and architecture are the culmination of the Florentine tradition beginning with Cimabue and Giotto in the late 1200s and early 1300s. Subsequently, Florentine art came to full bloom in the architecture of Brunelleschi, the sculpture of Donatello, and the painting of Masaccio. These artists created the new style of the 1400s and from this perfect plateau Michelangelo's work grew.

Michelangelo's Life

Italian painter, sculptor, and architect, Michelangelo di Lodovico Buonarroti Simoni (his baptismal name) was born in the small town of Caprese near Arezzo

161

in Florentine territory, Italy, March 6, 1475, about eight o'clock at night. His mother was Francesca di Neri (1455–1481). His father, Lodovico di Lionardi Buonarroti Simoni (1446–1531), 31 years old at the time, wrote the details of the birth of his second son using Florentine calendar computations, not the Nativity of Christ: "'I record that on this day the 6th of March 1474 a son was born to me . . . and he was born on Monday morning before 4 or 5 o'clock . . . at Caprese" (Bull, p. 7).

From the beginning, sensing he had an inordinately special child, Lodovico, a *podestá* or provincial administrator (mayor) at the time, named his son Michelangelo, spelled Michelangiolo in Florence (Florentia). Although the full form of his name was Michelagniolo di Lodovico Buonarroti-Simoni, Giorgio Vasari called him Michelangnolo (Goldscheider, p. 5).

Although Lodovico wanted his child to become a government bureaucrat, he believed the boy was inspired by heaven; he was convinced he saw in the infant something curiously supernatural, even beyond human experience. A superstitious man, he noted that his son's horoscope showed Mercury and Venus in the house of Jupiter in perfect harmony. Based on this, he believed his son would be exceptional and that not only his mind but also his hands were destined to create noble works of painting, sculpture, and architecture. Curiously, no one is sure how Michelangelo, who became a great sculptor, learned to carve marble. But as a child he learned quickly and easily anything he put effort into.

After Michelangelo's birth Lodovico didn't remain in Caprese because his term in office had expired. According to Hibbard, "less than a month later the family moved back to a high, dank house [in the Via de' Bentccordi] near the church of Santa Croce in Florence" (Hibbard, p. 15). In this section of Italy one finds stone in abundance, also stonecutters and sculptors. Hartt writes that the wife of a local stonecutter, a woman named Settignano, took the baby Michelangelo in to nurse where he "was, as he put it himself, 'drinking in the love of stonecutters' tools with his wet-nurse's milk'" (Hartt, p. 460). Michelangelo did not return to his family until he was two or three years old. By the time he was six years old his mother was dead.

Eventually, Lodovico found himself in such difficult financial circumstances he had to place his sons with the Wool and Silk Guilds. It was thus that at age seven Michelangelo went to grammar school, where he came under the tutelage of Francesco da Urbino. Scholars agree Michelangelo did not like school, although when considering his high level of literacy as an adult one concludes that "he must have had more [schooling] than we know about" (Hibbard, p. 16).

Certainly a mediocre classroom was not the place for a brilliant, gifted child obsessed by drawing, a child who sneaked away to draw whenever and whatever he could, even under threat of punishment. His father wanted him to stay in school and become a responsible, hard-working citizen. In fact, he hoped Michelangelo would become a government bureaucrat. The rest of the family agreed. The older family members probably considered it unworthy for the child to waste his time drawing pictures no matter the degree of his talent.

Although Michelangelo's life has been extensively researched, little has been made known concerning his family members. However, information, not always consistent, abound. According to Ruskin, "Michelangelo was the son of a family of faded aristocratic lineage. . . . An artist was, at the time of Michelangelo, still regarded as an artisan, and his father . . . did everything possible to discourage his precocious boy from his growing interest in art" (Ruskin, p. 21).

Lodovico married again in 1485 when Michelangelo was 10 years old, to a woman named Lucrezia Ubaldini (d. 1497). At this time, Michelangelo lived with his father, his new stepmother, four brothers, and an uncle.

Michelangelo became friendly with several painters trained in the studio of the master Italian fresco painter Domenico Ghirlandaio (1448–1494) and in the Medici Gardens. Among them was Francesco Granacci (1469/70–1543), whose work, mediocre at best, could not compete with Michelangelo's. Granacci was among the first to perceive Michelangelo's genius for drawing. Every day Granacci showed Michelangelo drawings by Ghirlandaio, who had organized a successful and growing workshop in Florence. Every knowledgeable person regarded Ghirlandaio as one of the most accomplished and thriving living masters.

Inspired by not only Ghirlandaio's pictures, but everything he encountered, Michelangelo drew every day, sometimes from dawn to dusk. When Lodovico saw this and knew there was no hope of forcing his son to give up drawing, he decided to have Michelangelo taught by an accomplished master. Thus on April 1, 1488, at age 13, he was properly apprenticed to Domenico Ghirlandaio for a term of three years (Osborne, p. 717). From this master Michelangelo learned the rudimentary elements of drawing. At the time, the artists in Ghirlandaio's workshop worked on the fresco cycle in the choir of Santa Maria Novella in Florence. As testimony to the child's enormous talent, art historians still endeavor to attribute sections of these frescoes to the 13-year-old Michelangelo.

Regardless of his accomplishments at age 13, Michelangelo's gift developed rapidly. He and his art matured quickly, so that an overwhelmed and astonished Ghirlandaio observed him drawing and painting far beyond the capacity of other children his age. Eventually the prodigy's drawings surpassed all the painter's other pupils and, before Michelangelo left his teens, even the master himself.

Examples of Michelangelo's genius abound. A young student working in Ghirlandaio's studio copied some draped figures of women from his work in pen and ink. According to Michelangelo's biographer Vasari, "Michelangelo took what he had drawn and, using a thicker pen, he went over the contours of one of the figures and brought it to perfection" (Vasari, p. 328). Michelangelo's natural abilities and skills far surpassed those of all his contemporaries—students and artists. Vasari says that later in Rome, in 1550 when the 75-year-old Michelangelo saw the drawings, he remembered the figure he had redrawn. "He said modestly that as a boy he had known how to draw better than he did now as an old man" (Vasari, p. 328).

Always energized and inspired, during the three years he spent studying in Ghirlandaio's workshop, Michelangelo drew everything he saw, even the most

insignificant objects. He drew numerous sketches of Ghirlandaio's students helping the master. When Ghirlandaio studied Michelangelo's drawings, he admitted that he saw more genius in his young student's quick, offhand sketches than he himself had been born with. The originality, maturity, and sensitivity of a child so young surpassed his belief. The young boy's drawings revealed qualities beyond what one might find in the work of an older artist who had been drawing and training for years.

During these formative years Michelangelo never once thought of leaving his gift undeveloped. He drew assiduously and studied the work of other artists every day and, as time progressed, drew figures to a perfection other artists could not reach. Most scholars agree, however, that from Ghirlandaio he probably learned not only drawing, but also the fresco technique, which involves painting on wet or dry plaster. Murry and Murry say, "it must have been Ghirlandaio who taught him the elements of fresco technique, and it was probably also in that shop that he made his drawings after the great Florentine masters of the past" (Murry and Murry, p. 293). His training in fresco painting later proved invaluable. It provided him the knowledge and ability to paint the now famous ceiling and the back wall of the Vatican's Sistine Chapel in Rome. Also, it was under the influence of Ghirlandaio's drawing technique that he began to use heavier, darker, more powerful crosshatching, or shading with parallel lines to vary lights and darks. The energy of his lines impressed Ghirlandaio, whom his contemporaries considered a master connoisseur of drawings.

On one occasion Michelangelo copied an engraving by the German engraver–painter Martin Schongauer (c. 1430–1491), who had always been an inspiration. He was the most famous artist of his day in Germany (followed by Dürer); his works "were among the first truly artistic renderings of popular religious imagery" (Osborne, p. 1049). Michelangelo's remarkable sketch of Schongauer's engraving, retaining Schongauer's unusual, personal emotional imagery, astounded all who saw it. The work also brought the young artist attention in that he had drawn a perfect pen-and-ink copy of Schongauer's famous engraving that depicted, in great detail, St. Anthony tormented by his demons. (St. Anthony, although devoting his entire life to self-denial and spiritual growth, found himself tempted by erotic visions. His long and intense struggles against visions and dreams he called his demons, in the form of monsters, became a popular subject in art.)

Michelangelo remained with Ghirlandaio only a short time. Hibbard says that "Michelangelo's apprenticeship lasted only a year or so, but it was fruitful" (Hibbard, p. 17). After this, around 1489 or 1490, a new opportunity came his way: a new school located in the Medici gardens, established by the ruler of Florence, Lorenzo, called Lorenzo il Magnifico (the magnificent) (1449–1492), the Italian merchant prince and patron of the arts.

During the fifteenth century Lorenzo housed a treasure of the rarest, most expensive antiques of the day. He kept them in his garden on the Piazza di San Marco and employed Italian sculptor Giovanni di Bertoldo (1420?–1491) to maintain the collection. Lorenzo also kept the artist employed as a teacher. Con-

temporaries knew Bertoldo, a former pupil of Donatello, for having "developed a new type of sculpture—a small-scale bronze, intended, like the small illustration known as the cabinet picture, for the private collection" (Osborne, p. 132). Oddly, when mature and successful, Michelangelo, having attended the school as a student and having been in Bertoldo's classes, did not ever mention him.

When organizing his school, Lorenzo had looked to locate only the brightest, most talented students. To find them, he asked Domenico Ghirlandaio to send his most gifted students to him, and he promised they would receive only expert training. Shortly thereafter, Ghirlandaio sent Lorenzo his most promising young sculptors, Michelangelo among them. It was thus that Michelangelo transferred from Ghirlandaio to the new school, a different learning environment. When the young artist arrived at the school he began his stay with Lorenzo by watching a student form a clay figure. It wasn't long before he too began to make figures.

Bertoldo also taught Pietro Torrigiano (1472–1528). At the time Torrigiano learned to model figures in clay, and it is thought Michelangelo learned the technique also. Curiously, though they may have worked together, they never became friends, and in fact, over time they became enemies. According to Hibbard, "Torrigiano, at first a friendly rival of Michelangelo's, became so jealous of the young prodigy that he hit Michelangelo in the nose, breaking it and disfiguring him for life" (Hibbard, p. 20). With no way to straighten his flattened nose, Michelangelo kept the ugly mark for life, a terrible wound for one so acutely aware of beauty. After this, Florentines who loved Michelangelo hated Torrigiano and ran him out of Florence. Because of his violent temper, Torrigiano could not stay out of trouble. A while later the leaders of the Roman Inquisition called him before their court, but before they finished their interrogations he stopped eating and starved to death. Before he died, Torrigiano was uncharacteristically helpful regarding Michelangelo's influences, confirming that he studied the young Italian master Masaccio (1401–1428). Determined and persistent in everything he did, Michelangelo had spent months in the church of Santa Maria del Carmine in Florence making copies of the frescoes of the talented young Italian painter Masaccio (1401–1428). In the Carmine one finds, among many other of Masaccio's works, the fresco *Tribute Money,* c. 1427, a painting greatly revered by Michelangelo.

Sometime later, when Lorenzo saw Michelangelo's sculpture, he was overwhelmed with not only the boy's talent but also his ambition and ability to learn. Lorenzo became Michelangelo's patron. Thus, when only 15 years old, Michelangelo copied an old and wrinkled antique faun's head in marble that Lorenzo kept in his garden. (A faun has the body of a man, but the horns, pointed ears, tail, and hind legs of a goat.) Although this was Michelangelo's first attempt at working with marble, he impressed Lorenzo with his achievement. Michelangelo had altered the model by carving the old faun's mouth with all its teeth. Lorenzo told him it was impossible to see old people with all their teeth. Michelangelo agreed and chiseled out one of the faun's front teeth. When Lorenzo saw the faun with

one tooth missing, he laughed; after that, he loved telling his friends the story. After this incident, he promised to assist the young sculptor all he could.

Later, when Lodovico agreed that his son could move into Lorenzo's household, Lorenzo gave Michelangelo a room of his own and cared for the boy as if he were a respected member of the Medici household. The 15-year-old ate at Lorenzo's table with the sons of the family and any guests, even important dignitaries, who sat at the table. The Medici dressed him as one of their own and treated him with kindness and high regard. In this way, exposed everyday to Italy's most refined, genteel company, the most elegant manners and gracious people, he grew up a gentleman.

While attending school in the sculpture garden, Lorenzo paid Michelangelo five ducats a month. Responsibly, the boy gave all of it to his father. Lorenzo also appointed Michelangelo's father to the post of excise or tax officer in the customs office, a job he came to like, although he later lost it. Besides the salary, Lorenzo gave Michelangelo a purple cloak he had coveted; in general, Lorenzo gave Michelangelo the best of all he wanted.

Michelangelo also copied the frescoes of the Florentine proto-Renaissance painter Giotto (1266/7–1337) with impressive exactness, and around 1489 he carved the famous *Madonna of the Steps*, revealing his earliest known draped figures.

It was thus that the boy lived with the Medici for four years until Lorenzo died April 8, 1492. Piero de' Medici invited Michelangelo to live in the palace again but gave him only one commission—to build a snowman.

When he was 16, to further his education, Michelangelo studied under Lorenzo's tutor, Angelo Poliziano or Politian (1454–1494), Italian poet in Latin and Italian, philologist, and humanist. Still working with stone, Michelangelo carved a piece of marble given to him earlier by Lorenzo, a scene he named *The Battle of Hercules with the Centaurs*. He stopped working on it just before Lorenzo died in 1492 and, typically, left it unfinished. The piece was so accomplished that everyone who saw it said it could not have been carved by a 16-year old boy; it must have been the work of an advanced master. *Hercules and the Centaurs* exists today because Michelangelo's nephew Lionardo kept it in memory of the artist after his death. He also kept a little marble *Madonna* in bas-relief (sculpture in which the figures project only a little from the background), only two feet high. Today it is the only existing sculpture in bas-relief by Michelangelo.

Along with all his other talents, Michelangelo had learned to copy the works of old masters with exactness. At times he even burned his copies around the edges, a technique to make them appear darkened and mutilated by age. He let them steep in smoke and sometimes buried them in dirt for weeks. In the end no one could tell his drawings from the ancient originals. He transformed his work in this way to trade his copies for the originals, which, ironically, he sometimes surpassed with his own copies.

But Michelangelo's life changed dramatically after 1492, after the death of his patron Lorenzo. Then 17 years old, he returned home to live with his father. At

this time he began work on a huge block of marble and from it carved an eight-foot statue of Hercules. The *Hercules* remained on display in the Palazzo Strozzi for several years until the Florentines sent it to France as a gift to King Francis, where it found its way to Versailles and then disappeared.

A natural carver of stone, Michelangelo used materials other than marble for his sculpture. He carved, for example, a wooden crucifix for the area above the lunette (architectural shape like a half circle) of the high altar for the Florentine church of Santo Spirito. He made this crucifix because the prior had given Michelangelo permission to use his personal rooms to dissect cadavers to study the bones and muscles of the human body. These studies gave him the understanding of human anatomy, the comprehension of which is necessary for sculpture. Working on cadavers gave him the more precise powers of composition he used for not only sculpture but also for painting. He put his private anatomy lessons to good use for the rest of his life and, in fact, sculpted and painted human figures almost exclusively.

A few weeks before the ruling Medici left Florence, after the tide of feeling began to turn more strongly against them and they were expelled temporarily, Michelangelo left for Bologna. He traveled to Venice, where the talented of the day congregated. But he was unable to find any means of making money in Venice, so, disappointed, he returned to Bologna. However, when he entered the city gate, he thoughtlessly did not obtain the password for leaving. (Foreigners who could not give the password to exit had to pay a penalty of 50 Bolognese lire.) Michelangelo, having no money to pay the fine, visited Giovan Francesco Aldovrandi, one of the Sixteen of the Government. The man had sympathy for him, and they became friends. After this he allowed the artist to live in his own home, where Michelangelo remained for over a year.

In Bologna, Aldovrandi took Michelangelo to see the tomb of San Domenico (1170–1221), founder of the Roman Catholic Order of Preachers in 1216 called Dominican or Black Friars. The tomb had been carved by Giovanni Pisano (c. 1245/50–after 1314) with the help of a lesser-known artist. Original statues of an angel holding a candelabra (a large branchlike candlestick) and a St. Petronius (Bishop of Bologna, who died about 450) no longer stood at the tomb. Aldovrandi, who wanted to restore the tomb, asked Michelangelo if he would carve an angel with candelabra and a statue of St. Petronius. Michelangelo agreed and in 1495 carved three statuettes about two feet high for the tomb to repay Aldovrandi for his kindness.

Aldovrandi continued to enjoy Michelangelo's company, especially his evenings when Michelangelo read him works by the Italian poet Alighieri Dante (1265–1321), Italian poet and humanist Francesco Petrarch (1304–1374), and Italian author Giovanni Boccaccio (1313–1375). After a year had passed, Michelangelo returned to Florence, where he carved for Lorenzo di Pierfrancesco de'Medici a marble statue of the youthful St. John, now lost.

Then, Cardinal San Giorgio called Michelangelo to Rome to work for him. He was in Rome June 25, 1496, and remained with the cardinal 10 or 11 months; he stayed in Rome for the next five years. Historians find Michelan-

gelo's stay with the Cardinal San Giorgio especially noteworthy because the Cardinal was not a patron of the arts. According to Vasari, "he [Michelangelo] was summoned to Rome to enter the service of Cardinal San Giorgio, with whom he stayed nearly a year, although the cardinal, not understanding the fine arts very much, gave him nothing to do" (Vasari, p. 335).

While in Rome Michelangelo carved his first large-scale marble sculpture, the *Bacchus* (1496–1498), an over-life-size pagan rather than Christian work that was so well executed it rivaled antique statuary. Jacopo Galli purchased the Bacchus, and it remains in Florence at the Museo Nazionale del Bargello.

Also, at this time in Rome Michelangelo began work for the Cardinal Jean de Villiers de la Groslaye on the most famous of all Michelangelo's marble *Pietàs*. Carved between 1498 and 1499, it was destined for the basilica of St. Peter's. Completed before the artist reached his twenty-fifth birthday, it is the only work he signed.

After this Michelangelo returned to Florence, where he carved the marble *David* between 1501 and 1504. *David*, the artist's most famous sculpture, became the symbol of Florence. Yet, even while working on the *David,* he was commissioned in 1502 to cast a bronze *David*, which was sent to France and has since been lost. Also, after carving several other figures, he was commissioned to paint a mural, the *Battle of Cascina* for the Sala dei Cinquecento of the Palazzo Vecchio. Its location was to be across from Leonardo's *Battle of Anghiari*, but neither artist finished the commission beyond drawing a cartoon or preliminary drawing. Michelangelo drew a series of figures, both clothed and nude in a vast array of poses, that became a prelude to his next commission, the ceiling of the Sistine Chapel in the Vatican.

When called to Rome again in 1505 by Pope Julius II, Michelangelo accepted two commissions. One was for the ceiling in the Sistine Chapel, the first half of which he finished in 1510. The second commission was for Julius II's tomb. While in Rome at this time he examined many of the newly discovered classical statues, such as the Greek marble from Titus's palace in Rome, the early first century A.D. *Laocoön*.

He began work on the frescoes for the ceiling in 1508 and worked on them until 1512. The second commission Julius II hoped would be the most magnificent tomb ever produced. He wanted it to be located in the new St. Peter's, then under construction. For the tomb, Michelangelo planned 40 figures of Carrara marble (a fine white marble that would take months to quarry outside the city of Carrara in northwest Italy) before he could begin work. However, the pope, experiencing a shortage of money, ordered Michelangelo back to the Sistine Chapel ceiling. Finally, when he returned to the tomb, he redesigned on a more modest scale, although the sculpture program included his famous *Moses* (c. 1515).

Turning to architecture, in the 1520s Michelangelo designed the *Bibliotheca Laurenziana* or the Laurentian Library and the entrance hall for it. Rather than use the classical language of architecture articulated by the Greeks, he designed

his own columns, entablatures, and pediments and produced the most unusual vestibule the world had ever seen.

In addition, Michelangelo also took the commission for the Medici tombs located in the New Sacristy of San Lorenzo. For Giuliano de' Medici, duke of Nemours, and Lorenzo de' Medici, duke of Urbino, Michelangelo designed two large wall tombs facing each other. Work on the two tombs continued with assistants even after the artist returned to Rome in 1534.

In 1536, in Rome, Michelangelo began painting the largest fresco of the Renaissance. He completed it in 1541. It depicts the *Last Judgment* on the back or altar wall of the Sistine Chapel. Although he painted every figure in the nude, 10 years later Pope Paul IV (1446–1559, pope 1555–1559), during his campaign to abolish corruption, rid the church of worldliness, and purify the clergy, ordered drapery painted over some nudities. Italian mannerist painter and sculptor Daniele da Volterra (1509–1566) completed the drapery between 1559 and 1560. During that time he gained the nickname "Breeches Maker." A friend of Michelangelo, Volterra was at his side when he died.

After working on the Sistine Chapel Michelangelo again directed his work toward architecture. On Capitoline Hill, the civic and political center of the city of Rome, renovations were in progress for the buildings surrounding the Campidoglio or Capitol. Michelangelo designed the plans, not put into effect until the late 1550s and not finished until the seventeenth century, around an unusual oval shape. In addition to this uncommon shape, for the façade of the Palazzo dei Conservatori he created a new unity for public architecture using Roman architectural vocabulary.

Finally, in 1546, Michelangelo took responsibility for the altar end of the new St. Peter's on the exterior and for the dome above the giant crossing. When he finished his model for the dome in 1561 he was 86 years old.

Devoting a long life to painting, sculpture, and architecture,

Michelangelo lived to be nearly ninety. With typical bitter humor he described himself in his declining years: "My teeth rattle like the keys of a musical instrument; my face is a scarecrow; In one ear a spider spins his web, in the other a cricket chirps all night; my catarrh rattles in my throat and will not let me sleep. This is the end to which art, which proves my glory, has brought me." (Ruskin, p. 38)

Madonna of the Steps, 1489–1492

Before Michelangelo was 18, he carved (in a style he never used again) his first extant work and his first religious sculpture, a small marble bas-relief, or low relief, the *Madonna of the Steps* (21 3/4 inches x 15 3/4 inches). At this time he was influenced by Donato Donatello's (c. 1386–1466) daring new bas-relief technique *rilievo schiacciato,* Italian for "squashed relief," which he had used on the base for his St. George statue. Also, the Madonna recalls Donatello's powerful figure types, a type Michelangelo found himself drawn to. Equally as im-

portant as Donatello's influence were ancient marble reliefs and cameos in the Medici collections.

Curiously, Michelangelo did not completely finish or explain either the Madonna or the background, and much controversy exists. For example, puzzling children in the distance could possibly be angels, and the balustrade might mean the wood of the coming Cross. The cloth the children hold might be Christ's wrapping sheet. Also, Hibbard says, thinking beyond the figures:

> [T]he cube on which the Virgin sits might symbolize a kind of Pythagorean or Hermetic perfection; it is also stone, which recalls an image often found in earlier writings—the Virgin seated *super petram* [on the rock of the church]. The foundation stone of Christianity is of course Christ, whom she holds. (Hibbard, p. 28)

But beyond any symbolism Michelangelo might have intended, *Madonna of the Steps* has a classic grandeur and harmonious profile that recalls fifth-century grave stelae or grave markers. The briefest observation reveals why later critics commented that his figures, although clothed, appeared nude: The relief features his earliest known draped figure. He carved silklike material that falls over the figure and the stone cube upon which the Madonna sits. The illusion of silk made from carved stone illustrates his early virtuosity with marble, his ability to render an extremely low relief effectively.

In a usual presentation, Mary holds her child against her breast, staring into space possibly as a seer, contemplating Jesus' coming sacrifice. The child is asleep in a position that causes his bare back to face the viewer. His right arm, twisted behind him is large and powerful. Hartt noted, "[T]he back and right arm of the Christ Child are extraordinary, already surpassing the greatest sculpture of the Early Renaissance in fullness of muscular power" (Hartt, p. 461). A sadness predominates and persists throughout the relief and might be Michelangelo's personal way of pointing to Christ's pending sacrifice.

Finally, although he never finished the relief, Michelangelo carved, around the outer edge, a narrow frame that accentuates the extreme shallowness of the carving.

Besides the *Madonna of the Steps* relief, the most important work of Michelangelo's youth, before he was 25, was the *Pietà* for St. Peter's.

The *Pietà*, 1497–1500

In Rome, 23-year-old Michelangelo carved his first real masterpiece, the famous *Pietà* or the *Madonna della Febbre*. He carved it for the tomb chapel of French cardinal Jean de Villiers de la Groslaye, French Ambassador to the Holy See or court of the Pope. Before he began, a 150 ducat price appeared on the August 17, 1498, contract. The tomb chapel for which Michelangelo carved the statue was located in St. Peter's, although, according to Hibbard, "the Cardinal died on 6 August 1499 when the sculpture meant for his tomb chapel in St. Peter's was probably still unfinished" (Hibbard, p. 43).

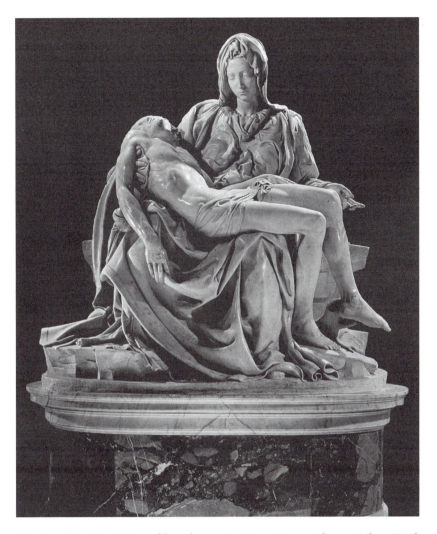

Michelangelo's *Pietà,* 1500 marble sculpture, Saint Peter's, Rome. The Art Archive / Dagli Orti.

With white Carrara marble, Michelangelo produced the *Pietà,* one of the world's most famous works; like Leonardo's *Mona Lisa,* most individuals have heard of it. The large sculpture must have seemed an anomaly to astonished Romans who gathered to see it for the first time because they had never before seen the subject. Some of Michelangelo's contemporaries found it heretical. In fact, according to Goldscheider, "an orthodox writer of 1549 describes it as a 'Lutheran notion'" (Goldscheider, p. 10). The idea of Mary holding the dead Christ on her lap is not Italian. A German creation, it reached France in the 1300s. The French Cardinal had seen the subject; the Italians had not. Not totally unknown, though, Hibbard says that "by 1497 a number of sculptured Northern Pietàs had reached Italy and a few Italian paintings of the subject ex-

isted" (Hibbard, p. 45). Most individuals, however, had not seen one either in painting or in sculpture and in the beginning many of them resisted the idea.

The *Pietà* (Italian for pity), is an uncommon representation of the Virgin Mary grieving over the body of her son (who is dead and rests on her lap). This scene occurs after the Crucifixion and the Deposition, or bringing the body down from the cross. Usually, but not always, artists depict the sorrowing Virgin alone with Christ's dead body. "No mention is made of this theme [Pietà] in the Gospels, but the subject is found in the Byzantine painter's guide, in the *Revelations of Saint Bridget* of Sweden (fourteenth century), and the *Meditations* of Giovanni de Caulibus (thirteenth century)" (Earls, p. 228).

Actually, the subject depicts one of the Seven Sorrows of the Virgin, the Virgin as the Mater Dolorosa, or the grieving mother. Artists used the ideas as subjects of devotion in the fifteenth century. The other six sorrows are *Flight Into Egypt, Christ Lost by His Mother, Bearing of the Cross, Crucifixion, Descent from the Cross,* and *Ascension* (when Christ finally parted from his mother) (Hall, p. 325).

In this version, Michelangelo chose to seat Mary on the rock of Golgotha on which Christ's cross had been placed. He created an enormous pyramid (the statue is 68 1/2 inches tall), with a seated Virgin Mary large enough to hold the body of her dead son without appearing overwhelmed. On her lap, the dead body of Christ flows, almost like silk, along the lines of her robe. Every fold of Mary's drapery, deeply cut, Michelangelo polished, and each one reveals his love of intricate detail. Her face is as beautiful as Michelangelo could envision and is finished with finely incised detail. Her son's face is as handsome as the artist could imagine a man to be. Most critics agree that the technical virtuosity Michelangelo displayed here as a young man he never surpassed. Although this is the only work he signed, it wasn't until after the statue had been displayed that he carved his name across the sash over Mary's chest.

Vasari gives the reason for the signature:

> The reason [was] that one day he [Michelangelo] went to where the statue was and found a crowd of strangers from Lombardy singing its praises; one of them asked another who had made it, only to be told: 'Our Gobbo from Milan.' Michelangelo stood there not saying a word, but thinking it very odd to have all his efforts attributed to someone else. Then one night, taking his chisels, he shut himself in with a light and carved his name on the statue. (Vasari, p. 336)

The statue was not without criticism. According to Osborne, some who saw the large statue did not approve of its realistic qualities. "There is a story that objection was taken to the fact that the Virgin seemed too young to be the mother of the dead Christ, and Michelangelo countered this by observing that sin was what caused people to age and therefore the immaculate Virgin would not show her age as ordinary people would" (Osborne, p. 718).

Following the adverse comments made about Mary's age, an insignificant Italian painter Ascanio Condivi (d. 1574), one of Michelangelo's pupils, wrote in 1553 his *Life of Michelangelo.* He included Michelangelo's counter statement in this work. "'Do you know,' [Michelangelo] said, 'that chaste women retain their

fresh looks much longer than those who are not chaste?'" (Hibbard, 48). Most historians agree that Condivi wrote from intimate personal knowledge, that often Michelangelo dictated letters to him. Many scholars believe that Michelangelo said what Condivi wrote concerning Mary's purity.

Originally officials installed the *Pietà* in the *Petronilla* chapel, the French chapel of the old St. Peter's, demolished in 1535. In 1749 officials placed the *Pietà* in the *Cappella del Crocifisso* or *Cappella della Pietà*, where it remains. It would seem that the statue would be safe from harm in St. Peter's, but twice it has been damaged. On the Madonna's left hand four fingers were broken off and restored in the eighteenth century. In 1972 a man with a hammer damaged Mary's face, and restorers mended it.

The display of this great statue has never been to the liking of many critics and art historians. Its placement is mentioned by Hartt: "Today one must view the work against a Baroque background of multicolored marble, whose opulence would certainly have offended Michelangelo; also, it is raised to such a height that in order to see it at all from below it had to be tilted forward by means of a prop of cement inserted at the back" (Hartt, p. 464).

Late in his life, Michelangelo carved more Pietàs, including one he intended to stand at his own tomb. In view of a fascination with one particular subject, Hibbard says, "we can at least ask whether the particular theme so moved him because of his own missing mother, even though such a question might appear foreign to so exalted a work of art" (Hibbard, p. 46).

Following the *Pietà,* on August 16, 1501, Michelangelo signed a contract with the *Operai* of the Cathedral in Florence to carve, in two years, a statue of David.

David, 1501–1504

Michelangelo carved the marble *David* in Florence from a marble block called "the giant" previously ruined and abandoned by perhaps the sculptor Agostino di Duccio or Baccellino, who had attempted unsuccessfully to carve a *David*. Of this disfigurement of marble, Hibbard says, "[T]here is simply no point in trying to imagine what condition the block was in before he [Michelangelo] started to carve—all that can be known now is that some kind of figure had been begun" (Hibbard, p. 56).

By the time he began the huge statue, Michelangelo had become the most important sculptor in Italy, but the *David* established him as the number one artist in Florence. The *David,* representing the shepherd boy who became king of Israel, was meant to be placed on the tribune or supporting buttress of Santa Maria del Fiore, the Cathedral of Florence. Vasari writes that the plans didn't work out that way. "When the work was finally finished he [Michelangelo] uncovered it for everyone to see. And without any doubt this figure has put in the shade every other statue, ancient or modern, Greek or Roman . . . To be sure, anyone who has seen Michelangelo's *David* has no need to see anything else by any other sculptor, living or dead" (Vasari, p. 339). Once complete, no one thought about hoisting it up onto the buttress. In-

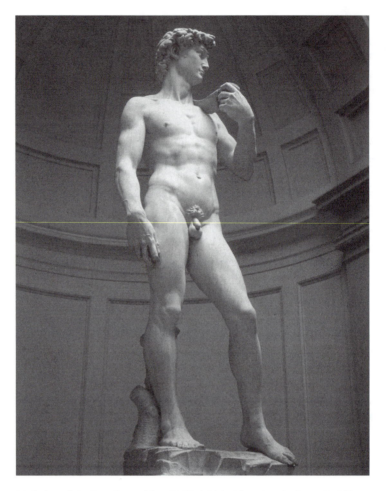

Michelangelo's *David,* marble, 1501–1504. The Art Archive / Galleria dell'Accademia, Florence / Dagli Orti.

stead, it was taken to the Piazza della Signoria in May of 1504. However, according to Goldscheider, it didn't remain there: "In 1873 the statue was removed to the Accademia and a marble replica was placed in front of the Palazzo Vecchio" (Goldscheider, p. 10). Today the original is in the Galleria dell'Accademia in Florence.

Although with modern-day photography, scholars have the means of capturing the most minute details and close-ups, one must be aware that it was not Michelangelo's intent for anyone to view any part of the *David* up close. Having carved the statue for a buttress on the Florence Cathedral, which would have placed it high above the pavement, he knew the features, large and overemphasized, would be seen from far away. One should also consider what Michelangelo intended. Hibbard called it "a psychologically charged pause of apprehension before doing battle with Goliath" (Hibbard, p. 61). To depict this, he needed deeper carving for a more dramatic sculptural chiaroscuro to convey

to viewers below this "pause of apprehension." Earlier sculptors such as Donato Donatello (1386–1466), with his famous bronze *David*, had shown the hero and traditional author of the Psalms after his victory and thus had no need to present hints of premonition or anxiety.

Michelangelo's *David*, a valiant hero of perhaps 16, not completely grown, stands in the typically favored Greco-Roman pose. At over 16 feet, 10 1/2 inches high including the base, miraculously he neither walks nor stands still. He is in ponderation or the *contrapposto* pose, that is, the asymmetrical arrangement of limbs with the weight mostly put on one leg. This pose gives the body a sense of normal action and the possibility for movement in any direction with any limb. David's body depicts the Greek athlete, the Hellenistic youth, strong and perfect, fluid, able to move quickly and accurately.

Of this tense, taut pose that appears so calm yet is actually "ready to spring into action," Ruskin says, "when it was finally unveiled two years later, the feverishly awaited *David* struck awe into all who saw it. . . . He [David] turns to look out at the world with proud defiance" (Ruskin, p. 24).

Besides his success with the *David* and an enormous talent as a sculptor, Michelangelo painted with oil and with fresco, and as with all other endeavors, he surpassed his contemporaries. The Sistine Chapel Ceiling frescoes in the Vatican on the vault of the papal chapel include nine scenes from the Book of Genesis. So powerful were the images he created, so perfect was the human anatomy that with this enormous undertaking Michelangelo changed the course of art.

The Sistine Chapel Ceiling, 1508–1512

Before Michelangelo's work, the vault of the Sistine Chapel in Vatican City, Rome, was painted blue and punctuated with flat gold stars. Although Michelangelo insisted he was not a painter and his interest in painting was not primary (his major works until then had been in sculpture), Pope Julius II, in 1508, insisted he take the commission to paint the ceiling of the Sistine Chapel.

At the time Michelangelo was inexperienced in the technique of fresco, or painting on wet plaster. Even more daunting were the ceiling's height (nearly 70 feet above the pavement), the complex problems presented for perspective by the vault's curve and height, and the ceiling's dimensions (5,800 square feet, or 128 feet by 45 feet). Yet, in spite of nearly insurmountable obstacles, miraculously, in less than four years he produced a fresco unprecedented in the history of art.

As part of the ceiling, Michelangelo painted, seated on marble thrones on both sides of the ceiling, scenes from Genesis and five pagan sibyls, or women endowed with the gift of prophecy from classical antiquity who foretold the coming of Christ. He alternated the sibyls with Hebrew prophets who had also prophesized the coming of the Messiah. He arranged the prophets so they face the sibyls across the ceiling. The thrones, painted to appear as marble, are a part of the simulated architecture of the ceiling. Also, sky can be seen above the thrones of the prophets and the sibyls at either end of the ceiling. Hibbard states

they are strategically placed. "The Prophets and Sibyls are clearly to be understood as sitting in front of the Ancestors of Christ, painted in the spandrels and lunettes [or half-round shapes]" (Hibbard, p. 105).

Down the center, at the apex of the vault, facing east, the *Last Judgment* wall, is the *Separation of Light from Darkness*. Next to this is *The Creation of Sun, Moon, Plants; The Separation of Land from Water; The Creation of Adam; The Creation of Eve; The Expulsion of Adam and Eve from the Garden of Eden; the Sacrifice of Noah; The Flood;* and the *Drunkenness of Noah.*

Furthermore, the vault ceiling has four corners in the shape of pendentives or triangular pieces of vaulting springing from the corners of a rectangular area serving to support a rounded or polygonal dome. In these areas Michelangelo painted four Old Testament scenes: *Moses and the Serpent of Brass, David and Goliath, Judith and Holofernes,* and *The Death of Haman.* He placed Zechariah and Jonah at either end as balancing figures.

Then, filling the triangular areas above the windows, *ignudi*, or nude youths, accent the corners of the central panels. In grisaille, or painting using only gray tints and giving the effect of sculpture in relief, Michelangelo painted pairs of putti or young children. He used these figures to appear to support the painted cornice, somewhat like a frame, surrounding the entire central panel.

Moving to the central panel, Michelangelo painted the *Creation of Adam.* Here, Adam, whose name means "earth," on the left, barely able to lift his left arm, confronts God, gigantic and menacing yet extraordinarily paternal, and only inches away from touching Adam's finger. Soon, Adam, love for God in his eyes, will begin to breathe. Waiting for God's signal, he reclines in a barren landscape, except for the cornucopia bursting with leaves and the acorns of the Della Rovere family. (Acorns are symbols for the Church and here they appear to grow from the dry ground.) All the former magnificence and glory, the gold and ornamentation found in medieval depictions of God no longer exist. Here, radiating dreadful power, God wears only a simple tunic which, nearly transparent, reveals the mightiness of his body. God's frightening right arm, bare, is an arm of such immense power that nothing like it has been seen in any work of art prior or even after its execution.

Then, beneath God's left arm is a small, cringing female peeking out at the world who might represent Eve, though recently Kleiner and Mamiya "have suggested she may be the Virgin Mary (with the Christ Child at her knee). If the new identification is correct, it suggests Michelangelo incorporated into his fresco one of the essential tenets of Christian faith. This is the belief Adam's original sin eventually led to the sacrifice of Christ, which in turn made possible the redemption of all humankind" (Kleiner and Mamiya, p. 651).

The *Last Judgment* on the Altar Wall of the Sistine Chapel, 1534–1541

On September 25, 1534, Pope Clement VII had the idea of a new decoration for the back or altar wall of the Sistine Chapel, the Resurrection of Christ. So

intent was he on the project that a scaffold was already in place. However, only days after Michelangelo arrived in Rome in September of 1534, the Pope died suddenly, aged 56. A Roman cardinal named Alessandro Farnese (1468–1549) became pope in 1534.

The new Farnese pope became one of the most astute diplomats of the church. He opened a new era in the papacy, historically known as the Catholic Reformation, a time when the church had to face a growing Protestant religion. According to Hibbard: "Paul III in his own person illustrates the transformation from Renaissance to Counter-Reformation. He had sired four children as a younger cardinal, but his reign 1534–1549 marks the true beginning of internal reform of the Church" (Hibbard, p. 240).

From the beginning, Farnese, elected as Paul III, coveted a work by Michelangelo. This interest extended to continuing the decoration of the Sistine Chapel. He gave many commissions to artists, hoping art could help him restore the former glory and prominence needed to boost a post-Reformation Catholic Church. His art patronage, therefore, can be seen as an indispensable part of the Church's Counter Reformation actions.

Primary in all Paul III's papal commissions and one of the first he wanted completed was the back wall fresco for the Sistine Chapel. So adamant was he that he told Michelangelo, who had agreed to paint the giant *Last Judgment* fresco, that he would not be denied. Furthermore, Paul, being completely enamored of Michelangelo's work, made sure the artist stayed busy. Among many other commissions, he made Michelangelo the architect of St. Peter's.

Not only would Paul III not be denied the art of Michelangelo, he kept him so close, according to Hibbard, he would not allow the artist to engage in other commissions. "At the time he was given the unprecedented title of Chief Architect, Sculptor, and Painter to the Vatican palace—Paul wanted his exclusive service" (Hibbard, p. 241).

For the pope's altarpiece on the back wall of the Sistine Chapel, Michelangelo began studying the project with serious intensity and by September of 1535 was preparing the cartoons. On the back wall of the Sistine Chapel Michelangelo depicted Christ reigning from a cloud like an angered tyrant. He painted Christ, his Herculean right arm lifted above his cringing Mother, as if ready to slap down every sinner in the world. His Mother shrinks from the raised hand, from the frightening power. All the while the formidable judge of the world raises the blessed from the dead and issues them, forgiven, into heaven. He holds out his sharply foreshortened left hand to powerfully and with utter finality send to hell all sinners. Into spaces below him, toward the viewer's left, the forgiven ascend. Between heaven and hell, angels blow trumpets and carry out the Divine commands. On Christ's right angels help the sanctified, the saved. On His left, descending figures of the wicked have their evil spirits dragged by the Devil's helpers toward the fires of hell. They struggle to clamber back into the heavens, where they hope God will forgive them. Beneath all this, however, waits Charon in his boat floating on the River Styx. He raises his oar to thrash back without mercy several condemned souls who attempt escape.

Below, in the middle, in the air close to the earth, seven angels with trumpets call the dead to judgment. Two accompanying angels hold a great open book, in which every person reads not only the sins but also the good deeds of his own life. Below, graves open and the dead issue from tombs, crypts, and burial pits. Here Michelangelo painted "Ezekiel's poetic allegory of the valley of dry bones that were reclothed in flesh and restored to life (37:1–14) . . . seen as a prefiguration of the general resurrection of the dead . . . found as a motif in the Last Judgment" (Hall, p. 118).

Beyond this, below and beside God as judge, hover Christian martyrs. They show God the judge their symbols of martyrdom: St. Sebastian shows his arrows, St. Lawrence holds his gridiron, St. Biagio lifts his combs of iron, St. Catherine holds the wheel upon which she was broken, St. Andrew (or possibly the good thief) his cross, and St. Bartholomew the knife with which he was flayed, and his skin, its hanging face a distorted self-portrait of Michelangelo.

Above the saints, to the right and to the left at the uppermost section of the wall are angels wrestling with the symbols of Christ's Passion: the cross, the crown of thorns, the nails, the column of flagellation, and the sponge.

In the end, after Michelangelo finished the wall, Vasari wrote: "Michelangelo laboured for eight years on the *Last Judgment,* and he threw it open to view, I believe, on Christmas Day in the year 1541, to the wonder and astonishment of the whole . . . world. That year, I went to Rome myself, travelling from Venice, in order to see it; and I along with the rest was stupefied by what I saw" (Vasari, p. 383).

"According to [Sydney J.] Freedberg, [*Painting in Italy: 1500–1600*] 'This is the image in which Michelangelo's own *terribilità* [the Italian word for terribleness was sometimes used to describe the austere, tragic grandeur of Michelangelo's work] conjoins absolutely with the meaning and the stature of the theme, and it is his most awesome creation'" (Hibbard, p. 254).

Michelangelo's Roman Architecture

Capitoline Hill—The Piazza del Campidoglio, 1537

Because Rome had no central piazza or square in which to receive dignitaries, Pope Paul III Farnese gave Michelangelo a commission to design one in 1537, even as Michelangelo still worked on the *Last Judgment* fresco on the back wall of the Sistine Chapel. In spite of this, he did not refuse the Pope and in 1537 began the reorganization of Rome's Capitoline Hill, the Campidoglio, albeit too late for an important visit from Charles V (1500–1558), Holy Roman Emperor 1519–1558.

An important location during the Roman Empire, Capitoline Hill had been the site of ancient Roman triumphs. It was the Empire's spiritual capitol, the setting for the chief temple of the state religion and the grandest temple of the Roman world dedicated to Jupiter, *Optimus Maximus.* Also kept on the hill were

the Roman state archives, and sacred relics such as the Etruscan bronze *She-Wolf* c. 500 B.C. Paul III intended to change the hill into an indomitable symbol not only of reformed Rome's power but also that of the Catholic popes.

Having designed a new base for an ancient statue of Marcus Aurelius, Michelangelo planned the new piazza to surround it. Because engravers preserved his design, after his death, construction went mostly according to his plans. In the end, the project was not finished until the mid-seventeenth century.

When designing the large space, Michelangelo's main problem was to incorporate two buildings into his plans. He planned new façades for the *Palazzo dei Senatori*, or Palace of the Senators, to the east, and the fifteenth-century *Palazzo dei Conservatori*, or Palace of the Conservators, to the south. He designed an architectural screen for the palace fronts that would reflect two stories yet remain unified. To do this he put together, for the first time, a ground-floor loggia with a post and lintel system instead of the usual arcade, which had roots going back to the Roman Colosseum (c. 80). He divided each bay or space between the columns with an order of colossal Corinthian pilasters that rise through two stories to support a wide entablature. All of this he surmounted with a balustrade topped with statues. These three façades formed a trapezoidal space approached by a ramp leading into the small end of the trapezoid. In the center is the egg-shaped statue base, rising subtly and elegantly to support the statue of Marcus Aurelius. This commemorates the ancient idea of the Roman capitol as the center of the world in the same way that Marcus Aurelius symbolizes Rome's imperial strength.

In addition to Michelangelo's innovations in the palace façades, another unusual feature in the plan was the oval form. One of the few to discuss how Michelangelo put together the plan is Hibbard: "Michelangelo, who may have invented a compass for inscribing ovals, used it here to unite an irregular space—both centralizing and longitudinal—to emphasize the centrality of the statue and still to encompass the façades of the three palaces, two identical but not parallel, one divergent" (Hibbard, p. 295). Not an easy form to work with, historians must look ahead to the work of seventeenth-century architects of the Roman baroque such as Gianlorenzo Bernini (1598–1680) and Francesco Borromini (1599–1667) to find the oval used in any situation of consequence.

Michelangelo's plans went beyond all architectural expectations. Hibbard details the masterpiece's components: "Despite the fascination of such details, it is the intimate yet monumental grandeur of the Capitol, the unity of diverse parts, the focus within divergent systems—oval, trapezoid, longitudinal—which made this an almost holy space, the most resonant and impressive piece of city-planning ever built" (Hibbard, p. 296).

During his life, because of works like the Campidoglio and the Sistine Chapel frescoes and others, Michelangelo came to be called "divine." His extraordinary accomplishments, including his design for the dome of St. Peter's, remain unequaled. Two generations of Italian painters, sculptors, and architects gleaned ideas from his works and, coupled with their own ideas, moved sculpture, painting, and architecture toward the future.

Michelangelo's Works

Michelangelo's long career, including work as an architect, began in 1516. He worked for princes and popes including Lorenzo de' Medici, Leo X, Clement VII, and Pius III. He also accepted commissions from cardinals as well as poets and painters. He proved beyond any doubt that he was as eminent in architecture as in painting and sculpture. He became one of the greatest creative geniuses in the history of architecture, though even in old age he claimed he had never been an architect. His buildings, many sculptural in appearance, seem as if the masses of a structure were organic forms capable of being molded and carved, of expressing movement, of forming chiaroscuros of light, shadow, and texture. Innovative in many aspects of his work, he also almost single-handedly invented the use of the interior stair as a major sculptural feature of architectural design.

Michelangelo also carved the sculpture for the Medici tombs in the Medici Chapel in San Lorenzo in Florence. The Medici funerary chapel includes the statues of the four phases of the day: *Night*, *Day*, *Twilight*, and *Dawn*. He also carved statues of Guiliano de' Medici, Lorenzo de' Medici, and the Medici Madonna, a statue of the Virgin Mary with her child. Although Michelangelo designed the tombs as honorific monuments for the Medici family, they preserve his genius more effectively than the honor of Guiliano and Lorenzo de' Medici. He also designed the architecture for the chapel.

Other architectural works include the vestibule, or *ricetto,* leading to the *Bibliotheca Laurenziana* or the Laurentian (Medici) Library. This entrance hall, foyer, or room, is the most astonishing part of a design for a project that, even from the beginning, Michelangelo claimed he could not properly execute. When asked to do the work, he confessed: " I will do what I can, although it's [architecture] not my profession" (Hibbard, p. 214).

Astonishingly, age did not slow Michelangelo. Even in advanced old age he remained a ferocious carver of marble.

> A French visitor reported that Michelangelo, even in frail health, could "hammer more chips out of very hard marble in a quarter hour than three young stone carvers could do in three or four . . . and he went at it with such impetuosity and fury that I thought the whole work must go to pieces, knocking off with one blow chips three or four fingers thick, so close to the mark that, if he had gone even slightly beyond, he ran the danger of ruining everything. (Hibbard, p. 282)

At age 71, he accepted the commission to design the colossal dome of St. Peter's. Although he did not live to see it completed, architects did not depart from his design. Today most of the world has seen his dome.

In 1564 Daniele da Volterra watched Michelangelo work all day on a *Pietà,* his last statue. Two days later he became ill. And after two days in bed he died February 18, 1564, in the presence of several doctors and friends, including Volterra, the artist who had painted the drapery on his Sistine Chapel figures.

According to Goldscheider, "the body is taken to the church of the Santi Apostoli and the Pope wishes it to be buried in St. Peter's, but Michelangelo's nephew and heir, Leonardo Buonarroti, secretly removes coffin and body to Florence" (Goldscheider, p. 8).

Florentines buried Michelangelo in Santa Croce, the church of his old neighborhood in Florence. Giorgio Vasari designed his tomb using some of the artist's favorite motifs. But it was not surmounted by the *Pietà* as he had desired. Instead, a bust of the artist, old and with a beard, draped around the neck with heavy cloth, and female statues representing painting, sculpture, and architecture mourning his death adorned it.

Michelangelo's work still astonishes those who see it for the first time. Painters, sculptors, and architects still copy his ideas. If he had not reluctantly become an architect, the domes of St. Paul's in London, St. Isaac's in St. Petersburg (formerly Leningrad), and the Capitol in Washington, DC, would not have their present shapes. Michelangelo, genius, talented beyond measure, infused with supernatural powers, today, hundreds of years after his death, remains one of the major fountainheads of art.

His career, long and fruitful, has not been matched by more than a few artists. When he died at age 89 in 1564 he still worked on Saint Peter's and the Capitoline Hill. Few artists, including his contemporaries, worked without his influence. Differences in his style, both during his life and after his death, even before it matured, provided inspiration and ideas for centuries. His mastery of the nude figure has never been surpassed, and all artists interested in the human body have found Michelangelo their highest inspiration.

Finally, Michelangelo brought a new dignity to the artist as a person. With presence and noble bearing, he raised the station of the artist in society. Thanks to Lorenzo the Magnificent, he was one of few artists to come from a distinguished social background. As a young man he learned manners and kept company with great minds. All he learned he brought to his art.

Bibliography

Bull, George. *Michelangelo: A Biography.* New York: St. Martin's Press, 1997.

Earls, Irene. *Renaissance Art: A Topical Dictionary.* Westport, CT: Greenwood Press, 1987.

Goldscheider, Ludwig. *Michelangelo: Paintings, Sculptures, Architecture.* Greenwich, Phaidon Publishers, 1961.

Hall, James. *Dictionary of Subjects and Symbols in Art.* Oxford: Westview Press, 1979.

Hartt, Frederick. *History of Italian Renaissance Art.* Englewood Cliffs, NJ: Prentice-Hall, Inc., and New York: Harry N. Abrams, Inc., 1987,

Hibbard, Howard. *Michelangelo.* New York: Harper & Row, Publishers, 1974.

Holt, Elizabeth Gilmore. *A Documentary History of Art.* Vol. II. New York: Doubleday & Co., Inc. 1958.

Kleiner, Fred S. and Mamiya, Christin. *Gardner's Art through the Ages.* 11th ed. New York: Harcourt College Publishers, 2001.

Murry, Peter and Murry, Linda. *A Dictionary of Art and Artists.* New York: Penguin Books, 1977.

Osborne, Harold. Ed. *The Oxford Companion to Art.* Oxford: The Clarendon Press, 1978.

Ruskin, Ariane. *Art of the High Renaissance.* New York: McGraw-Hill, 1968.

Vasari, Giorgio. *Lives of the Artists.* Middlesex, England: Penguin Books, 1972.

Raphael (Raffaello Santi or Sanzio), 1483–1520

The youngest of three giants of the Italian High Renaissance (the others being Michelangelo and Leonardo da Vinci), Raphael was a painter and architect. He is best known for his Madonnas, depictions of Mary, the mother of Jesus, and for large figure compositions. Historians admire his work for its clarity, its perfect and balanced composition, its human beauty.

Raphael's work had a tremendous influence on not only his fellow artists, but also on those who followed him, especially painters. Even painters with little talent gained from his ideas. They learned from his perfect symmetry, his softer chiaroscuro, and his delicate modeling of contours. Finally, his simplified colors and his color combinations made an impact on all who saw them.

According to Hartt, "Raphael has stood as the perfect High Renaissance painter, probably because of his idealism. . . . His pictures mirror Renaissance aspirations for human conduct and Renaissance goals for the human mind" (Hartt, p. 471). Raphael painted his figures and backgrounds simple, graceful, smooth, and harmonious, beautifully integrated. His figures move with slow though vital energy. Critics consider some of his paintings, such as the *Sistine Madonna,* to be the most beautiful ever painted.

Raphael's Life

Raffaello Sanzio, or Raphael, was born in Urbino on Good Friday of 1483. He was the son of Giovanni Santi, known as an exceedingly kind man, and Magia de Battista Ciaria, a good and caring mother who died eight years after his birth.

Raphael's father was a minor painter working in the Umbrian School or style of the time. Umbria became known in the fifteenth century for this school of

painting (Earls, p. 292). Such painting involved soft, sweet depictions of figures and scenes. Raphael's father was also a man of culture who stayed close to the advanced artistic ideas at the court of Urbino. Giovanni gave Raphael his first lessons in painting, but the teaching did not continue because he died when the child was 11. By that time, in 1494, Raphael had been introduced to the court of Federico of Montefeltro, a condottiere, or mercenary soldier and also one of the most enlightened patrons of the day in literature and art. It was well known that his library was one of the finest in Italy. Raphael also had access to the Palazzo Ducale, where Italian culture had found one of its most eminent settings. In fact, under the guidance of Federigo, the city became one of the most important centers of Renaissance culture. Hartt tells us that "Raphael . . . was brought up in [Urbino's] extraordinary atmosphere of literary, philosophic, and artistic culture and cosmopolitan elegance" (Hartt, p. 472). Daily he walked among and listened to great minds and he looked upon great art.

Likewise, Frederico introduced Raphael to the works of Florentine painter Paolo Uccello (1397–1475), whose main interest was perspective; Italian painter Luca Signorelli (1441?–1523); and other Italian artists as well as Northern Renaissance artist Hieronymus Bosch (c. 1450–1516). When he was 17 (historians are not sure of the date), his father sent him to Perugia to the great Umbrian master Pietro Perugino. Biographer Vasari says, "When Pietro saw how well Raphael could draw and what fine manners and character he had he formed a high opinion of him, which in time proved to be completely justified" (Vasari, p. 285).

At this time, Raphael spent four years working with Perugino, a master painter, and learned virtually all the master could teach him. From Perugino Raphael learned how to compose a concise and clear composition and to avoid excessive detail. So well did he learn that Raphael's early painting can barely be distinguished from Perugino's. Of course, in time, Raphael, who had been born with a great gift, surpassed the master. Vasari says, "[He]e painted a small panel picture of the *Marriage of our Lady* [*Marriage of the Virgin*] which shows very forcefully the way his own style was improving as he surpassed the work of Pietro" (Vasari, p. 286).

Perugino's influence can be seen especially in the long, open piazza or square obviously revealing perfect orthogonals, or lines of perspective, that recede to a vanishing point. One also discerns Perugino's influence in the order and placing of relationships between the figures and the graceful wholesomeness, the perfect balance between the figures and the architecture. The paintings Raphael did in his master's style made him popular, and a multitude of commissions came his way. And although he had learned most of what he knew from Perugino, by late 1504, the far more talented Raphael, had to look for other models in order to progress. His desire to go beyond his master drove him to search beyond Perugia.

Gradually and cautiously, Raphael altered his style and mastered the great innovations of Leonardo and Michelangelo. In his 1504 *Marriage of the Virgin,* he conforms closely to the work of the same subject by Perugino, painted between 1500 and 1504. Although his placement of figures and background is similar,

he presents details that reveal the newest achievements in art, such as the architecture of the High Renaissance.

In 1504 Raphael was associated with the Italian painter of the Umbrian School, Bernardino Pinturicchio (c. 1454–1513), who had also studied under Perugino. In the beginning Pinturicchio's decorative works interested Raphael and, in search of new ideas, he followed him to Siena. It wasn't long, however, before he left the artist and moved to Florence. This time Raphael carried with him a letter of recommendation to the Gonfalonier (high official) Soderini from the Duchess of Montefeltro.

In this period of unique change in the arts, forceful debates surrounded painting, which still struggled against medieval ideas, trends, and even patrons who preferred Gothic figures and gold backgrounds. This period on the cusp of the sixteenth century marks the time when Leonardo had just painted his *Mona Lisa* and Michelangelo had just completed his *David*. Raphael, at the time 21 years old, could have felt overwhelmed with such a plethora of new ideas. Whether he did or not, his work changed. Vasari noted that "after Raphael had been in Florence, that influenced by the many works he saw painted by the great masters he changed and improved his style in painting so much that it had nothing to do with his earlier manner; in fact, the two styles seemed to be the work of two different artists, one of whom was more proficient than the other" (Vasari, p. 289).

Raphael was a kind, well-liked person, and his patrons accepted and admired every panel he painted. Hartt says of this period in his life: "He fell into an avid market. Appetites that had been excited by the unattainable Leonardo and Michelangelo could be satisfied rapidly by the facile Raphael. In three short years, in addition to other major works, he painted no fewer than seventeen still-extant Madonnas and Holy Families for Florentine patrons" (Hartt, p. 472).

Subsequently, Giuliano della Rovere or Pope Julius II (1443–1513; pope 1503–1513) called him to Rome. At this time neither painters nor patrons in Rome knew him. It wasn't long, however, before he made a profound impression on not only Julius II but also the entire papal court. After this, overwhelmed with commissions, his authority as a master grew and continued to grow until his death. No doubt his manners, quiet charm, and personal dignity helped him.

Accordingly, patrons showered Raphael with important commissions. "Julius II . . . entrusted [Raphael] with the frescoes for one of the papal rooms in the Vatican, the stanza della Segnatura" (Osborne, p. 950). After this, he worked in Rome until his early death in 1520. Pope Julius II had hired Raphael acting upon the counsel of Italian High Renaissance architect Donato Bramante (1444–1514), originally from Urbino and one of the architects of St. Peter's. Though the pope could not claim it was his idea, he never regretted his decision.

At length, Raphael was to paint a cycle of frescoes in a suite of medium-sized rooms in the Vatican papal apartments, collectively called the stanze, the area in which Julius lived and worked. Northern Italian painter Giovanni Sodoma (1477–1549), who had worked around Siena, had done the preparatory work, and Sienese painter Baldassare Peruzzi (1481–1536) had been commissioned earlier; however, Julius had never been satisfied with either of them.

To begin, Julius gave Raphael instructions for the stanze to center around a theologically outlined *concetto* or theme. Following the pope's suggestions, Raphael decorated the *Stanza della Segnatura* between 1508 and 1511 and the *Stanza d'Eliodoro*, 1512–1514. The third, the *Stanza dell'Incendio,* 1514–1517, Raphael designed himself but, overwhelmed with work, had pupils and assistants do the painting. As the commission was inordinately ambitious, Raphael had to recruit an army of pupils and assistants. He recruited so many, in fact, that it is not a simple matter in some cases to determine which work the various painters executed. However, historians have definitely concluded that one room is from the hand of Raphael: the first stanze, the *Stanza della Segnatura*—so called because it was in this room that the Pope put his signature on important documents.

Raphael began his work in 1509 and from the beginning abandoned completely the detail characteristic of renowned Italian painters such as Sandro Botticelli (1445–1510), Domenico Ghirlandaio (c. 1448–1494), and Piero della Francesco (c.1410/20–1492). Other contemporary artists based their work on the styles of these famous painters. In contrast, Raphael felt no influence from the accepted artists and composed in a simple, grand style that culminated in the harmony, symmetry, and balance for which he became known. His work, placed beside, for example, a Botticelli or a Ghirlandaio, looks modern, soft and fresh, whereas the great artists' works appear staid and stiff.

In the end, historians conclude that Raphael's most important commission were the four walls of the *Stanza della Segnatura.* For his subject he painted the historical justification of the power of the Roman Catholic Church through Renaissance Neoplatonic philosophy. The four frescoes are the *Disputa,* the *School of Athens* (the two most important), the *Parnassus,* and the *Cardinal Virtues.* The first two are large works; he painted the latter two on the smaller walls.

Following this, Raphael spent the last 12 years of his short life working on several masterpieces in Rome. Unlike other artists, he remained of mild temperament and was never prone to fits of anger. Also, he never found himself in combat with either patrons or other artists, and he avoided the great conflicts and insoluble, overwhelming problems that seemed to constantly torment other great Florentine artists. In addition to a moderate temperament, he moved quietly and effectively from one masterpiece to the next, improving his works with every new commission. Today one discerns the energy that vibrates within his paintings, a stirring that generates intensity from within.

One of Raphael's first masterpieces, persuasively dynamic while appearing staid and introspective, that has always found success and is still admired and studied is his *Marriage of the Virgin.*

Marriage of the Virgin, 1504

One of Raphael's earliest works is the *Sposalizio* or *Marriage of the Virgin,* a small oil on wood (5 feet 7 inches x 3 feet 10 1/2 inches) painted for the chapel of Saint Joseph in the church of San Francesco in Città di Castello, southeast of

Florence. Although an exact chronology of many of Raphael's works has not been agreed upon, according to James Beck, "it [the Marriage] is signed and dated 'Raphael Vrbinas MDIIII,' which establishes an early firm point in the artist's development" (Beck, p. 86).

After completing *Marriage of the Virgin*, Raphael left Umbria for Florence, where the rapidly evolving, style-altering artistic innovations influenced his art. This marriage scene is the last work Raphael painted in which he used Perugino's tried-and-true style. Most historians agree also that in this painting he surpassed his teacher's ability in every nuance. Moreover, after this work his new

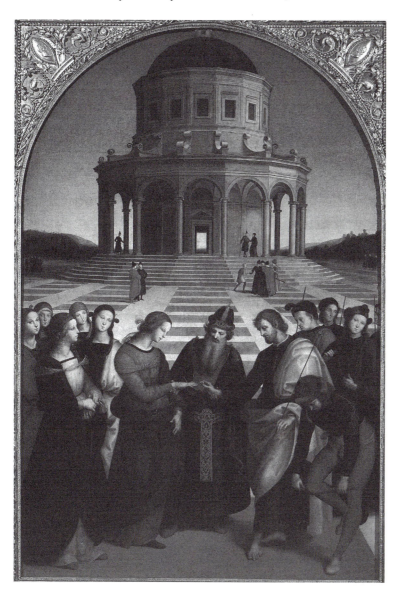

Raphael's *Marriage of the Virgin*. The Art Archive / Galleria Brera, Milan / Dagli Orti (A).

ideas, his softer figures, prevailed within his personal preferences over those Perugino had taught him.

Although the marriage of Mary to Joseph is not mentioned in the gospels, it has been a familiar theme since the earliest depictions of Mary. Jacobus de Voragine mentions the story in his *The Golden Legend*. Written in the thirteenth century, since its inception the book has been an important source of information on religious figures. Voragine wrote: "The Virgin Mary dwelt in the Temple with the other Virgins from her third year to her fourteenth and there made a vow to preserve her chastity, unless God otherwise disposed. Then she was espoused to Joseph, God revealing His will by the flowering of Joseph's staff" (Voragine, p. 204). Taking the story beyond Voragine and included in Raphael's painting are "seven virgins who had been Mary's companions during her upbringing in the temple [and] saw Joseph's rod burst into bloom and knew he was the chosen one" (Earls, p. 178).

For the marriage scene, Raphael depicted the episode in which Joseph, holding his rod, flowers bursting from the top, places a ring on Mary's finger. (The ring, supposedly the real one, is kept in the Cathedral of Perugia.) While Joseph places the ring on Mary's finger, five virgins stand behind her on the left. At the same time on the right her unsuccessful suitors, some annoyed, congregate behind Joseph. Close to Joseph an angry suitor breaks his rod over his right knee, realizing that Joseph's blooming rod was the secret to marrying Mary. The figure to the right front works as a *repoussoir*, or figure in the foreground of the painting to give depth to and enhance the principal scene. Also in this work Raphael reveals his mastery of the foreshortening perspective he learned from Perugino. Another aspect learned from Perugino, is the perfectly drawn, balanced scientific linear perspective seen in the form of an open piazza behind the figures. Orthogonals, in the form of pavement stones, run to the polygon centralized temple in which Mary lived before her marriage. The cupola or dome reaches the rounded frame at the top of the painting.

For the feeling of infinite space, Raphael opened the temple doors front and back so that the viewer sees through the temple to infinity blurred by aerial perspective, also known as sfumato or haze. Raphael used architect Filippo Brunelleschi's (1377–1446) delicate, elegant arcades that form a loggia, a walkway with columns on the outer side, around the entire temple. In the immediate foreground, the figures perform the marriage. In order to bring the two scenes together Raphael scattered smaller figures between the temple and the primary drama in the front. They talk in groups and walk about the spacious piazza.

One is reminded of the Marriage scene painted by Perugino. There seems, at first study, a resemblance between the two, but Raphael did not just copy his master's work. In fact, in most pictures of this subject, not just Perugino's and Raphael's, the arrangement of the figures is almost the same. For the purpose of balance and symmetry, and being situated to marry the couple, the priest stands in the center. Facing the viewer, he takes the hands of the betrothed to join them together. To the right are Joseph's companions, to the left are Mary's. In the background is the simple landscape with the temple.

Differences do exist, however. For example, the foreground group of figures in Perugino's fresco appears boardlike and heavy. Also, his men and women look hard, as if painted from sculpture, and his priest does not possess stern dignity. Furthermore, his figure of Mary does not have the elegance and grace of Raphael's; his Joseph does not have the same gravity. At the same time, Raphael's supportive figures are more somber and dignified. Raphael's virgin is shy and modest, even in the manner in which she extends her hand to her new husband Joseph. The virgins behind her are properly serious and solemn. Finally, one cannot compare Perugino's hybrid building behind the figures to Raphael's more modern temple.

Even beyond all comparison with Perugino's, Raphael's *Marriage of the Virgin* is an example of masterful narrative painting revealing the young artist's solid, practiced expertise. Although he had been trained well by Perugino, his gift went beyond the master's, and by the end of 1504, after this painting, he left Perugino's style and searched elsewhere for inspiration.

Notwithstanding portraits and other works such as *Marriage of the Virgin,* the Renaissance world knew Raphael primarily as a painter of beautiful Madonnas. One of his most balanced, loveliest, most beloved masterpieces is the *Madonna of the Meadows.*

Madonna of the Meadows, 1505

Madonna of the Meadows is Raphael's first of a series and one of the artist's finest paintings. An oil on panel, it was painted in 1505. Scholars know the date precisely because of an inscription on the edge of the Virgin's dress. The *Madonna of the Meadows,* executed early in Raphael's career for Taddeo Taddei, shows traces of Leonardo's influence, especially his *Madonna and St. Anne.* Muntz separates the influence, however: "As regards types, expression, and colouring, this work was conceived under the influence of Leonardo, but the arrangement of the picture is wholly Raphael's, and the various preliminary studies show with what care he prepared for it" (Muntz, p. 138).

Specifically, in a typical Renaissance landscape, subdued and blurred in atmosphere, the painting offers a wide view of the Florentine countryside and hills behind the Madonna and her Child and the infant John the Baptist. (Viewers identify John, even though a small child, by his camel skin.) Although the painting is an original, in one concession to Perugino, Raphael situated the Madonna in the manner of his master. He seated her in front of faraway hills and arranged lower hills directly behind her purposely and perfectly located to emphasize her presence without overwhelming the babies Jesus and John the Baptist. Here, according to Kleiner and Mamiya, "Raphael placed the large, substantial figures in a Peruginesque landscape, with the older artist's typical feathery trees in the middle ground" (Kleiner and Mamiya, p. 656).

Using a carefully calculated design, Raphael balanced the composition with a perfect triangle as its basic design, placing the Madonna's head at the apex. Muntz tells us that "for the first time we find him [Raphael] putting into appli-

cation the pyramidal grouping which he had so long been studying with his friend, Fra Bartolommeo" (Muntz, p. 138).

To make the primary focus the Virgin, Raphael placed her in the center of the panel, and he turned her somewhat to the right so that she looks at the two children before her. She steadies the hesitating steps of her young child, holding a cross and moving toward John the Baptist. John is on his knees to receive it. Muntz describes the Virgin, presiding over this scene, and the landscape behind her: "The Virgin, at once gentle and proud, is very beautiful, especially in the contour of her shoulders, which the dress does not hide, and the drawing of the hands. Raphael has in this instance rivaled Leonardo in grace and he has also drawn inspiration from him in the landscape which forms a framework for the composition" (Muntz, p. 139). Although Raphael rivaled Leonardo in figures and landscape, he did not reach the earlier master's virtuosity with chiaroscuro. He experimented somewhat with Leonardo's gradations of light, but he never matched them and always returned, sometimes subtly, to Perugino's lighter colors. He preferred the precise, not the vague or unclear figures that chiaroscuro might produce. He never found himself fascinated with ambiguousness that might hide details.

In the seventeenth century Taddeo Taddei's heirs sold *Madonna of the Meadows* to the Archduke Ferdinand Charles of Tyrol, who hung it in his Château at Ambras; from there it moved to the Kunsthistorisches Museum at Vienna in 1773.

School of Athens, 1510–1511

The fresco *School of Athens* is located in the Vatican in Rome in the *Stanza della Segnatura*. The misleading title survives from the eighteenth century. Hartt provides an explanation: "The picture, universally recognized as the culmination of the High Renaissance ideal of formal and spatial harmony, was intended to confront the Disputa's theologians of Christianity drawn from all ages with an equally imposing group of philosophers of classical antiquity, likewise engaged in solemn discussion" (Hartt, p. 509).

In this work Raphael placed emphasis not upon the figures' discussions, but upon a harmonious horizontal composition. He lined the figures, at the top of stairs, in isocephaly (in which all the heads are in a row, all close to the same height). The result is that they appear as statuary groups arranged in a half-circle of great depth.

Raphael painted the two central figures—Plato and Aristotle, the two greatest philosophers of antiquity—set apart from the other, their heads somewhat higher for emphasis, before a wide arched doorway. Plato points toward the sky with his right hand and in his left he holds his book *Timaeus,* the Greek historian of Tauromenium (c. 356–c. 260 B.C.). Aristotle, beside him, also holds with his left hand a book, the *Nichomachean Ethics*. His right hand motions toward the figures all about him. Surrounding them are figures from the world of classical antiquity.

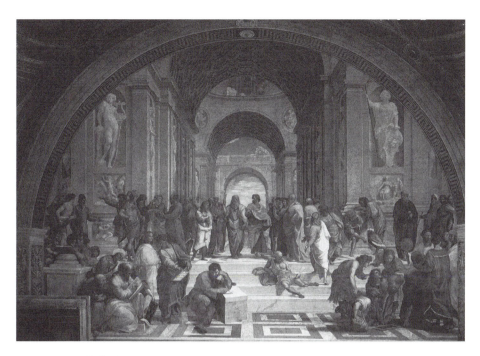

Raphael's *School of Athens,* 1510–1511, fresco Stanze della Segnatura Vatican for Pope Julius I, center Plato and Aristotle. The Art Archive / Vatican Museum, Rome / Album / Joseph Martin.

Raphael further divides the knowledge of antiquity into smaller groups and in other characters on either side of the figural arrangement centralized by Plato, pointing to heaven, and Aristotle. Diogenes, for example, sprawls on the steps a little to the left below Aristotle in perfect perspective. Below, at the lower left, the sixth century B.C. philosopher and mathematician Pythagoras writes while a servant holds up the harmonic scale or a series of numbers whose reciprocals are in arithmetical progression. Second-century Alexandrian astronomer and mathematician Ptolemy, on the right, holds high a globe for consideration. Also holding a globe close by is the astronomer Zoroaster. To his right, Greek Mathematician Euclid (c. 300 B.C.), draws a circle on a slate placed on the floor proving a theorem for students. Raphael painted Euclid as Donato Bramante (1444–1514), an Italian High Renaissance architect fascinated by geometry. Raphael also painted himself beside Giovanni Sodoma (1477–1549), at the extreme right, no small compliment to the Italian painter who was himself greatly influenced by the young master. Significantly, Raphael placed himself on the right side of the painting with the mathematicians and scientists. On the left are the ancient philosophers, men debating mysteries concerned with this world.

Surprisingly, from the left a youth, nearly nude, runs into the area holding under his right arm a loosely rolled scroll. Raphael filled him with such intensity that one feels he might carry new information that will settle a philosophical argument. The picture presents a few figures who merely appear to listen, others who only write, and others who offer comment. Raphael has painted the room of a school where intelligent individuals discuss ideas.

The room is a classical academic setting for the ancient philosophers and sci-entists of the ancient world. The viewer sees its interior covered with a bright open dome behind the two main figures. Above them are a deeply coffered vault and giant piers and aediculae, or niches holding statues—Apollo, to the left, and Minerva on the right. Intended to preside over the meeting, all are painted to recede into depth with an infinity of sky and white clouds beyond. Raphael based the *Apollo*—legs, body, and head—on Michelangelo's sculpture the *Dying Slave*. Raphael admired Michelangelo's work; however, though they lived in the same city, they were of different dispositions and were never friends. Michelan-gelo's temperament and lack of all normal sociability did not encourage other painters into his close acquaintance.

On the lower left, a little off center, a man sits alone within the fresco's math-ematically ordered space on the steps in the foreground. Seemingly not aware of the hum and bustle around him, absorbed in his own ideas, he leans on his left elbow and has his head propped firmly on his hand. With his right hand he writes on a piece of paper spread before him on a marble block. Curiously, every-thing about the man is different. For instance, he does not wear the clothes of the philosophers or their attendants surrounding him, and he has a beard. Also, he is large and wears the short, hooded smock and boots seen on sixteenth-century stonecutters. Historians know Raphael added him later because the fig-ure does not appear in the cartoon or preliminary drawings for the other fig-ures. More important, it has the face of Michelangelo. This is Raphael's portrait of the dark-haired Florentine sculptor, solitary, sitting alone, and directly in front, where the viewer will notice him first. Hartt speculates on his aloof pres-ence: "Apparently Raphael went into the Sistine Chapel with the rest of Rome in August 1511, experienced the new style [Michelangelo's] with the force of revelation, and returned to pay this prominent tribute to the older master" (Hartt, p. 511). It is possible Raphael saw Michelangelo sitting alone within a group or beside one of his marble blocks sketching. A great tribute to the mas-ter, Raphael's figure of Michelangelo is the most powerful of all the figures in the painting or even in his entire oeuvre before the *School of Athens*.

Philosophically, Raphael goes beyond painting with his simplicity of figures and perfection in architecture, in beauty and aesthetics. He reaches the higher realms one might consider the equivalent to an epic poem. The architectural background for the figures features a single story using a pseudo Roman Doric Order. (The Roman Doric Order is characterized by a base, a column, a capital with abacus and echinus surmounted by an architrave with a frieze of triglyphs and metopes.) However, the viewer cannot determine the shape of the room or even what holds up parts of the ceiling which has two supports in the form of two barrel vaults. Pendentives (triangular pieces of vaulting that spring from the corners of a rectangular area, serving to support a rounded or polygonal dome) with two circular roundels (round ornamental panels) end at the sides. The pen-dentives move straight to the floor and turn into walls.

Throughout the years, scholars, painters, and all those interested in beauty and history have admired this painting. Muntz says:

Every form of admiration has for centuries been lavished on the *School of Athens,* yet fresh beauties are to be discovered in it every day, and it may be said that the completion of this great work realized the dream of the Renaissance. The works of antiquity were at length equaled if not surpassed, and the *School of Athens* was the crowning point in a long series of centuries, but it is more than a point of development, it is a model in which no man has since attained. (Muntz, p. 270)

Finally, one recognizes that Raphael's *School of Athens,* replete with unusual color and movement, is part of an illustrated encyclopedia of the intellectual life and heritage of Julius II's Rome.

Galatea, c. 1512

Raphael painted the *Galatea*, a fresco, for the Sienese banker and patron of the arts Agostino Chigi. He painted the fresco on a wall of Chigi's Villa Farnesina in Rome. The story of Galatea derives from the ancient Roman poet Ovid's *Metamophoses* 13:750–897. It gave Renaissance artists, including Raphael, an exciting subject for composition using the nude. According to the story:

> Galatea was a Sicilian Nereid, or sea-nymph. She loved a handsome shepherd, Acis, and was herself loved and pursued by the Cyclops Polyphemus. The monstrous one-eyed giant sat on a hill overlooking the sea and played love songs to Galatea on his pipes. Later, while wandering along the seashore, he discovered her in the arms of Acis and crushed the youth under a huge rock. Galatea, in response to Acis' pitiful cries, turned him into a river, and she dived into the sea off the coast of Sicily. (Earls, p. 124)

Raphael's friend, Agostino Chigi, a self-made Sienese banker and art patron, had such wealth he became one of the most powerful men of his age, and with his money patronized the arts. He managed the state's papal affairs and kept himself in surroundings almost as opulent as those of the Pope himself. An uneducated man, he compensated for this lack with a quickness of intelligence and a real dislike for erudition and education. However, he pursued anything that would help him embellish and make more comfortable his existence. Painters found in him a supportive benefactor and protector and in this role he exercised influence over the development of art in Rome. His name became linked with Raphael's when he commissioned the painter to decorate his palace in Rome on the Tiber River, the Villa Farnesina (then the Villa Chigi). For his walls he requested some of his favorite scenes from classical mythology. Following Chigi's requests, Raphael painted the walls of the Villa Farnesina, capturing the essence of the ancient world in fresco. No one is certain of the exact date. Of all the paintings, one of the best is the large *Galatea* or *Triumph of Galatea*, which measures 9 feet 8 inches by 7 feet 5 inches.

In this work Raphael depicted the beautiful Galatea running from her gauche admirer the huge Cyclops Polyphemus (painted on a wall next to the *Galatea*) by Venetian painter Sebastiano del Piombo (c. 1485–1547). In a twisted, exaggerated *contrapposto*, or position in which the weight of the body is placed on

one foot, she voluptuously rides a shell, holding two reins, pulled sharply to the left by two fat leaping dolphins. While being placed in the center of the composition, her arms and her body twist toward her playful dolphins, one of which crunches an octopus with inordinately pointed teeth.

Above the scene, playful amoretti, or little cupids, flutter in the sky aiming their arrows directly at Galatea. They attempt to shoot her full of Polyphemus's arrows so that she won't be able to resist him. (Cupids traditionally remind the viewer that the theme of the story depicted involves love.) In the far right corner, partly concealed in fluffy clouds above the fracas, a lone cupid holds a battery of extra gold arrows of the sort that were destined to kindle love.

The first thing the viewer notes is that the fresco erupts in unbridled revelry and bacchanalia, frenzied merrymaking exploding in praise of human beauty and life completely abandoned to love and its multitudinous pleasures. Galatea, in a feat of twisted *contrapposto*, stands sturdy as the central figure while all others spiral around her in exuberance and excessive merriment. She carries an arch of drapery above her head blown wildly by the wind, the classical attribute of a sea-goddess seen frequently in Roman art. Surrounding her are playful erotic Nereids and tritons, or half men, half fish mermen with fins at their hips. Leading the parade is Cupid, or the Greek Eros, presented as a beautiful winged child. Galatea, herself a Nereid, flees, her head sharply turned so that she looks back and glances in the direction of the giant Polyphemus in Piombo's adjacent fresco.

Sistine Madonna, Madonna di San Sisto, 1512–1513

Painted on canvas, measuring 8 feet 8 inches by 6 feet 5 inches, the most beautiful of Raphael's portraits of Mary depicts her moving on clouds from another world toward the viewer. Raphael painted the Madonna probably through the offices of Julius II for the main altar of the Church of St. Sisto in Piacenza, a north Italian city situated on the Po River.

While the painting has always been a tour de force, much has been written about it. Beck tells us that "the Sistine Madonna is perhaps the most thoroughly discussed and analyzed of all Raphael's paintings—more than one lengthy monograph has been devoted to it—yet questions of interpretation remain unanswered" (Beck, p. 144).

Although the canvas does not have international stature in the wide world of art of all subjects, the *Sistine Madonna* is probably one of the most famous of all the many paintings of Mary. She looks upon her viewers with lovely enormous eyes that seem deeper and more penetrating than any Raphael ever painted. Mysteriously, he provided her with a perfect and intelligent comprehension of what will happen to her son, whom she has nestled carefully in both her arms. Also, her stance, her noble poise is identical to the posture admired by Michelangelo as one of the alternate designs accepted for the tomb of Julius II in 1505.

Specifically, on the left, on the authority of Beck, the pope's "features are recognizable in the person of the third-century Saint Sixtus II (in Italian, *Sisto*, hence

'Sistine')" (Beck, p. 144). Thus Raphael cleverly alludes to the Della Rovere family of St. Sisto; Julius's uncle, Pope Sixtus IV; and also in Julius himself.

With its great triangular composition, its quiet balance of design, and its splendid and unusual golds, grays, blues, greens, the *Sistine Madonna* is one of Raphael's paramount creations. Its beauty far surpasses any ideas a painter or critic might have had about Perugino's young pupil Raphael when he arrived in Rome ready to paint. No one would have thought the young boy would so quickly find himself holding the title of great master in a city spoiled by the best of Leonardo and Michelangelo.

To the right of the Madonna is the third century Christian martyr St. Barbara. According to the story, as told by Hall, her father had locked her in a tower with only two windows, hoping to discourage suitors. A little later, a workman added a third window at her request. After this, a priest, in the guise of a doctor, came into the tower and baptized her a Christian. "When Dioscurus [her father] returned she told him the three windows symbolized the Father, Son and Holy Ghost . . . Her father was enraged, and Barbara fled . . . with him in pursuit and hid in a clef in a rock . . . a shepherd betrayed her . . . and her father handed her over to the Roman authorities . . . she was tortured and just as she was executed by her father's sword, he was struck dead by lightning" (Hall, p. 40).

To present the story, Raphael painted curtains, like those of a stage, drawn to each side, to form a clever trompe l'oeil. He painted them open to reveal Mary and her Son, and they seem to stand like sacred relics on a stage temporarily for a second or two. This is not the first time artists employed curtains to emphasize a figure or subject. Medieval and Renaissance tomb artists used stagelike curtains in both bas-relief and three-dimensional sculpture. It is possible that such tombs provided Raphael with ideas that he used to suit his own purposes. Beck gives a good account of what the curtains reveal: "The vision is set before a wooden parapet upon which rests not only the papal tiara with the acorns of the [Della] Rovere *impresa* [motto] but delightful, seemingly bored, winged putti, who serve as a suitable counterpoint to the sacred figures above" (Beck, p. 144).

Raphael arranged the figures to form an equilateral triangle. He placed his figures against a vast palette of colors and clouds, and if one looks closely enough, one sees that he composed the clouds of countless cherubim, colored with heavenly pinks and blues, purples and golds.

Besides the picture itself, its figures, composition, color, is its history. Muntz gives an account of the picture's background: "The Madonna di San Sisto was painted for the convent of San Sisto at Piavcenza; it was acquired by the Elector Augustus III of Saxony in 1753 for 60,000 thalers (about £9,000). And has ever since been the chief ornament of the Dresden Gallery" (Muntz, p. 421).

The Madonna of the Chair, La Madonna della Sedia, 1514–1515

Raphael painted the oil on panel *The Madonna of the Chair* in Rome as a tondo, or round picture. In this work he changed not only the size of his three figures,

but also the shape of the picture's perimeter. The Madonna with her Child and the Infant John the Baptist occupy all the space available and even, upon close inquiry, seem to be squeezed into the circular space, nearly too small for three individuals. In measurement, if Jesus stood at the base of the circle, his head would touch the top. Even beyond this, to emphasize the round shape, most lines in the painting form circles: the drapery, arms, heads, the top of the Virgin's chair, her halo, and John the Baptist's halo.

Raphael designed his composition skillfully yet delicately within the tondo's severe restrictions. He purposely composed the figures in profile so that the design would appear less crowded; yet he included the Madonna's legs to provide a space for her child to sit. Although the figures appear natural and comfortable and relaxed, a person trying the position would find it cramped. Raphael painted as the outer limit toward the viewer the corner of the chair. It suggests a round globe or a sphere, the shape of which is repeated in the Madonna's right arm and her Child's left arm.

Raphael's curled composition of maternal affection—immensely appealing because of the figures' tight closeness, the quiet, gentle touching of faces, the pudgy feet, the exuded love—reveals a beauty unmatched. Raphael punctuated all this with unusual color choices, some quite daring for the time—for example, the green of the Virgin's dress, the red-orange sleeve that seems to be the softest velvet ever created, the round gold cuff that terminates the sleeve. The lower part of her dress, in shadow but delicately highlighted with points of gold light, is certainly a precursor for Rembrandt's late work in the 1660s.

Baldassare Castiglione, c. 1515

Raphael painted a portrait of his close friend Baldassare Castiglione, author of the famous *Book of the Courtier* (*Il libro del cortegano*), the manuscript finished in 1516 though not published until 10 years later. It outlined the characteristics expected of a gentleman at the court of Urbino, truly a model of sixteenth century Italian dignity. Castiglione himself, with his grace, intellect, seriousness, elegance, self-control, and balanced temperament, exemplified the perfect Renaissance writer and gentleman, he sat only twice for the portrait.

Raphael's tremendously successful portrait, originally painted on a wooden panel and transferred to canvas, depicts the famous author looking directly at the viewer. He is a kind, knowing philosopher, grave, serious, solemn, whose portrait Raphael focused with a calm, generalized light that highlights the face. Here, to emphasize the person Castiglione, Raphael used the spiral principle design of his earliest works. In composition, the knowledgeable viewer can follow the delicate spiral in the hat and the tilt of the head and the folds of the costume. Raphael also successfully captures the *riposo,* or self-control Castiglione recommends as one of the qualities of a true gentleman. Raphael shows the author in a dignified pose, a three-quarter view. Unfortunately, a section at the bottom, including part of the hands has been cut off. Old copies show both hands.

If the hands were there, as they can be imagined, the inner calm Raphael painted would become complete.

As with other portraits of the period, Leonardo's *Mona Lisa* influenced the pose. And like the Leonardo, Raphael concentrated on his subject's noble character, inner serenity and individual uniqueness. The neutral and toned-down colors, quiet umbers, ochers, and somber grays, match the disposition and spirit of Castiglione, a quiet, contemplative man. To heighten the figure, Raphael chose a pale, achromatic background and used a generalized light. Also, he included no buildings or charming countryside tableaux, as did other artists of the day. At the same time, he exaggerated nothing. The soft grays of Castiglione's costume reflect the cultivated gravity and self-restraint he successfully wrote about for a society tired of gaudy late fifteenth-century dress.

Critics agree Raphael's portraits are unique. Regardless of the passing of time, they continue to reveal their sitters in a moment of perfect peace, that time when their faces mirror their best qualities. The only defects Raphael considered were physical, since he was not willing to paint for posterity the features of only those who were beautiful to look at. Castiglione's hands indicate a man who appreciated and understood the powers of beauty in his own way, a message he articulated convincingly in the *Book of the Courtier.*

Besides the sitter, the painting itself had persuasive powers. As told by Hartt, "Rembrandt once tried to acquire this painting at auction. Forced to retire when the bidding went out of his reach, the great Dutch painter never forgot the composition, and twice did his own self-portrait in the pose and style of the Castiglione" (Hartt, p. 516).

Pope Leo X with Cardinals Giulio de' Medici and Luigi de' Rossi, c. 1517

After the death of Julius II, Leo X, a Medici, took the papal throne. At the time the Medici was the most powerful family in Italy. Leo was 38, fun loving, luxury loving, and exceedingly corpulent. Because he knew Michelangelo, with whom he had been acquainted since childhood, had a violent temper, he claimed he could not deal with him in any way. Therefore, commissions at the Vatican went to other artists. Raphael, always of good temper and liked by everyone, was one of the primary artists he commissioned.

Many people are shocked to discover that Leo X filled the Vatican with poets, philosophers, musicians, dancers, animal tamers, clowns, burlesque performers, and artists. All had equal importance in his eyes. Of course his penchant for entertainment drew, according to Hartt, some critics: "Pious pilgrims from northern Europe were shocked by the appearance of the pope and his cardinals in hunting dress and would have been even more outraged if they could have attended Vatican ceremonies, including funerals and beatifications, at which the Olympian deities were extolled at the expense of Christianity" (Hartt, p. 517). It was this personality that Raphael captured in Leo.

Leo X sat for the group portrait probably in 1517, and at the time Raphael painted a likeness that did not flatter him. In this oil on panel that measures 60 5/8 inches x 47 7/8 inches, Raphael established a higher level of individual personality examination than had ever before been achieved. He depicted the pope not occupied with affairs of the church, as some would have liked and expected, but with antiquarian scholarship mixed with the greed of the gratification of ownership.

To accomplish this look, Raphael painted Leo seated before a covered table taking personal pleasure in a magnificent, exceedingly expensive trecento illuminated manuscript. He painted the book in such minute detail and with such care that authorities have verified the original, located now in Naples.

Beside the book, a dazzling silver bell, ornamented with gold edges and a gold top, placed on the table, embellished with curls and vines, awaits the pope's hand. So precise are both the manuscript and the bell that historians believe Raphael must have used a magnifying glass to enlarge the minutiae. In fact, he painted, using the same tiny detail, an ornamented gold-framed magnifying glass in the myopic pope's left hand.

Curiously, facing Leo X from a peculiar angle at the right stands his cousin, the Cardinal Giulio de' Medici, who subsequently became Pope Clement VII (1523–1534) and also became a patron of Raphael. He was the son of Giuliano de' Medici, the younger brother of Lorenzo. Clement VII was therefore first cousin of Pope Leo X. Raphael, sensing the man's lack of strength, emphasized his weakness by painting him looking at nothing. To the left of Leo X is his nephew Cardinal Luigi de' Rossi, son of the pope's sister, who looks out of the picture and past the viewer, in fact also looking at nothing. He became cardinal on July 6, 1517, the year of the Protestant Reformation. In studied recognition of what these men were, Raphael highlighted both cardinals with a cross light; this light reveals two cheerless, almost ugly masks. Leo X is amazingly set off from both of them with a different, intensified light and altogether different colors. Viewers may not realize that all three men are close to the same age.

If not for the table leg at the lower right, the composition would be a perfect X-shape. Beyond this, for some unexplained reason, Raphael painted diagonal architecture at the top in the form of a molding, which recedes into the picture from the left, closest to the viewer, and moves to the right. When studied, the diagonal gives the portrait a curious ungrounded feel, and overall the picture leaves most viewers unsatisfied but usually unable to say why.

Adding to the feeling of unrest is Raphael's choice of colors. The cardinal's robes are an orange red, and the pope's biretta or square cap and mozzetta or short cape are purple magenta and exist on variously textured cloths in a odd polychromatic palette of reds. Strangely, above the meeting of the architecture and the colors is the pope's sullen, bloated face, painted in the kind of detail one sees in the work of mid-fifteenth-century Flemish painter Jan van Eyck. His head floats suspended in a strange, surreal space, his neck poking from his mozzetta. Still, Raphael has shown the pope with the aura of the power he possessed; he captured the grand dignity of his office. He did not change the man's

personality; rather he ennobled it as if the pope had sat for him at the height of his physical powers and the powers of his office. Yet, overall, including figures and background, the portrait's tense atmosphere almost quivers, and no doubt exists that Raphael captured every aspect of the pope's character, a person who allowed the Reformation to grow. Leo X, according to Hartt, "the peaceable pontiff, who had immediately dropped the aggressive political policy of his terrifying predecessor had no comprehension of his spiritual mission . . . and no inkling of what effects the revolt led by Martin Luther was bound to wreak. His learned and well-composed bulls were not enough to stop the Reformation" (Hartt, p. 517). Raphael's portrait captures as no other the man's stern power that, in the end, had no effect, the man's office that, against the formidable tide of Protestantism, accomplished little.

But the painting has much more. Raphael painted, just below Cardinal Rossi's head, a polished brass ball on the chair back that has a distorted reflection of the room. Recalling the famous convex mirror in Jan van Eyck's *Arnolfini Wedding* panel of 1434, in which Arnolfini and his bride are reflected from the back, one can discern, lighted from a window on the right, Raphael's own figure, albeit only a few vague brush strokes. (He is shown on the left of the sphere in the window's glare.)

Working for Pope Leo X, Raphael found himself in the midst of power and wealth not reached by many artists. His paintings show it. He omitted no details. As Vasari said: "One can see the pile of the velvet, with the Pope's damask robes rustling and shining, soft and natural fur of the linings, and the gold and silk imitated so skillfully that they seem to be real gold and silk rather than paint" (Vasari, p. 305).

Finally, with each individual depicted carefully and with immense insight, Beck finds that the portrait is all the more remarkable because no other like it existed at the time. "There is no picture quite able to match this group portrait, among the most successful of Raphael's career, until the next century and Rembrandt's *Syndics* [*The Syndics of the Draper's Guild,* 1662]" (Beck, p. 166).

Transfiguration, 1517

Three years before Raphael's death, Cardinal Giulio de'Medici commissioned the artist to paint a large oil on panel of the *Transfiguration* for his Cathedral of Narbonne in France. The final work measured 13 feet 3 3/4 inches by 9 feet 1 1/2 inches.

Although it was mostly finished by April 15, 1520, Raphael died at the age of 37 while painting it. His career, when compared to Michelangelo or Titian, who both lived nearly a century, was brief. Appropriately, the painting was on display at his funeral in the Pantheon in Rome.

The masterpiece, sections painted by Giulio Romano after 1520, possessed such power that the cardinal kept it at San Pietro in Montorio in Rome rather than, as had been intended, sending it to the Cathedral of Narbonne in France.

The story of the Transfiguration, which Raphael followed closely, is told in the gospels of Matthew (17:1–13), Mark (9:2–13), and Luke (9:28–36). According to Matthew: "And after six days Jesus took with him Peter and James and John his brother, and led them up a high mountain apart. And he was transfigured before them." (Matt: 17:1–2). This was "when Christ manifested his divine nature to the disciples Peter, James and John. He took them up a mountain . . . and in their presence became transfigured: his face shone like the sun and his clothes became dazzling white. Moses and Elijah appeared on either side of him and conversed with him" (Hall, p. 307).

Although one tends to think of the Transfiguration as a phenomenon of the western church, it is possible to find the subject in the eastern church as early as the sixth century. At this time the Transfiguration was celebrated as a feast. But besides the Transfiguration itself, Raphael also painted the biblical account that immediately follows the scene, when Christ descends from the mountain and finds his apostles arguing with Jewish scribes. A father had brought his epileptic son to Christ to be cured. The apostles could not cure the sick young boy when Christ was not on earth during the Transfiguration. Christ cured him when he returned to earth.

For emphasis, Raphael depicts this scene directly under the Transfiguration. In this lower drama, the lighting is darker with extreme contrasts of light and dark. Above, the upper half is radiant with the nearly blinding light of God, a light so bright in fact, its intensity threatens to blind Christ's three disciples. Drawing the two scenes into one is Raphael's spiral composition, a huge figure eight from the top of the design to the bottom that sweeps elegantly from arms to heads.

Yet even though Raphael unified the composition with a figure eight, the viewer sees immediately the discrepancy in the two painting styles—Raphael's on the top and a few of his pupils, probably especially Giulio Romano's, on the bottom. Romano's cold, hard style is seen in the possessed boy. One figure, however, at the far bottom left stands out to the viewer as being by Raphael: St. Andrew on his saltire, or X-cross, who cannot heal the afflicted boy, with his left arm and right foot depicted in extreme foreshortening straight out of the picture plane and into the viewer's space. Unusual for the early sixteenth century are the deep and contrasting lights and darks surrounding him. As Beck observed, the figure, with its extreme and twisted *contrapposto*, its severe and dramatic contrasts of light, became a model 70 years later for the baroque painter Caravaggio (1573–1610). "The *Transfiguration,* with its exceptional and complicated light, was for Caravaggio and his enormous following in the seventeenth century what Michelangelo's *Cascina* and Leonardo's *Anghiari* cartoons had been for sixteenth-century painters" (Beck, p. 174).

The panel, when cleaned, revealed far brighter than expected colors, especially the lower half, where colors take on the force and energy of sunlit stained glass, especially the reds and greens. These piercing oil colors against their dark, dramatic background of tenebrous corners and deep drapery folds, inspired in-

numerable artists for years. Contrasting the lower figures are those on the upper half, where Raphael blended blues with dusty golden lights. Golden motes shift and swirl, blown by the unseen, unheard energy of the heavens, spun through the entire heavenly transfiguration and Christ's white robes.

Other Works

When Bramante died in 1514, Raphael was named papal architect. In this position he was to continue the construction of St. Peter's in Rome. Nevertheless, commissions for Madonnas, frescoes, mosaics, and portraits continued to come his way. Also, he was asked to decorate a third stanza in the Vatican, the *Stanza del-Incendio*, and to do paintings for other rooms in the Vatican. This included the loggia, or gallery with one open side, designed by Bramante.

Raphael also directed artists on new structures, including a palace, church, and villa for Cardinal Giulio de'Medici. At the same time, he was appointed superintendent of antiquities and given complete power regarding excavations on papal lands. He drew a map of ancient Rome on which he identified all known monuments. He became so busy he had to employ assistants to help, including painters who were called in for special assignments. Because so many hands contributed to the project, the work is in places uneven. Figures by lesser pupils are, in some cases, obvious. "[A]nd yet, all in all, more than half the surface is surely by him [Raphael], especially in the most important commissions" (Hartt, p. 518).

The most impressive of the pictorial projects for which Raphael was commissioned was a series of 10 tapestries. For this project he had to produce 10 full-scale cartoons or preliminary sketches in color. He painted these in about 18 months between 1515 and 1516. The 10 tapestries were to be woven by tapestry weavers in Flanders. The finished tapestries were to represent scenes from the Acts of the Apostles to complete the lower walls of the Sistine Chapel. The results were so exciting that weavers reproduced the cartoons in many new tapestry series up through the eighteenth century. Artists also reproduced the engravings as well and surprisingly they influenced more artists than any of Raphael's other works. French baroque painter Nicholas Poussin (1593/ 94–1665) in the seventeenth century and French Neo-Classic painter Jacques-Louis David (1748–1825) and Jean Auguste Dominique Ingres (1780–1867) in the nineteenth century, for example, were enormously influenced by Raphael's work.

According to Hartt the process for making the tapestries ran into some difficulties:

> Although Raphael knew that he must design his compositions for execution in reverse, it is not clear whether he understood how different his colors would look when translated by the weavers into dyed wools heavily intermingled with gold threads. The tapestries were subsequently in part mutilated, three cartoons were

lost, and the other seven were acquired by King Charles I of England in 1630. The original cartoons had been cut in strips for the convenience of the weavers and were not remounted and exhibited as works of art until 1699. (Hartt, p. 518)

During his last years Raphael occupied himself with architecture. Italian engraver Marcantio Raimondi (c. 1480–c. 1534) produced many of Raphael's designs as engravings and through prints his work spread and his influence became immense. He became the divine painter, the model of all schools. His place in the history of art is certainly secure if only for the technical ability to draw rounded forms on a two-dimensional surface. In this he remains still unrivalled.

In the end, every artist has his critics, and Raphael was no exception. One critic had this to say about Raphael's overall oeuvre: "Raphael never did, in fact, perfect his representation of the nude with the genius of a Michelangelo. But he made up for this failing by attacking every other artistic problem with gusto: the rendering of landscape and clothing, the anatomy of animals and the human likeness in portraiture, the portrayal of the light of day or night" (Ruskin, p. 40).

Finally, too many duties exhausted Raphael's strength. He died in Rome after a short illness on Good Friday, April 6, 1520, on his 37th birthday. The Vatican held a mass for his funeral in Rome. At his request The *Transfiguration*, the enormous altarpiece that was his last painting (commissioned in 1517), was placed at the head of the bier, and he was buried in the Pantheon in Rome. His tomb was placed inside so that through the unglazed oculus or round window at the apex of the dome, the light would always shine down on him.

Raphael's death marked the end of an important period in art, a summit of ideal classical beauty and virtue not reached since. In his work the important ideals of Christianity and the perfect models of classical antiquity existed in exact harmony.

Bibliography

Beck, James. *Raphael.* New York: Harry N. Abrams, 1976.

Earls, Irene. *Renaissance Art: A Topical Dictionary.* Westport, CT: Greenwood Press, 1987.

Hall, James. *Dictionary of Subjects and Symbols in Art.* Revised ed. Oxford, England: Westview Press, 1979.

Hartt, Frederick. *History of Italian Renaissance Art.* 3rd ed. Englewood Cliffs, NJ: Prentice-Hall, Inc., and New York: Harry N. Abrams, 1987.

Kleiner, Fred S. and Mamiya, Christin J. *Gardner's Art through the Ages.* 11th ed. New York: Harcourt College Publishers, 2001.

Muntz, Eugène. *Raphael, His Life, Works and Times.* Boston: Longwood Press, 1977.

Osborne, Harold. Ed. *The Oxford Companion to Art.* Oxford: Clarendon Press, 1978.

Vasari, Giorgio. *Lives of the Artists.* Trans. by George Bull. Middlesex: Penguin Books, 1971.

Voragine, Jacobus de. *The Golden Legend.* Trans. by Granger Ryan and Helmut Ripperger. New York: Longmans Green and Co., 1969.

Glossary

Abacus (pl. abaci) The square block that forms the uppermost part of a capital.

Acanthus leaves The saw-toothed leaves of a thistle plant used as an architectural enrichment on capitals and in other places for ornamentation. They form the leaves on the Corinthian and Composite capitals.

Aedicula, also aedicule or adicule (pl. aediculae, aedicules, or adicules) The architectural frame of an opening, consisting mainly of two columns supporting an entablature and a pediment. A niche for a statue.

Annunciation The announcement to the Virgin Mary by the angel Gabriel of the Incarnation of Christ. Usually a dove appears to indicate that Mary has conceived by the Holy Spirit and will give birth to the Son of God.

Architrave The main horizontal beam or lintel, the lowest part of the three primary divisions of the entablature, sometimes called the epistyle. The word is loosely applied to any molding around a door or window.

Archivolt The continuous architrave band on the front of an arch, following its contour.

Arriccio The rough, first coat of plaster that an artist spreads on a wall in making a fresco. Compare with intonaco.

Attic story A story over the main entablature of a building. Also, the upper story of a building yet possibly not as high as those under it.

Balustrade Short posts or pillars in a series supporting a rail form a balustrade.

Barrel vault Also called tunnel vault and wagon vault. The simplest vault form, it is in the shape of a semicylindrical arched roof or covering. Tunnel vaults can be subdivided into bays by transverse arches.

Basilica A term used for any church whose plan was taken from Roman public buildings. Usually entered from one end, it has a longitudinal nave terminated by an apse and flanked by two or more side aisles.

Bay An area into which a building may be subdivided. A space formed by architectural supports such as columns. Also, a vertical division of the exterior or interior of a building marked not by walls but by windows, architectural orders, transverse arches, pilasters, or buttresses.

Biretta A square hat worn by priests, bishops, and cardinals in black, purple, and red, respectively.

Buttress Support for a building that counteracts the lateral pressure from a vault or an arch.

Caduceus An attribute of peace. Later the emblem of a Greek messenger used to guarantee unmolested passage. Also, an attribute of one of the 12 gods of Olympus, the Greek god Hermes (the Roman Mercury). It has two serpents wrapped around it and two small wings at the tip.

Campanile A bell tower from the Italian word for bell, *campana*. It can be standing close to or attached to a building.

Canon law Law governing the ecclesiastical affairs of a Christian church. Canon laws, called *Corpus Juris Canonici*, governed the Roman Catholic Church until 1918. Also *Codex Juris Canoniel*.

Capital The uppermost part of a column, pilaster, or pier surmounted by the lowest part of an entablature.

Carmelite Order This order was begun in the mid-twelfth-century by the crusader St. Berthold (born at Limoges in France, died 1195) and his followers, who settled in caves on Mt. Carmel and led lives of silence, seclusion, and abstinence. About 1240 they migrated to Western Europe, where the rule was altered, the austerities lessened, and the order changed to a mendicant or begging one analogous to the Dominican and Franciscan orders.

Cartoon From the Italian *cartone,* meaning a big sheet of paper. A full-sized drawing (or a fragment) made for a painting, tapestry, or other large work made in minute detail. When complete, it is ready for transfer to a panel, canvas, or wall. Used before the Renaissance by Gothic glaziers, a cartoon was indispensable for making stained glass. Renaissance painters may have borrowed the idea from this earlier period.

Casein A phosphoprotein used in painting that is one of the chief components of milk. Casein is used in coating paper and in making cold-water and emulsion paints.

Catasto A graduated tax in Florence in 1427 on income and property needed to pay for the city's defense.

Chiaroscuro A word used to indicate shading in drawing and painting. From the Italian *chiaro* for light and *oscuro* for dark. Less frequently used, the French *clair-obscur* means the use of light and dark in a painting or drawing to produce the effects of modeling.

Closed garden A garden in which the Virgin Mary sits. A symbol of her purity.

Coffer A recessed or sunken panel in a ceiling that can be a variety of sizes and shapes. Also called caisson or lacunar.

Colossal Order Any order whose columns extend from the ground up through two or several stories. Sometimes called a Giant Order.

Composite Order This order combines features of the Ionic with the Corinthian Orders. It was first identified by Alberti (c. 1450) and is considered the most elaborate of the five orders in architecture.

Condottiere An Italian word for a mercenary (hired soldier) military leader, such as a captain.

Console A bracket in the form of an S-shaped scroll with one end wider than the other. A console has many uses, either vertical—against a wall to carry a portrait bust, for example—or horizontal, as the visible part of a cantilever for support. Keystones (the central stone of the arch) of arches are sometimes modeled as consoles.

Contrapposto An Italian word that once meant a pose in which a position of the human body involved twisting of the vertical axis, resulting in head, shoulders, and hips turned in different directions. A position in which parts of the body are in opposition to each other situated on a central vertical axis.

Corinthian Order Invented by the Athenians in the fifth century B.C. is differentiated from the Ionic by its acanthus leaf–encircled capital. The Corinthian Order has no separate rules for the cornices and other ornaments.

Cornice In classical architecture, the top, projecting architectural feature on a building. The uppermost part of the three primary divisions of the entablature.

Crenellation Indentations or notches used along the tops of walls in citadels and battlements or for decoration.

Cross-hatching A kind of shading marked in two layers of parallel lines, one layer crossing the other at an angle. Hatching is shading with one layer of parallel lines.

Cupola A dome crowning a roof or turret (small, slender tower).

Dentils Small, sometimes closely placed, blocks forming one of the members of a cornice or top of a building.

Diptych An altarpiece consisting of two panels joined together.

Di sotto in sù The Italian phrase *di sotto in sù* (sometimes *sotto in sù*) means "from below upward." Artists use the term to describe extreme foreshortening or representing the lines of an object shorter than they really are. This extreme illusionistic representation may show figures on a ceiling so foreshortened as to seem actually floating above the spectator. Artists sometimes use the term "frog perspective" to indicate such foreshortening.

Dome A roof formed by a series of rounded arches. A large cupola supported by a drum or vertical wall.

Donor The patron of a painting sometimes represented in the picture.

Doric Order The Greek Doric and Roman Doric both have a Greek origin but they developed differently. Both have triglyphs and metopes in the frieze. Also, in both, the capital or top of the column consists of an abacus supported by an echinus. The Greek Doric has no base, whereas the Roman Doric always has a base.

Drum A cylindrically shaped vertical wall supporting a dome.

Entablature The upper part of an architectural order consisting of an architrave, frieze, and cornice and supported by columns.

Entasis (pl. entases) A subtle curve sometimes beginning one-third of the way up a classical column. (All classical columns are wider at the base than at the capital.)

Eucharist From the Greek word for thankfulness and gratitude. Also Holy Communion, The Lord's Supper, and the consecrated bread and wine used.

Façade In architecture, the front, face, or exterior of a building. In general, the front part of anything.

Fluting Shallow, concave grooves that form vertical channels cut in a shaft, column, or other surface. They may meet at a sharp edge and form an arris or be suspended by a flat ridge called a fillet. Found in all orders except the Tuscan, although optional in the other four orders (Doric, Ionic, Corinthian, and Composite).

Fresco Italian word for fresh. A painting done on wet lime plaster with pigments suspended in water so that the plaster absorbs the colors. Lime plaster and pigment, chemically bound, become part of the wall. True fresco is known as *buon fresco*. Fresco *a Secco* (*secco* is Italian for dry) is painting on dry plaster, which is less durable and tends to flake.

Frieze The middle of the three main divisions of the entablature. It is a plain horizontal band between the cornice above and the architrave below. The Doric frieze usually has triglyphs and metopes, whereas the Ionic, Corinthian, and Composite sometimes have figure sculpture or other decoration.

Gilding Overlaying with a thin layer of gold paint or a gold-colored substance.

Golden Legend A book by Jacobus de Voragine, archbishop of Genoa, written in the thirteenth century, that is a collection of the lives of the major saints and other individuals.

Golgotha From the Aramaic word for skull. Calvary. The place where Jesus was crucified. Also, a place of agony or sacrifice.

Grisaille Painting using only one color, usually grays. Renaissance artists used grisaille for effects of modeling and often imitated sculpture with this technique. Giotto's series of *Virtues and Vices*, in the Arena Chapel in Padua, suggest gray stone.

Guilloche A decorative design in which two or more lines or bands are interwoven to make circular spaces between them.

Harpy From the Greek word for snatcher. In Greek mythology, a creature with a woman's head and a bird's wings, legs, claws, and tail that seizes the food of its victims and carries souls of the dead to hell.

Impost block In architecture, a block with splayed sides placed between the abacus and the capital.

In scurto Extreme foreshortening or representing lines of an object shorter than they actually are in order to give the illusion of proper size.

Intarsia A surface decoration made by inlaying small pieces of wood in patterns; a kind of mosaic woodwork.

Intercolumniation In architecture the distance, measured in diameters, between two columns. Also known as a bay. Different intercolumniations are possible, as in the Doric order, where spacing is controlled by the triglyph-metope locations in the frieze.

Intonaco The finishing coat of fine plaster in fresco painting. Compare arriccio.

Ionic Order An order originating in Asia Minor about the middle of the sixth century B.C., defined in Roman architecture by two main characteristics: 1. A voluted or spiral-scrolled capital. 2. Dentils or small square blocks in the cornice.

Loggia (pl. loggie) An open gallery or arcade.

Lunette A small round, crescent-shaped, or arched-top window in a vaulted or covered ceiling or roof. Also, a semicircular opening. Can also be referred to as a tympanum. The term can also be applied to any flat, semicircular surface that might be decorated. Sometimes spelled lunet.

Medium The material in which an artist works; for example, a sculptor's favorite medium is stone. More specifically, in painting, the vehicle, usually liquid, with which the pigment is mixed.

Metope The square area between two triglyphs in the frieze of a Doric order. Sometimes artists leave the metope plain, but it can also be decorated with bucrania or ox skulls, trophies, or other ornaments. The Greeks sometimes used the metope space to depict in low and high relief Lapiths and Centaurs battling.

Mezzanine In architecture, a low-ceilinged story between two main stories in a building, usually immediately above the ground floor and sometimes in the form of a balcony projecting only partly over the floor above it. Also called an *entresol,* French for mezzanine.

Module A unit of measure that is half the diameter of the column just above its base. In classical architecture, the relative sizes of all parts of an order are usually given in modules.

Mozzetta A short cape with a small hood worn by the pope and other dignitaries of the Roman Catholic Church.

Niello The art of carving on silver.

Niello prints Niello plates have engraved designs filled with a black composition of metal alloys used for decoration. Impressions taken from such plates or from plaster casts of such plates are called niello prints. In Italy they existed in the second half of the fifteenth century.

Oeuvre French word for work. The oeuvre of an artist includes all the works he or she created in a lifetime. An *Oeuvre Catalogue* is a record of every painting, drawing, statue, and building by a single artist.

Order The total aggregation of parts comprising the column and its proper entablature. The principal divisions of the column are base, shaft, and capital. The principal components of the entablature are architrave, frieze, and cornice. A base under the column is not an essential part of the order, but various bases are described by different architectural theorists.

Orthogonals Lines running at right angles to the picture plane. In scientific linear one-point perspective, they converge at one vanishing point in the distance.

Palazzo (pl. palazzi) Italian word for a large house.

Passion A word used in the church to describe the sufferings and death of Christ during his last week of earthly life—the events leading up to and following the crucifixion.

Pediment In classical architecture, used to indicate a low-pitched gable or triangular space above a portico created by the sloping eaves and horizontal cornice line of a gabled temple or other classical building.

Pendentive Shaped like a spherical triangle, a concave spandrel going from the angle of two walls to the base of a circular dome. Architects use the shape to support a circular dome over a square or other shaped space.

Piazza Italian word for an open public square, usually surrounded by buildings.

Pietà An Italian word meaning pity and piety. A representation in painting and sculpture of Mary, the mother of God, grieving over the body of her Son after the Crucifixion.

Pietra serena A brownish-gray limestone used in architecture.

Pilaster A flat, vertical, shallow pier or rectangular column projecting only slightly from a wall of which it forms a part. In classical architecture, it conforms with one of the orders; that is, it has a base and a capital and can be fluted. Pilasters are ornamental but may have a quasistructural function when acting as *responds* (half piers).

Plinth A square piece of masonry or other material under the base of a column or pedestal.

Podium A base or plinth supporting a column.

Polyptych An altarpiece made up of more than three panels joined together.

Post and lintel A trabeated (in contrast to arcuated or arched) system of architecture in which two posts support a lintel.

Predella Italian for "kneeling stool." A horizontal band below an altarpiece. Usually the artist of the altarpiece paints scenes on the predella that coincide with the main subject. The word is also applied to a raised shelf at the back of an altar, to a picture on the front of such a shelf, and, loosely, to any subsidiary picture forming an appendage to a larger one, especially a small painting or series of paintings beneath an altarpiece.

Prie-dieu (pl. prie-dieux) A small, low reading desk with a ledge for kneeling at prayer. In painting the Virgin Mary is sometimes shown at her prie-dieu.

Putto (pl. putti) Italian for "little boy." Cherubic winged boys used in Renaissance painting, sculptural, and architectural decoration. The chubby child originated in the Greek god of love, Eros, or the corresponding Latin personifications, Cupido and Amor.

Quattrocento Italian for 1400s or fifteenth century.

Quoins From the French *coin* for corner. The dressed stones at the corners of buildings, usually put in place so that their faces are alternately large and small.

Relief Sculpture that is not freestanding. It has a background, thereby approximating the appearance of painting. Several names indicate different depths of projection. The highest is *alto-rilievo*, or high relief, which is nearly detached from the ground (e.g., stone or bronze). *Next highest is mezzo-rilievo,* then low or bas-relief (*basso-rilievo*), and finally *rilievo stiacciato* or *schiacciato*, which can be mere scratching. *Cavo-rilievo* is relief in reverse, that is, sunk into the surface.

Rilievo schiacciato Italian for "flattened relief," referring to a kind of sculpture created by Donatello in the fifteenth century which distance within the picture is achieved by physically shallow optical suggestion rather than sculptural projection.

Rustication Architectural term for beveling the edges of stone blocks to emphasize the joints between stones. The textural effect of a surface can be exaggerated or, when not deeply cut, deemphasized. Several styles of rustication exist. Rustication is also known as cyclopean or rock-faced with large rough-cut blocks straight from the rock quarry, or carved in a way to look as if they were. Diamond-pointed rustication displays each stone cut in the form of a low pyramid. Frosted rustication displays stone cut to simulate icicles. Smooth rustication has neatly finished blocks that present a flat surface with chamfered edges (a flat surface created by cutting off a square edge) to emphasize the deep-cut joints. Vermiculated rustication has blocks carved with shallow, curly channels like worm tracks on every block's surface. Italian architects used rustication as a way to create grandeur to palazzi (palaces or imposing residences) by emphasizing as much as possible the massiveness and strength of the stones.

Sacra conversazione Italian for "holy conversation." A Madonna and Child conversing with several saints from different epochs—for example, St. Francis (1182–1226) and St. John the Baptist, who lived during the time of Christ.

Sfumato Italian word for "smoky." A method of painting developed by Leonardo that softens outlines with subtle gradations of light and dark.

Shaft That part of a column between the base and the capital.

Sibyl In ancient Greece and Rome, a woman consulted as a prophetess or an oracle.

Silverpoint Drawings made in the fourteenth and fifteenth centuries with a stylus made of sterling silver, producing a fine line. Finished drawings were usually on paper or parchment. Also, a stylus made of silver.

Size Substance artists use as glaze or filler on porous materials, as on plaster, paper, or cloth. It can consist of any layer or any thin, pasty substance such as glue, flour, varnish, or plant secretions such as resin.

Soffit The underside, or intrados, of any architectural element where it does not rest on columns.

Stanza (pl. stanze) Italian for "room."

Stele (pl. stelae) A Greek word indicating a carved stone monument used to mark a grave or carry an inscription.

Stucco Sculptural stucco (not to be confused with plaster or calcium sulphate) is dehydrated lime (calcium carbonate) mixed with finely crushed marble dust and glue. Some artists strengthen it with hair. This formula resists weather and can be colored. Artists use stucco for ornamental decoration of ceilings, walls, outside, or inside. The process dates to ancient Egypt. Some early Egyptian pyramids c. 2500 B.C., contain stucco work still intact.

Tempera From the Italian *temperare,* which means to mingle. Tempera is a process of painting in which pigments (any coloring matter used to produce color) are mixed with size in the form of glue, flour, varnish, or plant secretions such as resin, casein, or egg, and especially egg yolk. This mixture produces a paint that dries to a dull finish.

Tenebrism In painting, the use of extreme light and dark.

Tondo A round painting or relief sculpture.

Triglyph A feature of the frieze of the Doric order. It consists of a vertical element with two vertical channels and two half-channels at the edges. Together these channels equal three grooves.

Triptych A three-paneled altarpiece or painting.

Trompe l'oeil A painting or decoration whose main object is to deceive the eye as to the actual reality of the objects represented and give a convincing illusion of reality.

Tuscan Order One of the five orders, resembling the Greek Doric but with unfluted columns and bases. Also features more space (intercolumniation) between each column.

Volute A spiral, scroll-like form, an ornament resembling a rolled scroll. Especially prominent on capitals of the ancient Greek Ionic and Roman Composite Orders.

Voussoir A wedge-shaped block used when building a true arch. The central voussoir, which firms the arch, is the keystone. A voussoir is one of a series constituting an arch.

Index

ABOUT THE AUTHOR

IRENE EARLS is an independent scholar of art history. She is the author of *Renaissance Art: A Topical Dictionary* (Greenwood, 1987), *Napoléon III: L'Architecte et l'Urbaniste de Paris* (1991), *Baroque Art: A Topical Dictionary* (Greenwood, 1996), and *Young Musicians in World History* (Greenwood, 2002).